ADVANCE PRAISE FOR

Avatar, Assembled

"Much like the multiple customization options many games offer to videogame players, *Avatar, Assembled* offers the reader multiple fascinating angles from which to understand game avatars. Covering the social and technical aspects that make up our digital representations, the book draws on specific game examples, highlights well-known avatars, and brings in classic as well as cutting-edge theory about how and why these representations come to matter to us so much. For games scholars and interested players, this volume is not to be missed."

—Mia Consalvo
Professor, Communication Studies
Canada Research Chair in Game Studies and Design
Concordia University (Montreal, Canada)

Avatar, Assembled

Steve Jones
General Editor

Vol. 106

The Digital Formations series is part of the Peter Lang Media and Communication list.
Every volume is peer reviewed and meets
the highest quality standards for content and production.

PETER LANG
New York • Bern • Frankfurt • Berlin
Brussels • Vienna • Oxford • Warsaw

Avatar, Assembled

The Social and Technical Anatomy of Digital Bodies

Edited by
Jaime Banks

PETER LANG
New York • Bern • Frankfurt • Berlin
Brussels • Vienna • Oxford • Warsaw

Library of Congress Cataloging-in-Publication Data

Names: Banks, Jaime, editor.
Title: Avatar, assembled: the social and technical anatomy of digital bodies /
edited by Jaime Banks.
Description: 1st Edition. | New York: Peter Lang.
Series: Digital formations, vol. 106 | ISSN 1526-3169
Includes bibliographical references and index.
Identifiers: LCCN 2017026099 | ISBN 978-1-4331-3560-6 (pbk.: alk. paper)
ISBN 978-1-4331-3828-7 (hardback: alk. paper) | ISBN 978-1-4331-3829-4 (ebook pdf)
ISBN 978-1-4331-4326-7 (epub) | ISBN 978-1-4331-4327-4 (mobi)
Subjects: LCSH: Information technology—Social aspects. | Avatars (Virtual
reality)—Social aspects. | Internet games—Social aspects.
Classification: LCC HM851 .A927 | DDC 303.48/33—dc23
LC record available at https://lccn.loc.gov/2017026099
DOI 10.3726/978-1-4331-3829-4

Bibliographic information published by **Die Deutsche Nationalbibliothek.**
Die Deutsche Nationalbibliothek lists this publication in the "Deutsche
Nationalbibliografie"; detailed bibliographic data are available
on the Internet at http://dnb.d-nb.de/.

The paper in this book meets the guidelines for permanence and durability
of the Committee on Production Guidelines for Book Longevity
of the Council of Library Resources.

Table OF Contents

Figures

Tables

Tables

Acknowledgments

My sincere thanks goes to the remarkable scholars and designers who contributed to this book, and to my family (human and canine) who suffered fewer gaming sessions, sleepings-in, phone calls, and tennis balls as this book was completed. Thanks to West Virginia University who supported the authors' conference that helped make this project what it is, and in particular to the Department of Communication and our fearless leader Dr. Matt Martin for support. Thanks also to Cheryl Campanella Bracken, Joe A. Wasserman, and Andrew Gambino for their insight during that conference. Respect goes to myriad game developers who have given us digital bodies to engage. A serious high five goes to the artist Frenone who so brilliantly interpreted the notion of a body that balances human and technology (cover) and of a modern da Vincian avatar (Fig. 0.1). And thanks to Jonathan Blow of Number None and Mads Wibroe from Playdead for generous permissions to reprint their game graphics. ~JB

Introduction

(Dis)Assembling the Avatar

JAIME BANKS

Arms outstretched, legs prone, buck naked, and staring intensely, Leonardo da Vinci's *Vitruvian Man* sketch is the ink-and-paper manifestation of his philosophy that certain proportions and geometries are divine blueprints for the human body and for the universe more broadly (Lester, 2012). In the iconic image, the artist-scientist[1] depicted ideal human proportions based on the principles of the architect Vitruvius (c. 1480/1914): a palm is four fingers, a foot is four palms, a cubit is six palms, four cubits make a pace, a man is 24 palms. The anatomical diagram is the combined output of his scientific readings, his own scientific observations and artistic interpretations, and the shared da Vincian-Vitruvian philosophy that divine geometries are the foundations of humanity, its creations, and the universe. "Man is the model of the world," he noted—reflected in its corporeal microcosm are the mountains (in bones), the tides (in pulse), and the elements (in organs; Schneer, 1983). By some accounts, humans can't *help* but look at the world through such androcentric metaphors and parallels—we only understand what it is to be human so we apply human frameworks to nonhuman things to understand our world and our place in it (Bogost, 2012).

In the case of videogames, digital worlds, and other interactive media, these frameworks are often applied to avatars: digital bodies that extend a user's presence and agency into digital spaces. The term "avatar" is adapted from the Sanskrit *avatara*, best translated generally as "descent" but theistically as the divine in corporeal form, from *ava* for "down" and *tr* for "to cross over" (see Sukdaven, 2012). In this

1. While traveling a long, dark road …

way, an avatar is a "mythic figure with its origin in one world and projected or passing through a form of representation appropriate to a parallel world. The avatar is a delegate, a tool or instrument allowing an agency to transmit signification to a parallel world" (Little, 1999, p. 3). In its modern form, then, it is a digital delegate for a human to convey intentions and actions through a descent into digital spaces.

THE VITRUVIAN AVATAR

The term "avatar" was first used regarding the experience of digital bodies in the novel *Songs from the Stars* to refer to seemingly "monstrous" entities in computer-generated experience (Spinrad, 1980), and first used to reference on-screen game characters in the LucasFilm roleplaying game *Habitat* (1985). Cyberpunk fiction—a sci-fi genre characterized by dystopic, high-tech, near-future societies—was pivotal in bringing the concept to the forefront. While William Gibson's classic *Neuromancer* (1984) introduced the notion of digital bodies navigating immersive space, the term was later popularized in the cyberpunk novel *Snow Crash* (Stephenson, 1992) as a simulated human form in the Metaverse, a collective digital reality. Today, it is used quite broadly to refer to representations of users in a range of digital spaces—from a screen name or social network profile image to the complex, animated, graphic bodies such as those found in three-dimensional videogames.

Many early references to avatars (and still many contemporary characterizations) frame them as digital embodiments of a human user's self, whereby some dimension or the whole of the player's existence—appearance, behavior, personality, intention—is translated by, reinterpreted through, or transferred to the digital body. Given that human experience draws intimately from the ways that our bodies engage physical environments through our senses (see Shapiro, 2011), it's not altogether surprising that we should draw on metaphorical digital bodies to engage the content and dynamics of digital games (Martey & Stromer-Galley, 2007) to make sense of the tasks and the fantasies when we cannot draw on all the faculties of our physical bodies. In the fantastical worlds of many multiplayer roleplaying games—and in a host of other game genres—players seek to complete challenges, to get lost in alternate spaces and stories, and to connect with others seeking the same (Yee, 2006). However, our hands cannot cast spells, our feet cannot tread pixelated ground, we cannot respawn after a dragon-breath death, and our human sensibilities cannot likely deal with the carnage inflicted through gameplay combat. So, we rely on complex digital bodies wrapped in "convenient fictions" (Knowles, this volume) to engage gameworlds. These avatars are just human enough to make sense to us, and just nonhuman enough to make sense in the digital world.

Importantly, an avatar's translational functions—the ability to signify and perform meanings and actions across an interface—emerge out of the relationship

between its parts and its whole. As Vitruvius noted of temple architecture, "there ought to be the greatest harmony in the symmetrical relations of the different parts to the general magnitude of the whole" (1480/1914, 3.1.3). Although most perspectives on videogame and digital world avatars treat them as whole bodies to be controlled, identified with, and interacted through, it is important to consider avatars' own architectures—what they are made of, how those components are assembled, and how that assemblage is experienced during gameplay. For the sake of discussion, let's take a *Vitruvian Elf* (Figure 0.1, a variation on an archetypical roleplaying game avatar). The Elf *can* cast spells (through its staff and code-driven abilities, per the strength of its statistics), *can* tread pixelated ground (through the shape of its body, its programmed movement, and its physics), *can* return from death (according to the narrated rules and mechanics for digital life and resurrection), and *can* resolve the psychological tensions of murderous activities (via its character story and its imbued moral system). Confiscate *any one* of these components from the assembled digital body and the player's experience will be very different.

In perhaps the same scientific spirit that moved da Vinci to effectively deconstruct the human form—recognizing it at once as an organic form *and* as a technical object (cf. Pevsner, 2002)—the project of this book is to break apart the whole-bodied avatar into its constitutive components. As the Vitruvian Man was articulated according to two centers of the organic body (that of heavenly magnitude in the circle and that of corporeal gravity in the square; Keele, 1983), the avatar is here dissembled according to two functional centers: the social (components supporting its humanness, often through visuals and narrative) and the technical (components supporting its functionality, often through logic and process). And we can perhaps consider, as da Vinci followed the mathematical philosophies of Pythagoras (cf. Stanley, 1687/2010) to suggest that the fitting of the human body into both heavenly and earthly shapes as evidence of dual nature, that avatars through their social and technical components warrant similar consideration— dissembling and associating the sociality and technics of digital bodies. To this end, this book works to consider how the intersections of these components give rise to the da Vincian "vital spark" that makes them real and alive and relevant in contemporary human life (The Lancet, 1902). In other words, in playing avatars, we may need both their human-like and technology-like features for them to seem real as tools for our gameplay, as extensions of ourselves, or as distinct social beings (Banks, 2015).

This anatomical dissembling is not an easy task and, as a result, it may be instinctive to critique some chapters as incomplete or narrow or somehow dissociated from the lived experience of whole avatars. Importantly, this slicing of the avatar is purposeful. As da Vinci noted about the messiness and precision of anatomical work: "you who say that it is better to see an anatomy performed than to

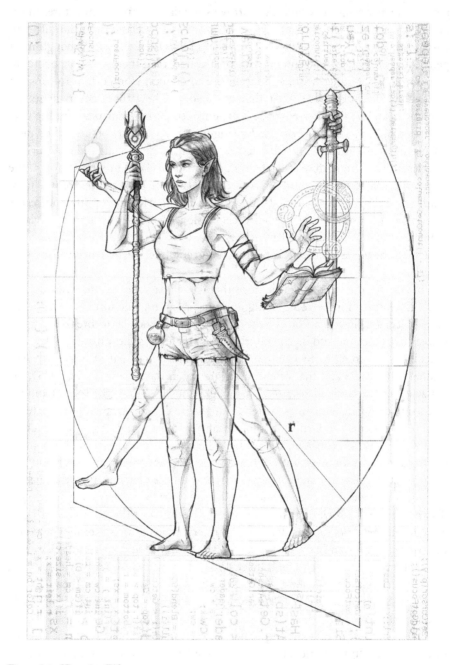

Figure 0.1. Vitruvian Elf.
(Source: Frenone, with permission)

see these drawings would be right if it were possible to see all these things which are demonstrated … in a single figure, in which with all your cleverness you will not see or acquire knowledge of more than some few veins" (1452–1519/2008, p. 144). This is not to say that as gamers, designers, or scholars that you, the reader, are not discerning, but that the critical dissection of bodies is untidy, imperfect, and sometimes tedious—in contrast to the arousal and fantasy of gameplay—but necessary to fully understand its inner workings. Just as the artist knowing the "nature of the sinews, muscles, and tendons" of the human body is better "able to reveal the nature of man and his customs" (pp. 145–146), one with an understanding of the components and dynamics of avatars will be better able to strategically engage, artfully design, and thoughtfully examine the importance of those digital bodies.

AVATARIAL ASSEMBLAGES

Videogames, gameplay, and players have themselves been described as assemblages (Taylor, 2009), mangles (Steinkuehler, 2008), collusions (Giddings, 2009), and networks (Banks, 2017)—dynamic aggregations of human and nonhuman, digital and physical, and even immaterial elements, from rules and cultural norms to skills and technologies. These characterizations are rooted in network perspectives that originally had nothing to do with games at all. In the 1980s, three sociologists— Michael Callon, John Law, and Bruno Latour—in their sociological works noticed that vast, complex phenomena in the world were actually made from much smaller combinations of material and immaterial things that *hung together* to sustain the phenomena for extended periods of time. Their approaches focused on identifying *material-semiotic* relations among these different things—connections through both meaning and through physical associations—such that the world is made up of objects that exist in webs of temporary connections with other objects (Haraway, 1991). Through this lens, things that are immaterial are just as important to making up the world as things that are physically material—they are all *actors* existing in highly dynamic *networks* (Latour, 2005).

While that may seem like a hefty and overly complicated philosophy for understanding something as seemingly mundane as videogame avatars, this *actor-network* framework forces us to do three important things when thinking about digital bodies. First, it forces us to pay attention to the small parts of avatars—the "missing masses" (Latour, 1992, p. 152) of digital bodies. Avatar components like encoded algorithms, covert polygons, and inconspicuous aural "blips" and "boops" make important contributions to avatars, but are often woefully overlooked as inconsequential ingredients of the more legitimate, whole body; by attending to the small bits of digital bodies, we can not only understand each part's "micronature" as "part(icipant)s" in avatar-mediated gameplay but also their interplays and "mutual

becomings" as the parts contribute to a whole (Giddings, 2009, p. 152). Second, it deprivileges the human in the existence of an avatar (see Harman, 2009) so that we can see the ways that all sorts of things make up digital bodies independent of our interactions with or expectations for them. Since all things exist in webs of relations—whether human or nonhuman, material or immaterial—then all things exist on an even plane, with no one object more important than any other object contributing to a network (Latour, 2005). This is not to say that humans don't matter at all, merely that a player's organic, physical body doesn't dictate the nature of an avatar's designed, digital body, in whole or part. Each component is a thing-in-itself. Finally, it makes us sensitive to how things are linked together and encourages us to abandon our biases for what counts as a proper set of associations (Latour, 2005).

Take, for instance, the case of one player's experience of an avatar in *World of Warcraft* (WoW; Blizzard, 2004; as reported in Banks, 2013). This player, Marc, held as his favorite avatar a male Tauren Druid named Labris. He was a casual gamer, playing mostly with his partner, but his connection with his character was anything but casual. Marc identifies as genderqueer (assigned male at birth) and explained during an interview that he struggles with mainstream, cultural expectations for masculinity in his everyday life, describing feelings that he was never able to settle on a "fulcrum of peace" between how he sees himself and the expectations others have of him. Labris evoked several meaningful stories for Marc. For instance, the name Labris—from labrys, a symmetrical two-bladed axe—was his preferred name for a female character; when he opted for a male character (as a counterpoint to his partner's female character) he decided to keep the name as reflective of affinities for radical lesbian feminism (Morrow & Messinger, 2006). He also recounted how Labris held a sort of moral system of his own that would govern the actions that Marc would take with the avatar—he saw Labris as a rather gentle soul who occupied a particular stance in the gameworld. Specifically, when faced with the task of completing the infamous torture quest (in which the character is charged with electrocuting a non-player character with a tool called the "Needler" until the NPC gives up "crucial" intelligence), he recounted how as a gamer he wanted to see the quest played out but "[Labris] didn't do it. I just could not do that quest with him and it made no sense ... he would not do that for a whole host of reasons that I know are personal for him." He also described Labris as representing a balance of roles he wished he could find in life: rugged and strong but nurturing and kind, through having a massive minotaur-like body but serving a patient and loving healing role. Finally, he described Labris as a personal champion; when struggling with his gender in relation to normative masculinities, Marc recounted thinking multiple times daily that Labris was cheering him on: "I can do it. You can do it."

Taken as a whole digital body dependent on a human user, Labris might be interpreted as a tool for gender identity expression and social and narrative play on

behalf of Marc. But if we pay attention to the small bits that make up Marc's experience of Labris, we see a host of objects emerge: gender, personality, traits, motivations, social expectations, norms, mental states, emotion, name, histories, politics, relationships, life partner, morality, control, soul, role, cognition, balance, advocacy, encouragement. When one considers each of these "ingredients" of the avatar—some of them formally part of the avatar, some of them outside of but related to the digital body—the avatar can be seen as something more than a tool. It becomes instead a dynamic entity emerging out of the interplays of things inside and outside the game proper, under the player's control and not, organic and human conditions and structured and technological conditions. Each component of the avatar contributed specific material and meaningful influence and when assembled into a whole body those components were fully engaged as a higher-order component of gameplay. Indeed, research has suggested that avatars may be most important to players—whether as tools to play games, as extensions of identity, or as whole personalities—when they are piecemeal constructions of human-like and technological elements aggregated in meaningful ways (Banks, 2013).

THIS VOLUME

In considering how avatar "parts" become entangled and disentangled during users' engagements of digital bodies, several problematic and persuasive dualities emerge. That is, there are things that seem like they shouldn't be separate but are and things that seem they should be separate but aren't. And each duality comes with an invitation to embrace and challenge it.

Perhaps most evident in this book is the parsing out of those two centers of digital bodies: the social and the technical. While we've carved avatar parts into two distinct sections for the sake of organization and highlighting intuitive framings, some might argue that this division is somewhat artificial. Many of the elements in the social half could be argued to belong in the technological half. For instance, "gesture and movement" and "voice and speech" are portrayed here as embodied, expressive components of avatars, but they could just as easily be described as coded, strategic components made real by a series of translations (e.g., voice actor interpretation of a script to actual voiced lines, voiced lines to data, raw data to edited files, edited files incorporated with myriad other components of code). Conversely, "spells and statistics" and "class and role" are presented here as technical dimensions of avatars given their functions in ludic dynamics of gameplay, but they could alternately be considered expressive human-like components, made real by the narrative framings of avatars as embodied, social agents. These tensions of simultaneous sociality and technics importantly call out the inherent, material-semiotic connections among avatar components and the limitations of this volume:

even in breaking the avatar into 60 discrete components, there are even finer components to consider and emergent connections among them. In this vein, I invite you to consider the various components, subcomponents, higher-order phenomena, and complex interconnections of them as you play, design, and study avatars.

A more implicit duality is the popular heuristic for designating things inside digital environments as "virtual" and things in physical spaces as "real." This division is problematic in that it positions anything digital as *unreal*—as somehow existing outside the realm of influence and mattering to everyday life, and ignoring the important ways that the digital and the physical are entangled and enmeshed (see Jurgenson, 2012). While it's important to acknowledge ways that avatars, their actions, and their environments may be apart from physical realities, it's likewise important to consider how avatars and their components *are connected with* and *do matter* in contemporary life. In terms of social elements, it's useful to consider how social norms are embedded in their appearances, how our concern with weapons and statistical power reflect our values, and how bits of the digital can be exported to physical spaces in meaningful ways. In terms of the technical, we can see exemplars for humans' penchants for control and freedom in how we break avatars' rules, see the importance of playful experimentation in how we engage avatar glitches, and find a history of human innovation in the history of avatar graphics. While each may depend on variations on and interplays of materiality (the digital and the physical), I invite you to consider how each of them are decidedly *real*.

Finally, you'll see played out in this book's chapters a shifting between "games" and "digital worlds" and between "characters" and "avatars." While games can be worlds and worlds can be games, the two are not the same—games rely specifically on challenge systems with specific rules and valued outcomes (Juul, 2011), while worlds are aptly characterized according to their internally consistent properties that move us to engage and believe in them (cf. Klastrup, 2008). Similarly, a character can be an avatar and an avatar can be a character, but the two are not the same—characters are digital bodies with predefined or emergent personas, while avatars are generally understood to be those bodies that are user-created and controlled. In the chapters that follow, you'll see authors referring to one or the other, or even both, in many ways because the principles apply to both and to the similarities among them. Your invitation here, then, is to consider the ways that their differences might matter in how we consider these avatar components. That is, how do gameful challenges, worldness, predefinition, and player creativity contribute to how digital bodies emerge and the ways that they matter in player or user experience?

Although this book is organized in two sections, following from the invitations above it need not be read in a linear fashion or even assuming the concreteness of those categories. Rather, these sections are intended to offer a hint as to the authors' theses about how the component may function in relation to other components. You'll see the 60 avatar components (two in each chapter) addressed

from perspectives ranging from the scholarly domains of social science and critical/rhetorical studies to the practical domains of game design and law. This multidisciplinary crew of experts may come from diverse backgrounds, but they are all gamers and/or digital world denizens themselves.

In Part One addressing the social, the authors consider avatar components most likely to contribute to the avatar's humanness or sociality. They are the dimensions of the digital body that support the perception of personhood—that the avatar is a legitimate social being—which tends to rely on the game's narrative framework or on the avatar's visual properties, most often with links to the formal elements of gameplay. In Part Two, chapters address avatar components that emerge principally from the digital body as a technology—as a collection of influences from graphics, code, rules, processes, and devices. Each author has endeavored to offer some new contribution to how we think about and engage these components, from thinking about glitches as strategic advantages rather than errors to considering cosplay and conventions as exporting the digital into physical space so that the player becomes the avatar's avatar. These new ideas are intended as springboards for considering ways that avatars and their components matter in contemporary life. In parallel to da Vinci's musings that man is "the world in miniature," perhaps the avatar can be considered man in miniature, a representative assemblage of our constellated social and functional bits.

REFERENCES

Banks, J. (2017). Multimodal, multiplex, multispatial: A network model of the self. *New Media & Society, 19*(3), 419–438.

Banks, J. (2015). Multimodal, multiplex, multispatial: A network model of the self. *New Media & Society, 19*(3), 419–438.

Banks, J. (2013). Human-technology relationality and self-network organization: Players and avatars in World of Warcraft. (Unpublished doctoral dissertation). Fort Collins, CO: Colorado State University.

Bogost, I. (2012). *Alien phenomenology: Or what it's like to be a thing.* Minneapolis, MN: University of Minnesota Press.

da Vinci, L. (2008). *Notebooks.* (I. A. Richter, Sel.; T. Wells, Ed.). Oxford: Oxford University Press. (Original works published 1452–1519).

Gibson, W. (1984). *Neuromancer.* London: HarperCollins.

Giddings, S. (2009). Events and collusions: A glossary for the microethnography of videogame play. *Games and Culture, 4*(2), 144–157.

Haraway, D. (1991a). A cyborg manifesto: Science, technology, and socialism-feminism in the late Twentieth Century. In *Simians, cyborgs, and women: The reinvention of nature* (pp. 149–182). New York: Routledge.

Jurgenson, N. (2012, Oct. 29). Strong and mild digital dualism. *Cyborgology* [blog]. Retrieved from: <https://thesocietypages.org/cyborgology/2012/10/29/strong-and-mild-digital-dualism/>

Juul, J. (2011). Video games and the classic games model. In *Half real: Video games between real rules and fictional worlds* (pp. 23–54). Cambridge, MA: MIT Press.

Keele, K. D. (1983). *Leonardo da Vinci's elements of the science of man*. New York: Academic Press.

Klastrup, L. (2008). The worldness of EverQuest: Exploring a 21st Century fiction. *Game Studies, 8*(2).

Latour, B. (2005). *Reassembling the social: An introduction to Actor-Network Theory*. New York: Oxford University Press.

Lester, T. (2012). *Da Vinci's ghost: Genius, obsession, and how Leonardo created the world in his own image*. New York: Free Press

Little, G. (1999). An avatar manifesto. *Intertexts, 3*(2).

Morrow, D. F., & Messinger, L. (2006). Sexual orientation and gender expression in social work practice: Working with gay, lesbian, bisexual, and transgender people. Columbia University Press.

Pevsner, J. (2002). Leonardo da Vinci's contributions to neuroscience. *TRENDS in Neurosciences, 25*(4), 217–220.

Schneer, C. J. (1983). The renaissance background to crystallography: The search for harmonious proportions and perfect shapes in the natural world opened the way to the science of crystals. *American Scientist, 71*(3), 254–263.

Shapiro, L. (2011). *Embodied cognition*. New York: Routledge.

Spinrad, N. (1980). *Songs from the stars*. New York: Simon and Shuster.

Stanley, T. (2010). *Pythagoras: His life and teaching, a compendium of classical sources*. (J. Wasserman & J. D. Gunther, Eds.). Lake Worth, FL: Ibis Press. (Original work published in *The History of Philosophy*, in 1687).

Steinkuehler, C. (2008). Cognition and literacy in massively multiplayer online games. In J. Coiro, M. Knobel, C. Lankshear, & D. J. Leu (Eds.), *Handbook of research on new literacies* (pp. 611–634). New York: Lawrence Erlbaum.

Stephenson, N. (1992). *Snow crash*. New York: Bantam Dell.

Sukdaven, M. (2012). A systematic understanding of the evolution of Hindu deities in the development of the concept of *avatara. Dutch Reformed Theological Journal, 53*(1), 208–218.

Taylor, T. L. (2009). The assemblage of play. *Games and Culture, 4*(4), 331–339.

The Lancet. (1902). Leonardo Da Vinci as an anatomist. *The Lancet, 160*(4123), 693–693.

Vitruvius (1914). Book III. *The ten books on architecture*. (M. H. Organ, Trans). Cambridge, MA: Harvard University Press. (Original work published c. 1480).

Yee, N. (2006). Motivations for play in online games. *CyberPsychology & behavior, 9*(6), 772–775.

The Social

Life & Death

The Meaning of (Digital) Existence

TERESA LYNCH & NICHOLAS L. MATTHEWS

Life and death have been the focus of philosophical quandaries throughout human history. In contemporary culture, these matters extend into digital realms, inspiring questions about the boundaries and values of avatar life and death. Avatars do not live and die in corporeal senses, rather we draw on the life/death metaphor as we would for batteries or stars. Yet, functionality alone does not define avatar aliveness. An avatar's life emerges through a player's interaction with social and technical gameworld constructs. Developers simulate life and death using a variety of biological signals and social norms, thus encouraging a *sense* of the avatar's aliveness and death. This sense gives significance to the avatar, the relationship with the avatar, and gameworld itself.

BOUNDARIES, FUNCTIONALITY, AND THE SIGNIFICANCE OF LIFE AND DEATH

The term avatar derives from the Sanskrit *avatara*, referencing the Hindu notion of a transformative alighting of an immortal deity to an embodied state (Parrinder, 1997). Whereas Hindu deities descend by taking physical forms, players descend into a gameworld by taking on digital bodies. An avatar's life does not begin with birth, but initiates upon player creation. Players descend into avatars, assuming control through technical components bounded by hardware (e.g., the game console) and software (e.g., programming). The player's descent into the

avatar is a necessary but insufficient condition of its aliveness. An avatar is alive while its operating state remains functional. For many games, especially those with persistent worlds, temporarily abandoning the avatar by logging out does not constitute its death, but renders it into a state of stasis or non-aliveness. An avatar dies when gameplay renders it non-functioning. Thus, the avatar's life and death are often analogous to gameplay success and failure.

Representations of avatar life vary substantially across videogames. Because avatars are often anthropomorphic, depictions tend to rely upon metaphorical reflections of biological life. For example, avatars do not require air to breathe, food to nourish, nor rest to recuperate. However, avatars commonly drown if underwater too long, enjoy replenished health after eating, and convalesce after sleeping. Genres featuring human avatars prominently feature these types of characterizations and likely encourage suspending disbelief. Games that rely on biological metaphors sometimes use those characterizations as central components of gameplay. For example, the graphic fatalities of avatars in games such as *Mortal Kombat* (1992) depict brutal, realistic violence such as dismemberment that could easily kill a human. However, avatars' bodies tend to be less fragile than human bodies. Avatars commonly continue fighting and adventuring at full strength following extreme injury. When avatars die, their bodies tend to remain in the environment for a time and then eventually fade, dissipate, or remain as semi-permanent or symbolic features of the landscape (e.g., tombstones) rather than decay. Similarly, indicators of injury rely on biological referents. Although avatars do not have vital organs, the sound of a heartbeat or haggard breathing may indicate impending death. Although these distress signals are not functional components of the avatar's body, the incorporation of these elements conveys a sense of aliveness.

Overlaying basic human needs onto an avatar—through such biological indicators—serves to communicate the avatar's status to the player. Players intuitively recognize game objects that sustain life even if those objects are symbolic (e.g., images of food; Lang & Bailey, 2015). Vitality (i.e., health) is perhaps the most salient representation of life. Some games feature hyperrealistic mechanics to convey life—for example, the survival mode of *Fallout 4* (2015) requires avatars to stay hydrated, well fed, and rested to survive, while illness detriments several character attributes (e.g., stamina) and gameplay functions (e.g., ability to heal from eating). Other games are less realistic. For instance, *The Legend of Zelda* (1986) merely requires that players avoid taking damage to remain healthy and symbolize Link's vitality through cartoonish hearts. Representing health is not unique to human-like avatars. The racing game *San Francisco Rush: Extreme Racing* (1997), for example, features an inorganic vehicle-avatar, and the car's apparent physical damage (e.g., dents and smoking) serves as proxies for vitality.

Some games feature states between life and death using liminal spaces—those "in-between" states. These spaces serve as a digital limbo of sorts in which the

avatar is not incapacitated (as with death), but persists without many of the abilities inherent to their alive states. For example, *Demon's Souls* (2009) and *World of Warcraft* (WoW; 2004) feature events known as corpse runs. After an avatar dies in these games, the player assumes control of an avatar's ghost/soul that spawns elsewhere in the game environment. Corpse running requires that players return to the location of death to recover resources and to rejoin the avatar's ghost to its fallen body. Avatars often lose the capability to interact with some gameworld elements during corpse runs. However, not all games use liminal space to punish failure. For instance, *The Legacy of Kain: Soul Reaver* (1999) makes liminal spaces fundamental to gameplay by having players take on the role of the already-dead Raziel as he moves between the Material Realm where living creatures reside and the Spectral Realm of the dead. In the Spectral Realm, Raziel enjoys strengthened abilities, but must return to the Material Realm to progress the narrative.

TECHNOLOGICAL CONSTRAINTS SHAPING LIFE AND DEATH

Life, death, and liminal space can function as mechanics of gameplay or as narrative events (Klastrup, 2007), but videogame technologies constrain the function and rules that govern and constitute these spaces. Consequently, avatar life and death correspond to generational shifts in technological functions of game systems. Early arcade-style games such as *Asteroids* (1979) and *Pac-Man* (1980) provided players with single-sitting avatars. With the technology to save gameplay progress largely unavailable, these avatars persisted for as long as the game was running or until the player failed enough times to end the game. Only by earning a record-setting high score could the avatar enjoy any semblance of permanence—not in its embodied form, but in a formal shift to leaderboard initials. Since death was common in these early games, all players lived a similar life through each instantiation of the pre-defined avatar as long as the player had the skill required to keep the avatar alive.

The introduction of new technologies in later games allowed players to save and continue their progress, which meant that avatars could persist indefinitely. *Mega Man's* (1987) passcodes are an early example: upon completing a level, the game presented codes allowing players to stop and (after re-entering the code) re-start at a certain instance of the gameworld, complete with specific avatar abilities. Using an alternative technological solution, *The Legend of Zelda* featured battery-powered RAM in the game cartridge, enabling saving progress without the use of passcodes as long as the battery's charge held. Powered cartridges eventually gave way to the longer-lasting memory cards and internal hard drives found in many of today's gaming systems. These advances facilitated the introduction of save-anywhere technology in games like *Doom* (1993), allowing players to save as

often as they wished, toward perfect playthroughs by loading earlier saves following player errors. To combat this exploitive practice, developers limited saving to specific, well-distanced locations in the game level via save stations or checkpoints. Likewise, some save-anywhere games punished players for forgetting to save, even ending entirely upon death (e.g., *Deus Ex*, 2000). Others would restart the level, but essentially killed off the avatar and replaced it with a fresh version of the avatar sans resources (e.g., *Doom*).

For some time, saving anywhere or checkpoints was prolific. Players could freeze avatar lives and gameworld states, returning to them when ready. Persistent worlds such as those in online games and RPGs like *Fable* (2004) altered this by featuring gameworlds that existed and evolved with or without the player. *Grand Theft Auto V* (2013) innovated by allowing the game's three main characters to continue their lives independently whenever the player switched to another character or stopped playing. With each of these technological shifts, avatar aliveness likewise altered. Multiple deaths did not necessarily end the game. Rather, failure in keeping an avatar alive became a smaller setback (e.g., repeat the level but keep collected resources). The technological changes weakened the link between player skill and avatar life, as novice players could repeatedly try until they eventually experienced an entire story or leveled their character. These technologies also provided the means for greater involvement with avatars. Avatars persisting beyond a single session substantially changed their aliveness by granting players the time to define the avatar's identity within gameworld parameters.

CONSEQUENCES AND FUNCTIONING OF DEATH

Although save functionality allowed for persistent avatar engagement, that did not mean it negated death's impact on players. Rather, the death of an avatar usually involves consequences for players such as temporary item loss, lowered starting health, or geographic displacement. In some instances, consecutive deaths strengthen avatars to make a game's difficulty more manageable, as with the death-streak bonus in *Call of Duty: Modern Warfare 2* (CoDMW2; 2009). In addition to altering the nature of gameplay, a special animation may accompany death. Joel's cinematic demise at the hands of The Infected in *The Last of Us* (2013) is particularly gruesome, as they tear his body apart before fading to black. Because of the range of outcomes, an avatar's death can evoke a gamut of player reactions from amusement and playfulness (Klastrup, 2007) to exhausted horror (Lynch & Martins, 2015).

Additionally, the technical systems in some games offer functional or strategic information to players upon death. Games such as *Limbo* (2010) and *Shadowgate* (1987) use avatar death to guide player actions in subsequent attempts; others (e.g.,

CoDMW2) mark the exact location of avatar death so teammates know where to find opponents. Game success sometimes necessitates trial and error, often resulting in death. Given this, it may be fruitful to reconstrue notions of avatar life and death. Klastrup (2008) argues that studying digital death necessitates consideration of its technical design. Life may mean operating optimally within game-rule boundaries. In online games, for instance, violating the conduct standards associated with the gameworld and its community risks avatar death through banishment or deactivation (Martínez, 2011). Death and injury may also be aberrations from perfection (i.e., the game revealing its own parameters) or the fundamental rules of the game as in the roguelike genre (e.g., *Rogue Legacy*, 2013) where one avatar's death results in replacement by a new, randomly generated avatar.

Atypical representations of life and death can also make games stand out in an increasingly competitive market. *Halo 2* (2004) innovated on the ability to play after death by introducing a regenerating health/shield system that made death less frequent. Similarly, developers today sometimes use permanent death ("permadeath") not out of technological necessity, but as a distinct style of gameplay. Despite being very punishing, permadeath has become a popular selling point for games such as *DayZ* (2013) because its finality may heighten emotional reactions to gameplay events (Groen, 2012). The pressure of permadeath likely influences motivation to stay alive, making small successes seem more rewarding and threats more intimidating. Permadeath may also appeal to players who desire the challenge of perfect play, allowing core players to distinguish themselves from casual players.

LAYERS IN THE SOCIALITY OF AVATAR DEATH

Whereas technological and design choices are pre-existing, life and death shape the emergent relationships between player and avatar. Player-avatar interactions have various levels of perceived sociality, ranging from entirely non-social (avatars are merely objects) to fully social (avatars are autonomous agents; Banks & Bowman, 2016). The social nature of the avatar is one force prompting the player to keep it healthy and alive, as people tend to have concern for digital characters similar to physical individuals (Lewis, Weber, & Bowman, 2008). Specific relational characteristics can motivate peculiar behaviors. For example, a player might decide that it is simply an avatar's time to die or that it is time to sever ties with an avatar permanently. If the player has invested significant time into developing the avatar and feels connected to it, this may be a difficult proposition, sometimes leading them to document the ending of their avatar's life ceremoniously (e.g., Ki, 2007). This practice, known as ritual quitting, emerged among core MMO players. These rituals likely serve either as coping mechanisms to assuage the grief of bond-breaking or as demonstrations of players' sincerity in quitting permanently.

Player-avatar sociality also influences the way other players respond to avatar death. For instance, physical death of players results in the abandonment of their corresponding avatars. The abandoned avatar may represent an instantiation of the passed player, and so may have genuine meaning to surviving loved ones and friends; in online gaming contexts, this can be an intense social experience (Ferguson, 2012). Despite this, death experienced through or by an avatar is not sacrosanct. For instance, the now infamous attacks by the guild <Serenity Now> on avatars gathered at a digital funeral for the physical death of a young player (Graziani, 2006) prompted outcry from the WoW community. Some considered the attack an outrageous moral violation. Others argued that the attackers were justifiably capitalizing on an in-game scenario. This ethical conundrum demonstrated that the real-world social values associated with the sanctity of death carried over into the gameworld for some, but not others. This is meaningful because the cultures that form in different social systems often stem from death rites and beliefs (Klastrup, 2007). Thus, those that emerge from representations and functions of avatar life and death—especially in online, social games—may represent a rich area for digital culture scholars to explore.

BOUNDARIES AND ETHICS

As technology advances, avatars may prove to be more like humans than unlike humans. However, the unique ability of an avatar to live, die, and resurrect represents an important departure from the realities of human life. Perhaps it is this aspect of avatars that encourages identification with them and wishful extension of one's own life through digital existence—the player may subvert the rules of death that bind them in the physical world.

Gameworlds that allow users to generate their own rules (e.g., *Second Life*, 2003) can lead to instantiations of aliveness that present players with unique ethical conundrums. For instance, Lessig (2009) describes a conflict that occurred between two avatars in *Second Life* when one's digital dog ate the other's poisonous flowers and died painfully. This scenario prompts two questions. First, why were the digital flowers poisonous to the digital dog? Second, why was the digital dog's death painful? The answers rest in the code written by the two players who programmed the flowers and dog, respectively. Lessig argues that players do not want their gameplay experiences to depart too far from physical reality, such that perhaps the dog's digital death was made painful to make the act of dying meaningful. The player cares that the dog suffered—even if it is only a digital dog—because that reaction is normative in the physical world. The concern was conveyed to the other player and, in Lessig's example, the players adopted new rules to protect the lives of other digital pets. The negotiated terms of digital life and death emerging

from players' behaviors stand to tell scholars much about how such norms emerge and negotiations occur (Klastrup, 2007).

Games that do not grant the player the authority to adjust the terms of life and death still convey and reinforce norms in meaningful ways. Take for instance, the hyperviolent world of *Mortal Kombat* (MK; 1992). In MK, the entire point of gameplay may be to reduce an opponent to ashes. Does it matter than an avatar suffers a gratuitously violent death? Unlike the dog in *Second Life*, it is unlikely that the player would feel grief or remorse for the assumed agony of the MK avatar because game's *aim* is to deal death, such that violence and its consequences are normalized.

Gameworlds buck the adage that death is certain. Yet—as with biological life—death in a gameworld can increase the salience of life. This, in turn, may increase perceptions of aliveness in ways that encourage prosocial interpretations of the avatar and its respective interactions with the gameworld. In other words, by seeing avatars according to their aliveness, gamers may be prone to treating them (and their backstage players) as valuable in that aliveness. One way this may occur is by reducing perceptions of the avatar as an object. Scholars have noted a relationship exists between reducing a person to the status of an object (i.e., objectifying) and dehumanization (Heflick, Goldenberg, Cooper, & Puvia, 2011). Broadly speaking, objectifying individuals robs them of their unique and agentic characteristics, effectively stripping them of their humanity. This phenomenon can lead to justifications of violence against the objectified individuals (Haslam, 2006). Depictions of non-aliveness can purposely facilitate dehumanization. For instance, videogames featuring zombies typically portray these non-playable characters as lifeless, mindless enemies; this skirts moral concerns associated with killing them (Krzywinska, 2008).

However, consistently dehumanizing avatars with respect to their social identities (e.g., race, gender) may encourage perceptions of some groups as less alive. The intersections of aliveness and social identities also have implications for the formation and maintenance of prejudicial attitudes, as these attitudes shift target from physical-world manifestations to counterpart representations in gameworlds. Other sections of this book (Fox, this volume; Nowak, this volume) discuss these matters at length; these portrayals are relevant to life and death in their conveyance of the relative aliveness of some groups with respect to others. For instance, despite an overall decrease in the sexualization of female avatars in recent years, they remain devalued through portrayals in secondary and ornamental roles (Lynch, Tompkins, van Driel, & Fritz, 2016). These portrayals may shape perceptions of social groups' humanness and corresponding valuation of their lives.

The value of avatars' lives is not only of social concern; it is also a legal matter. When a player dies in the physical world, various aspects of their digital presence (e.g., social media, saved files, forum posts) persist. Because they are digital

instantiations of players, they may also be meaningful remains of the deceased (Ferguson, 2012). So, what happens to the avatar once its creator dies? An ongoing disagreement in the legal literature about the status and definition of digital properties complicates this question (see Ochoa, this volume). As Harbinja (2014) notes, involvement in a gameworld requires time and effort entitling players and their devisees to property rights of the digital artifacts therein. She specifically notes that the unique relationship of the avatar and player can constitute a meaningful component of one's self-definition that potentially extends to social networks outside of the gameworld. These factors principally support the argument for legal entitlements to the avatar as property, but the practical, ethical, and philosophical considerations of these matters remain unresolved.

The unique characteristics of avatar life and death give perspective to games' magnetic attraction. Players descend into the avatar having the opportunity to live, die, and live again fulfilling a cycle of digital reincarnation. These characteristics of game environments contextualize and constrain the avatars and to a lesser understood extent, the players who use them and cultures that emerge around them. This notion presents an interesting lens upon which to consider the tensions of play as the avatar life-death-reincarnation cycle persists, reflects, signifies, and gives meaning to digital life.

REFERENCES

Banks, J., & Bowman, N. D. (2016). Emotion, anthropomorphism, realism, control: Validation of a merged metric for player–avatar interaction (PAX). *Computers in Human Behavior, 54*, 215–223.

Blaustein, M. (2016). I was sexually assaulted—in virtual reality. Tech—New York Post. Retrieved October 30, 2016. Retrieved from:

Clark, A. (2008). *Supersizing the mind: Embodiment, action, and cognitive extension.* New York: Oxford University Press.

Ferguson, R. (2012). Death of an avatar: Implications of presence for learners and educators in virtual worlds. *Journal of Gaming & Virtual Worlds, 4*(2), 137–152.

Fox, J., & Bailenson, J. (2009). Virtual virgins and vamps: The effects of exposure to female characters' sexualized appearance and gaze in an immersive virtual environment. *Sex Roles, 61*(3/4), 147–157.

Graziani, G. (2006, July). Massacre in Winterspring. *PC Gamer Magazine*, 80.

Groen, A. (2012, Nov. 27). In these games, death is forever, and that's awesome. *Wired.* Retrieved from: <https://www.wired.com/2012/11/permadeath-dayz-xcom/>

Harbinja, E. (2014). Virtual worlds—A legal post-mortem account. *SCRIPTed, 11*(3), 273–307.

Haslam, N. (2006). Dehumanization: An integrative review. *Personality and Social Psychology Review, 10*(3), 252–264.

Heflick, N. A., Goldenberg, J. L., Cooper, D. P., & Puvia, E. (2011). From women to objects: Appearance focus, target gender, and perceptions of warmth, morality and competence. *Journal of Experimental Social Psychology, 47*(3), 572–581.

Ki, S. (2007). Quitting World of Warcraft. Retrieved from: <https://www.youtube.com/watch?v=ah20hvEK28c>

Klastrup, L. (2007). Why death matters: Understanding gameworld experience. *Journal of Virtual Reality and Broadcasting, 4*(3).

Klastrup, L. (2008). What makes World of Warcraft a world? A note on death and dying. In H. Corneliussen & J. W. Rettberg (Eds.), *Digital culture, play, and identity: A World of Warcraft reader* (pp. 143–166). Cambridge, MA: The MIT Press.

Krzywinska, T. (2008). Zombies in gamespace: Form, context, and meaning in zombie-based video games. In S. McIntosh & M. Leverette (Eds.), *Zombie culture: Autopsies of the living dead* (pp. 153–168). Plymouth: The Scarecrow Press.

Lang, A., & Bailey, R. L. (2015). Understanding information selection and encoding from a dynamic, energy saving, evolved, embodied, embedded perspective. *Human Communication Research, 41*(1), 1–20.

Lessig, L. (2009). code 2.0. Paramount, CA: CreateSpace.

Lewis, M. L., Weber, R., & Bowman, N. D. (2008). "They may be pixels, but they're MY pixels:" Developing a metric of character attachment in role-playing video games. *CyberPsychology & Behavior, 11*(4), 515–518.

Lynch, T., & Martins, N. (2015). Nothing to fear? An analysis of college students' fear experiences with video games. *Journal of Broadcasting & Electronic Media, 59*(2), 298–317.

Lynch, T., Tompkins, J. E., van Driel, I. I., & Fritz, N. (2016). Sexy, strong, and secondary: A content analysis of female characters in video games across 31 years. *Journal of Communication, 66*(4), 564–584.

Martínez, N. M. (2011). Liminal phases of avatar identity formation in virtual world communities. In A. Peachey & M. Childs (Eds.), *Reinventing ourselves: Contemporary concepts of identity in virtual worlds* (pp. 59–80). London: Springer London.

Parrinder, E. G. (1997). Avatar and incarnation: The divine in human form in the world's religions. Oxford: Oneworld Publications Limited.

Smith, S. L., Lachlan, K., & Tamborini, R. (2003). Popular video games: Quantifying the presentation of violence and its context. *Journal of Broadcasting & Electronic Media, 47*(1), 58–76.

Stokes, P. (2016). Deletion as second death: The moral status of digital remains. *Ethics and Information Technology, 17*(4), 237–248.

Thompson, K. M., & Haninger, K. (2001). Violence in E-rated video games. *Journal of the American Medical Association, 286*(5), 591.

Shape & Size

The Body Electric

JAMES M. FALIN & JORGE PEÑA

When players step into digital worlds and videogames, they often use some object or entity—avatars—to navigate those worlds; these digital representations serve as bodily extensions, allowing players to traverse places they cannot physically touch. Much like human bodies, avatar bodies and their physical builds are diverse. From the ultra-macho physique of Kratos (*God of War*, 2005) to the lithe and agile frame of Lara Croft (*Tomb Raider*, 2001), the bodies of avatars are not only a part of strategic gameplay (e.g., strong warrior vs. agile scout classes offering different play style benefits), but also of game narratives (e.g., Leisure Suit Larry's pudgy belly reflects his hedonic lifestyle). Perhaps the most obvious aspect of avatars, then, is their physical structure. Although avatar bodies aren't always human (Nowak & Rauh, 2005), most still rely on human-*like* forms of variable shapes (overall physiques) and sizes (volume or weight). Together, shape and size are useful ways to characterize the apparent physical structures of digital bodies. Importantly, though, these terms describe the *perceived* or *visual* shape and size of the avatar. Because avatars are made of polygons, sprites, and textures and not organic muscles and bone (Altizer, this volume), the physical structure of avatars shows the conscious and unconscious preferences of game designers and players, and as such they communicate a message not only to others but also to ourselves.

CREATION AND SELECTION

The size and shape of videogame avatars take shape in many ways. Developers of a platform may design non-modifiable avatar bodies, may allow users to customize or

"tweak" an avatar, or may provide a mix of the two. Broadly, customizability refers to the ability to use an interface to make changes to digital content as a way of suiting personal preferences (Kalyanaraman & Sundar, 2008). In videogames, customizability means that players can tweak avatar bodies for expressive or strategic purposes.

In some cases, designers create a main character or roster of playable characters from which players may select. If playing *Super Mario Bros.* (1985), the Mario avatar's short, squat shape has been pre-selected and created by a team of professional artist and designers (Swain, 2008). In some of the franchise's games, players can opt for one of Mario's friends such as the taller Luigi or Princess Peach, but game designers have already set all possible avatar body choices. A variation on these limited physiques is common in story-driven single-player games, such as *Metal Gear Solid V* (2015), *Witcher III* (2015), or *Horizon Zero Dawn* (2017). In these titles, you play as Venom Snake, Geralt of Rivia, or Aloy, respectively, and though the shape and size of these characters cannot be altered, players may select clothes, hair, and weapons. In comparison, players have ample choices in the *Saints Row* franchise (2006), such as creating slender, emaciated, obese, burly, and bodybuilder-shaped avatars. *Grand Theft Auto: San Andreas* (2004) presents an interesting variation in which player actions shift avatar appearance: CJ, the protagonist character, must eat to keep his health. If the player chooses for CJ to eat large meals often, he becomes obese and less nimble in the game; CJ can then be put on a "diet," but this risks losing game health if fasting for too long. Players can also send CJ to the gym for him to become more athletic, learn new game moves, and improve in-game health and stamina.

All of these cases illustrate how an avatar's body can function as a message. From a game design perspective, an avatar's shape and size are intentional (see Isbister, 2006), as digital bodies may communicate the disposition and backstory of a particular character within the potentials and limitations of a game engine or defined art direction. For example, art director Sébastien Mitton for the game franchise *Dishonored* (2012) studied the size and shape of the bodies of British and Southern European people for game characters to fit with the Victorian era game setting: noble-born characters are tall and sinewy whereas guards are more muscular. Additionally, Mitton and his team explained that the anatomy of game characters had exaggerated limbs and body movements for players to feel the speed or strength of game avatars (Game Informer, 2015). Designers also make use of avatar physiques to subvert players' expectations. For instance, obese *Street Fighter* (1987) franchise characters, such as Rufus and E. Honda are deceptively fast. In addition to these designer choices, an avatar's size and shape may also reflect users' motivations and game choices in game contexts where players can choose physiques. It may be appropriate to apply Watzlawick, Beavin, and Jackson's (1967) classic proposal that it is impossible to *not* communicate, given that—in the same way that human bodies "give off" information (cf. Goffman, 1959)—players can make

statements with their avatar's body. For instance, selecting a hulking Orc or diminutive Goblin in *World of Warcraft* (2004) could reflect an eschewal of traditional beauty norms (Banks, 2013). Players may also give away that they are "noobs" (novices having no game experience) or even that they do not care about their avatar's body by selecting the recognizable default human body frames in *Second Life* or by selecting default lead characters in role-playing games such as *Fallout* (1997). Even if players do not *intend* to communicate anything at all, their choices (or lack thereof) when it comes to an avatar's body may signify something to other players because the process of perceiving and assessing another person's avatar seems to mirror the process of making attributions about other humans (Nowak, 2015).

Because people can make attributions based on avatars, it is also possible that an avatar's digital body's size and shape could serve as *mis*communication, failing to transmit or elicit interpretation of an intended meaning (cf. Coupland, Giles, & Wiemann, 1991) or in some sense functioning as an ambiguous, indirect, contradictory, and evasive message (cf. Bavelas, Chovil, & Mullett, 2009). Moreover, an avatar's size and shape may even serve deceptive purposes. For example, miscommunication occurs when a player has a specific goal in mind (e.g., creating a muscular warrior with the intention of being perceived as powerful) but other players may deem the character as rather generic or too stereotypical. Players also use avatar bodies in an equivocal manner when—for instance, playing *Final Fantasy XIV* (2013) and using a petite female character as a rugged tank—the small body size may suggest to other players a diminutive skill or strength, but the avatar's class features nonetheless make it very survivable (see Milik, this volume). Male players are thought to use smaller, female-bodied avatars in online multiplayer games not only because of role-playing purposes or because they enjoy the visual appearance of female avatars, but also because of deceptive purposes as they believe that female avatars allow them to gain advantages, such as more attention and in-game help and favors (Yee, 2001).

CRAFTING PHYSIQUES: STRATEGIES, LIMITATIONS, AND MOTIVATIONS

When creating or tweaking avatar bodies, several strategies are common (see Vasalou & Joinson, 2009): replicating the user's appearance (i.e., creating a representation of oneself in the gameworld), enhancing specific traits of the user (e.g., making an avatar taller or thinner), fitting traits to game-world norms (e.g., making thin elves or bulky Orcs), and creating avatars as a strategic distraction (e.g., deceptively agile massive fighter; petite female tank). The options available for designing avatars are particularly important as people show frustration when options important to expressing personal identities are missing from avatar creation

toolkits (Dunn & Guadagno, 2012; Vasalou et al., 2008). In some cases, other people's lack of customization options may frustrate *other* players who may then discourage people from staying with default or simple shapes and sizes (Schultze, 2014).

Quite frequently, avatar choices and creation toolkits are very limited to physically idealized or amusingly unconventional body types and shapes (see Fox, this volume). However, some players may wish to express their own physicality through avatars, but may not be able to do so as a function of the technical requirements for removing or crafting body parts from avatars (Nardi, 2010). For instance, many games do not allow for the creation of avatars with non-normative physiques (Nardi, 2010), such as with missing limbs or morbidly overweight figures. These "imperfections" may be important to an individual user's identity—unique players have unique histories, and often enjoy crafting avatars that reflect their own history; this reflection impacts not only game enjoyment but also ties back to the deeper core of players' identities and their abilities to express themselves through the avatar bodies under their control (Nardi, 2010).

The importance of self-expression through avatar size and shape may lie in *identification processes* (Klimmt, Hefner, & Vorderer, 2009). Cohen (2001) explains that identification occurs when "an audience member imagines him or herself being that character and replaces his or her personal identity and role as audience member with the identity and role of the character with the text" (p. 251), where the text is the continuity of a world in which a character exists. In this sense, the user psychologically becomes the character they are using. In tandem, it is possible that while some players may identify with avatars, other players may actually see avatars as a distinct and separate agent, prompting the development of a player-avatar relationship (Banks, 2015). Digital bodies' shapes and sizes could play an important role in this relational process. For instance, if a player identifies with an avatar that has a *similar* appearance, and that avatar gains weight as a reflection of the player not exercising (Fox & Bailenson, 2009) or from eating unhealthily (Fox, Bailenson, & Binney, 2009), witnessing changes in the self-similar avatar's size and shape tend to carry over to the player's physical activities. In such cases, players have been shown to subconsciously pay more attention to their own diet and exercise routine, at least temporarily. Conversely, if players see avatars as *different from themselves* based on outward appearance then changes in avatar body size and shape are less impactful on the player.

An increased *sense of control* may also explain why people would customize the size and shape of their avatars (see Sundar, Jia, Waddell, & Huang, 2015). According to Grodal (2000), players may derive a sense of enjoyment, mastery, and increased self-esteem due to increased active control of the emotional, cognitive, and physical demands of playing videogames. From this perspective, the size and shape of avatars are important because avatar physiques provide players with a

vehicle for engaging game content in ironic or counter-narrative ways. For instance, players may experience pleasure from creating and controlling an avatar that looks as it does in their mind's eye or whose size and shape even subverts the game narrative, as when the hero character is short and skinny and not tall and muscular.

Avatars' physical frames may also reflect gameplay strategies, as it can impact on how players may progress through games. Games often make uses of *hitboxes*, which can be thought of as the invisible, targetable area of a character for determining if an attack lands or not (Baartz, Heregeth, Wagner, Marewski, & Wedowski, n.d.). Hitboxes have a major impact on the overall experience of an avatar, determining whether an attack successfully hits—the bigger the hitbox, the easier it is to target and hit. This means the size of an avatar's body (and, in tandem, its hitbox) can be the key to winning or losing in player-versus-player encounters. While one might assume that any attack that connects with the body of an avatar will land, the virtual space for an attack may extend far beyond the visible area or may even be slightly smaller. In games with enormous enemies like *Final Fantasy XIV*'s Sephirot, the valid area for landing hits is vast. In *Dragon's Dogma* (2012), avatars with small body frames are harder to hit and lose stamina more slowly, a mechanic reflecting the physical properties of different organic body types (see Lynch & Matthews, this volume). Racing games are also bound by similar rules. In the *Mario Kart* series, the massive Bowser is a much slower racer but benefits from being able to knock lighter characters around to prevent them from passing. On the other hand, Toad is small and very fast but must avoid coming into contact with other characters or risk being knocked off track. Though Ratan (this volume) refers to companions and vehicles, here we make reference to how the body size of the avatar driver affects how the virtual vehicle handles. In these ways, an avatar's size directly impacts how players engage with a game.

AVATAR PHYSIQUES' IMPACT ON PLAYERS

Thus far we have discussed how the choices of users and designers are important to the expressive and ludic purposes of avatars. However, the bodies of avatars serve purposes beyond fulfilling functional and aesthetic aims, also having psychological and behavioral effects on players. In addition to facilitating control over characters for expressive purposes (Sundar et al., 2015), tweaking an avatar body's appearance can have persuasive effects and improve the influence of health messages embedded in games. When people use an avatar that they themselves created, there is a stronger desire to protect that avatar's health and safety compared to a pre-designed avatar they are simply assigned (Kim & Sundar, 2011). This implies that managing the size and shape of one's avatar increases our sense of responsibility over that character. When we create characters, our desire to see

that character succeed and survive appears to make the choices most beneficial for that avatar. Games like *Fable* have implemented this concept as losing battles may permanently scar the body of a player's avatar.

But what happens when users cannot choose or customize their avatars and instead are assigned to a predetermined digital body? According to the *Proteus effect*, the physical appearance of an avatar affects user behavior and activates specific thoughts and memories, as it reminds us of expected stereotypes and social roles (Peña, Hancock, & Merola, 2009; Yee & Bailenson, 2007). After playing with a large or thin avatar, a player may temporarily show more sluggishness or agility, respectively. For example, playing a game of motion-controlled *Wii Sports* (2006) tennis, players randomly assigned to thin avatars showed increased physical activity compared with those assigned to obese avatars while playing (Peña, Khan, & Alexopoulos, 2016). In other words, people appear to take cues from their avatars about how thin or obese people *tend* to behave, and follow those cues in their physical activities. In addition to considering the physique of their own avatars, people also consider also that of their in-game competitors. Players size up their virtual opponents and, thus, engage in social comparisons between the body size of self and opponent avatars. Players showed higher physical activity when using a normal-weight avatar playing against a normal-weight computer-controlled agent, whereas players showed lower physical activity when assigned to an overweight avatar playing against a normal weight computer-controlled agent (Peña & Kim, 2014). This shows that the selection of one's avatar can impact their play experience and the overall intensity of play. A main implication is that whether one wins or loses a match may be determined, in part, at the moment of avatar selection. In popular tournament games like *Super Smash Bros.* (1999), matches may be considered won before they begin due to how the physiques of characters impacts the player, and how those physiques match against others.

WEIGHT HACKING AND OTHER FUTURES

As outlined above, the size and shape of avatars may intentionally or unintentionally reflect players' realized or idealized identities, or may reflect strategic attempts to perform better in digital games; without the tools to customize avatar physique for such expression or strategy, players may experience real frustration. When one game developer removed a breast-size slider feature in the western localization of *Xenoblade Chronicles X* (2015)—a slider that allowed players to determine the breast size of female characters—many players were incensed because they felt censorship was impeding their ability to fully enjoy the game using the type of character they wanted to play with (Splechta, 2015). Along these lines, *Conan Exiles* (2017) pushes the envelope of how much avatar physiques may be customized

in videogames, as game developers state that it will feature nudity and will allow players to customize avatar penis and breast size (Scott-Jones, 2017; cf. Fox, this volume). Though perhaps this makes sense in the context of the Hyborean fantasy age described in the novels of Robert E. Howard, games such as *Conan Exiles* are important to consider because they challenge *how much* of an avatar's physique players really want to see or be able to tweak (Fahey, 2017) as norms and technologies evolve.

Indeed, entirely new questions about avatar bodies are likely to emerge, especially in relation to users' physical bodies. For instance, to what degree does the experience of modifying the size and shape of avatars affect players' self-perceptions and behaviors of their own bodies? The concept of "weight hacking" draws on avatarial metaphors (e.g., character statistics such as stamina, agility, and strength; "best" character build; log and inventory management; modding, cheating, and hacking) to encourage geeks and gamers to apply such principles to their own bodies in order to lose weight. Gamers are primed to understand the consequences of game actions and activities on their character (e.g., Grand Theft Auto's CJ gaining or losing weight depending on in-game choices), and thus may apply that knowledge to tweak their own size and shape (Engler, in press).

Current technological developments also force us to ponder how people adapt to modified bodies in games and virtual reality. For example, one new area of exploration examines how individuals adapt to having extra appendages such as a third arm (Won, Bailenson, Lee, & Lanier, 2015). Despite the novelty of having an extra limb, people using avatars with a third arm quickly adapted to and mastered the control of the additional arm. They define this adaptivity as "homuncular flexibility," wherein people can shift embodied control by changing the connection between their own movement and a digital body's movement. Such flexibility could also extend to how people adapt to unfamiliar body sizes as motivators to lose weight, as therapies for amputees getting accustomed to an artificial limb, or perhaps to individuals undergoing gender reassignment procedures. Indeed, the promise and perils of human body augmentation are central themes in game franchises such as *Deus Ex* (est. 2001) and *BioShock* (est. 2007).

Further, how do users psychologically parse out events happening to digital bodies from those affecting their physical bodies? In making use of digital bodies to navigate environments, people appear to protect those digital bodies from harm; for instance, people have a tendency to take extra care to not let their digital hand come into contact with a spinning saw blade (Argelague, Hoyet, Trico, & Lécuyer, 2016). These dynamics have implications for creating safety training courses using virtual reality, where trainees might on one hand safely experience work hazards without having to deal with the real costs of carelessness. Studies in virtual training courses for industrial safety have so far found positive results, showing that

seeing harmful consequences to one's digital body may be perceived as realistic and impactful (Pedram, Perez, Palmisano, & Farrelly, 2016).

While more definitive answers to such questions about the synergies and effects of digital and physical physiques are emerging, it is clear that the sizes and shapes of avatars are more than just aesthetic or ludic features. They tie back to fundamental questions connected to players' psychological experiences of digital environments—questions linked to the intentional vs. unconscious nature of communication, to miscommunications, equivocations, and deceptions, and to the dynamic interplays of digital and physical bodies.

REFERENCES

Argelaguet, F., Hoyet, L., Trico, M., & Lécuyer, A. (2016). The role of interaction in virtual embodiment: Effects of the virtual hand representation. In *Virtual Reality (VR), 2016 IEEE* (pp. 3-10). Piscataway, NJ: IEEE.

Baartz, D., Hergeth, H., Wagner, A., Marewski, J., & Wedowski, J. (2016). Developing a virtual reality game [report]. Retrieved from: <https://www.graphics.rwth-aachen.de/media/projects/swpp-ss14-d_report.pdf>

Banks, J. (2015). Object, me, symbiote, other: A social typology of player-avatar relationships. *First Monday, 20*(2).

Banks, J. (2013). *Human-technology relationality and self-network organization: Players and avatars in World of Warcraft* (Doctoral dissertation, Colorado State University).

Bavelas, J. B., Black, A., Chovil, N., & Mullett, J. (2009). Equivocation. In H. Reis & S. Sprecher (Eds.), *Encyclopedia of Human Relationships, 1* (pp. 537–539). Thousand Oaks: SAGE Publications.

Cohen, J. (2001). Defining identification: A theoretical look at the identification of audiences with media characters. *Mass Communication and Society, 4*(3), 245–264.

Coupland, N., Giles, H., & Wiemann, J. M. (Eds.). (1991). *"Miscommunication" and problematic talk.* Newbury Park, CA: Sage.

Dunn, R. A., & Guadagno, R. E. (2012). My avatar and me: Gender and personality predictors of avatar-self discrepancy. *Computers in Human Behavior, 28*(1), 97–106.

Engler, C. (in press). *Weight hacking: A guide for geeks who want to lose weight and get fit.* [currently in crowdfunding].

Fahey, M. (2017, January 31). *Playing with Conan Exile's NSFW character creation.* Retrieved from: <http://kotaku.com/playing-with-conan-exiles-nsfw-character-creation-1791820986>

Fox, J., & Bailenson, J. N. (2009). Virtual self-modeling: The effects of vicarious reinforcement and identification on exercise behaviors. *Media Psychology, 12*, 1–25.

Fox, J., Bailenson, J., & Binney, J. (2009). Virtual experiences, physical behaviors: The effect of presence on imitation of an eating avatar. *Presence: Teleoperators and Virtual Environments, 18*(4), 294-303.

Game Informer (2015, April 17) *Inside Dishonored 2's exaggerated art direction.* Retrieved from https://www.youtube.com/watch?v=qYANPK5Gv1s

Goffman, E. (1959). *The presentation of self in everyday life.* New York, NY: Doubleday.

Grodal, T. (2000). Videogames and the pleasures of control. In D. Zillmann, & P. Vorderer (Eds.), *Media entertainment: The psychology of its appeal* (pp. 197–213). Mahwah, NJ: Lawrence Erlbaum Associates.

Isbister, K. (2006). *Better game characters by design: A psychological approach.* San Francisco, CA: Elsevier.

Kalyanaraman, S., & Sundar, S. S. (2008). Impression formation effects in online mediated communication. In E. A. Konijn, S. Utz, M. Tanis, & S. B. Barnes (Eds.), *Mediated interpersonal communication* (pp. 217–233). London: Routledge.

Kim, Y., & Sundar, S. S. (2011, May). Can your avatar improve your health? The impact of avatar attractiveness and avatar creation. Paper presented at the 61st annual conference of the International Communication Association, Boston, MA.

Kim, Y., & Sundar, S. S. (2012). Visualizing ideal self vs. actual self through avatars: Impact on preventive health outcomes. *Computers in Human Behavior, 28*(4), 1356–1364.

Klimmt, C., Hefner, D., & Vorderer, P. (2009). The videogame experience as "true" identification: A theory of enjoyable alterations of players' self-perception. *Communication Theory, 19*(4), 351–373.

Nardi, B. (2010). *My life as a night elf priest: An anthropological account of World of Warcraft.* Ann Arbor: University of Michigan Press.

Nowak, K. L. (2015). Examining perception and identification in avatar-mediated interaction. In S. S. Sundar (Ed.), *The handbook of the psychology of communication technology* (pp. 89-114). Hoboken, NJ: Wiley-Blackwell.

Nowak, K. L., & Rauh, C. (2005). The influence of the avatar on online perceptions of anthropomorphism, androgyny, credibility, homophily, and attraction. *Journal of Computer-Mediated Communication, 11*(1), 153–178.

Pedram, S., Perez, P., Palmisano, S., & Farrelly, M. (2016, February). A systematic approach to evaluate the role of virtual reality as a safety training tool in the context of the mining industry. In N. Aziz & B. Kininmonth (Eds.), *Proceedings of the 16th Coal Operators' Conference, Mining Engineering* (pp. 433–442). University of Wollongong, Australia.

Peña, J., & Hancock, J. T., & Merola, N. A. (2009). The priming effects of avatars in virtual settings. *Communication Research, 36,* 838–856.

Peña, J., Khan, S., & Alexopoulos, C. (2016). I am what I see: How avatar weight affects physical activity among male gamers. *Journal of Computer-Mediated Communication, 21,* 195–209.

Peña, J., & Kim, E. (2014). The influence of self and opponent avatar weight on physical activity among female gamers. *Computers in Human Behavior, 41,* 262–267.

Schultze, U. (2014). Performing embodied identity in virtual worlds. *European Journal of Information Systems, 23*(1), 84–95.

Scott-Jones, R. (2017). "Equality and all that," say Funcom on penis and breast sliders in *Conan Exiles* AMA. *PC Games N.* Retrieved from: <https://www.pcgamesn.com/conan-exiles/conan-exiles-ama>

Splechta, M. (2015). The breast slider in *Xenoblade Chronicles X* has been removed for US release. Retrieved from: <http://www.gamezone.com/news/the-breast-slider-in-xenoblade-chronicles-x-has-been-removed-for-us-release-3427713>

Sundar, S. S., Jia, H., Waddell, T. F., & Huang, Y. (2015). Toward a theory of interactive media effects (TIME). In S. S. Sundar (Ed.), *The handbook of the psychology of communication technology* (pp. 47–86). Hoboken, NJ: Wiley-Blackwell.

Swain, C. (2008). Master metrics: The science behind the art of game design. Paper presented at the NLGD Conference, Utrecht, Holland.

Vasalou, A., & Joinson, A. N. (2009). Me, myself and I: The role of interactional context on self-presentation through avatars. *Computers in Human Behavior, 25*(2), 510–520.

Vasalou, A., Joinson, A., Bänziger, T., Goldie, P., & Pitt, J. (2008). Avatars in social media: Balancing accuracy, playfulness and embodied messages. *International Journal of Human-Computer Studies, 66*(11), 801–811.

Watzlawick, P., Beavin, J., & Jackson, D. (1967). *Pragmatics of human communication.* New York: W.W. Norton.

Won, A. S., Bailenson, J., Lee, J., & Lanier, J. (2015). Homuncular flexibility in virtual reality. *Journal of Computer-Mediated Communication, 20*(3), 241–259.

Yee, N. (2001). *The Norrathian Scrolls: A study of EverQuest.* Retrieved from: <http://www.nickyee.com/report.pdf>

Yee, N., & Bailenson, J. (2007). The Proteus effect: The effect of transformed self-representation on behavior. *Human Communication Research, 33*(3), 271–290.

Race & Otherness

The Utopian Promise and Divided Reality

KRISTINE L. NOWAK

Imagine walking into a room where you are surrounded by flying pigs, lobsters with three claws, talking unicorns, and a host of human bodies that are different from yours. Consider how you would move and feel if your body was suddenly a different gender, race, or species—the body of an "Other." This ability to experience "Otherness"—states of being alien to one's own social identities (Miller, 2008)—in digital spaces emerges from the customization and editability of avatars. Thus, digital avatars can allow people to embody (to be digitally represented by) a digital body that presents another race with different skin color and hair and eyes, or an other species such as an alien, or a fantasy creature. Will people alter gaits, postures, speech, or behaviors when their digital bodies present an Other? How will they shake hands or move if they embody a tree, or a person with only one arm, or a coral reef? The ability to engage in this experimentation with appearance, movement, and interaction can allow people to experience the bodies of others, frequently called identity tourism (Nakamura, 2002). In this way, avatars can give people unique embodiment experiences and perspectives that may allow them to experiment with different parts of own their identities and potentially—even problematically—see Others in a unique light.

CONSIDERING THE UTOPIAN PROMISE AND THE RACIAL DIVIDE

Avatars can give users the freedom to choose whether and how to self-present. Early researchers and cyber enthusiasts were optimistic that this freedom would create spaces where people could be *any*body or *any*thing (Lanier & Biocca, 1992). Essentially, people can select digital bodies that present only what a user chooses and do not necessarily depict the actual physical appearances or traits of the user (Nowak, 2015). This ostensibly free choice is a significant difference between online and offline presentations of the self as it relates to group identity and membership. For example, while racial identity exists both online and offline, digital worlds allow people to make conscious choices about how and if they wish to present their racial identity to others. Thus, people can digitally embody Others, allowing them to experience different races, species, or even imaginary characters. Some argued that this freedom from corporeal bodies would facilitate a utopia of equal participation in discussion and community development (Turkle, 1995).

This so-called *utopian promise* may have been technologically possible but was not reflected in online behavior; instead, race categories' social meanings were retained in digital spaces (Biocca & Nowak, 2002). Daniels (2013) argued that the Internet not only neglected to provide an escape route from race or racism but further entrenched and complicated racial identity. Race is an important cultural, political, and economic category, which has been used interchangeably with terms including type, kind, breed, and species; people tend to use physical markers and appearance cues to mark social boundaries among groups even though race does not reflect actual physical or genetic differences (Smedley & Smedley, 2005). While some may assume racial identity based on discourse or narrative, explicit and intentional racial identity presentations may be enabled or limited by avatar graphics or interface structures like drop-down menus (Brock, 2011). For instance, those wishing to explicitly present a non-White identity will have limited and generally stereotyped options (Nakamura, 2002). Even when avatars are presented with black or brown skin colors, they do not always vary on features such as skin tone, eye shape, lip thickness, or hair texture and style, which are also associated with racial identification (Smedley & Smedley, 2005).

Even if interfaces overcame these imitations, some may hesitate to disclose race because they don't feel safe or because non-White avatars are often subject to racism in digital environments (Nakamura, 2009). This has implications beyond just online interactions given that people use the visible characteristics of avatars to infer the offline identities of users, and non-Whites are less likely to reveal race or to participate when they feel they are in the minority (Lee & Park, 2011). White males appear over-represented while non-Whites are both under-represented

and stereotypically presented in digital environments. This may perpetuate the assumption that everyone in the online world is a White male (Brock, 2011), leading some non-White participants to feel alone, invisible, isolated, and unwelcome.

In a sense then, seeing Otherness in people is part the instinctive categorizations humans make as they seek to sort people as either "in-group" (belonging to the same social categories) or "out-group" (belonging to different categories; Tajfel & Turner, 1979). Essentially, given the innate desire to assign others an in-group or out-group status, a sex- and race-free space would not be consistent with a utopian vision to *value* diversity. In this way, the attempt to create color-blind spaces could have visibly erased diversity in these digital spaces, which may have inadvertently entrenched and contributed to the sense that Whiteness is normal and even idealized (Daniels, 2013). The question, then, becomes how to support diverse racial presentation without further entrenching racial stereotyping in the face of digital Othering.

PERSPECTIVE TAKING AND IDENTITY TOURISM

In what has been called progressive embodiment (Biocca, 1997), technological advances will increasingly allow tighter coupling between users' senses (sight, sound, haptics) and digital bodies, allowing for more immersive and natural experience and control in digital worlds (Biocca & Nowak, 2002). This progressive embodiment theoretically allows people to be more immersed and fully experience digital worlds as an Other, which could enhance people's ability to experience a phenomenon called "identity tourism"—a form of racial appropriation in which someone playing a raced avatar may *pass as* but not fully *be as* someone of that race (Nakamura, 1995). Embodying and interacting with avatars representing different races and species, even temporarily, can provide important experiences that provide new ways of understanding different perspectives (Behm-Morawitz, Pennel, & Speno, 2016).

These "tourism" experiences do influence the way users navigate digital worlds or play games through what has been called the Proteus Effect, in which an avatar primes thoughts and behaviors by activating social scripts (Yee & Bailenson, 2007) such as those associated with how a person of a given race should behave (Ash, 2016). Embodying avatars of different races or species influences behaviors and attitudes toward others (Ash, 2016; Groom, Bailenson, & Nass, 2009) both during the online experience and days or even weeks later, and progressive embodiment seems to increase this effect (Yee & Bailenson, 2009).

These touring experiences are the closest people can come to experiencing the world as a person with different physical characteristics, or perhaps even an animal or object. The progressive embodied experience is likely more powerful

than simply imagining the experience. For instance, immersing oneself in a head-mounted display to embody a different species made people feel more connected nature than watching the experience on video (Ahn et al., 2016). Although being fully immersed and embodying a digital other can provide understanding, it does not come close to the experience one would gain after a lifetime of experience with a different racial identity. In this way, even with progressive embodiment, the avatar selected is synonymous to selecting clothing in that it can be worn more than once and while worn it alters behavior during the embodied experience. For example, people behave differently when wearing a bathing suit than when wearing a business suit because clothing and context changes influence posture, gestures, tone of voice, and even word choice (Weiner & Mehrabian, 1968). The avatar selected also provides information about the user by displaying interests or aspects of identity, but in highlighting one aspect of the self the user is downplaying or not presenting others (Nowak, 2015). The avatar is also like clothing in that it can be taken off, exchanged, and traded when the user disconnects from the digital world or switches avatars.

THE UTOPIAN PROMISE—KEPT AND BROKEN

The utopian promise of technology predicted a "liberation from marginalized and devalued bodies," where everyone can experience being "typical" in a world where "Otherness" is eradicated (Nakamura, 2002, p. 4). Some optimistically predicted that technology could provide spaces where race and sex were irrelevant, so everyone was equal and no one was Othered. This incorrectly presumed the absence of visible indicators of race would reduce its importance to identification and perception, and that people would *want* to cast off their racial identities. Even if this casting-off was possible, reducing mental salience of race could further entrench Whiteness as a typical, privileged, preferred, or normative state (Nakamura, 2002), and could lead non-White users to believe that passing as White is the only way to avoid discrimination or to be "typical."

The experience of progressively embodying avatars that represent non-White groups could be prosocial by expanding experience with other cultures and encouraging open-mindedness and ideally reduce reliance on stereotypes. These experiences could be antisocial, however, if they entrench stereotypical beliefs and behaviors, privilege one race over another, or contribute to the belief that race is biologically determined instead of socially constructed. In scientific investigations of this dilemma, for some White users, the experience of embodying Black avatars seemed to entrench stereotypical beliefs, stimulating more racial bias than those who embodied White avatars, initiating more aggressiveness, and leading to a greater perception that Black individuals are more aggressive (e.g., Groom,

Bailenson, & Nass, 2009). Altogether, such studies suggest that the embodiment of a Black avatar, or experience with others who are embodying Black avatars, could lead to increased implicit racial bias in at least some contexts, possibly because that embodiment activates race-based schema and triggers implicit negative racial attitudes (Groom, Bailenson, & Nass, 2009).

Under *some* conditions, however, the experience of embodying a non-White avatar has reduced racial bias and prejudice (Behm-Morawitz, Pennell, & Speno, 2016), but is yet unclear exactly what factors bring about prosocial results. It does seem that more prosocial effects (reduced racism) occurred when users were free to explore the environment or engage in less structured tasks and when they experienced greater immersion and control of the avatar (Peck et al., 2013). In other words, racial bias reduction was more likely to happen when players could more naturally control the embodiment and choose what they did in their tour of racial identities, perhaps triggering a sense of self-likeness.

It is important to recognize the limitations of identity tourism, which is usually a one-time experience where, for example, a White user navigates a digital world in a non-White body. Although studies have shown this tourism can result in prosocial effects (reduced bias), antisocial (heightened bias) effects may emerge if White users garner an exaggerated sense that their superficial touring experience allows them to know what it feels like to be non-White or to experience racism, leading them to downplay their racial privilege (cf. Nakamura, 1995). They may not realize that this limited experience in a context without sustained, real-world consequences does not accurately reflect the effect lifetime experiences of bias through harassment, discrimination, and even job security. Identity tourists do not experience long-term effects of potential discrimination (e.g., as Other-raced avatars they do not have to apply for jobs or ask for raises), and they know that at the end of the experience they return to the comfort of a privileged identity. Thus, identity tourists have at best a superficial experience with discrimination as they do not experience how Otherness could be a meaningful liability (Nakamura, 2002).

Although the notion of identity tourism has, to date, been applied principally to racial identities, these patterns may extend to other avatar forms as digital bodies convey other kinds of Otherness; seeing avatars as variably othered or even as non-human may trigger a sense that the entities behind the avatars have less social potential or autonomy, possibly increasing sympathy. For example, people embodying avatars presenting a disability led to increased helping behaviors and empathy (Ahn, Le, & Bailenson, 2013), and embodying non-human species (e.g., cow, coral reef) led to empathy and feelings of connection with nature even several weeks later (Ahn et al., 2016). It is important to continue exploring when and how identity tourism increases empathy, and whether this increased empathy influences future behavior or attitudes.

FUTURES OF AVATARIAL OTHERNESS

Given the tensions between prosocial and antisocial outcomes of identity tourism, videogame and digital world developers should carefully consider the moral and practical implications inherent to degrees of freedom in avatar-based self-presentation (Oravec, 1996). Allowing people to opt out of presenting racial identity (e.g., through nonhuman forms or skins) does not remove race from the identities or perceptions of users. Since racial categorizations of self and Other—through both physically lived and digitally embodied cues—can activate stereotypes that influence behavior without one's conscious awareness (Ash, 2016), applying "human" categories to online characters may emerge even when the avatars are not anthropomorphic. Given that early attempts to try to create digital worlds without racial identification may have actually heightened minority isolation and marginalization, designers should not ignore the implications of trying to create avatars without race.

Digital worlds are filled with both human-driven avatars and algorithm-driven agents, which raises the question of whether digital bodies may be considered a unique "species" of entities who are difficult to categorize as in-group or other because they are both and neither. While it is easy to understand that either a human or a bot could be represented by the same body, consider that a single body could actually represent *both* at different times and one may not know who was behind an action. For instance, a given avatar that usually represents a person is—while the person is offline—imbued with the personality or autonomous decision-making of that same person. This avatar would then look like, be authorized to make decisions for, and represent this person based on some agreed-upon decision tree, as when an offline *Farmville* (2009) player's avatar autonomously visits a friend's farm. Or consider how a digital body is *neither* fully representing a human or an algorithm, as when a gamer decided to marry a character—he felt the female-skinned bot was the most supportive and understanding "woman" he had ever met (Lah, 2009). That is, through the merging of human and technological characteristics, avatars could be perceived in practice as a new kind of entity somewhere in-between, able to complete tasks on behalf of a person, satisfy interaction goals, and keep people company. Thus, avatars—this ostensible new kind—are not quite Othered in that they can be shaped to be like us, are neither animal nor object, and cannot neatly be categorized unliving. Thus, people could begin to assign them to emergent categories instead of relying on human social categories. For instance, European governments have debated the label "electronic persons" for intelligent agents (Larson, 2017).

Digital worlds force us to consider how to present and perceive race and Otherness online, which presents a challenge when human beings with racial identities are embodied by animal or non-human forms without racial signifiers (e.g., the

five creatures in *Botanicula*, 2012), by differently raced humanoids (e.g., Blood Elves versus Night Elves in *World of Warcraft*, 2004), or when engaging multiple marked digital bodies (e.g., trainer and monster in *Pokémon GO*, 2016). Given humans' innate tendencies to assign in-/out-group status to encountered individuals, it is difficult to determine which markers people will use to make category assignments when the body is not humanly raced—and when it is made up of pixels and digits that can be transformed and modified at will (Biocca & Nowak, 2002). Experiences with nonhuman, intelligent others (e.g., digital agents) may give rise to categories that are not proxies for categories based on the human body and based instead on the pixels of digital bodies. People may evolve new criteria for evaluating digital bodies, such as the quality of the image, level of realism, clarity, clear connection of abilities to metaphor or promise, ability to evolve and adapt, or the usefulness of the interface.

In contrast to tendencies to self-differentiate from other humans through nuanced out-group assignment (Tajfel & Turner, 1979), engagement of these new categories of human-but-not agents—where differences are overt—may instead lean toward seeking some commonality, connection, or something familiar to reduce uncertainty. This could explain why people seem to feel more empathy when the avatar is less anthropomorphic, perceived to be less human, or even less capable. Thus, digital worlds can make salient new categories associated with digital bodies so people can opt in or out in any given interaction. This could allow people to decide to be in-group, which will promote identification if users are driven to seek commonality. Alternatively, perhaps embodying an Other that is intentionally very different could increase empathy, identification, or enhance the sense of connection to those seen as out-group. As Banks and Bowman (2016) suggest, "It may be that when the avatar is approached as 'we' (perhaps with empathy, loyalty, and protection cues) rather than as 'I,' humans may enter into interactive media toward more meaningful experiences with digital bodies" (p. 1273). If avatars are to be engaged for prosocial outcomes, it will be important to discover the conditions that facilitate reducing bias, but perhaps in some cases this means making Otherness salient—to foster its instinctive reduction—and focus on ways of ensuring that embodying an avatar leads to increased empathy and connection to others who are different from the self.

The future of avatar interactions may depend largely upon design decisions, which will influence progressive embodiment experiences in all sorts of digital worlds including games, classrooms, social media, and augmented reality systems. If avatars—with varying degrees of human-likeness—are processed as something entirely new, it could lead to the creation of different indications of status or category membership. Perhaps instead of Othering non-humans (or even humans categorized as out-group) experience in online worlds will allow people to recognize or perceive a continuum between human and non-human with avatars embodying

entities will somewhere in the middle (see Waytz, Epley, & Cacioppo, 2010), which would allow people to seek a connection to and commonality with Others as people recognize that the human/non-human boundary is not exactly binary.

REFERENCES

Ahn, S. J., Bostick, J., Ogle, E., Nowak, K. L., McGillicuddy, K., & Bailenson, J. N. (2016). Experiencing nature: Embodying animals in immersive virtual environments increases inclusion of nature in self and involvement with nature. *Journal of Computer-Mediated Communication, 21*(6), 399–419.

Ahn, S. J., Le, A. M. T., & Bailenson, J. N. (2013). The effect of embodied experiences on self-other merging, attitude, and helping behavior. *Media Psychology, 16*(1), 7–38.

Ash, E. (2016). Priming or Proteus effect? Examining the effects of avatar race on in-game behavior and post-play aggressive cognition and affect in video games. *Games and Culture, 11*(4), 422–440.

Banks, J., & Bowman, N. D. (2016). Emotion, anthropomorphism, realism, control: Validation of a merged metric for player–avatar interaction (PAX). *Computers in Human Behavior, 54*, 215–223.

Behm-Morawitz, E., Pennell, H., & Speno, A.G. (2016). The effects of virtual racial embodiment in a gaming app on reducing prejudice. *Communication Monographs, 83*(3), 396–418.

Biocca, F. (1997). The cyborg's dilemma: Progressive embodiment in virtual environments. *Journal of Computer Mediated Communication, 3*(2).

Biocca, F., & Nowak, K. L. (2002). Plugging your body into the telecommunication system: Mediated embodiment, media interfaces, and social virtual environments. In D. Atkin & C. Lin (Eds.), *Communication technology and society: Audience adoption and uses* (pp. 407–447). Cresskill, NJ: Hampton Press.

Brock, A. (2011). "When keeping it real goes wrong": *Resident Evil 5*, racial representation, and gamers. *Games &Culture, 6*(5), 429–452.

Daniels J. (2013). Race and racism in Internet studies: A review and critique. *New Media & Society, 15*, 695–719.

Fisher, J. (1997). The postmodern paradiso; Dante, cyberpunk, and the technosophy of cyberspace. In D. Porter (Ed.), *Internet culture* (pp. 111–132). New York: Routledge.

Groom, V., Bailenson, J. N., & Nass, C. (2009). The influence of racial embodiment on racial bias in immersive virtual environments. *Social Influence, 4*, 1–18.

Lah, K. (2009, Dec. 17). Tokyo man marries video game character. *CNN*. Retrieved from: <http://www.cnn.com/2009/WORLD/asiapcf/12/16/japan.virtual.wedding/>

Lanier, J., & Biocca, F. (1992), An insider's view of the future of virtual reality. *Journal of Communication, 42*: 150–172.

Larson, S. (2017, Jan. 26). Killing the immortal: Why scientists are debating the life span of robots. *CNN*. Retrieved from: <http://money.cnn.com/2017/01/26/technology/kill-switch-ai-ethics/index.html>

Lee, J. E. R., & Park, S. G. (2011). "Whose Second Life is this?" How avatar-based racial cues shape ethno-racial minorities' perception of virtual worlds. *CyberPsychology, Behavior, & Social Networking, 14*, 637–642.

Miller, J. (2008). Otherness. In L. M. Given (Ed.), *The SAGE encyclopedia of qualitative research methods* (pp. 588–591). Thousand Oaks, CA: SAGE Publications, Inc.

Nakamura, L. (2002). *Cybertypes: Race, ethnicity, and identity on the Internet*. New York, NY: Routledge.

Nakamura, L. (1995). Race in/for cyberspace: Identity tourism and racial passing on the Internet. *Works and Days*, 25(26). Retrieved from: <https://pdfs.semanticscholar.org/3531/da9329d2b7158b-d697e1aa8ef073f78de6fb.pdf>

Nowak, K. L. (2015). Examining perception and identification in avatar mediated interaction. In S. S. Sundar (Ed.), *The handbook of the psychology of communication technology* (pp. 89–114). Hoboken, NJ: Wiley-Blackwell.

Nowak, K. L., Hamilton, M. A., & Hammond, C. (2009). The effect of image features on judgments of homophily, credibility, and intention to use avatars in future interactions. *Media Psychology*, 12(1), 50–76.

Nowak, K. L., & Rauh, C. (2008). Choose your "buddy icon" carefully: The influence of avatar androgyny, anthropomorphism and credibility in online interactions. *Computers in Human Behavior*, 24(4), 1473–1493.

Oravec, J. (1996). *Virtual individuals, virtual groups: Human dimensions of groupware and computer networking*. Cambridge: Cambridge University Press.

Peck, T. C., Seinfeld, S. Aglioti, S. M., Slater, M. (2013). Putting yourself in the skin of a Black avatar reduces implicit racial bias. *Consciousness and Cognition*, 22, 779–787.

Smedley, A., & Smedley, B. D. (2005). Race as biology is fiction, racism as a social problem is real: Anthropological and historical perspectives on the social construction of race. *American Psychologist*, 60(1), 16–26.

Tajfel, H., & Turner, J. (1979). An integrative theory of intergroup conflict. In W.G. Austin & S. Worchel (Eds.), *The social psychology of intergroup relations* (pp. 33–47). Monterey, CA: Brooks/Cole.

Turkle, S. (1995). *Life on the screen: Identity in the age of the Internet*. New York: Simon & Schuster.

Waytz, A., Epley, N., & Cacioppo, J. T. (2010). Social cognition unbound: Insights into anthropomorphism and dehumanization. *Current Directions in Psychological Science*, 19(1), 58–62.

Weiner, M., & Mehrabian, A. (1968). *Language within language: Immediacy, a channel in verbal communication*. New York: Appleton-Century-Crofts.

Yee, N., & Bailenson, J. N. (2009). The difference between being and seeing: The relative contribution of self-perception and priming to behavioral changes via digital self-representation. *Media Psychology*, 12, 195–209.

Boobs & Butts

The Babes Get the Gaze

JESSE FOX

Given the primitive graphics of early videogames, it took several years for game developers to enable human-like representations. With the development of human characters and related plots or storylines, it became necessary for designers to create representations with human-like traits such as biological sex and gender to illustrate these narratives. Historically, representations of women have been distinguished physiologically by accentuating the curvature of women's bodies, whereas men were imbued with masculine traits such as muscularity or facial hair. Moreover, this physiology may be exaggerated. Male characters are often hyper-masculine, emphasizing traits such as a strong jaw line and excessive musculature. These features are associated with power and aggression and are often relevant to character goals. Female characters, on the other hand, are often hypersexualized. Breasts and butts are exaggerated to unrealistic proportions, creating an idealized hourglass shape with an excessively narrow waist. This figure is further accentuated through revealing and often impractical clothing. Rather than conveying strength or other relevant capacities, such depictions focus on women's sexuality.

Although both male and female avatars may appear in revealing clothing, it is a false equivalence to suggest that these depictions are the same. Men are typically shown shirtless to flaunt musculature and strength, whereas the revealing nature of women's clothing is designed to highlight their sexuality. If male characters were similarly sexualized, they might don pants with peekaboo cutouts or very short shorts to show off their butts. Tight or revealing clothing would emphasize excessively large penises that may sway or bounce with character movements. Such

representations of men, however, are extremely rare. This inequality in representation, and particularly the sexualization of women, has a wide range of implications for players and viewers of games, both within and outside of the gameworld.

INTERPRETING THE DIGITAL AS THE REAL

The computers as social actors perspective (CASA; Nass, & Moon, 2000) suggests that human brains have not evolved to distinguish mediated representations from the real world. When people encounter mediated entities and messages, they process them mindlessly and react similarly to how they would react to the same stimulus in the physical world. If a media representation appears to be human or behaves in a human-like fashion, people will judge and react to it similarly as to a human. What they learn from this interaction may be encoded as information about human behavior in general rather than qualified as an inauthentic media representation.

Supporting the claims of CASA, several studies have shown that individuals perceive and behave toward gendered avatars in ways similar to how they respond to men and women generally. Children have been shown to trust female representations more than male representations on topics such as princesses and makeup, but trust male representations more than female representations on topics such as football and dinosaurs (Lee, Liao, & Ryu, 2007). In digital worlds, greater interpersonal distance is maintained in male-male avatar dyads than in male-female or female-female dyads (Yee, Bailenson, Urbanek, Chang, & Merget, 2007), as is common in physical encounters. Female avatars are also subject to more sexual harassment than male avatars (Behm-Morawitz & Schipper, 2016), but are more likely to receive help than male avatars (Lehdonvirta, Nagashima, Lehdonvirta, & Baba, 2012). These findings suggest that gendered attributions and behavior carry over to digital environments, even though these representations are not inherently sexed.

Given that CASA indicates that people do not necessarily distinguish between physically present and mediated figures, this has important implications for how people interpret, process, and learn what they observe about sex and gender in media. Other perspectives (e.g., social cognitive theory; Bandura, 1977) also suggest that we do not necessarily distinguish what we encode as physically present or mediated. Thus, gendered representations in videogames are likely to be interpreted by, and contribute to, consumers' broader understanding of sex and gender.

SOCIAL AND BIOLOGICAL ROOTS OF GENDERED BODIES

Before discussing gaming contexts, it is important to understand the origin of preoccupations with demarcating and differentiating males and females. Biological sex is one of the first traits that individuals try to determine when encountering

a human form (Buss, 2003). From an evolutionary perspective, this practice may be a somewhat instinctual way of assessing sexual viability for mating based on distinct biological features. Beyond genitalia, this sexual dimorphism may include differences in size, shape, or color. Humans also feature secondary sexual characteristics that appear during puberty but are not essential to reproduction; in women, these characteristics include growth in the breasts, hips, and buttocks. Humans further elaborate on biological differences by developing gendered types of dress and appearance norms in many cultures.

In human experience and practice, however, sex and gender are not rigid categories (Bem, 1981). Biological markers of sex can be changed through alterations in hormones or surgery. Gender identity may parallel one's sex, or not; a person may identify as a man, a woman, or as genderfluid or nonbinary. Similarly, one may express masculinity, femininity, androgyny, ambiguity, or nongenderedness. Regardless, sex and gender remain one of the primary ways individuals perceive and categorize others (Bem, 1981). Although biological markers are not clear indicators of gender identity, nor is gender identity or expression necessarily tied to biological sex, individuals often interpret gendered cues as inferences to biological sex. Similarly, when consumers encounter videogame characters, they typically seek biological markers or gender cues to attempt to categorize the person and apply gendered schema (Beasley & Standley, 2002).

A key point to consider when examining the history of female portrayals in videogames is that the ability to convey sex and gender cues is constrained by the affordances of the medium. On the phone, for example, only features like the pitch and tone of a person's voice are available to infer sex. In early videogames, programmers had to cope with crude, heavily pixelated graphics that yielded blocky representations. These constraints made it difficult to create detailed human features. Thus, when early games provided a female character, the programmers had to find cues to indicate maleness and femaleness. One early example is the titular characters from *Pac-Man* (1980) and *Ms. Pac-Man* (1981). To distinguish her from Pac-Man, Ms. Pac-Man's avatar sported a bow (rather odd given she lacked any hair to hold it up). Perhaps more notably, the arcade machine for Ms. Pac-Man featured a completely different figure from the simple, pie-shaped avatar. Her humanized face wore heavy makeup, and shapely legs were wedged into high heels. She posed like a centerfold, with a hand behind her head and a sultry gaze. Even a simple yellow orb, once marked as female, could be sexualized.

The portrayal of Ms. Pac-Man is also exemplary of other functions of gendered appearance. Sex and gender differences in appearance have evolved to facilitate reproduction by helping humans efficiently identify potential mates (Buss, 2003). Other videogames capitalized on sex differences in the human form to distinguish men and women, albeit crudely. Female characters often appeared as jagged hourglass figures with long hair and dresses to distinguish from the more square-bodied,

pants-wearing male figures. For example, in the popular Nintendo arcade game *Donkey Kong* (1981), Lady (later known as Pauline) has long orange hair and a pink dress cinched at the waist, whereas Jumpman (later known as Mario) sports facial hair and coveralls. As evolutionary scholars note that such markers as hip-to-waist ratios (via larger hips, butts, breasts and smaller waists) indicate a hardiness to sustain pregnancy and nurture offspring (Buss, 2003), it makes sense that these areas may be focal areas for attraction. Another perspective suggests that culture has played a large part in directing attention toward women's bodies.

FIXATIONS AND (HETERO)NORMATIVE GAZES

In the early 1980s, videogames began to make their way outside of public arcades and into the home. Home consoles did not have the processing power of many arcade machines, however, and representations remained rather crude. Distinguishing male and female characters was important for a burgeoning genre made more feasible by the adoption of consoles in private homes: adult videogames. Seeking to mimic mainstream pornography, these erotic games were designed to reflect heterosexual male fantasies (Payne & Alilunas, 2016).

One such example was the highly controversial game *Custer's Revenge* (1982) released by Mystique for the Atari 2600. The player, controlling an avatar based on U.S. General George Custer, was to rape a naked Native American female tied to a pole. To distinguish the characters, the female character featured exaggerated breasts and buttocks and wore a feather atop her head; Custer sported a Cavalry hat, boots, and an erection. These crude shapes were similar to another pornographic game by Mystique for the Atari 2600, *Beat 'Em & Eat 'Em* (1982), in which a naked, erect man ejaculated from a rooftop. Players controlled female avatars distinguished by long hair and exaggerated breasts, who stood beneath the building with mouths open to catch the man's semen.

Beyond the erotic game genre, however, fixations on women's bodies continued. Graphical improvements in pixelation, color array, and shadowing made female characters more identifiable, but the focus on exaggerated hourglass figures remained. Games began to feature more detailed and sexualized depictions of female characters, perhaps to attract male players. These portrayals reflect the *male gaze* (Mulvey, 1975), which suggests that heterosexual men are envisioned as the default audience. Media thus depict phenomena through a masculine perspective, and women become objects to be looked at rather than agentic beings.

Notably, the stereotypical representations of women in videogames also enabled perhaps the greatest character reveal in gaming history. Lacking the typical exaggerated hourglass figure or other gendered markers, the protagonist Samus Aran in Nintendo's *Metroid* (1986) was assumed to be male until the victory screen in which

she revealed her sex. Subsequent iterations of the character, however, later presented Samus in the typical hypersexualized body, often wearing a skintight "zero suit."

Sexualized depictions of women continued to be a point of controversy in videogames throughout the 1980s, 1990s, and 2000s. In the *Leisure Suit Larry* series (1987), players controlled the "loser" character, Larry. The goal of the game was to obtain sex from various sexualized women by earning money to buy gifts, which gradually broke down a woman's resistance until she revealed her breasts or complied with sexual advances. *Duke Nukem 3D* (1996) featured gameplay in which women appeared as strippers. Duke could command them to "Shake it, baby!" as they danced; alternatively, the player could kick or punch them. A patch to *Tomb Raider* (1996) stripped the female protagonist Lara Croft so that the game could be played with a nude avatar. In the *Grand Theft Auto* series, starting with *Grand Theft Auto III* (2001), players could seek services from female, but not male, prostitutes.

As graphics capabilities became more nuanced in the early 2000s, the developers of the *Dead or Alive* series, including games such as *Dead or Alive: Xtreme Beach Volleyball* (2003), saw this as an opportunity to improve avatar animations. Instead of other avatar features that are challenging to animate such as hair or facial expressions, the developers chose to focus on "breast physics," also commonly referred to as "jiggle physics" (Bardzell, 2006). Breast bounce had nothing to do with gameplay mechanics, but was ostensibly designed to titillate heterosexual male players. Indeed, the *Dead or Alive* developers did not merely add default breast animations to avatars; they added a range of options so that players could control the degree to which buxom female characters' breasts bounced during gameplay. Notably, no comparable "jiggle physics" are offered for male characters in any of the series' games.

As these examples indicate, videogames have a long history of focusing on women's breasts and butts. Indeed, content analyses over the past two decades have supported the assertion that women are objectified and sexualized in videogames much more frequently than men. Women's roles seem constrained to being sex objects or damsels in distress (Summers & Miller, 2014). Compared to male characters, female characters wear more revealing clothing and are more likely to feature hypersexualized body parts (Downs & Smith, 2010). Indeed, reflecting the heteronormative male gaze, it is difficult to identify games in which a male character's package is as pronounced and exaggerated as female characters' breasts often are.

OBJECTIFICATION OR EMPOWERMENT?

Women's unequal and unrealistic body representations in videogames are important to consider from several theoretical perspectives. Objectification theory states

that people are socialized to treat girls and women as objects to be looked at and evaluated (Fredrickson & Roberts, 1997), an acculturated perspective like the male gaze (Mulvey, 1975). Girls and women are taught by peers, family, and media that their value is in their appearance and sexuality rather than their personality traits and skills. Over time, girls and women internalize this perspective and learn to see and judge themselves based on their appearance. This process of *self-objectification* has been tied to a range of detrimental outcomes, including body preoccupation, depression, and eating disorders (Moradi & Huang, 2008). Several studies have found that objectified and sexualized representations of women in media—including women avatars—can promote self-objectification in women (e.g., Fox, Bailenson, & Tricase, 2013). In other words, sexualized media portrayals can have negative outcomes because they reinforce gendered norms and suggest that women's value is contingent on their beauty and sexuality.

Social cognitive theory also suggests that individuals learn from mediated models (Bandura, 1977). One element of social learning is identifying with characters who are similar on traits such as sex. This is problematic given girls and women playing videogames have limited positive role models and are far more likely to encounter a sexualized representation. Thus, the models they are most likely to identify with may be conveying messages about how women should behave: they should dress in a titillating manner and emphasize their sexuality but also subjugate themselves to men. Further, players are likely to see women treated like objects. For example, many racing games feature women as rewards for winning a course. Other games, such as those in the *Leisure Suit Larry* and *Grand Theft Auto* series, are more explicit in incorporating sexualized women as objects, rewards, and Easter eggs in gameplay. Given the player can often earn rewards such as points or money—or sexual arousal—social cognitive theory would suggest they would associate positive outcomes with this treatment of women and be more likely to seek or imitate such behavior.

These theoretical perspectives both indicate that the focus on boobs and butts may be more than just a design choice; the sexualization and objectification of women in videogames may be problematic. Sexualized female avatars have been shown to diminish women's self-efficacy and encourage men and women to perceive women as less intelligent (Behm-Morawitz & Mastro, 2009), promote hostile sexism (Fox & Bailenson, 2009), and increase men's likelihood to sexually harass (Yao, Mahood, & Linz, 2010). Experimental and survey studies have also found that women who embodied sexualized avatars experienced higher levels of self-objectification than those embodying non-sexualized avatars (e.g., Behm-Morawitz & Schipper, 2016).

Other scholars, however, have suggested that sexualized representations can be "empowering" for women who play these games. These claims parallel the idea of empowerment through sexual agency espoused by third wave feminists (Gill,

2008). According to these scholars, the ability to control the character yields feelings of empowerment: unlike objectified women in other media such as television or magazines, the user can *control* the sexualized representation, making the avatar more of an agentic subject than an object. For example, Lara Croft of the *Tomb Raider* series was one of the first playable female characters in a successful, mainstream videogame. As such, the character has been labeled a "feminist icon" (Kennedy, 2002) and has been conceptualized as a positive example of how digital spaces evolved to accommodate women (Jenson & De Castell, 2010), even though she is hypersexualized and objectified. Opposing views, however, argue that most "strong," "dominant" female characters depict a double bind and are disempowered through their sexual objectification (Brown, 2011).

At this time, however, research on the impact of viewing, interacting with, and controlling sexualized representations of women is limited. Any number of factors, including personality traits, affordances of the gaming environment, game variables, experiences with other players, and the scope of an individual's gaming and media diet may contribute to potential effects on players and viewers of videogames. For example, existing attitudes toward women or levels of sexism are both likely to influence how a player would respond to a sexualized female character. Other factors worth investigating (experimentally and longitudinally) are experiences such as embodiment, social presence, or immersion in the environment; social identity or involvement with a game or character; social interactions with or through the character; other players' responses or comments about the character; other behaviors of the character, such as gender stereotypical or counter-stereotypical actions; and goals or actions within the game, such as competing or collaborating.

In the meantime, a critical question is whether sexualizing women's representations offers any positive effects or benefits. Experimental research has refuted the argument that sexualized representations are empowering to women (Halliwell, Malson, & Tischner, 2011), and disputed the oft-cited claim that "sex sells," noting no relationship between the sexualization of characters and market success (Lynch, Tompkins, van Driel, & Fritz, 2016). Given that sexualized representations have not demonstrated any noted benefit and may be alienating part of the market, it remains unclear why they remain prevalent. When sexualization is irrelevant and may have the potential for harm, it seems simple enough to avoid incorporating such representations. Moreover, it seems designers should be interested in more diverse and complex representations of characters in general rather than reproducing the same banal, tired tropes.

The continued inequality of men's and women's representations, however, begets some challenging questions for developers. If sexualization is defended as something that is enjoyable or tantalizing to players, why do developers only cater to the heterosexual male gaze? If developers are trying to appeal to a variety of players and do not intend to be sexist or heterosexist in their games, why are male

characters not equally sexualized so that women, gay men, and others attracted to men find these experiences equally enjoyable? Indeed, perpetuating inequitable representations seems an indefensible position if developers are truly catering to a diverse audience and not just the stereotypical heterosexual male gamer.

FUTURES OF SEXUALIZED BODIES

Although current research indicates some ongoing inequalities in the portrayals of women in videogames, it is interesting to consider how these representations may change. After all, human bodies themselves are becoming more malleable through hormones, plastic surgery, and other forms of body modification. The exaggerated hourglass reflected in hypersexualized videogame characters may become more attainable with the growing popularity of procedures such as breast augmentation, butt implants, and liposuction. Further, perceptions of sex and gender roles are changing; several cultures that have adhered to rigid roles are acknowledging more androgynous and genderfluid forms of self-representation. What is seen as typical of men and women may become considerably less distinct in the future. Given the flexibility of affordances in computer-mediated communication and digital environments, videogames can be designed to provide players with a near-infinite range of bodily options—they have the potential to transcend existing norms and paradigms for the representation of women's bodies in ways that many traditional media cannot.

Thus far, videogames have mostly replicated representations of women in mainstream media rather than challenging this paradigm or innovating. Given that videogames themselves have evolved from a niche hobby to mainstream entertainment, it will be interesting to see if they continue to rely on homogeneous content and perpetuate stereotypical depictions of women, or if game developers will capitalize on the affordances of the medium and the creative opportunities of the narrative format to diversify women's representations beyond boobs and butts.

REFERENCES

Bandura, A. (1977). *Social learning theory.* Englewood Cliffs, NJ: Prentice-Hall.

Bardzell, S. (2006, July). The submissive speaks: The semiotics of visuality in virtual BDSM fantasy play. In *Proceedings of the ACM SIGGRAPH symposium on video games* (pp. 99–102). New York: ACM.

Beasley, B., & Standley, T. C. (2002). Shirts vs. skins: Clothing as an indicator of gender role stereotyping in video games. *Mass Communication & Society, 5,* 279–293.

Behm-Morawitz, E., & Mastro, D. (2009). The effects of the sexualization of female video game characters on gender stereotyping and female self-concept. *Sex Roles, 61,* 808–823.

Behm-Morawitz, E., & Schipper, S. (2016). Sexing the avatar: Gender, sexualization, and cyber-harassment in a virtual world. *Journal of Media Psychology, 28*, 161–174.

Bem, S. L. (1981). Gender schema theory: A cognitive account of sex typing. *Psychological Review, 88*, 354–364.

Brown, J. A. (2011). Dangerous curves: Action heroines, gender, fetishism and popular culture. Jackson, MS: University of Mississippi Press.

Burgess, M. C. R., Stermer, S. P., & Burgess, S. R. (2007). Sex, lies, and video games: The portrayal of male and female characters on video game covers. *Sex Roles, 57*, 419–433.

Buss, D. M. (2003). *The evolution of desire: Strategies of human mating.* New York: Basic Books.

Downs, E., & Smith, S. L. (2010). Keeping abreast of hypersexuality: A video game character content analysis. *Sex Roles, 62*, 721–733.

Fox, J., & Bailenson, J. N. (2009). Virtual virgins and vamps: The effects of exposure to female characters' sexualized appearance and gaze in an immersive virtual environment. *Sex Roles, 61*, 147–157.

Fox, J., Bailenson, J. N., & Tricase, L. (2013). The embodiment of sexualized virtual selves: The Proteus effect and experiences of self-objectification via avatars. *Computers in Human Behavior, 29*, 930–938.

Fredrickson, B. L., & Roberts, T.-A. (1997). Objectification theory: Toward understanding women's lived experienced and mental health risks. *Psychology of Women Quarterly, 21*, 173–206.

Gill, R. (2008). Empowerment/sexism: Figuring female sexual agency in contemporary advertising. *Feminism & Psychology, 18*, 35–60.

Halliwell, E., Malson, H., & Tischner, I. (2011). Are contemporary media images which seem to display women as sexually empowered actually harmful to women? *Psychology of Women Quarterly, 35*, 38–45.

Jansz, J., & Martis, R. G. (2007). The Lara phenomenon: Powerful female characters in video games. *Sex Roles, 56*, 141–148.

Jenson, J., & De Castell, S. (2010). Gender, simulation, and gaming: Research review and redirections. *Simulation & Gaming, 41*, 51–71.

Kennedy, H. W. (2002). Lara Croft: Feminist icon or cyberbimbo? On the limits of textual analysis. *Game Studies: International Journal of Computer Games Research, 2*(2).

Lee, K. M., Liao, K., & Ryu, S. (2007). Children's responses to computer synthesized speech in educational media: Gender consistency and gender similarity effects. *Human Communication Research, 33*, 310–329.

Lehdonvirta, M., Nagashima, Y., Lehdonvirta, V., & Baba, A. (2012). The stoic male: How avatar gender affects help-seeking behavior in an online game. *Games & Culture, 7*, 29–47.

Lynch, T., Tompkins, J. E., van Driel, I. I., & Fritz, N. (2016). Sexy, strong, and secondary: A content analysis of female characters in videogames across 31 years. *Journal of Communication, 66*, 564–584.

Moradi, B., & Huang, Y.-P. (2008). Objectification theory and psychology of women: A decade of advances and future directions. *Psychology of Women Quarterly, 32*, 377–398.

Mulvey, L. (1975). Visual pleasure and narrative cinema. *Screen, 16*, 6–18.

Nass, C., & Moon, Y. (2000). Machines and mindlessness: Social responses to computers. *Journal of Social Issues, 56*, 81–103.

Payne, M. T., & Alilunas, P. (2016). Regulating the desire machine: *Custer's Revenge* and 8-bit Atari porn video games. *Television & New Media, 17*, 80–96.

Summers, A., & Miller, M. K. (2014). From damsels in distress to sexy superheroes: How the portrayal of sexism in video game magazines has changed in the last 20 years. *Feminist Media Studies, 14*, 1028–1040.

Yao, M. Z., Mahood, C., & Linz, D. (2010). Sexual priming, gender stereotyping, and likelihood to sexually harass: Examining the cognitive effects of playing a sexually-explicit video game. *Sex Roles, 62*, 77–88.

Yee, N., Bailenson, J. N., Urbanek, M., Chang, F., & Merget, D. (2007). The unbearable likeness of being digital: The persistence of nonverbal social norms in online virtual environments. *CyberPsychology & Behavior, 10*, 115–121.

Face & Hair

Looks That Change Behaviors

SUN JOO (GRACE) AHN

The face is often referred to as the "window to the soul" because it is an essential way of expressing emotions to others. More than 10,000 expressions can be made using facial muscles (Ekman, 1972) and among the human body parts used to express and communicate emotions, the face is one of the richest sources of nonverbal information (Collier, 1985). The ability to recognize these expressed emotions and identify a person from their facial appearance is an essential skill for daily social interactions (Weigelt, Koldewyn, & Kanwisher, 2012), because people often attempt to estimate others' traits and characteristics—from trustworthiness to competency—through their facial features.

Then what about the facial features and expressions of *digital* figures, like those in videogames and digital worlds? With virtual reality and gaming technologies reaching the mainstream (Pew Internet Research, 2015), we are increasingly exposed to and interacting with digital agents (bodies driven by computer algorithms) and avatars (bodies driven by human users). Although these digital figures may not exist in the flesh and bone, research suggests that interacting with digital agents and avatars can not only influence the way that we think about them in the digital world but also change the way that we think and behave in the physical world. One reason that agents and avatars can be so influential may be because of the human brain's predisposition to respond to dynamically moving human faces, even the digital ones (Kilts, Egan, Gideon, Ely, & Hoffman, 2003). Because humans are, by nature, social animals, our brains are programmed to understand and respond to social (versus non-social) interactions. In digital worlds, such as *Second Life* or *The Sims*, for instance, users talk to, mingle with, fight against, and

build relationships with other avatars, mimicking elements of physical world social interactions. The similarities between physical and digital worlds likely serve as cues for users to imbue human-like characteristics to digital beings and apply the same judgment criteria they would to humans—in particular, to human faces.

DIGITAL FACES VERSUS PHYSICAL FACES

In many digital spaces, customization platforms and human creativity mean that one could choose to be represented by almost any figure—a symbol or icon, a human or a non-human entity, and as a being of any gender, race, or species. Nevertheless, people seem to prefer digital representations that have expressive faces to those that don't (such as a box or symbol), especially when the expressive faces are of the same biological sex (Nowak & Rauh, 2006). Even for computer-controlled agents, people tend to infer personalities and trait characteristics based on recognizable facial features and expressions. For example, people perceived varying levels of dominance, trustworthiness, and aggression based on the facial features of agents, such as width-to-height ratio and eye size and shape (Ferstl, Kokkinara, & McDonnell, 2016). Although wider human faces have traditionally been linked with perceptions of aggressiveness (Geniole, Denson, Dixson, Carré, & McCormick, 2015), in digital worlds, narrow faces in were perceived as most aggressive and most dominant (Ferstl et al., 2016). Perhaps this is a result of animated media content which often portrays villains with thin, long facial features (e.g., The Evil Queen in *Snow White*, Cruella De Vil in *101 Dalmatians*), leading to associations between perceived aggression and narrow facial features in computer-generated characters.

In the physical world, people often learn about appropriate facial expressions from social norms (i.e., unwritten rules for what is normal in society), which can be unique in different cultures (Ekman, 1972). This culturally driven knowledge about facial expressions can also carry over to digital spaces. For instance, in rating facial expressions of digital humans, Japanese people focus more on facial cues around the eye region, whereas Hungarians focus more heavily on the mouth (Koda, Ruttkay, Nakagawa, & Tabuchi, 2010). Interestingly, people better recognize facial expression of digital figures when the figures are designed by artists from their own or neighboring cultures (Koda, Ishida, & Rehm, 2009).

Despite some inconsistencies, the consensus seems to be that digital faces elicit perceptions and responses relatively like those elicited by organic human faces. This is an interesting phenomenon because, unlike in the physical world where responses to facial or hair features would be synonymous to responses toward the same person (e.g., perceiving dominance from a person's face would be the same as thinking that person is dominant), in digital worlds, a person may be represented by anyone or anything of his or her choosing. Thus, a very timid user

may be represented in the digital world with face and hair features that may be perceived as courageous by others (imagine a videogame warrior avatar). But people who interact with the warrior avatar cannot know the user's physically embodied identity; the identity of the user and his or her digital representation stand independent of each other (Banks & Carr, 2017). This means that perceptions of a digital agent or avatar may not align with perceptions of the user behind the digital representation.

Scholars have several theories of why people still tend to form impressions of personality and characteristics from digital faces and hair, despite these distinctions between humans and avatars. It may be that when digital agents and avatars—through their facial characteristics—are perceived to be sufficiently real so people feel as if they are interacting with another human (Biocca & Nowak, 2001), the digital representations elicit naturalistic responses. Alternatively, when people socialize with avatars it reminds them of physical-world interactions, so their mental model of the physical world is activated—along with scripts for how people behave in physical interactions (Shank & Abelson, 1977). For example, scholars have noted that the rules and expectations of mundane social interactions, such as visiting and hosting guests in the physical world also carry over into digital worlds in the game, *The Sims Online*: hosts are expected to provide food for avatar guests and clean room and board, and the guests are expected to clean up after themselves and follow the hosts' rules, even in digital homes (Martey & Stromer-Galley, 2007).

HAIR AS A KEY CUSTOMIZATION FEATURE

A handful of studies point to the importance users place on hair in constructing digital agents and avatars. Ducheneaut and colleagues (2009) posit that the importance of hair may be understood as an indication of insufficient customization options—when faced with lack of options to personalize avatars' facial expressions, users may resort to radical changes in hair to differentiate their avatars from others. Another study found that certain hairstyles were associated with perceptions of personality characteristics (Bélisle & Bodur, 2010), with long and stylish avatar hair related to perceived extraversion and blond hair related to perceived agreeableness. People even perceived digital hairstyles to be "creepy" (Inkpen & Sedlins, 2011), perhaps as a function of the technical difficulty in rendering realistic hair and the pursuant "uncanny" feelings when a human-like entity doesn't look quite right (cf. Mori, 1970/2012). Designers and developers of digital environments have begun to pay greater attention to the importance of hair as a key customization feature and are seeking ways to allow greater freedom and creativity in incorporating hair into avatar design. *Black Desert Online* (2014), a popular massively multiplayer online roleplaying game, is one such example. Players can freely select

and adjust a myriad of customizable features to design avatar hair. One can choose hair length, dictate exactly which parts of the hair are to be curly and which parts straight, and color different sections. Most digital environments, however, typically offer a very small range of preset configurations for facial (e.g., eye color, skin color) and hair (e.g., hairstyle, hair color) features. The point of concern is that the designers who decide the range of preset options may inadvertently be promoting their own perspectives on social norms (Pace, Houssian, & McArthur, 2009). That is, if a designer believes that a female or a male should have certain facial features and that his or her hair should look a particular way, by limiting the preset options to only the ones that the designer agrees with, the designer may be indirectly promoting a certain set of gendered or raced beliefs that are forced upon players. Even if a player wanted to construct a character that goes against physical world norms, he or she would not even be given the option. Such lack of choice may lead to lost opportunities to promote diversity and break down social problems propelled by gendered or racial norms (see Fox, this volume; Nowak, this volume).

TRANSFORMED SOCIAL INTERACTIONS

Avatar customization platforms offer users varying degrees of control and manipulation of facial and hair features at the push of a button or the click of the mouse (Bailenson et al., 2008). Of course, the idea of manipulating facial and hair features is not new—people have experimented with make-up, hair styles, and even cosmetic surgery for many years. But digital worlds allow users to modify and "enhance" the features of their digital representations with unparalleled ease. The popular action roleplaying game, *Fallout 4* (2015), is one representative example of the freedom users have in not simply selecting and modifying facial features but also to completely morph the structure of the face and hair; players are known to experiment with their ability to sculpt avatar's features by recreating celebrities and well-known comic characters (e.g., Brad Pitt, Tony Spark; see Ochoa, this volume). This means players may choose to adopt and embody the identity of their favorite celebrity at any time. These enhancements and modifications may be further customized so that they are visible only to the specified users. For example, the digital smile on your avatar may be widened (e.g., by 1.5 times), but displayed only to people on which you wish to make a good impression. People prefer interacting with avatars with wide smiles and evaluate their interaction with such avatars as more favorable (Oh, Bailenson, Krämer, & Li, 2016). Following, it may be possible to, for instance, optimize your success at your job by customizing your avatar to put on a wider smile only when you are interacting with your bosses' avatars, a departure from the limitations of human facial cues that can be only unilaterally expressed.

Gaze—the qualities of one's visual attention—is another central component of the face in nonverbal communication (Argyle, 1988), whereby the direction and duration of gaze facilitates social interaction by informing interactants of communication cues such as intentions to speak. In the physical world, gaze is zero-sum in that when an individual locks his or her gaze with another person, it is difficult to gaze at another person simultaneously. Because avatars and agents may be infinitely duplicated and manipulated, gaze may also be augmented in digital worlds so that it becomes an unlimited, non-zero-sum resource (Bailenson, Loomis, Blascovich, & Rex, 2003).

When traditional ways of interacting are transformed through such departures from physically embodied dynamics, it will inevitably impact our current understanding of social rules and norms. Some of these changes may be positive. Managing a positive impression and putting your best foot forward in digital worlds would be much easier with the limitless ability to modify, enhance, and customize avatar features. With the ability to augment gaze, group interactions may become more engaging because speakers will seem as though they are attending to a given user, rather than dispersing gaze to across the group. However, some changes may be negative or morally ambiguous. Trust in interpersonal relationships is likely to be negatively influenced because the true emotional state of the user behind the avatar may be obscured—the avatar may be smiling when the physical user is frowning. When social interactions become transformed through the decoupling of digital and physical cues, how will individuals draw on such cues to develop trust? In digital worlds, the face would no longer serve as "a window to the soul" and every user would be able to don a perfect "poker face." Deceptions related to "identity theft" could elevate to a new level when avatar faces of any person may be easily constructed, replicated, and disseminated. New rules and social norms to discern true emotional states and identities may be sought in efforts to reduce such uncertainty.

DIGITAL DOPPELGÄNGERS—REFLECTIONS WITH MINDS OF THEIR OWN

Another affordance of avatars is the ability to create *digital doppelgängers*, or on-screen representations that share photorealistic similarities with one individual but that may be easily controlled by a different individual (Ahn, 2015). That is, even if a digital agent has your face and hair, it can move around with a mind of its own, controlled by another person or a computer.

This potential to craft and control a photorealistic replica of a person (through such technologies as FaceRig and Microsoft Kinect) is interesting is because digital doppelgängers can yield strong social influences, and may change the way people

think and behave (Ahn & Fox, 2016). Being exposed to a scenario that presents your own digital doppelgänger may promote feelings of personal relevance to the situation (e.g., "It's about me") and may also increase the perception of presence (e.g., "I was there"). For example, if a third party were to create an advertisement that featured your face, you might be more likely to develop a preference toward the brand than if you had seen an unfamiliar model's face (Ahn & Bailenson, 2011). In another variation, seeing a digital agent with your own face engaging in unhealthy behavior and suffering the consequences might change your eating behaviors (Ahn, 2015). For example, if you saw your digital doppelgänger drink sugar-sweetened beverages (e.g., soda, energy drinks) and gain substantial weight over time, you are more likely to reduce your consumption of sugar-sweetened beverages than if you had seen an unfamiliar digital agent. The impact of digital doppelgängers manifests even among young users. When children watched a digital human with their own face engage in an implausible event in the digital world (e.g., swimming underwater with whales), they were more likely to believe that the event had really taken place than when they watched an unfamiliar digital human (Segovia & Bailenson, 2009). Furthermore, once created, these doppelgängers may be easily modified to transcend the temporal and spatial boundaries of the physical world so that faces may be aged or made to gain weight in a matter of minutes.

Viewing these modified doppelgängers leads people to reassess and change their behaviors in the physical world, posing potentially exciting benefits and worrisome misappropriations of their ability to persuade (Ahn & Fox, 2016). Doppelgängers may be used to encourage modeling and mimicking of positive behaviors, such as helping others in need, and consumers may be able to make better purchasing decisions if they can vicariously experience the brand or product through watching doppelgängers' consumption experiences. At the same time, ethical questions linger, warranting further consideration of the potential to negatively manipulate psychological and behavioral responses. Because doppelgängers may easily be created with "selfies" sometimes publicly available on the Internet (e.g., through social networking sites), and because empirical evidence points to the potential for doppelgängers to influence changes in attitudes and behaviors and even create false memories, careful consideration must be given to ethical standards, particularly for vulnerable audiences (e.g., children, older adults) or unsavvy users (e.g., digital immigrants). This is particularly worrisome as extant literature in social psychology confirms that individuals tend to hold positivity-biases toward the self (Baumeister, 1998). That is, people generally like to believe that they are better than others in many aspects of life—e.g., more intelligent, better looking, more resistant to illnesses. Because of these positive biases, audiences (particularly vulnerable ones) may find it difficult to negate persuasive efforts from doppelgängers—many would find it difficult to say "no" to their own faces. Another point to consider might be the potential of seeing your doppelgänger involved in

negative or traumatic events. For example, if games with varying levels of violence allow players to create photorealistic avatars, then players may be exposed to situations wherein they must watch a self-similar digital body undergo traumatic experiences in the game's narrative (e.g., serious injuries or death). Empirical evidence on this issue is not yet available, but vicariously experiencing violent trauma through one's digital doppelgänger is likely a salient and impactful negative event.

BLURRED BOUNDARIES

All told, the face is often a fundamental element for the construction of self-concept and self-awareness (Rochat, 2009). Because the advancement of digital technology affords the creation of dynamic and realistic facial expressions and hair features in digital humans, these features have become critical elements in the construction of self-awareness in digital environments. However, these environments offer a seemingly infinite degree of malleability in the customization of facial and hair features; this flexibility blurs the boundaries of traditional understandings of identity by shifting to scenarios in which digital bodies that looks exactly like one person may be controlled by someone else. In a world where appearances and beauty are nothing more than a stroke of the keyboard or mouse, we may gradually learn to minimize the instinct to judge a person by their looks (see Nowak, this volume). But for now, inhabitants of these digital spaces must be aware that the digital heads they create and interact with may leave lasting imprints on physical-world attitudes and behaviors.

REFERENCES

Ahn, S. J. (2015). Incorporating immersive virtual environments in health promotion campaigns: A construal-level theory approach. *Health Communication, 30,* 545–556.

Ahn, S. J., & Bailenson, J. N. (2011). Self-endorsing versus other-endorsing in virtual environments. *Journal of Advertising, 40*(2), 93–106.

Ahn, S. J., & Fox, J. (2016). Persuasive avatars: Extending the self through new media advertising. In Brown, R. E., Jones, V. K., & Wang, M. (Eds.), *The new advertising: Branding, content, and consumer relationships in the data-driven social media era* (Vols. 1–2). Santa Barbara, CA: Praeger.

Argyle, M. (1988). *Bodily communication* (2nd ed.). London: Methuen.

Banks, J., & Carr, C. T. (2017, April). Exploring the agency and complexities of avatar-mediated interactions via the PaaP model. Paper presented to the 2017 BEA Research Symposium, Video games: A medium that demands our attention. Las Vegas, NV.

Baumeister, R. F. (1998). The self. In D. T. Gilbert, S. T. Fiske, G. Lindzey (Eds.), *Handbook of social psychology* (4th Ed.; pp. 680–740). New York: McGraw-Hill.

Beall, A. C., Bailenson, J. N., Loomis, J., Blascovich, J., & Rex, C. (2003). Non-zero-sum mutual gaze in collaborative virtual environments. In *Proceedings of HCI International,* Crete, Greece (pp. 1108–1112). Mahwah, NJ: Erlbaum.

Bélisle, J-F., & Bodur, H. O. (2010). Avatars as information: Perception of consumers based on their avatars in virtual worlds. *Psychology & Marketing, 27,* 741–765.

Biocca, F., & Nowak, K. (2001). Plugging your body into the telecommunication system: Mediated embodiment, media interfaces, and social virtual environments. In C. Lin & D. Atkin (Eds.), *Communication technology and society* (pp. 407–447). Waverly Hill, VI: Hampton Press.

Ekman, P. (1972). Universals and cultural differences in facial expressions of emotion. In J. Cole (Ed.), *Nebraska Symposium on Motivation* (pp. 207–283). Lincoln, NE: University of Nebraska Press.

Ferstl, Y., Kokkinara, E., & McDonnell, R. (2016). Do I trust you, abstract creature? A study on personality perception of abstract virtual faces. In *SAP'16: Proceedings of the ACM Symposium on Applied Perception* (pp. 39–43). New York: ACM.

Geniole, S. N., Denson, T. F., Dixson, B. J., Carré, J. M., & McCormick, C. M. (2015). Evidence from meta-analyses of the facial width-to-height ratio as an evolved cue of threat. *PLoS One, 10,* e0132726.

Inkpen, K., & Sedlins, M. (2011). Me and my avatar: Exploring users' comfort with avatars for workplace communication. In *CSCW'11: Proceedings of the ACM 2011 conference on Computer Supported Cooperative Work.* New York: ACM.

Kilts, C. D., Egan, G., Gideon, D. A., Ely, T. D., & Hoffman, J. M. (2003). Dissociable neural pathways are involved in the recognition of emotion in static and dynamic facial expressions. *NeuroImage, 18,* 156–168.

Koda, T., Ishida, T., & Rehm, M. (2009). Avatar culture: Cross-cultural evaluations of avatar facial expressions. *AI & Society, 24,* 237–250.

Koda, T., Ruttkay, Z., Nakagawa, Y., & Tabuchi, K. (2010). Cross-cultural study on facial regions as cues to recognize emotions of virtual agents. *Lecture Notes in Computer Science, 6259,* 16–27.

Martey, R. M., & Stromer-Galley, J. (2007). The digital dollhouse: Context and social norms in The Sims Online. *Games and Culture, 2,* 314–334.

Mori, M. (1970/2012). The uncanny valley (K. F. MacDorman & N. Kageki, Trans.). *IEEE Robotics & Automation Magazine, 19*(2), 98–100.

Mojzisch, A., Schilbach, L., Helmert, J. R., Pannasch, S., Velichkovsky, B. M., & Vogeley, K. (2006). The effects of self-involvement on attention, arousal, and facial expression during social interaction with virtual others: A psychophysiological study. *Social Neuroscience, 1,* 184–195.

Nowak, K. L., & Rauh, C. (2006). The influence of the avatar on online perceptions of anthropomorphism, androgyny, credibility, homophily, and attraction. *Journal of Computer-Mediated Communication, 11,* 153–178.

Oh, S. Y., Bailenson, J., Krämer, N., & Li, B. (2016). Let the avatar brighten your smile: Effects of enhancing facial expressions in virtual environments. *PLoS One, 11*(9), e0161794.

Pace, T., Houssian, A., & McArthur, V. (2009). Are socially exclusive values embedded in the avatar creation interfaces of MMORPGs? *Journal of Information, Communication, & Ethics in Society, 7,* 192–210.

Rochat, P. (2007). *Others in mind: Social origins of self-consciousness.* New York: Cambridge University Press.

Segovia, K. Y., & Bailenson, J. N. (2009). Virtually true: Children's acquisition of false memories in virtual reality. *Media Psychology, 12,* 371–393.

Shank, R. C., & Abelson, R. P. (1977). *Scripts, plans, goals, and understanding.* Hillsdale, NJ: Lawrence Erlbaum Associates.

Weigelt, S., Koldewyn, K., & Kanwisher, N. (2012). Face identity recognition in autism spectrum disorders: A review of behavioral studies. *Neuroscience & Biobehavioral Reviews, 36*(3), 1060–1084.

Voice & Sound

Player Contributions to Speech

HANNA WIRMAN & RHYS JONES

Turning the sound off on your favorite game offers a peak into just how much information is conveyed via music, sound effects, narration, and spoken dialogue. Game soundtracks and character voice remixes continue to garner audiences, such as the *Final Fantasy* franchise's (1987) translation into orchestral concerts and the *Diablo* franchise's (1996) Blood Raven voice sample remixed by the dubstep artist Ephixa. To this point, we often recognize canonical game characters based on what they sound like: Pac-Man's *paku-paku-paku,* Sonic's successive *pings* when colliding with gold rings, or Ryu's *Hadouken!* Avatars' voices—the aural, spoken qualities of speech—and the other sounds they make (from pings and grunts to spell effects) are important components of how players engage avatars.

THE HIGH COST OF AVATAR SOUND

While story-based PC games are typically well-crafted and often unique in atmospheric sound, game avatars remain without much aural variety. Except a few rare cases (e.g., *Saints Row: The Third,* 2011), it is typical for customizable avatars to either be silent or limited to variations in only the pitch and tone of their grunting and attacking sounds (e.g., *Dark Souls III,* 2016). More frequently, voice qualities are pre-assigned based on avatar race and gender (e.g., *World of Warcraft,* 2004). Options are limited by design or due to technical constraints, since customizable avatar sounds require significant financial and technical resources. In terms

of development cost, multiple voices are expensive to produce, with multiple voice actors having to record entire scripts, quickly increasing a game's budget for each voice variation introduced. If a game is aimed at multiple regions, speech also takes additional resources to translate and localize. From a technical point of view, storing several sound files that facilitate customizable speech is resource-hungry. Marks (2009) notes that implementing high-quality sound in a game consumes relatively much more storage space than other game assets, while artificial intelligence and graphically intense scenery is often a higher development priority.

To have a game avatar's entire dialogue spoken aloud for the player to hear is typically referred to as *full voice acting*. Although resource-heavy, Collins (2008) suggests that such voiced dialogue (and sound in general) can influence gameplay experiences, as it contributes to the "suspension of disbelief, adding realism and creating illusion" such that "the illusion of being immersed in a three-dimensional atmosphere is greatly enhanced by the audio" (p. 132). Similarly, Stockburger postulates that the voice of the avatar acts as a "suture of the player into the fictional game universe" (2010, p. 286). While full voice acting for avatars is becoming more common in contemporary games, not all developers are in favor of it. The lead designer on *The Elder Scrolls: Morrowind* (2002) and its sequel *The Elder Scrolls: Oblivion* (2006), Ken Rolston, appears to lament the implementation of voice acting suggesting that "[f]ully-voiced dialogue is less flexible, less apt for user projection of [the player's] own tone, more constrained for branching, and more trouble for production and disk real estate" (Varney, 2006). Accordingly, in addition to being a thematic distraction, this perspective suggests that hearing the voice of a playable avatar actually makes them *less* relatable.

AVATAR VOICES AS CO-CONSTRUCTED

Recent videogames, beyond so-called music games and high-cost AAA development, continue to utilize sound primarily to provide immediate feedback and to create mood through special effects and ambient music. When preferences are not met, players themselves surpass the repetitive and non-dynamic music scores by adding their own background playlists (Wharton and Collins, 2011) through existing customization tools (e.g., in *Grand Theft Auto*, 1997; *Gran Turismo*, 1997) or by using game modifications like Ambience or Custom Music Disc mods (Minecraft, 2009). Similarly, in the absence of game-provided dialogue, players have started to fill the sensory gap by crafting voices for their avatars to make the story personally relevant (see McKnight, this volume). In much the same way that the blank "gutter" between comic book panels prompts readers to fill in the action—to provide "closure" (McCloud & Martin, 1994)—a lack of voicing may prompt the player to take a more active role in materializing an avatar's perceived

thoughts and motivations. From this frame, it is interesting to consider the importance of avatar voices by examining what happens when an avatar has *no* voice.

While the archetypical "silent protagonist" in many games are assumed to be more identifiable through their voicelessness, an interesting instantiation of this phenomenon comes in the practices of "Let's Play" video production. In these videos, "Let's Players" record video playthroughs of games and provide voice-overs, such that avatars are voiced through the co-creative contribution of dedicated fans (cf. Banks & Potts, 2010). The performative voice acting by Let's Players is a key component of these videos. Indeed, the voice-over is what makes a video a Let's Play video in the first place—remove it and you have a mere gameplay walkthrough.

Let's Play videos find their origins in online videogame voice interactions among players. Although most games allow for text chat between players, stopping to type in text can often break the flow of action. As a result, third-party voice chat services (e.g., Ventrilo, Skype, or Discord) have long been popular among online gamers. The link between gameplay and players' voices appears to have emerged primarily out of convenience—players can talk to their friends orally, bypassing the text function and leaving the keyboard free for in-game actions, but can still engage in "mode-switching" by shifting among voice and chat (Collister, 2011). Social integrations of players' voices into gameplay, then, originated from a practical need to organize teams faster than text chat would allow.

These practical, ludic considerations were later expanded as technological affordances supported voice as an integral part of roleplay—a form of play in which players play games *as the avatar's character*, rather than as themselves. Players traditionally take the role of their playable character through written output created from the avatar's point of view. Roleplaying is inherently performative in nature, and with the introduction of voice chat services, online gamers began to perform voice chats in character (IC) as their avatars rather than out of character (OOC) as themselves. One famous example can be found in Let's Play videos of *Grand Theft Auto V* (2013) "heists," a complex series of cooperation-intensive objectives. Before heists were formally implemented into the game, the Let's Play group called "Achievement Hunter" created a series of videos roleplaying their own various heists (LetsPlay, 2014). They roleplayed assuming a set of self-imposed rules. For instance, if a player's avatar died during the heist that player would go silent and other members would react as if the character died on the heist, having to carry on without them (even if the game itself allows the player to continue playing as the character quickly respawns nearby).

Let's Play videos, broadly, can concomitantly comprise three general types of player-originated voice-overs: roleplay talk (IC narrative dialogue), strategy talk (IC or OOC analysis of the game's ludic dynamics relative to outcomes), and feature review talk (OOC discussions of game qualities). Although strategy and

feature review talk is typical to many Let's Play videos, the apparently increasingly common roleplay talk bears a direct link with the diegetic function of avatars, or how the avatar helps the player's actions make sense in the gameworld narrative. More specifically, Let's Play voice-overs for avatars fall into three kinds of roleplay talk: identification, interpretation, and negotiation.

Identification

Identification can be understood "as a mental process whereby a reader or viewer to some extent takes the perspective of a character and, thus, imaginarily experiences their emotions and cognitions" (Van Looy, Courtois, Vocht, & Marez, 2012, p. 200). Although many scholars feel that identification is key to player-avatar relations, Fuller and Jenkins (1995) prefer addressing player's agency—the capacity and ability to have influence in the given context—and Klevjer (2012) proposes a phenomenological approach to player's "prosthetic telepresence" (fully perceptual immersion not dependent on immersive audio-visual technologies) in the game through an avatar. Let's Play videos, however, typically turn even non-narrative games into stories and therefore emphasize the characteristics and actions of the avatar—in a sense, the player becomes a vehicle for the avatar's intentions (see Lamerichs, this volume). In discussing how players co-construct avatar voices, identification here manifests through a Let's Player voicing a silent avatar in character.

Let's Players create fully customized voices to perform IC speech. In games that feature a silent protagonist, some Let's Players appear to seriously roleplay their avatars, voicing their thoughts and opinions of things IC as they play the game. For instance, Let's Player Criken2 (2016) often voices his character Edwad Emberpants in *Dark Souls III* (2016). Criken2 picks a "roleplay voice" in the first episode and continues to speak IC with that voice for the rest of the series. Criken2 uses a high-pitched, whiney, and deliberately grating voice in his playthrough as Edwad, an ironic juxtaposition against his supposed heroic role as "the chosen one." As Criken2 explores the gameworld with his two friends playing in co-op, he reacts to the world as if he *was* Edwad, doing unusual things for comedic effect instead of acting like the hero the game setup would expect him to be.

Roleplaying games (RPGs)—despite the genre's apparent focus on identification with a role—rarely feature customizable voices. This is in part due to the historical origins of RPGs which can be found in tabletop games such as *Dungeons & Dragons* (1974). Tabletop RPGs seldom feature entire conversations taking place between avatars as it causes confusion as to whether an action is within the gameworld narrative, or outside of it (Fine, 1983). In tabletop RPGs, players often voice their own avatars when interacting with other players or NPCs in the game, and to do this alongside more explanatory dialogue about what actions they perform.

Videogame RPGs have no such confusion since the actions can be completed in-game by an avatar without the player's need to vocalize its actions. The lack of voice acting in videogame RPGs can also be seen as a callback to tabletop origins, inviting the players to voice the silent avatar.

In Criken2's case, roleplaying the avatar with a voice-over adds a layer of personality to his portrayal of *Dark Souls III* gameplay. Possibly due to a unique name and video narration as much as personalized voice, the avatar of Edwad later became so popular that Criken2 started selling T-shirts with pictures of Edwad on it and his fans started drawing fan art of Edwad. Yet, viewers of the YouTube channel comment how annoying Edwad's voice can be in an almost so-bad-it's-good type of way. For example, one Twitter user noted they "cant [sic] get his stupid fucking voice out of my head."

Interpretation

Slightly stretching the definition of roleplay, interpretive voice-over refers to cases where a game's minimal or single-language voice acting requires the Let's Player to guess or interpret what their avatar is saying or thinking. This type of voice-over also allows players to make gameplay meaningful for new audiences through a kind of localization by adding a new language altogether. For example, in *The Sims* franchise (2000), avatars speak a made-up language called "Simlish" accompanied with icons in thought bubbles representing what a Sim avatar says. This has led *Sims* Let's Players to often interpret or translate what their Sims are saying based on the tone of the voices and images in the speech bubbles.

In their *The Sims 3* (2009) gameplay video, the Let's Player group Inside Gaming (2013) interprets and voices what avatars say based on the commands they have given them, as they follow the misadventures of a social misfit Sim. In one such video, the Let's Player selects the predefined avatar dialogue option "Tell funny story" and voice over what they think the avatar is saying: "huh, this one time, I stayed up all night staring at the back of a fridge." Based on little cues from the game, the group gives voices to avatars while in keeping with the general theme of the conversation set out by the game. When any of the members want to relay the voice of their *Sims* character, they have a distinctive, old-sounding, hoarse voice that they use to represent the avatar. As a result, multiple members of the Inside Gaming crew are able to voice their Sim at different moments, while making it obvious to the audience that they are no longer commenting OOC, but translating or interpreting their avatars IC.

Another game that incorporates an in-game language and that affords active interpretative Let's Play voicing around characters is *Octodad: Dadliest Catch* (2014), where the main character is an octopus pretending to be a human. When the playable character in the game, Octodad, interacts with humans, he

communicates through unintelligible *blubs* and *burbs*. Subtitles offer a translation such as "*burbling something accusatory and a bit rude*" and these cues provide Let's Players room for creative interpretation as to what exactly is being said. In these ways, incomplete, or suggestive avatar voicing invites player contribution and allows for multiple interpretations.

Negotiation

Finally, negotiation is a specific type of relationship with the avatar that arises from when a character has full voice acting yet the Let's Player does not agree with what the avatar says, but offers an alternative perspective instead, via voice-over. *Saints Row: The Third* took an interesting and an unusual decision to allow voice customization whereby players could choose from seven voices for their avatar (three male, three female, and one zombie voice). The avatar would be fully voiced in all cutscenes and would speak in the chosen voice during gameplay dialogue. However, the inclusion of the zombie voice reveals how little impact pre-selected voices may actually have on narrative dialogue of the game, as the lines of speech for the characters are almost identical. The game cutscenes' NPC dialogue, too, remains the same despite the specific customized zombie groans and moans inserted into the cutscene. This illustrates that the game is on a set narrative course regardless of the possibilities inherent to player-contributed voices, perhaps preventing player engagement with characters. In one Let's Play (GoldLove Let's Plays, 2012), a player comments on zombie talk:

GoldLove: hahaha he doesn't even say [sic] English *mimics zombie noise* there's subtitles for it
GoldLove: haha I can't take it seriously

Another game that introduced full voice acting after having a non-voiced protagonist in an earlier game of the franchise was *Fallout 4* (2015). Producer Todd Howard mentions in an interview that the decision to add voiced protagonists in *Fallout 4* was to allow "the game to tell a better story" (Roberts, 2015). Such a choice to focus on a compelling, yet linear story by the means of full voice acting was not well received by fans, however. Let's Play videos demonstrate players' negotiation around the limited number of options available in dialog trees. For example, Let's Player Robbaz plays a cannibal *Fallout 4* character, based on a trait (or a "perk," as the game calls them) available in character customization. In his videos, Robbaz frequently references his character's cannibalism in his voice-over, because there is no voice option to display this trait via the character's native, game-provided voice. Take as an example the following exchange from one of Robbaz's videos (2015b) in which Robbaz's avatar talks to the security guards of Vault 81, trying to convince them to let him inside.

Officer Edwards (NPC):	And what sort of business are you looking to take care of here in 81?
Robbaz (voice-over):	I don't know, I'm probably going to mutilate you and eat you.

In the associated dialog tree, only four speech options are available for selection, none of them relevant to cannibalism: (1) Third Degree? (2) Looking to trade. (3) Just let me in. (4) Just a traveler. Robbaz' voice-over then suggests a more character-appropriate line as an alternative. Similar examples can be found in his other videos (e.g., Robbaz, 2015a), such as:

Codsworth (NPC):	Welcome back sir! I do hope you were able to find some assistance in Concord.
Robbaz (voice over):	Yeah, I ate some people as well, tasted great.
Robert (in-game character):	You could say that. I made a few new friends.
Codsworth:	Can't have enough of those these days. I realize that I'm no Mr. Gutsy, but if needed, I'd be honored to accompany you throughout the commonwealth. Just say the word.
Robbaz (voice-over):	You can be my companion now? You're the only one who isn't shit! All the characters in the game this [sic] far have been flat as paper.

What is being said by the Let's Player and what is being said by the in-game character are at odds with each other with the line "You could say that. I made a few new friends." being robbed of any ironic tension when one realizes it is a standard line available to characters during every playthrough. While the character Robert states he has made some new friends, Robbaz laments that all the NPCs so far have been "shit" and he does not like any of them. The interplay of game speech and player voice-over serves as an example of differentiating avatar-based interaction and roleplaying (Klevjer, 2006). In the examples, Let's Players roleplay a game that does not fully support their preferences and interests in respect to avatar skills leading to negotiation in their video output. The official take on the implemented voiced dialogue soon changed, too, as the producer Howard himself noted during an interview how "obviously the way we did some dialogue stuff [...] didn't work as well [as other new features in the game]" (O'Dwyer, 2016).

VOICE AS CRITICAL TO CHARACTER

Players engage with avatars beyond the digital bodies' looks, stories, and actions. Examples from the Let's Player community serve to demonstrate that players may care about what avatars *sound* like and that, in videos created by players, sound

offers an additional layer to further explain and comment on avatar behavior. As in Let's Plays, players may not only be interested in bringing avatars to the public domain but in doing so also negotiate their personal preferences and gameplay styles with the interests of the viewers as key denizens of a valued player community. Here, personal play experiences with and through the avatar meet an inherently performative function of the avatars in Let's Play videos, such that both natively voiced and player-voiced avatar speech contribute materially to the experience of avatar-mediated gameplay. In most games, avatar sound remains as a non-critical game element that can be bent to a multitude of directions in players' stories and performances. Through Let's Plays—and specifically because of the dynamics between avatar and player voices—avatars are built into fleshed-out characters that often gain new, secondary audiences and fans themselves.

REFERENCES

Banks, J., & Potts, J. (2010). Co-creating games: A co-evolutionary analysis. *New Media & Society*, *12*(2), 253–270.

Collins, K. (2008). *Game sound: An introduction to the history, theory, and practice of video game music and sound design*. Cambridge: The MIT Press.

Collister, L. B. (2011). *Mode-switching in digital game environments: A multimodal phenomenon* (Doctoral dissertation, University of Pittsburgh).

Criken2. (2016, April 24). Dark Souls 3: Edwad Emberpants the chosen - Part 1 [Let's Play video]. Retrieved from: <https://www.youtube.com/watch?v=LzWWoG0C1ns>

Fine, G. A. (1983). *Shared fantasy: Role-playing games as social worlds*. Chicago: University of Chicago Press.

Fuller, M., & Jenkins, H. (1995). Nintendo and new world travel writing: A dialogue. In S. Jones (Ed.), *Cybersociety: Computer-mediated communication and community* (pp. 57–72). Thousand Oaks: Sage.

GoldLove Let's Plays. (2012, January 5). Saints Row 3 - Co-Op walkthrough - Part 2 "The best character" [Let's Play video]. Retrieved from: <https://www.youtube.com/watch?v=wXPR40sto-Y>

Inside Gaming. (2013, September 14). I wanna be an actor - Sims 3 gameplay! Part 2! [Let's Play video]. Retrieved from: <https://www.youtube.com/watch?v=lEYUmt-EvHo&index=1&list=PLQ2uc-bCRaPchVXaNn8axPqu2cxAxf_XT>

Klevjer, R. (2006). What is the avatar? *Fiction and embodiment in avatar-based singleplayer computer games* (Doctoral dissertation, University of Bergen).

Klevjer, R. (2012). Enter the avatar: The phenomenology of prosthetic telepresence in computer games. In J. R. Sageng, H. Fossheim, & T. M. Larsen (Eds.), *The philosophy of computer games* (pp. 17–38). Dordrecht: Springer Publishing Company.

LetsPlay. (2014). Achievement Hunter GTA V heists [Let's Play video]. Retrieved from: <https://www.youtube.com/playlist?list=PLU-TpLyQJBY9xRlMBpmOk5_aDOXByflin>

Marks, A. (2009). *Aaron Marks' complete guide to game audio: For composers, sound designers, musicians, and game developers*. Boca Raton: Taylor & Francis.

McCloud, S., & Martin, M. (1994). *Understanding comics: The invisible art*. New York: William Morrow.

O'Dwyer, D., & Kish, M. (2016, 14 June). Todd Howard talks modding at Bethesda - E3 2016. *Gamespot*. Retrieved from: <http://www.gamespot.com/videos/todd-howard-talks-modding-at-bethesda-e3-2016/2300-6432858/>

Robbaz. (2015a, November 10). Fallout 4 - Powerarmor Vs Deathclaw "E3 spoilers" #2 [Let's Play video]. Retrieved from: <https://www.youtube.com/watch?v=TWwiPRfLNME>

Robbaz. (2015b, December 8). Fallout 4—Visit to vault 81 #6 "Alien companion" [Let's Play video]. Retrieved from: <https://www.youtube.com/watch?v=0Jf_0p5wgkI&t=202s>

Roberts, D. (2015, June 17). Fallout 4's voiced protagonists make the story better. *Games Radar*. Retrieved from: <http://www.gamesradar.com/fallout-4s-voiced-protagonists-make-story-better/>

Van Looy, J., Courtois, C., Vocht, M. D., & Marez, L. D. (2012). Player identification in online games: Validation of a scale for measuring identification in MMOGs. *Media Psychology, 15*(2), 197–221.

Varney, A. (2006, May 23). Oblivion's Ken Rolston speaks. *HardOCP*. Retrieved from: <http://hardocp.com/article/2006/05/23/oblivions_ken_rolston_speaks/2>

Wharton, A., & Collins, K. (2011). Subjective measures of the influence of music customization on the video game play experience: A pilot study. *Game Studies, 2*(11).

Gesture & Movement

Indices of Presence

SITA POPAT

Three players bring their avatars to the same in-game location to start a quest together. As they arrive, the gnome bounces on the spot and waves. The elf throws back her head in laughter before dancing with a provocative hip sway. The human salutes smartly and bows. Each of these gestures communicates information about the avatars themselves and about the interaction choices of the players controlling them.

An avatar's movement includes a range of motions, from programmed gaits and postures to the ways in which the avatar moves in and through digital space as guided by the player. Gestures are a subset of this movement—a specific kind of motion that encodes personal, social, and cultural information. Gestures can be decoded by others who share an understanding of the relevant codes, communicating information about intentions, emotions, and responses to events and to other people. Gesture and movement can play a key role in avatar-mediated relationships—both in interactions with other players and in information exchanges between players and their own avatars. The importance of these conveyances may be intensified in immersive gaming as an avatar's digital body becomes more closely aligned with a player's physical body, with the potential for influences on the player's embodied experience.

GESTURING TO OTHERS

As humans interact in physical spaces, there are inherent tensions between gestures as "signifiers for meanings" (linguistic indicators) and gestures as "indexical

of subjectivity and presence" (evidence of the presence and intentionality of an individual subject; Noland, 2008, p. xii). In other words, there is a disjoint between movements as expressions of ourselves as subjective beings and what those movements *mean* in terms of a specific socio-culturally agreed gestural language—one might, for instance, ball a fist in an expression of internal tension, but that may be interpreted by others as aggressive. Videogames cause such tensions to be heightened as the subjective being is the player, but most of the gestural content belongs to the avatar and the game. As with other avatar features, avatar gestures tend to be predefined by game programming, creating limited palettes of socio-culturally agreed-upon meanings that promote in-game communication norms. Players may choose gestures from those palettes by typing words or phrases known as "emotes" (e.g., /bow, /salute, /cheer), and these commands cause the avatar to perform the designated gestures. These words describe gestures but may also emphasize their linguistic, semiotic roles as meaning-signifiers. In many games, several different types of avatars may perform the same basic gesture through the same mechanism (e.g., typing /wave). However, the movement alters qualitatively in terms of shape and effort for different races or species—an Elf may wave in a large, high, smooth, open movement, whereas a Goblin's wave may be abrupt, constrained, and closer to the body—but the predefined gesture retains its underlying form and thereby its signification of meaning (Elam, 1980).

In most massively multiplayer online (MMO) games, this common gestural grammar remains constant across all races. For example, although *World of Warcraft* (WoW) players from different factions (Alliance and Horde) cannot speak to each other in-game since the game's design constrains it, they *can* use gestures to communicate, since many gestures are universally understood and since an enacted emotion also appears as descriptive text in the game's chat window. Yet in everyday human life, not all gestural meanings are shared across different cultures (Morris, Collett, Marsh, & O'Shaughnessy, 1979). Even the apparently simple action of nodding or shaking one's head may vary in cultural translation. This caused issues when *Final Fantasy X-2* (2003) was translated into English. In the original Japanese version, the protagonist Yuna finds a sphere that belongs to a rival group and is asked whether she will return it. She nods to indicate, "You are right, I will not return it." However, within the spoken context an English-speaking audience was deemed likely to interpret the gesture as, "Yes, I will return it." The standard route for audio-visual translation would be to adjust the dubbed text/vocals to ask a different question to which a nod is the appropriate response. However, on this occasion the company decided to change the gesture. Thus, in the English version, Yuna shakes her head to indicate that she will not return the sphere, rather than nodding (O'Hagan & Mangiron, 2013).

As exemplified by the nodding dilemma, research in linguistics has shown that speech and gesture are tightly bound in effective communication (Kita, 2009).

"We gesture *in order to think*" (Ventrella, 2014, p. 349), such that people gesture even when they cannot be seen, as when talking on the telephone (Bavelas et al., 2007). Even people who have been blind from birth and have not seen others gesturing during speech will often gesture when speaking (Iverson et al., 2000). In computer games, many non-player characters (NPCs) are programmed to gesture while speaking, and sometimes avatars will gesture independently when interacting with others, according to their programmed design. Yet when MMO players are communicating with other players in text-chat or via headsets, their avatars usually will *not* gesture automatically. Given the deep connection between speech and gesture, it is not surprising that players tend to flavor conversations with their own choice of avatar gestures, although the manner of doing so varies. Some employ the predefined emotes, using the forward-slash key and the appropriate word; in games like *LittleBigPlanet* (2008) a controller joystick might drive gestures, or in *Second Life* (2003) gestures may been driven by an interface control panel. Regardless of control method, when one player makes an emote gesture, other players will often join in, so if a player types /cheer it can lead to a group of avatars cheering together (Newon, 2011). However, some emotes are not accompanied by avatar movement, including most gestures that would involve physical contact with another. In WoW, typing the /hug emote brings up text describing the action and the target but the avatar does not move. The giver and receiver of the hug can still acknowledge the linguistic "gesture," together with those nearby, as its mere description signifies an agreed cultural concept (the social hug), but if the hug is unwanted then it can be ignored.

Sometimes players supplement limited options by defining their own expressive gestures from within the game's parameters. For instance, MMO players will sometimes greet others by bowing and casting unnecessary healing spells on avatars, such that the player's "own cognitive and button-pushing abilities were combined with the avatar's in-world abilities to jointly perform an intended friendly act" (Banks, 2015, para. 41). Communication theorist John Fiske describes this type of redundant messaging (i.e., unnecessary heals) as keeping existing channels "open and useable," like shaking hands (1990, p. 14). It is also common in MMOs for groups of players waiting for something to happen to begin dancing with each other. The act of dancing is triggered by typing the /dance emote, making the avatar perform a set dance sequence specific to its race and/or gender. No further action is required by the player for the dancing to continue, and indeed a player can leave the computer for a short while and the avatar will continue to dance. Despite this, dancing in groups seems to be used as a way of indicating presence while waiting, likely because it simulates a social bond of shared activity that keeps "existing channels" open. In these exchanges, gesture shifts away from being a "signifier of meaning" and toward being "indexical of subjectivity and presence"

(Noland, 2008, p. xii)—an indication that a person is present and available for interaction.

GESTURING TO ONESELF

In phenomenological terms, gestures and movements "are not only productive of communication between agents, they also provide the individual agent with a private somatic experience of his or her own moving body" (Noland, 2008, p. xi). While one might not perceive the movement of someone else's avatar as being expressive at an embodied level, the relationship between the player and her own avatar is another matter. The physical movement of the player is encoded via the control mechanism (e.g., pressing the keyboard, moving the joystick) and decoded into the digital movement of the avatar, so that the player experiences correlations between her own movements and those of her avatar (known as natural mapping), or between her *intentions* and her avatar's actions (e.g., typing the emote / bow). Natural (imitative) movement mapping control mechanisms (such as using a steering-wheel controller for driving games or a guitar for music simulations) have been associated with increased presence in digital worlds—a stronger sense of being in the game environment (Skalski et al., 2011).

In MMOs, jumping is an intuitive example of movement mapping. Pressing and releasing a thumb on the space bar correlates with physically bending and releasing the knees for a jump, creating a somatic link between player and avatar. It could be argued that this kind of direct mapping can be just as strong as a full natural movement mapping mechanism when it is learned as part of a player's embodied experience of gaming (cf. Rogers, Bowman, & Oliver, 2015). Jumping is often used to indicate presence to other players, or to gain attention from them, or simply to show excitement or impatience (Newon, 2011; Ventrella, 2014). However, it is also not unusual to see lone players jumping outside MMO dungeons and raids, where the movement may be a way of maintaining a sense of embodied connection and presence in/with their avatars while waiting for other players to arrive; as such, there may be more to effective movement mapping than simple imitation of real-world actions.

MAPPING GESTURAL QUALITIES

The interaction between player and avatar movement is well-exemplified in the experiences of amateur sportsman Peter Gray during his training for the Brain-Computer Interface Race in the 2016 Cybathlon games in Switzerland (personal communication, June 24, 2016). Gray is paralyzed from the shoulders

downward and trained for two years to race a digital avatar using only his thoughts to control it. A close-fitting cap held electrodes against his head to pick up tiny electrical signals from his brain as he focused on a particular thought. It was against the games' rules to move physically, so Gray thought hard about reaching for a bar of chocolate with his left hand or punching someone with his right fist. He rehearsed these "thought gestures" independently of the avatar for the first few months, so that the technical team could work on picking up the signals. However, when he came to control the avatar in the game (comparable to that in the smartphone game *Temple Run* [2011]), he found that the technical team had mapped his reaching thought to the avatar's jumping movement, and his punching thought with the avatar sliding under a barrier. Despite his physical paralysis, this mapping felt wrong to Gray. His thought gestures did not match the qualities of the avatar's movements. The extended, even gesture of reaching for the chocolate was inconsistent with the avatar's sharp, repeated movements when jumping, while the tense, fast gesture of punching did not equate to the avatar's smooth sliding. Eventually the technical team had to swap the inputs so that Gray could control the avatar's movements with thought gestures that he experienced as being naturally somatically connected.

Gray's experience demonstrates the importance of gestural communication channels between avatar and player. The somatic inconsistency between his gestures and his avatar's was sufficient to confuse the signals passing along that channel. Sometimes players perceive avatars as connecting to their body schema in the form of "faux body parts and physical tools" (Ratan, 2013, p. 325; see also Ratan, this volume), but Gray's account suggests that he experienced his relationship with the avatar in a different way. Instead, he engaged his body image as a primarily conceptual sense of identity: the body, whole or part, "is recognized as 'my' body rather than an alien object" (Gallagher, 1986, p. 545). While playing computer games, many people switch freely between referring to their avatar as "me" ("I am doing this") and as "it/her/him" ("the avatar is doing this"), thus appearing to shift between incorporating and excluding the avatar in their body image. Although this may seem like a sense of faux body identity, per Gallagher, body schema "is a non-conscious performance of the body" (p. 548), applied to "the lived physiology, but also to the way the body lives its environment" (p. 549). The lack of correlation between Gray's thought gestures and the avatar's movements directed his consciousness to the point of disjuncture between his body schema and the avatar. Correcting that correlation by creating somatically consistent mapping (but not natural mapping, formally) strengthened the player-avatar communication channel, resulting in a sense of shared movement, rather than of owned-but-distinct avatar body. This critical distinction between body image and body schema highlights the importance of movement and gesture in the connection between player and avatar, where they function as carriers of both identity and lived embodied experience (see also Lamerichs, this volume).

EMBODIED IDENTITY

Although avatars' gestures and movements may diverge from those of players, the recent rise in augmented reality and virtual reality (AR/VR) gaming has shifted avatar engagement well beyond the traditional physical/digital body relation. Players are now perceptually injecting their bodies into digital environments (e.g., *Batman Arkham VR*, 2016), and digital characters are appearing in physical-world spaces (e.g., *Pokémon GO*, 2016). So how do these dynamics change the meaning and function of movement and gesture? What happens if the avatar looks identical to the player in AR, or if the avatar's and player's bodies appear to share the same corporeal space in immersive VR? In these cases, the mapping of physical gesture and movement to the avatar is more direct, creating a potentially more integrated player-avatar relationship (see Popat, 2016).

Movement researcher Susan Kozel performed in Paul Sermon's 1994 installation *Telematic Dreaming*, and subsequently wrote a detailed phenomenological study exploring the experiences of her "electric body" (Kozel, 1994, p. 13). Her account reveals how her sense of embodiment fused with her avatar to enable presence with other people in a remote location. While not billed as a game, per se, the installation was deeply playful and raises issues that are likely to apply to immersive gaming in the future.

Telematic Dreaming used ISDN lines to connect two rooms, each containing a double bed. Kozel was on Bed A with an overhead camera recording her. This camera-feed was projected in real-time onto Bed B, which was situated in an art gallery. Visitors to the gallery saw Kozel's image (or avatar) as a full-scale, two-dimensional projection on Bed B. They could approach the bed and get onto it if they wished. Another camera, positioned above Bed B, recorded Kozel's projected image combined with anyone who got onto the bed. This camera-feed was displayed on monitors around both beds, so that Kozel and the gallery visitors could see themselves together on the monitor screens. Kozel (1994; 2007) described how she worked through her projected avatar to interact with gallery visitors. This often began with tentative gestures, making connections between her virtual fingers and their physical fingers. One man moved on the bed with Kozel's avatar on several occasions during a day. He returned later to place a rose upon the pillow next to her virtual head—she caressed its projected outline, but could not pick it up. Kozel reported increasingly experiencing movement, gesture, and touch through extended embodiment, as if her body and her avatar developed a kind of connective membrane. At one point, someone placed a hand upon her virtual thigh, so she moved her own hand to the same place and was surprised to encounter the bulk of her own physical leg (Kozel, 2007). Another person punched Kozel's image in the stomach causing her instinctively to fold up as if hit, even though she could not feel the impact.

Gabriella Giannachi discusses *Telematic Dreaming* in her book on *Virtual Theatres*, describing the point of connection between body and avatar as the "hypersurface." She identifies what she calls "contamination" across the hypersurface between virtual and physical, where the two seem to bleed together (2004, p. 99). She notes that both Kozel and Sermon described some disorientation when leaving the installation after prolonged periods of interaction, as they struggled to re-orient themselves in their physical bodies without their avatar extensions. The deep correlation of gesture and movement between body and avatar had allowed their body schemas to become entangled with those of their avatars, in a manner more extended than Gray's Cybathlon training experiences. As bodies and avatars shared correlating movement and gesture, so there appeared to be some "bleeding together" of embodied experience and identity. The experiences of Gray, Kozel, and Sermon have implications for VR gaming, where prolonged participation in digital environments could result in experiences of extended embodiment (pre-conscious, and thus different from the personal identity associations that Ratan [2013] suggests), or conversely it could affect the experience of one's physical body when exiting the game.

CORPOREALITY AND IMMERSION

While Kozel's full-scale replication of the physical body in AR provides a visually representative avatar, the increasing use of head-mounted VR units provides another kind of experience. In many VR computer games and simulations, the user's physical body and the avatar's digital body appear to the user to share the same space. Movements of one's own head are matched with corresponding changes in perspective on the digital environment, to create a "response as if real" (Slater et al., 2009, p. 294). One might experience scaling a rock face (*The Climb*, 2016) or controlling a fighter ship in outer space (*EVE: Valkyrie*, 2016) almost as if one were physically there. This apparent co-location changes the relationship between physical and digital bodies—and their movements—particularly since there is often no visual representation of the avatar in VR games, simulations, and installations, as they tend to engage a first-person perspective. (*The Climb*, for instance, displays avatar hands, but no other sense of the digital body.) Thus, the movements of the player's body can seem still more closely aligned to those of the avatar. In her VR installation *In My Shoes: Dancing with Myself*, Jane Gauntlett uses simple techniques to encourage the participant to experience the avatar as if it were her own body, to convey something of what Gauntlett feels in the build-up to an epileptic seizure. The installation space includes physical objects, which the participant is instructed to touch while seeing the avatar touch similar digital objects. The combination of physical and digital touch and gesture is thought to bind the

participant's movement to the avatar's, increasing the sense of empathy and simultaneous physical/digital corporeality. Perceptions of avatar's and user's bodies bleed into each other through shared movement, gesture, and bodily experience, so that it becomes difficult for the user to perceive what is physical or digital.

Through self- and other-directed gestures, through extensions of identity and presence, and through potentials for stronger immersion and co-presence, gesture and movement play a critical role in player-avatar relations (via somatic exchange enhancing senses of "being" the avatar), and among players *via* their avatars. Active correlation between movements of player and avatar can lead to an extended body schema, and this will become more critical as VR gaming develops. Enhancement of the lived experience of gaming through bodily integration with the avatar via gesture and movement may lead to entanglement and permeability between physical and digital. This is deeply immersive but potentially also affects the player's lived bodily experience during and after the game session (Giannachi, 2004). Where such permeability occurs, the intensive nature of embodied experience in immersive digital environments might have significant ethical implications for VR gaming in the future, particularly in the case of violent or emotionally challenging content (Popat, 2016). How closely linked can the bodily experiences of avatar and player become before we begin to see gamers with post-traumatic stress disorder?

Throughout this discussion, the critical factor has not been whether the player claims the avatar's gestures as her own, but how far she experiences shared movement with an avatar. In the lived embodied experience of moving, player and avatar may become sufficiently entangled for conceptual distinctions between physical and digital to blur. Whether it is achieved via gestural communication, natural movement mapping or somatic correlation, sharing movement with an avatar is one of the key ways in which a player gains subjective presence in the gameworld.[1]

NOTE

1. This work was supported by the Wellcome Trust [201515/Z/16/Z]. The author is grateful to Andrew Barraclough, Peter Gray, Ivan Nixon and Calvin Taylor for their assistance during the research for this chapter.

REFERENCES

Banks, J. (2015) Object, Me, Symbiote, Other: A social typology of player-avatar relationships. *First Monday, 2*(2).

Bavelas, J., Gerwing, J., Sutton, C., & Prevost, D. (2008). Gesturing on the telephone: Independent effects of dialogue and visibility. *Journal of Memory and Language, 58*(2), 495–520.

Elam, K. (1980). *The semiotics of theatre and drama.* London: Routledge.

Fiske, J. (1990). *Introduction to communication studies*. London: Routledge.

Gallagher, S. (1986). Body image and body schema: A conceptual clarification. *Journal of Mind and Behavior, 7*(4), 541–554.

Giannachi, G. (2004). *Virtual theatres: An introduction*. London: Routledge.

Iverson, J. M., Tencer, H. L., Lany, J., & Goldin-Meadow, S. (2000). The relation between gesture and speech in congenitally blind and sighted language-learners. *Journal of Nonverbal Behavior, 24*(2), 105–130.

Kita, S. (2009). Cross-cultural variation of speech-accompanying gesture: A review. *Language and Cognitive Processes, 24*(2), 145–167.

Kozel, S. (2007). *Closer: Performance, technologies, phenomenology*. Cambridge, MA: The MIT Press.

Kozel, S. (1994). Spacemaking: Experiences of a virtual body. *Dance Theatre Journal, 11*(3), 12–13.

Morris, D., Collett, P., Marsh, P., & O'Shaughnessy, M. (1979). *Gestures, their origins and distribution*. New York: Stein and Day.

Newon, L. (2011). Multimodal creativity and identities of expertise in the digital ecology of a World of Warcraft guild. In C. Thurlow & K. Mroczek (Eds.), *Digital discourse: Language in the new media* (pp. 131–153). Oxford: Oxford University Press.

Noland, C. (2008). Introduction. In C. Noland & S. Ness (Eds.), *Migrations of gesture* (pp. ix–xxvii). Minneapolis: University of Minnesota Press.

O'Hagan, M. & Mangiron, C. (2013). *Game localization: Translating for the global digital entertainment industry*. Amsterdam: John Benjamins Publishing Company.

Popat, S. (2016). Missing in action: Embodied experience and virtual reality. *Theatre Journal, 68*(3), 357–378.

Ratan, R. (2013). Self-presence, explicated: Body, emotion and identity extension into the virtual self. In R. Luppicini (Ed.), *Handbook of research on technoself: Identity in a technological society* (pp. 322–336). Hershey PA: Information Science Reference.

Rogers, R., Bowman, N. D., & Oliver, M. B. (2015). It's not the model that doesn't fit, it's the controller! The role of cognitive skills in understanding the links between natural mapping, performance, and enjoyment of console video games. *Computers in Human Behavior, 49*, 588–596.

Skalski, P., Tamborini, R., Shelton, A., Buncher, M. & Lindmark, P. (2011). Mapping the road to run: Natural video game controllers, presence, and game enjoyment. *New Media & Society, 13*(2), 224–242.

Slater, M., Perez-Marcos, D., Ehrsson, H. H., & Sanchez-Vives, M. V. (2009). Inducing illusory ownership of a virtual body. *Frontiers in Neuroscience, 3*(2), 214–220.

Ventrella, J. (2014). The future of avatar expression: Body language evolves on the internet. In J. Tanenbaum, M. S. El-Nasr, & M. Nixon (Eds.), *Nonverbal communication in virtual worlds: Understanding and designing expressive characters* (pp. 345–352). Pittsburgh, PA: ETC Press.

Names & Labels

Strategic (De)Identification

MARK R. JOHNSON

Since the days of arcade high-scores, gamers have been identifying themselves through pseudonyms. Most arcade cabinets allowed players who reached a sufficiently high score to input three letters, generally capitals only, to record their identity within the device. In contrast to the contemporary ability to broadcast competitive gameplay to millions of connected viewers through live-streaming software, competitive gameplay in this era was "indirect" (McMillan, 2010, p. 184), whereby players would compete in the same games at different times and normally without directly witnessing the play of others. These names and their ordering thereby became sites of competition (Johnson, 2016)—players battled to reach ever-more perfect scores in arcade games, demonstrating their skills by placing three-letter signifiers next to high scores. Even at this earliest stage, and in an era far before online multiplayer games, something as seemingly trivial as a selection of three letters for denoting a player was already important. The (adopted) names and labels of gamers, and how they shape and influence play, therefore, go back almost as far as computer games themselves. Naturally, arcade tags are but one small component of names and labels and their roles in digital worlds, but the ability for even a simple three letters to have such social consequence begins to draw our attention to how important these might be, and how fundamentally they might structure how we respond to and think about our avatars, and the avatars of others.

Names and labels—the textual signifiers of individuals and associations—are often thought of as being quite trivial things that merit only a brief consideration before jumping into the game itself, and may even be a distraction preventing one from getting to the action. However, these signifiers can come to have a

tremendous influence on gameplay, as they not only perform the tasks of marking identities and demarcating bodies, but are remarkably important as strategic gameplay features enhancing survivability, (in)visibility, and social affiliations.

NAMES AND LABELS AS IDENTITY SIGNIFIERS

Names and labels of avatars take many forms, ranging from those spoken by other game characters to those in massively multiplayer online games (MMOs) that hover perpetually above characters, alongside labels like titles, locations, group tags, alignments, levels, stats, and interests. Four categories of names and labels can be identified across two axes: those used offline (privately) and those used online (publicly), and those which are fixed (pre-determined by game design) and those which are flexible (through character customization). Private names and labels exist in many games that have the player name their character although nobody else will ever see those names (e.g., changing Cloud Strife's name in *Final Fantasy VI* [1997]), while public names and labels exist in a tremendous range of digital worlds settings, from first-person shooters to MMOs, and even to digital leaderboards that act as an updated version of their arcade predecessors. Fixed names can be found in most story-driven games where the player's avatar has been named by the developers, and cannot be altered, such as the iconic protagonists in *Half-Life* (1998), *Tomb Raider* (2001), *The Legend of Zelda* (1986), and *Super Mario Bros.* (1985). Games that allow players to select a name for avatars are just as common, with examples including games such as the *Elder Scrolls* (1994) and *Fallout* (1997) series, most roleplaying games more broadly, and naturally all online games that require one player's username to be distinguished from another. Labels, meanwhile, can take a tremendous range of forms, as they signify traits or affiliations. These might include statistics, titles, and guild or clan membership. These often sit alongside names, both of which are important for identifying avatars and displaying gameplay-relevant information. For instance, in *Star Wars: The Old Republic* (2011), an avatar's guild name will float above the digital body (which can shift based on membership), and a character panel reveals its combat class (which generally cannot change). Names and labels therefore exist in a range of contexts, whether fixed or fluid, and each context shapes the form and function of those names.

The actual practices of players selecting avatar names—when they can do so—stem from a range of different concerns and motivations. Leslie & Skipper (1990), for example, consider nicknames to be "aspects of the process of social action" (p. 273) that can be studied and examined as indicative of a named entity's social context and of those doing the naming. In keeping with such an understanding, online names can be tied to demographic factors and everyday social identity groups (Almuhanna & Prunet, 2015), and therefore strongly represent the physical people behind the digital avatars, even if that representation is transformed

from complex sociocultural identities into brief strings of textual characters. This is a slowly growing point of interest for the field of "socio-onomastics," which is concerned with the interactions among naming conventions and social practices (Puzey, 2016); digital worlds and avatars offer a rich area of study for such enquiries. This chapter focuses on the social *practices* associated with avatar names, with the three case studies examined shortly being examples of the strategic use of naming within sociotechnical contexts. Such examples are important for demonstrating clearly how central naming and labeling practices are to digital bodies, how they are regarded by others, and how gameplay is structured by those names and labels.

NAMES, LABELS, AND GAMEPLAY

Although expressive functions (a user conveying a persona through a name) and technical functions (separating within a game's architecture one avatar from another) of an avatar are generally present, it is also important to consider the social functions of names as they distinguish actors in digitally mediated interactions and give information about those actors. This information, however, is not simply a reflection of player demographics, or just a method for one player to learn information about the avatar of another player. Names and labels can also have substantial *strategic* gameplay importance within the social space of player-versus-player competition (and collaboration). An investigation into this area will discover numerous cases where avatar names can have substantial impact on both the success and viability of the avatar to fully engage with the game, and the play experiences of their human controllers.

The Safety of the Alphabet

EVE Online (2003) is a massively multiplayer online game in which players control "capsuleers"—immortal cloned humans who pilot spacecraft and carry out battle, trade, and diplomacy in a vast, simulated universe. A single name is associated with a single capsuleer, and names are especially important in this world where all the past affiliations of a capsuleer are stored and maintained in perpetuity. The player culture in this universe is notorious for its lack of formal rules, and for the developer's acceptance of many practices that would ordinarily be considered unethical, such as scamming, lying to, and freely attacking other players. Battles in the *EVE* universe range from one-versus-one engagements to tremendously large "fleet battles" that can involve thousands of players in a single large engagement.

Given the size of these battles, "fleet commanders"—the players who direct these engagements on behalf of competing factions—must find some way to order and view the players on the opposing side. This is done through bringing

up in-game lists of all the pilots in the local area, normally sorting them *in alphabetical order*, and calling out primary targets for their fleet to attack by simply going down a list of names starting at the top (Vily, 2012). As a result, many guides recommend that all players select names whose first letters are drawn from the center of the alphabet, ideally "m" or "n" (e.g., EVEInfo, 2017). This means that whenever they fight alongside allies, who perhaps do not have this rule, their ships will be those the least likely to be attacked; equally, it is also valuable on an individual level, as not all pilots will adhere to these rules and therefore those who do will be advantaged *within* a given faction, as well as *between* those factions. This is a metagame (Carter & Gibbs, 2012; Paul, this volume) element of *EVE* gameplay that is driven by the desire not to be eliminated early in fleet battles, and founded on an understanding that the names of opposing pilots are normally ordered alphabetically (whether ascending or descending) in combat; therefore, those in the middle of the alphabet will in the long-run be likely to be the last ones killed in any engagement. Indeed, one of the reasons this author ceased playing *EVE* was due to having selected a username beginning with "A"—blissfully oblivious of this metagame element—and subsequently finding himself destroyed first in every major fleet engagement, somewhat reducing the excitement of these battles. Names and labels are therefore crucial elements of competitive play in *EVE* that can confer long-term strategic benefits upon those who are well-named, and exert such a sufficiently negative effect upon those who are ill-named that battles, money, and even affinities for the game can be lost.

Anonymity and High-stakes Gambling

Identity is everything for professional poker players. At the highest levels of play, success is heavily contingent upon being able to recognize the *playstyle* of one's opponents and play against that particular style. When playing in person at a physical card table there is naturally no way to mask one's identity from any opponent who is already aware of your name, your playstyle, and so forth. However, online poker rooms do offer such an affordance. In online poker rooms, each player's avatar consists of only two components: a username, and a generic display image. The presence of the image moves online identities in poker beyond simply a textual name and toward a more avatar-like representation; equally, the physical representation of the poker table on the site gives the impression of a more substantial avatar that moves among multiple tables and multiple games. Some poker sites even developed full human-size poker-playing avatars, although these were never as successful as the name-and-picture sort. Poker avatar usernames are ordinarily just as anonymous as usernames on any other site, but this is complicated on sites that sponsor well-known players to play on their sites. Becoming a "sponsored pro" means giving up the anonymous username and the generic avatar, and instead having your username changed to your real name,

and your avatar changed to a photograph of your face. Being a sponsored pro offers many benefits when it comes to monthly payment, travel expenses, and the like, but removes the ability for some top players to come and go online without other players knowing their identity, and therefore knowing how to play against them.

Numerous professional poker players have therefore specifically elected *not* to become sponsored pros precisely because they preferred a non-identifying user-name, believing their profits would be higher playing under normal anonymity, rather than taking all the monetary benefits of being sponsored but losing out on this element of secrecy (cf. Newell, 2016). This is a long-term strategic decision to prevent anyone knowing their identity at all, such that pseudonyms are selected to prevent online and offline identities from mingling, and to prevent one online identity from mingling with another. With substantial volumes of real-world money, as well as online kudos and respectability at stake, players have realized that such names are methods for giving oneself an edge over one's opponents, and for temporarily escaping celebrity and visibility. Using a vague name is not necessarily a sign of laziness or a disinclination to put effort into one's online appearance, but sometimes a specific, informed decision.

Clan Tags and Group Identities

Some of the earliest online multiplayer game competition took place in first-person shooter (FPS) games, such as the *Doom* (1993), *Quake* (1996), *UnReal* (1998), and *Counter-Strike* (2000) series. Many of the games in this earliest era only had technical affordances for a player inserting a single, short name to distinguish themselves from others. However, this proved insufficient as soon as players quickly began to band together into "clans" (e.g., Wright et al., 2002; Peña & Hancock, 2006; Przybylski et al., 2010). Clans were originally informal group-ings of players who shared an interest, geographical origin, playstyle, or preference for certain game-styles or strategies, and who would play together and associate themselves with one another (see Chen & Ask, this volume). Lacking any formal structure for something of this sort, most of the earliest clans would set up websites on free website-hosting services, listing their affiliations, the games they played, and sometimes their members. In some cases, members of one clan would battle against members of another clan, and although in most early cases the lack of for-mal structure meant there was no material impact from victories and losses, such competitions would affect a clan's social status. With the advent of such emergent social structures, it was deemed no longer sufficient for one's avatar name to simply contain the tag used identify oneself and apart from others; instead, it was now deemed important that one's *group* identity should be reflected.

However, the number of characters available for an avatar's name—which players were now trying to use for a name *and* a label—was very minimal, often no

more than one or two dozen characters. Given that clans often had quite lengthy names, this meant a level of innovation was required to create a short and succinct "clan tag." For example, if a clan was called "The Champions of Quake," their clan tag might be shortened to "[TCoQ]." The use of the square brackets quickly emerged as a method for delineating a *label*, as separate from a *name*. Thus, parts of an avatar's label that were previously the same as any other character, which is to say devoid of any universal meaning, came to be specific—a "[" or "]" in one's name, assuming it was accompanied by the other, always meant a clan tag (in some cases "(" and ")" were also used, but square brackets were by far the more common).

Clan tags soon came to be a strategic asset that would influence gameplay from all those within the gameworld who cared about clans (which is to say some, though not all, players). Some players would be targeted over others due to their clan tags. Other players would be derogatory and negative toward *anyone* with a clan tag, seeing them as a foolish concept, an affectation, or a pretension. Other still would treat those without clan tags as being inherently less important, and likely less skilled, than those with clan tags. Just as the names of *EVE Online* and online poker are designed to aid players engaged in in-game competition, the clan tags of these early FPS games did the same through the formation of clan alliances and the presence of reliable allies. However, these tags also influenced, structured, and even generated especially fierce competition where previously all players—with only names—had been "equal." In the case of the clan tags, therefore, the social dynamics of these emerging competitive spaces were formalized and regularized by their users, and then this very formalization came to further shape how sociality within these digital spaces evolved.

THE FUTURE OF DIGITAL NAMES

What might be the future of avatar names and labels in digital game environments, specifically regarding how they influence and structure moments of gameplay? A fruitful direction is to consider their functions in emerging virtual reality (VR) games. VR entails the use of a headset which replaces the player's complete field of vision, and when the player physically turns their head, the headset tracks their movements and adjusts the visual display appropriately (Desai et al., 2014). Although VR technologies have been routinely praised and then found wanting, in recent years more advanced technologies have driven renewed interest and investments from major companies—and with them a host of mainstream VR headsets and VR-specific games. Looking toward this different kind of ludic reality and how names and labels function within it highlights how strongly such textual identifiers shape the perception of in-game avatars for both those who control them and those others who observe them.

Firstly, VR will likely shift user experience such that in-game avatars will be seen in a fundamentally new way. VR makes the player more *perceptually* present, and therefore our associations with these avatars and their names may become far stronger than they are when the only *physical* connection between a player and an avatar is a keyboard or a controller. Names in traditional games function as identifiers for digital bodies that are controlled only indirectly by physical mouse-clicks and button-presses—the named body is distant. In VR, however, the named digital body may be controlled more directly by swing of a hand or the movement of a leg such that the traditional distance is upset. As such, an avatar name functions much more directly as a label for jointly engaged physical/digital-bodied dyad, rather than only for the avatar. Although this is only an initial prediction, such proximity of contact between the player and the avatar is bound to affect the proximity between the player and the *name* of that avatar—with potential implications for the ways that players identify with their digital bodies.

Secondly, VR is a form of high-presence game interaction focused, in principle, upon a perception of embodied realism (cf. Lombard & Ditton, 1997) and a very tactile digital environment, which does not necessarily leave space for the names of avatars to float above their heads as in many online games. The greater push toward this kind of realism in VR may remove some of the options for making avatar names and labels clear, resulting in new kinds of games and new ways for *displaying* these signifiers. For instance, might we have to pick an avatar's pocket to learn its name, or check a roster to see its faction affiliation? Although the emergence of realistic display mechanisms remains to be seen, how names are shown in virtual reality may come to differ quite substantially from how they are shown in traditional game spaces, as the affordances of game technology inevitably structure how names appear and how names function.

In these ways, although the names of avatars seem trivial and passing, they can become crucial elements of digital play experiences through our perceptions of avatars. For those so inclined, the selection of a username *can* be a strategic decision, with that strategy being dependent on one's interactions with allied players, opposing players, the overall structure of gameplay within the game in question, or the relationships between digital and physical spaces. Names also endure—very few online games allow players to change the name of their avatar after that name has been established, and unlike the appearance, wealth, power or abilities of one's avatar, names cannot "level up" (although many games allow titles or other kinds of labels to denote achievement and status). The name that one's avatar had at the very start of the game will often remain its name a decade in the future, and will accrue a set of associations with it that might last for years. In *EVE Online*, we saw how names have a lasting impact upon the ability for player avatars to survive its fierce battles; in online poker, we saw how a name can indefinitely provide an aura of mystery and a reliable pseudonym for players wishing to mask their playstyles;

in first-person shooter games clan tags bring individual players in and out of the shifting social groups of clans, and facilitate long rivalries and gameplay behaviors. Names and labels, especially when so many endure in so many contexts, matter deeply in our experiences of digital avatars, and what kinds of gameplay around those avatars emerges.

REFERENCES

Almuhanna, A., & Prunet, J. F. (2015). Numeric codes in the Arabian Peninsula: An onomastic device for the Digital Age. *Anthropological Linguistics, 57*(3), 314.

Carter, M., Gibbs, M., & Harrop, M. (2012). Metagames, paragames and orthogames: A new vocabulary. In *FDG'12 Foundations of Digital Games* (pp. 11–17). New York: ACM.

Desai, P. R., Desai, P. N., Ajmera, K. D., & Mehta, K. (2014). A review paper on Oculus Rift—A virtual reality headset. *International Journal of Engineering Trends and Technology (IJETT), 13*(4), 175–179.

EVEInfo. (2017). Choosing a Name. *EVE Info.* Retrieved from: <https://eveinfo.net/wiki/index~11.htm#Choosing_a_Name>

EVEUniversity, (2017). Fleet Command Guide. *EVE University.* Retrieved from: <http://wiki.eveuniversity.org/Fleet_Command_Guide>

Johnson, M. R. (2016). Bullet hell: The globalized growth of *danmaku* games and the digital culture of high scores and world records. In A. Pulos, & A. Lee (Eds.), *Transnational contexts of culture, gender, class, and colonialism of play: Video games in East Asia* (pp. 17–42). Basingstoke: Palgrave Macmillan.

Leslie, P. L., & Skipper, J. K. (1990). Toward a theory of nicknames: A case for socio-onomastics. *Names, 38*(4), 273–282.

Lombard, M., & Ditton, T. (1997). At the heart of it all: The concept of presence. *Journal of Computer Mediated Communication, 3*(2).

McMillan, L. (2010). All of your base are belong to us? Shmups as a source for better game design (Doctoral thesis). Griffith University, Gold Coast, Australia.

Newell, J. (2016). 4 benefits you receive as a Team PokerStars Pro. *PokerUpdate.* Retrieved from: <http://www.pokerupdate.com/articles/lifestyle/2242-4-benefits-you-receive-as-a-team-pokerstars-pro/>

Peña, J., & Hancock, J. T. (2006). An analysis of socioemotional and task communication in online multiplayer video games. *Communication Research, 33*(1), 92–109.

Przybylski, A. K., Rigby, C. S., & Ryan, R. M. (2010). A motivational model of video game engagement. *Review of General Psychology, 14*(2), 154–166.

Puzey, G. (2016). Linguistic landscapes. In C. Hough (Ed.), *The Oxford Handbook of Names and Naming* (pp. 395–411). Oxford: Oxford University Press.

Vily, (2012). The FC's lesson book: Target calling. *The Mittani.* Retrieved from: <https://www.themittani.com/features/fcs-lesson-book-target-calling>

Wright, T., Boria, E., & Breidenbach, P. (2002). Creative player actions in FPS online video games: Playing Counter-Strike. *Game Studies, 2*(2), 103–123.

Gear & Weaponry

Market Ideologies of Functional and Cosmetic Items

WILLIAM ROBINSON & DAVID CALVO

Often referred to as "loot," conventional depictions of the items videogame avatars use and carry include the blurry distinction of the things avatars wear (gear) and use to harm (weapons). The accumulation of items is enabled by a variety of game design techniques that dwindle or proliferate depending on socially negotiated preferences that emerge through in-game chat, forums, advertisement, and selective purchasing. Regularly, players are tasked with deciding what their avatars will hold and wear. This process is often central to building a narrative of progress, as the protagonist-avatar becomes richer and more capable. We can trace this power fantasy to antiquity, with what Joseph Campbell refers to as "supernatural aid," in which the willing adventurers receive items as both rewards for their perseverance and as tools to continue their journey (2008, p. 63). While Campbell demonstrates that this narrative arc is found throughout the world's myths and history, fiction has elevated the concept to a trope. In particular, Elias Lonnrot's 1835 retelling of the Finnish oral tales, collectively known as the *Kalevala*, emphasizes the relationships between mythical artifacts and heroes. Inspired by this work, J. R. R. Tolkien published *The Lord of the Rings* in 1954, once again depicting protagonists receiving magical items that help advance their quests. These objects, often properly named, such as Bilbo's *Sting* or Gandalf's *Glamdring*, not only motivate characters to act but, in some cases, force them to.

This chapter presents an incomplete chronology of in-game items and their relationships to utility and markets. The focus is on two different narratives: the first traces the emergence of functional items from *Dungeons & Dragons* (D&D,

1974) to the closure of *Diablo 3*'s (2012) Real-Money Auction House; and the second explores the emergence of cosmetic items from the opening of *Second Life*'s marketplace to the expanding reach of Steam's Community Market. While the former charts the end of an officially sanctioned financial market for functionalist digital goods, the latter signals the growth of a new kind of market for digital cosmetics. The unregulated markets of digital goods created a conflict inside the player community. This crisis ended with a re-imagining of digital items as identity markers signaling commitment to a game's universe.

A SNAPSHOT OF FUNCTIONAL ITEMS

In 1975, drawing from Tolkien, Gary Gygax created the fantasy supplement to his tabletop miniatures game, *Chainmail* (1971), his precursor to D&D. In it, Gygax introduces, among the faeries and ents, the concept of the magical sword and how it behaves differently from generic swords, adding an extra die roll in calculating damage done, lighting up dark spaces, and even allowing for combat with some magical enemies (1975, p. 38). By bringing in a fantasy object to a set of rules generally designed to represent historical forms of combat, Gygax would lay the groundwork for large swaths of game design. Later, in publishing *Advanced Dungeons & Dragons*, additional rules were added to determine the doling out of treasure, including magical items and gold (Gygax & Perren, 1979). Here gear and weaponry take on those same two roles they held in fiction and that they continue to bear to this day. Firstly, items are exciting because they empower the character/avatar/player, often offering new tools to solve future problems and thus enrich gameplay through diversification of available action. Secondly, they are rewards for having made it through part of the game. In this way, items signpost success to the player. These two processes produce a positive feedback loop wherein progress leads to items, which lead to progress and so on.

In addition to migrating fantasy items into a medieval rule-set and incorporating them into a narrative framework, Gygax created "loot tables." These were to be consulted by the Dungeon Master (DM; the player in charge of game events and narrative) to semi-randomly determine which treasure would drop from a monster when killed. The DMs, in these early games, held the role computers and game design companies often hold today, as they were responsible for constructing a fictional world replete with characters, towns, wildlife, and adventure. Guided by a rulebook, the DM would ensure a consistent and compelling collaborative story-crafting experience. The loot table was designed to offer an impersonal means of guaranteeing just rewards for slaying monsters of different difficulties. This structure still exists today as one of game design's greatest strategies for engrossing players. Academics (e.g., Karlsen, 2011) have written about the psychological

implications of the cyclical nature of loot droops and their relationship to play, suggesting that obsessive behaviors can be produced. In addition, game designers have repeatedly considered the captivating properties of videogame items, at times referring to a compulsion loop, where players repeatedly do the same action because it gives them pleasure (e.g., Grey, 2013). Gygax himself would opine on the matter in *Advanced Dungeons and Dragons,*

> It has been called to my attention that new players will sometimes become bored and discouraged with the struggle to advance in level of experience, for they do not have any actual comprehension of what it is like to be a powerful character of high level. In a well planned and well judged campaign this is not too likely to happen, for the superior DM will have just enough treasure to whet the appetite of players, while keeping them lean and hungry still, and always after that carrot just ahead. (1979, p. 12)

Here, we can see the role that the game designer holds over pacing in gameplay. Items act as both denouements of past moments and keys to future chapters. Determining the moments they drop is akin to the work authors do in keeping readers turning pages. In modern, computer-based roleplaying games, this work is conducted by game designers (in advance of gameplay) and computer algorithms (during gameplay), and the more ethereal, narratively constructed items are replaced with digital representations of those items ... and often the visual qualities of items are part of their appeal (Fron et al., 2007). In some ways, accumulating experience points and items in these games become stand-ins for the personal growth of the avatar in the fiction (Knowles, this volume). While game rules might not simulate the coming of age or self-realizations we might find in literature, they can nonetheless manage and point to the growth of characters and keep players identifying with their gains in ability.

DIABLO AND A CRISIS OF VALUE

In Gygax's musings on game management, above, one can see the conflation of loot and experience. The rule was simple: gold can be turned into experience points. This helpful abstraction of progress allowed players to adjust their wealth and level according to the campaign's requirements. This implied that a wealthy character might be able to sell golden armor to transform into a powerful wizard. Perhaps due the fictional incoherence of this design, this equation was dropped in subsequent D&D editions. The numerous videogames and genres that emerged continued for a time this separation between fictional wealth and fictional skill. It is well beyond the purview of this chapter to explore the totality of games borrowing from D&D's loot system, let alone all games with items. That said we highlight here a crisis within its historical context to act not only as an exemplar for items' usage in games

but also as a moment of reflection on communal preferences: the aesthetics of play, challenged by critiques of the relationship between fictional and real world wealth.

In 2014, two years after its release, Blizzard Entertainment closed *Diablo 3*'s real-money auction house (henceforth RMAH). To understand why it was created and why it failed, consider the first *Diablo* (1996). Much like the dungeon-crawling RPGs that stemmed from D&D, *Diablo* offered players an opportunity to bring a character from lowly warrior to the status of demigod to slay the titular antagonist. Players would enact the process of killing monsters to both accumulate gear and level up, so that they might kill greater things to grow in experience to retrieve greater gear to kill greater things until there was no more gear or no more things to kill. While there were ways to play *Diablo* online, it was only with *Diablo 2* (2000) that online play became the default. In that iteration, trading items became a central facet of play as the number of items available was orders of magnitude higher and the likelihood of a given drop being useful to the player who found it was particularly low. Eventually, growing use of the World Wide Web and increased restrictions on hacking would lead players to websites facilitating the trade of real-world money for in-game items. Wealth and experience began to equate with each other once more, as markets for each were formed. A *Diablo 2* player might find a sword and sell it, using the proceeds to pay a player to level-up their character for them. While the game attempted to produce a particular pacing for players trying to reach the end, they would begin to pay for a faster pace of in-game progress. These markets were unregulated and several people were cheated out of their money in a variety of ways. By the time *Diablo 3* was released, game developers were already finding ways to curb grey markets to claim brokerage fees for themselves and to offer safer and more reliable service.

Diablo 3 became known for its in-game RMAH, where players could place their digital items up for auction in hopes of selling them for a dollar value. This was useful in *Diablo 3* given that the extreme rarity and power of high tiers of play required inordinate hours of mundane play so that progress could be made. Once again, players would pay to increase the pace of progress. Entire forum threads were dedicated to complaining about the state of the market and the effects it was having on the game. Two years later, Blizzard would close the RMAH explaining,

The gold and real-money auction houses have provided a convenient and secure system for trading, but it's also become increasingly clear that despite the benefits they provide, they ultimately undermine *Diablo*'s core gameplay. A big part of *Diablo* is the thrill of battling demons and finding epic loot. While buying epic loot in the auction houses might be more convenient, it doesn't feel anywhere near as heroic as plowing through a pack of fearsome-looking monsters and having them drop that one awesome item that seems like it was made for your character. (Lylirra, 2013)

Today, several games use "pinch points" to stymie the player and lead them to consider spending currency on digital items to improve at a faster rate. These points

are moments of heightened difficulty that either slow the player down, or have that player pay money to pass them. For example, *Candy Crush Saga* (2012) creates an expectation for a certain pacing, tied to the usual burst-practices of the game ("I want to get to level 28 before my train reaches the next station, but I'm stuck at level 25 because it is too hard"). These kinds of games are derogatorily described as "pay-to-win," suggesting that the meritocracy of player skill is being undermined. However, some scholars have celebrated these kinds of games, given that they allow players with less privilege and time to keep up with those who have an exceptional amount of both (see Paul, 2018). While Blizzard acknowledged that "pay-to-win" undermined its design principles, thus siding with the hardcore player community, others have found ways to design games whose core gameplay might withstand its pitfalls, with one solution found in the creation of a market for cosmetic items.

DIGITAL ITEMS AS BUY-IN

While they began as something experimental and unserious, cosmetic items have revealed important facets of player desires and behavior. For years, functional items (i.e., items influencing avatar capabilities) have served less like new tools for interesting addition to gameplay and more like extrinsic rewards offered to players to keep playing. This has been done by scaling item power numerically in tandem with enemies—the +1 Sword to fight the Giant Rat is replaced by a +5 Sword to fight the Dragon and so forth. While, in the pragmatic sense, the +5 Sword seems more functional, it does not operate in a qualitatively different way. To signal these new items particularities, designers present them as larger, more beautiful pieces of work—more particle effects, better shapes, special animations, and so forth (see Kao & Harrell, this volume). Here, we witness a blurring between the functional and the cosmetic, the potential interaction of player's identity and avatar's appearance as a basis for a new economy, centered on customization and immersion. The pursuit and use of cosmetic items expresses an identification to a culture, to an imaginary world. The heightening of digital representation becomes a bankable aspect of games, especially in online environments, where the optimization of silhouette, textures, and fashion is seen as savviness, expertise, and taste—taking seriously the culture of an imaginary world (Martey & Consalvo, 2011). Beyond the extension and projection of the player's psyche unto the digital canvas, beyond the "cool factor," customizing an avatar reinforces the reality of the world, or how engrossing it is for everyone involved (see Teng, 2010).

The link between design elements and the enhancement of telepresence—and the links among avatars inside the simulated world—is becoming one the most important aspect of games, on par with the relation between the player and its avatar. In less obviously "gamey" digital spaces, like Second Life (2003), the tuning

of the avatar is central to the excitement of digital embodiment, and a goal in itself—"shall I look like myself? Like a better me? Like another self? Like something else?" In addition, Second Life allows players to create and sell their own content in a very efficient and fluent online marketplace. A virtuous cycle is thus created, as customizing one's avatar lends credibility to the world and its actors, which in turn incites players to take the world more seriously, which in turn leads to a desire to customize one's avatar to make one's participation in that world more authentic and valued. Cosmetic items, much like the functional counterparts, can drive the repeated return of the player (cf. Turkay & Adinolf, 2015), placing these items as quick rewards to regular in-game actions.

Increasingly, functional items and cosmetic items enter a dialogue between game and representation, substance, and surface. This reciprocity is allowing the "emergent" behavior of a system and exploiting its bugs, accidents, and unforeseeable uses as new features. In her talk at GDC 2014 about content economy, Valve's Bronwen Grimes stated that design first emphasized strong player identification with characters in *Counter-Strike* (2000) to prevent confusion without breaking the world's diegesis (that is, its internal narrative consistency), then shifted to weapon customization as a way of emulating real-life practices:

> We needed a reminder that although *Counter-Strike* is military inspired, it's not a military simulation. It's a sport. When our customers play, they don't aspire to be soldiers, they aspire to be elite *Counter-Strike* players. So maybe it's not that surprising that the closest real-world analogue we've got to our preferred aesthetic comes from a sport [paintball].

At that point, Valve discovered that players' visual aesthetic tastes can drive game culture: on May 21, 2009, a new discussion formed around Valve's introduction of decorative hats to *Team Fortress 2* (TF2, 2007). These hats were not the first cosmetic items for videogame play. They were not the first cosmetic items to be tradable between players. They were not first items to be randomly dropped and rewarded, as though they were functional items. Regardless, perhaps due to all of these factors, hats captured the imagination of the TF2 community. They were derided, ridiculed, and made into memes.

> Valve, a year later when releasing the Mac version of the game, wrote:

> For the first time, Mac users can experience the head-covering excitement by getting online this weekend and playing America's #1 war-themed hat simulator for themselves. Anyone logging into the game from a Mac will receive a limited edition set of in-game earbuds to wear on any class. PC users won't technically receive anything by logging in from a PC, unless you like shooting at Mac users—in which case, consider this earbud promotion a new "shirts vs. skins"-style game mode. (Valve, 2010)

These earbuds would become the currency of TF2 trading markets, with certain hats selling for as many as 15 earbuds, and with earbuds selling for $20 USD

apiece. One such item—a tricornered hat adorned with an octopus awkwardly holding a treasure chest—was cheekily named "The Hat of Undeniable Wealth and Respect." It was awarded to the players who managed to complete Valve's 28 achievements during Valve's 2010 Christmas sale. The hat itself was coveted by those who even knew of its existence and sold for prices nearing $800 USD. Here the hat in question was meant to denote achievement and wealth in-game without offering the player any advantages. If anything, the sheer size of the hat could give away one's position and aid enemy players. This kind of item does not affect aesthetic pacing, as with previous functional items, but social status. Just as with Blizzard's RMAH, Valve found itself trying to manage a grey market of real-money trading until 2012 when it released the Steam Community Market.

To address these concerns, the would-be Greek Finance Minister, Yanis Varoufakis, was hired by Valve in 2012, for his expertise in economics (a move mimicking the 2007 hiring of Eyjolfur Gudmundsson for dealing with the highly complex economy of the MMO *EVE Online*). The silly hat had produced a new tulipmania (cf. Garber, 1989), in which a decorative object of limited utility became desired to the point of becoming currency. By 2015, the market would be extended to all Steam games interested in selling digital items, which meant that—all of a sudden—making progress in one game on the platform could be ostensibly converted to progress in another. In 2016, Valve sent cease and desist letters to a variety of gambling websites, which used its marketplace's items as currency to escape regulation. Users were found to have millions of dollars' worth in their digital inventories. By then, hats had been renamed "skins" as they began to take on new forms and extend across more games.

Cosmetic items come in many shapes, and work on player vanity to convey accomplishment. Regularly, they compel players to collect them, often as a meta-game (see Paul, this volume). Meta-contests of people competing to get the rarest items can be games in themselves, and the customization of individual experience (and self-expression), the tailoring of game to suit the over-expanding needs of the players always expecting new content, has led to some new fields of game design, using promotional materials and micro-transactions as incentives to engage the players in more thorough gameworlds and personal growth. Cosmetic item storage management, when backed by tools allowing players to create UI, allows the community to deal with its increasing complexity—like inventory management mods in *Second Life* or the use of Void Storage in *World of Warcraft* (2004). One could state that, at this point, the avatar becomes of locus of vanity, an archive for the player's status signals, a china cabinet without value in itself, but a container of things of value.

As Mike Pondsmith wrote of the digital future and the cyberpunk genre, "It's all style and no substance" (1993, p. 2). Years ago, the idea of paying for cosmetic items was the laughingstock of gaming communities—a devolution of thoughtful gameplay into the superficial. It is now a reliable, sustainable alternative business model in the game industry, enabling designers to avoid resorting to "pay-to-win" models. Even if

they are not influencing the gameplay, per se, merely reinforcing the player's identifi-cation with a character and implementing the reality of the world, cosmetic items can also be source of enjoyment. When they do influence the gameplay, either by side-effect or intended design, they can represent both sides of a double-edged sword: on one hand, they are pay-to-win strategies and addiction reinforcement; on the other, they are profitable in a difficult business ecosystem and building new game habits.

REFERENCES

Campbell, J. (2008). *The hero with the thousand faces*. Novato, CA: New World Library.

Ducheneaut, N. Wen Ming-Hui, D., Yee, N., & Wadley G. (2009). Body and mind: A study of avatar personalization in three virtual worlds. In *Proceedings of the SIGCHI conference on human factors in computing systems* (pp. 1151–1160). New York: ACM.

Fron, J., Fullerton, T., Morie, J. F., & Pearce, C. (2007, Jan.). Playing dress-up: Costumes, roleplay and imagination. Paper presented at Philosophy of Computer Games 2007, Modena, Italy.

Garber, Peter M. (1989). Who put the mania in tulipmania? *The Journal of Portfolio Management, 16*(1), 53–60.

Grey, C. (2013, Apr 3). Emotions and randomness—loot drops [blog post]. Retrieved from: <http://www.gamasutra.com/blogs/ChrisGrey/20130403/188569/Emotions_and_Randomness__Loot_Drops.php>

Gygax, G. (1979). Advanced Dungeons & Dragons: Dungeon master's guide. Lake Geneva, WI: TSR Games.

Gygax, G., & Perren, J. (1975) *Chainmail: Rules for medieval miniatures*. Guidon Games.

Hussain, Z., Williams, G. A., & Griffiths, M. D. (2015). An exploratory study of the association between online gaming addiction and enjoyment motivations for playing massively multiplayer online role-playing games. *Computers in Human Behavior, 50*, 221–230.

Karlsen, F. (2011). Entrapment and near miss: A comparative analysis of psycho-structural elements in gambling games and massively multiplayer online role-playing games. *International Journal of Mental Health and Addiction, 9*(2), 193–207.

Lylirra (2013, Sept. 17). Diablo III auction house update FAQ [blog post]. Retrieved from: <http://us.battle.net/forums/en/d3/topic/9972208129>

Martey, R. M., & Consalvo, M (2011). Performing the looking-glass self: Avatar appearance and group identity in Second Life. *Popular Communication, 9*, 165–180.

Paul, Christopher. 2018. The toxic meritocracy of video games: Why gaming culture is the worst. University of Minnesota Press.

Pondsmith, M., & R. Talsorian Games Inc. (1993). *Cyberpunk, the roleplaying game of the dark future: 2.0.2.0., version 2.01*. Berkeley, CA: R. Talsorian Games Inc.

Teng, C. I. (2010). Customization, immersion satisfaction, and online gamer loyalty. *Computers in Human Behavior, 26*(6), 1547–1554.

Turkay, S., & Adinolf, S. (2015). The effects of customization on motivation in an extended study with a massively multiplayer online roleplaying game. *Cyberpsychology: Journal of Psychosocial Research on Cyberspace, 9*(3), Article 2.

Valve (2010). Earbuds. Retrieved from: <http://www.teamfortress.com/macupdate/earbuds/>

Companions & Vehicles

Permutations of Digital Entities

RABINDRA A. RATAN

Do you have a cat? A dog? A Zandalari Footlasher? If so, your pet likely fills a special need in your life, such as companionship, cognitive stimulation, or even—in the case of the *World of Warcraft* Footslasher raptor—assistance on quests of dire importance to the realm. Similarly, do you drive a car? Ride a motorcycle? Fly a Banshee? If so, your vehicle likely transforms your experience in the world, augmenting your mobility, capabilities, and (in the case of *Halo*'s deadly aircraft) potential to unleash carnage on the enemy. Companions and vehicles play important roles in our everyday, individual experiences. Similarly, *digital* companions and vehicles facilitate and augment the user's digitally mediated experiences, functioning alongside and in tandem with avatars. However, whereas an avatar is often perceived as an on-screen reflection of the user—one's digital self—digital companions and vehicles do not necessarily reflect any aspect of the user's self (e.g., behavior, appearance). So how exactly do digital companions and vehicles relate to avatars?

To address this question, it is useful to consider what an avatar *is* and *does*, relative to the user. According to the dual-congruity perspective of avatar use (Suh, Kim, & Suh, 2011), avatars vary in the extent to which their use is *functionally congruent* (utilitarian and task-related) versus *self-congruent* (expressive and identity-oriented). These congruencies vary in digital companions and vehicles, making them more or less *avatar-like* in relation to the user. Other factors, such as the extent of user control and character traits displayed, also influence digital companions' and vehicles' avatar-likeness. Ultimately, these considerations—and their sometimes-complex contextualization—set the groundwork for a new triadic

model of the relationships among digital companions, vehicles, and selves, all of which can be understood as avatars in varying degrees.

DIGITAL COMPANIONS

Drawing from the Oxford English Dictionary definition of "companion," a digital companion is defined here as a digital entity (e.g., a person or animal) with whom an individual spends significant time. Digital companions have been compared to avatars as self-congruent (Consalvo & Begy, 2015); for instance, a user may design a *Second Life* avatar to be accompanied by a digital canine companion to reflect an everyday affinity for dogs. Alternatively, digital companions may be understood according to degrees of functional congruence—the ways the companion does (not) reflect the control and intentions of the user. From this frame, digital companions arguably fall into four categories, defined here from lowest to highest avatar-likeness: *decorative, nurture-me, semi-autonomous,* and *briefly controllable.*

The simplest type, *decorative companions*, provide companionship through imaginative play, somewhat like stuffed animals or action figures. Such companions are only minimally avatar-like; they require little interaction from the user, though they do offer opportunities for self-expression. For example, in *World of Warcraft* (WoW; 2004), vanity pets generally serve as silent companions, offering an aesthetic enhancement to game environments. Although the digital pet is not necessarily utilized toward game objectives, the player's choice of specific pet and customization options potentially expresses the player's personality and avatar's personality (as in roleplay contexts), or otherwise enhances the game's social experience. Thus, decorative digital pets provide an important complement to the avatar-use experience. This might be especially true depending on players' personality types. For example, vanity pets tend to be more popular among people who are lower in extraversion (i.e., less outgoing) and higher in conscientiousness (i.e., more careful; Yee, Ducheneaut, Nelson, & Likarish, 2011).

In another form, *nurture-me companions* require that users attend to their (digital) health and happiness through feeding, grooming, and play (lest they expire). These digital companions are more avatar-like than decorative companions in the sense that they react to the user's behaviors, serving as indirect reflections of the user's agency (Consalvo & Begy, 2015). In other words, the companion's existence is evidence that the user is involved in the digital world. Studies have found that nurture-me digital pets can be designed to motivate healthy behaviors from users, as when users' physical activity is a direct input to the digital pet's health or happiness (e.g., *Pokémon GO*, 2016) so users become more physically active (Ahn et al., 2015). Similarly, nurture-me digital pets have been designed to engage users in educational activities, such as learning Chinese idioms by harnessing the user's

motivation to fulfill the digital pet's needs (Chen, Chou, Biswas, & Chan, 2012). This type of coupling between the pet's perceived health and user's health- or learning-related behaviors creates a symbiotic relationship between the user and digital pet. Ironically, by inspiring the user to nurture the digital pet, the digital pet nurtures positive behaviors in the user. Although the digital pet is not directly controlled by the user, it still helps the user accomplish some goal. This highlights the notion that digital pets—or digital companions more generally—may vary in the extent to which they facilitate the user's agency (i.e., capacity to act) and thus in avatar-likeness.

At the next level of avatar-likeness, *semi-autonomous companions* are integral to the user's ability to accomplish goals in a digital space. These digital companions are semi-autonomous in that their specific behaviors are controlled by a computer algorithm, but the *types* of behaviors in which they engage depend on the user's own behavior (Bailenson & Segovia, 2010). For example, many games include non-playable characters (NPCs) who serve as guides to the player's experience. These NPCs exist in the digital space seemingly regardless of the player's existence but also respond dynamically to the player's inputs in ways that enrich the player's experience (Moon, Lee, Kim, & Han, 2010). In other words, such NPCs are digital companions who not only accompany users but also facilitate users' navigation of digital space. Other semi-autonomous companions take a more subordinate role and allow for more direct intervention from the user. For example, in many games, the player can enlist a digital companion to fulfill directives, such as looting, hunting, or attacking enemies (Hamari & Lehdonvirta, 2010). Overall, whether NPCs or directable subordinates, such semi-autonomous digital companions are more avatar-like than nurture-me pets, offering a more direct manifestation of the user's agency, albeit still largely mediated by computer algorithms.

Finally, at the highest level of avatar-likeness, some digital companions allow the user to take over direct control from the computer algorithm to pursue a specific goal. Such *briefly controllable* companions (sometimes called *familiars* when in animal form) are more avatar-like than those controlled always by algorithms because users are able to directly intervene in the action, albeit transiently. In this sense, the digital companion is a sort of *ephemeral avatar*, as it usually acts autonomously—under the computer algorithm's control—but offers the user direct control when necessary. The ability to switch between direct and autonomous control is an integral mechanic in some digital environments, such as team sports videogames, like hockey or football. In these games, members of the user's team are normally guided by computer algorithms with little if any direction from the user, like a semi-autonomous digital companion. However, the user can assume control and switch among multiple team-mates in quick succession, choosing which one to embody as an ephemeral avatar depending on where the user's intervention is required. In another form, ephemeral digital entities are manifested as tangible physical toys that have digital, playable

correlates, such as *Skylanders* (2011; Antonijoan & Miralles, 2016). These are digital companions in that although the physical toy is materially manifest (similar to a more enduring decorative digital pet), the related digital manifestation becomes an ephemeral avatar during the time that it is controlled by the user in a digital environment.

These four types of digital companions vary in the extent of their avatar-likeness, based on the extent to which the user can intervene in the digital entity's behavior. Decorative digital companions are the least avatar-like in this discussion because they offer aesthetic and social enhancement but little function to the user (e.g., vanity pets in WoW). Nurture-me digital companions are more avatar-like because they mediate users' agency by coupling the digital companion's perceived well-being with the user's behaviors (e.g., *Tamagotchi*, 1996). Semi-autonomous digital companions offer even greater avatar-likeness because they pursue user-defined directives, albeit while under a computer algorithm's control (e.g., tamed animals in *Far Cry Primal*, 2016). Briefly controllable digital companions are the most avatar-like—and are characterized here as ephemeral avatars—because the user is able to directly influence their behaviors for short periods (e.g., teammates in team sports games).

Another factor that influences the avatar-likeness of digital companions—regardless of the ability to intervene in their behavior—is the extent to which digital companions exhibit a player's own versus not-own traits. The more own (and less not-own) traits, the more avatar-like the digital companion is. Such character traits may include appearance markers as well as other aspects of one's character, such as personality. For example, a digital companion with your facial characteristics and hair color is more avatar-like than one with just your hair color. Further, a digital companion that exhibits your personality characteristics (e.g., talkative versus quiet) is more avatar-like than one that does not.

While this factor of traits is orthogonal to the issues of autonomy and control discussed earlier, the two are sometimes correlated in practice. Namely, the more a digital companion reflects own traits (higher self-likeness), the more it also likely affords behavioral control to the user (again, higher avatar-likeness). However, as a counter-example, a digital companion can be given traits to appear identical to an individual who has no control over its behaviors. For such digital companions, which can also be referred to as digital doppelgängers (Bailenson & Segovia, 2010; see Ahn, this volume), avatar-likeness is high with respect to character traits but low with respect to the potential for behavioral control.

DIGITAL VEHICLES

Drawing from Oxford's definition of "vehicle," a digital vehicle is defined here as a digital thing used to transport characters or objects. Digital vehicles are not avatars in the traditional sense, but are more or less avatar-like—and

companion-like—depending on functional congruency versus self-congruency and autonomy versus controllability.

Digital vehicles vary in functional congruency based on the extent to which their use is guided by utilitarian and task-related goals. In *Gran Turismo* (1997), for instance, choice of digital vehicle is motivated to a significant extent by the degree to which its assets and performance make it possible to mirror the player's desired driving activity, as the game is known as a high-fidelity driving simulator. Importantly, because of such functional congruence, digital vehicles can be considered a variant on digital companions, depending on the extent to which the user asserts control over the vehicle. The more control the user has over the vehicle's behavior, the less the digital vehicle is like a companion. Conversely, the more autonomous a digital vehicle, the more it will may perceived as companion-like. This is consistent with the Media Equation (Reeves & Nass, 1996) postulate that media are naturally perceived as social entities, as well as Lang's more recent argument (2014) that media and mediated content to some degree are brain-like creatures, depending on variables such as autonomy. Illustrating this relationship in the context of digital vehicles, a drivable car in a racing game would be considered less companion-like than semi-autonomous vehicle units in *Starcraft 2* (2010; only minimally functionally congruent in that they autonomously navigate to user-defined destination points). Further, the less frequently a user must intervene in a digital vehicle's behavior, the more autonomous and companion-like the vehicle.

For example, in *Grand Theft Auto V* (GTAV; 2013), the player can be taken places by a taxicab without user intervention beyond initially setting the destination point. In this case, the digital vehicle is highly companion-like and even comes with a taxi-driver who speaks to the player. However, fully autonomous digital vehicles may not always provide companionship if the user can "fast-travel," reducing the time of transportation in the digital vehicle to less than what would be possible according to the normal physical mechanics of the digital environment. In GTAV, instead of waiting for the taxicab to drive across the digital environment, the player can choose to skip immediately to the destination (for a fee). Although this medium of transportation by teleportation is fully autonomous, the vehicle is not quite a digital companion because the duration of co-action is minimized. In other words, given that a digital companion is defined as a "digital entity with whom an individual spends significant time," if the time spent with the vehicle is not significant, then it is not a digital companion. Thus, a digital vehicle is most like a digital companion when the transportation requires a minimum amount of user intervention (i.e., setting a single destination point) and the duration of coaction is non-trivial.

Conversely, in games where the player's vehicle has little bearing on in-game performance (e.g., spaceships in *Destiny* [2014], which the user cannot control), choice of vehicle is likely motivated more by self-congruity (expressive and

identity-oriented goals), in terms of aesthetic preferences for forms or features that reflect players' desires and values. For instance, returning to *Gran Turismo*, a player might opt out of a high-performance vehicle that seems out of reach in everyday life in favor of the game's iconic Honda Civic, perhaps mirroring the comfortable mundanity of one's first car (see Malazita, 2017). Or in WoW, a player might opt for a mount that matches a hunter's rare combat pet (expressive of skill and aesthetic coordination), or even express "old-school" fandom by riding the "Big Blizzard Bear" exclusive to attendees of the 2008 Blizzard convention. Importantly, such self-congruencies may also intersect with functional congruencies to reflect avatar-likeness, given that choice of vehicle may influence the aesthetic or social experience of the digital environment in ways that have indirect functional effects. For example, spaceships in *Destiny* are displayed during loading screens and may signal the spaceship owner's experience, skill level, or aesthetic preferences to other players. The same argument can be made for digital vehicle customization. Some types of customization are driven by functional congruity because they affect game performance (e.g., adding turbo boosters to a *Gran Turismo* car) but they may also reflect self-congruity because they have expressive—though possibly indirectly functional—effects (e.g., changing paint color).

COMING FULL CIRCLE ... WELL, TRIANGLE

This chapter has provided a set of loosely connected examples of how digital companions and digital vehicles vary in avatar-likeness according to three fundamental avatar attributes: (1) functional congruency versus self-congruency, (2) autonomy versus controllability, and (3) own versus other character traits. A synthesis of these examples implies that avatars can be understood as digital companions, vehicles, *and* selves—in varying degrees—depending on the avatar's manifestation of these fundamental attributes.

Previous research on perceptions of avatars can be used to provide structure for this claim. Specifically, a recent typology defines four types of player-avatar relationships (PARs; Banks, 2015): avatar-as-social other (differentiated orientation), avatar-as-object (tool-based orientation), avatar-as-me (highly identified orientation), and avatar-as-symbiote (alliance of self and avatar). This typology is derived from a deep contextual understanding of how people view their avatars in online games and has been validated through multiple empirical measures. For example, people who see their avatars as social others were more likely to use third-person pronouns (e.g., *she, he*) when discussing their gameplay (Banks & Bowman, 2014) and to attribute anthropomorphic autonomy to avatars (Banks & Bowman, 2016).

Connecting the PAR typology to the avatar attributes described here, then, avatar-as-object relations are characterized by high functional congruency and

high controllability because the entities are used as tools on a screen, as digital vehicles tend to be. Avatar-as-other relations feature more autonomy and not-own character traits because the entities are independent agents, as digital companions tend to be. Avatar-as-me relations are characterized by high self-congruency and more own-character traits because entities are extensions of identity and expression, as digital selves (i.e., avatars, traditionally interpreted) tend to be.

Thus, digital entities can be situated within a common theoretical model that illustrates their relative similarities and differences. Social Cognitive Theory (SCT; Bandura, 1989a) is useful to this end. According to SCT, human behavior is influenced by a triadic relationship between environmental factors (e.g., others in the world), personal factors (e.g., perceptions of the self), and behavioral factors (e.g., perceived abilities—inherent or augmented through devices; Bandura, 1989b). From this frame, digital companions—as "othered" avatar components— would be considered an environmental factor, just as physical others are an environmental factor in SCT, because they are external to the individual. Digital vehicles—as tool-like extensions of self—would be considered a behavioral factor because they are the behavioral mechanisms. Digital selves—as ostensibly purer self-reflections—would be considered a personal factor because they represent the users' identity and self-congruent motivations. Importantly, as the reasoning from this chapter suggests, such digital entities easily shift among these factors based on one's orientation to each type of entity. For example, engagement with a digital companion is not purely observational (relating to environmental factors) if the user has some agency over its behavior but also not purely enactive (relating to personal factors) because the actions and outcomes of such agency are projected into the digital environment. Building on similar logic, previous research suggests that using an avatar is a *mediated enactive experience* (Peng, 2008). This implies that avatars are classified "in between" the factors defined by SCT—that is, no avatarial engagement relies purely in one factor or another. Further, given that enactive experiences are generally more influential over behavior than observational experiences (Bandura, 1986), avatar use may lead to more significant effects than passive forms of media use.

Building on this, PAR types can be mapped onto SCT's triadic relationship of reciprocal determinism (Figure 10.1) using the reasoning offered in this chapter to describe the relationships among elements. PAR types are described as distinct categories but also exhibit characteristics such as self-differentiation and sociality to different degrees (Banks, 2015). Thus, PARs can be treated as archetypical points along a sociality continuum, such that each PAR is not mutually exclusive but instead offers a framework for the multifaceted relationships people have with their avatars. This framework can be linked to SCT through the ostensible variations in avatar attributes inherent to different digital entities. Namely, an avatar becomes more like a digital companion (or associated PAR type or SCT element)

the more autonomous it is and/or the more it exhibits not-own character traits. An avatar becomes more like a digital vehicle (or associated PAR type or SCT element) the more controllable and/or functionally congruent it is. Finally, an avatar becomes more like a digital self (or associated PAR type or SCT element) the more self-congruent it is and/or the more it exhibits own-identity traits.

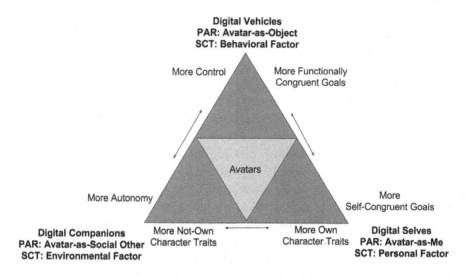

Figure 10.1. Triadic model of relationships among digital vehicles, companions, and selves. (Source: author)

This model potentially provides a useful guide for thinking about digital entities but could also be extended to understandings of non-digital entities. The model serves as a reference in the argument that avatars vary across all three types of digital entities and can be compared according to the avatar's manifestation of the three avatar attributes in the model (congruity, traits, and control). Building on this, the model could be used to inform research on gameplay motivations or to define a set of constraining factors on the Proteus effect, the phenomenon that users' behaviors tend to conform to avatars' identity characteristics (e.g., taller avatars lead users to negotiate more aggressively; Yee & Bailenson, 2007).

This model could also help frame research on non-digital entities that share traits with avatars, such as automobiles, which are similar to avatars in the way they facilitate transportation of body and traits (Ventrella, 2011) and vary in autonomy (they are *auto*mobiles, after all). Previous research has examined how driving safety and perceived social closeness with other drivers is influenced by the extent to which the car is treated as a self-expression or social companion (Ratan & Tsai, 2014; Ratan et al., 2016). Digital worlds, such as *Second Life*, have been suggested as ideal environments for testing autonomous-driving algorithms (Jiang

et al., 2010) as well as for advertising for automobile brands in online communities (Crawford, 2007). The model offered in this chapter could serve as a guide for research that merges these topics. For example, the extent to which people view personal vehicles as companions, selves, or functional tools may influence willingness to purchase cars with new autonomous-driving technology. Beyond these applications, the intersections of avatar attributes and social cognition may together meaningfully contribute to understanding how humans relate to their technologies, more broadly.

REFERENCES

Ahn, S. J. G., Johnsen, K., Robertson, T., Moore, J., Brown, S., Marable, A., & Basu, A. (2015). Using virtual pets to promote physical activity in children: An application of the youth physical activity promotion model. *Journal of Health Communication, 20*(7), 807–815.

Antonijoan, M., & Miralles, D. (2016, May). Tangible interface for controlling toys-to-life characters' emotions. In *Proceedings of the 2016 CHI Conference Extended Abstracts on Human Factors in Computing Systems* (pp. 2387–2394). New York: ACM.

Bailenson, J. N., & Segovia, K. Y. (2010). Virtual doppelgangers: Psychological effects of avatars who ignore their owners. In *Online worlds: Convergence of the real and the virtual* (pp. 175–186). London: Springer.

Bandura A. (1986). *Social foundations of thought and action: A social cognitive theory.* Englewood Cliffs, NJ: Prentice Hall.

Bandura A. (1989a). Human agency in social cognitive theory. *American Psychologist, 44*, 1175–1184.

Bandura A. (1989b). Social cognitive theory. In *Annals of child development, Vol 6: Six theories of child development* (pp. 1–60). Greenwich, CT: JAI Press.

Banks, J. (2015). Object, Me, Symbiote, Other: A social typology of player-avatar relationships. *First Monday, 20*(2).

Banks, J. & Bowman, N. D. (2016). Avatars are (sometimes) people too: Linguistic indicators of parasocial and social ties in player–avatar relationships. *New Media & Society, 18*(7), 1257–1276.

Banks, J., & Bowman, N. D. (2016). Emotion, anthropomorphism, realism, control: Validation of a merged metric for player–avatar interaction (PAX). *Computers in Human Behavior, 54*, 215–223.

Chen, Z. H., Chou, C. Y., Biswas, G., & Chan, T. W. (2012). Substitutive competition: Virtual pets as competitive buffers to alleviate possible negative influence on pupils. *British Journal of Educational Technology, 43*(2), 247–258.

Consalvo, M., & Begy, J. (2015). *Players and their pets.* Minneapolis, MN: University of Minnesota Press.

Crawford, J. (2007). Branding in virtual online gaming communities. Paper presented at the Social Media Marketing Symposium, Northwestern University.

Hamari, J., & Lehdonvirta, V. (2010). Game design as marketing: How game mechanics create demand for virtual goods. *International Journal of Business Science & Applied Management, 5*(1), 14–29.

Jiang, T., Miska, M., Kuwahara, M., Nakasone, A., & Prendinger, H. (2010, September). Microscopic simulation for virtual worlds with self-driving avatars. In *Intelligent Transportation Systems (ITSC), 2010 13th International IEEE Conference on* (pp. 1319–1323). Piscataway, NJ: IEEE.

Lang, A. (2014). Dynamic human-centered communication systems theory. *The Information Society*, *30*(1), 60–70.

Malazita, J. (2017). Honda Civic. In J. Banks, R. Mejia, & A. Adams (Eds.), *The 100 greatest video game characters* (pp. 75–78). Lanham: Rowman & Littlefield.

Moon, S. H., Lee, M., Kim, S., & Han, S. (2010, May). Controlling NPC behavior using constraint based story generation system. In *New Trends in Information Science and Service Science (NISS)*, 2010 4th International Conference on (pp. 104–107). Piscataway, NJ: IEEE.

Peng, W. (2008). The mediational role of identification in the relationship between experience mode and self-efficacy: Enactive role-playing versus passive observation. CyberPsychology & Behavior, *11*(6), 649–652.

Ratan, R. R., & Tsai, H. Y. S. (2014). Dude, where's my avacar? A mixed-method examination of communication in the driving context. *Pervasive and Mobile Computing*, *14*, 112–128.

Ratan, R., Verberne, F., Sah, Y. J., Miller, D., Semmens, R. & Renius, W. (2016, May). KITT, please stop distracting me: Examining the effects of communication in cars and social presence on safe driving. Paper presented at the 65th Annual Conference of the International Communication Association, Fukuoka, Japan.

Reeves, B., & Nass, C. (1996). *The Media Equation: How people treat computers, television, and new media like real people and places*. Cambridge: CSLI Publications.

Suh K.S., Kim H., Suh, E.K. (2011). What if your avatar looks like you? Dual-congruity perspectives for avatar use. *MIS Quarterly*, *35*(3), 711–729.

Ventrella, J. J. (2011). *Virtual body language: The history and future of avatars: How nonverbal expression is evolving on the internet*. Pittsburgh: ETC Press.

Yee, N., Ducheneaut, N., Nelson, L., & Likarish, P. (2011, May). Introverted elves & conscientious gnomes: The expression of personality in World of Warcraft. In *Proceedings of the SIGCHI Conference on Human Factors in Computing Systems* (pp. 753–762). New York: ACM.

Alignments & Alliances

Associations of Value

KRISTINE ASK & MARK CHEN

Avatars are not alone. While avatars invite players to experience the world through (usually) a single digital embodiment, this body is only meaningful because it is situated in specific historical, social, and material contexts. They are constructed through associations among players, games, and stories, and among people, technologies, and fantasies. Through these associations, the digital representation of self is rendered into a subject with values and positions, with histories and futures, with friends and enemies. In this chapter, we will further investigate the avatar's relationship to other actors, features, and symbols in and outside the game, and how they construct a preferred way of playing by unpacking the social components of alignments (the relative values held by the avatar as a character) and alliances (the formal associations held by the player and/or avatar).

Drawing on actor network theory (Latour, 2005), avatars may be understood as distributed through networks, or assemblages, as the avatars engage in different alliances to position themselves as encoded/enacted constructs. This approach highlights the relational; how phenomena come to be through associations between different actors (both human and non-human), and how such associations produce avatars with specific values and worldviews. Avatar's alignments are created through alliances in four ways: alignment through systems, alignment through factions, alignment through players, and alignment through technologies. For each alignment, different values are inscribed and enacted (Akrich 1992).

ALIGNMENT THROUGH ALLIANCES: SYSTEMS

As a way to map a set of values onto avatars (and their players), some games feature explicit ways to "align" them with standards and principles to direct player thought and behavior. By keeping track of the decisions players make as they select alternative approaches to in-game problems, the game will score the avatar behind-the-scenes and classify them within predetermined paths that correspond to an alignment. The predetermined paths are set by the game's developers, partly as a way to allow avatars to express different values and positions but also encourage players to define and roleplay their characters. In return, the game will react to an avatar's alignment in given situations. Alignment may thus be described as how avatars are philosophically positioned within the game's system, shaping what worldview the avatar has and how the world reacts to it.

Textbook examples of such alignment systems can be found in the BioWare roleplaying games, beginning with *Baldur's Gate* (1998) and continuing onto their other RPGs such as *Star Wars: Knights of the Old Republic* (KotOR; 2003) and *Mass Effect* (2007). In each of these games, alignment is made a feature of the avatar that is viewable when looking at its character sheet—an in-game screen that displays stats and details about the selected character that a player controls. This literal alignment both encourages action and limits the avatars possible interactions in the gameworld.

Baldur's Gate employs the alignment system of *Dungeons & Dragons* first introduced in its 1977 *Basic Set* (see Figure 11.1). During D&D character creation, a player specifies which alignment their character follows, along two axes—good versus evil and lawful versus chaotic—resulting in a character who is chaotic good or lawful evil or anywhere in between (Wizards of the Coast, 2008). Good characters generally act to help others and to value community-oriented goals. They act out of compassion or some other motivation to help those in need, sometimes at the cost of their own needs. Evil characters act out of selfishness or sometimes out of hatred, believing the world is there to be exploited, rewarding those who can manipulate others and take what they want. Lawful characters obey societal rules and norms. They believe in order and hierarchy. Chaotic characters have little use for laws and codes. By combining the two axes one can get, for example, chaotic good characters that bend the rules in seeking optimal fair outcomes, such as stealing from the rich and corrupt to help the poor, or lawful evil characters that obey laws or strict codes but do so out of greed.

The BioWare games do not force the avatar to act in accordance with alignment (keeping the scripted alignment open to opposition) so a player could choose to be lawful good and still attack innocent people in game. Nevertheless, the system primes the player to consider particular worldview dimensions during character creation, and, for some players, this brings an important layer to the avatar's story and thus the potential for roleplaying. Choice of alignment can also impact

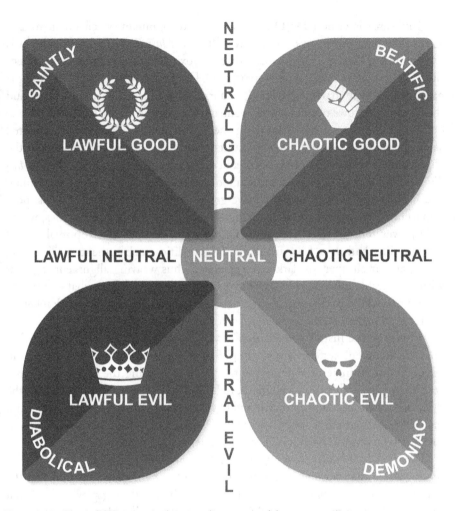

Figure 11.1. Classic RPG two-axis character alignment model.
(Source: adapted from Gygax, 1978)

how the game treats the avatar on a mechanical level. Certain items and abilities are limited by alignment, as is treatment from non-player characters (NPCs). For example, an NPC might consider whether it is safe to join a Lawful Evil character's party, or if it will be possible to achieve sinister goals if teamed up with a Lawful Good character. In later BioWare D&D-style games, such as *Neverwinter Nights* (2002), acting against one's specified alignment does have lasting game effects. Avatars could be stripped of their character class (e.g., paladins losing their paladin-hood) or prevented from using certain weapons if they switched alignments mid-game, based on avatar-player actions up to that point.

BioWare's later non-D&D-style games used alignment systems that work in similar, but simplified ways. In both KotOR and *Mass Effect*, avatar alignment is represented across one just one axis that approximates good versus evil (respectively, light vs. dark or paragon vs. renegade). Unlike in *Baldur's Gate* where alignment is chosen at character creation, avatars in these games start out neutral and the alignment grows out of choices made during play, primarily through dialogue options and dilemmas posed by the game. Consequently, alignment is rendered as a representation of past choices, rather than a pre-set ideal type, and as the alignment emerges it has several consequences for gameplay. In KotOR and *Mass Effect*, alignment affects how the avatar looks, where light side avatars look smiling and healthy and dark side avatars have greyish skin with a frown. Perhaps more importantly, in KotOR the avatar's alignment affects the cost of abilities, where light power abilities, like healing, are far cheaper (and thus more optimal to use) for light side characters. Likewise, dark power abilities, such as the iconic lightning shock, are far cheaper for dark side characters, thus weaving alignment together with measurable outcomes. In some cases, alignment also limits what equipment the avatar can use. In this way, aesthetics, story, and game mechanics work together to create an avatar assemblage where values and ideals are integrated.

However, the instrumentalization of values is not without its problems. Frequently alignment systems are so simplified that the labels "good" or "bad" can appear indiscriminate or arbitrary, to the point of pushing the player away from considering game dilemmas (Heron & Belford, 2014). Players need to feel like the decisions they make are significant and have effects on the world, which does not happen when alignment systems are reductionist or only give superficial dilemmas for the players to handle (Simkins & Steinkuehler, 2008).

Another problem is how alignments communicate two vital, yet conflicting messages: (1) that worldview is a key component of gameplay, implying that the player should care about making values-driven choices during play and (2) that values are a game mechanic, implying that the player should make decisions to elicit the most lucrative or beneficial outcomes. Where the first invites alignment choices from what Gee (2003) calls the "projected" self—an imagined, ideal self that roleplayers attempt to realize through the sum total of their in-game actions— the second invites players to simply "game the system" by maximizing rewards or scores. This is the case in KotOR (and many other games) where players, for the most part, are made aware of the consequences their value-based choices will have. Because of this, Sicart (2010) argues that the game discourages value-based reasoning, what he calls *ludic phronesis*, in favor of strategic calculation.

Interestingly, even if ludic phronesis does occur and the player takes a step back to consider the implications of a choice, the player might decode the inscriptions in ways other than the developers had intended. For example, in two separate playthroughs of KotOR—one as a Light Jedi and then as a Dark Jedi—one could

choose to save a Wookiee friend in both instances. As a Light Jedi, the choice might be based on loyalty and friendship, while, as a Dark Jedi, it may be for the Wookiee's future usefulness (Chen, 2009). Neither the design nor the outfall changed, but a shift in the avatar's dispositional alignment caused the actions to take on completely different meanings. This serves as a reminder that alignment systems are limited in what dimensions of play they can capture through direct input and thus what they can react to. For the alignment system to be worthwhile, the player has to engage with it and give it value, something which cannot be guaranteed by the design alone.

In these ways, alignments are both a representation of the avatar's possibilities—a way to map a system of values onto the avatar—as well as a way to encourage play with value-based choices. While some systems are reductionist to the point where they create distance between the player and the world, others bring nuance and complexity to the avatar's story and progression. As the player deliberates about which choices to make, the engagement with and through the avatar takes on qualities that potentially deepens the connection with the avatar and enrich the play experience. By positioning the avatar in a wider system of values, the avatar is also positioned in the world.

ALIGNMENT THROUGH ALLIANCES: FACTIONS

In the same way alignment systems are an attempt to position the avatar by giving it values and attitudes about the world, allying an avatar with a faction is a way to connect the avatar to a worldview. Factions can be made up of NPCs, players, or both. Similar to how alignment systems dictate how NPCs react and how plot progression is motivated, alliances are a way to orient the avatar in relation to the rest of the world: who are considered friends and enemies, what is praised, and what is shunned. And much like with alignment systems, some game-forced alliances have lasting impacts on gameplay, while others are relatively ambiguous.

This is strikingly clear when comparing the games *Pokémon GO* (2016) and *Deus Ex* (2000). In the roleplaying shooter game series *Deus Ex* there are vying factions that want to reshape the world's societies to their images of idealized life. Opting to align with of these factions is designed to alter the story in significant ways, leading to a different climactic ending that favors the chosen faction by giving it secret control of the world. In the series' second installment, *Deus Ex: Invisible War* (2003), the player must make many choices about whether and how to support the various factions such as the Knights Templar or the Illuminati (or to attempt a neutral path between all the factions). Allying oneself with a faction is intended to provide certain cues about what actions and social structures are considered "right" or "wrong" based on how the faction presents itself, and has consequences

for how further action is motivated and how past actions are understood. In this sense, the alliances represent a value system that the avatar can adhere to and be judged against. Importantly, the associations between the avatar and faction produce the potential for ludic phronesis, since many players make decisions based on a meta-gaming strategy (see Paul, this volume), sometimes opting for one faction over another purely out of curiosity over how the game system works.

The opposite is the case in *Pokémon GO*, where the team choice has little impact on the actual gameplay. In *Pokémon GO*, players are forced to join one of three teams upon reaching level five. The teams have names (Valor, Mystic, and Instinct), are led by in-game characters meant to embody each team's values and attitudes (domineering strength, thoughtful strategy, and uncritical chill), and include a team color (red, blue, and yellow; Belinkie, 2016). However, the choice of faction has little impact on gameplay, other than to help designate which teams one is (indirectly) competing against and the interface color palette, effectively functioning as a McGuffin for inter-team battles. Players on Team Valor will, for example, not have stronger pets, nor are Team Mystic players rewarded more for playing strategically. Ignoring the stated values of each team, a player could choose a team solely based on its color or even how its name sounds rather than what it means, for example, choosing Valor because it sounds differently than the others without any sibilant esses.[1]

This does not prevent players from making the factions' values part of how they construct their player and avatar identities. Many players have engaged with the broader *Pokémon GO* community online, creating a plethora of fan narratives where team solidarity and uniqueness is expressed. What the game lacked some players made up for on their own, with ample support of the preexisting vast Pokémon-verse (see McKnight, this volume). Many games have been defined as much by the communities made by players as by the game design itself. This indicates a third source of alliances that has effects on alignments: the alliances between players.

ALIGNMENT THROUGH ALLIANCES: PLAYERS

The role of alliances depends both on how alliances are scripted in the game and how player communities interpret such factions. Compare *Pokémon GO's* choice of team with the choice of faction in *World of Warcraft* (WoW; 2004). Unlike in *Pokémon GO* where players must choose a team but are largely free to ignore it for the duration of play, much of the content in WoW is scripted as group play. For players to explore and (hopefully) enjoy epic battles, they are reliant on forming player alliances such as guilds. Each guild has its own identity (though of varying strength and uniqueness), placing different values on things like friendliness, skill, competitiveness, and humor (Williams et al., 2006). For a player to truly become a

member of a guild, the player is expected to adhere to the guild's ideals. Depending on the guild's identity and purpose, this can put limitations and expectations on the player and the engagements of the avatar, including how to customize the avatar, what type of play to engage in, or how to treat fellow players.

A roleplaying guild might expect the avatar's story to continue the guild's lore (e.g., as an evil doomsday cult) as they are concerned with narrative aspects of play, while a competitive PvP guild might require the player to adopt a more elitist attitude and instrumental approach to play as elitism and success are frequently framed as mutually dependent (Ask, 2016). Since guild tags are visible under avatars' names, affiliations to guilds are known to other players, and a guild's reputation will in turn shape how other players perceive the avatar-player (see Johnson, this volume). Thus, when joining a player community, descripting (reading and describing) the design of the game (and community) turns into a collective endeavor, and players spend a considerable amount of time and effort in ensuring that a shared understanding of virtues of play are achieved. In this sense, the avatar is imbued not only with the values and ideals inscribed into the game but also by those constructed by the player community. This configuration takes place through several associations: between player and guild, between guild members, and between guild members and non-guild members. Furthermore, alliances are also made between the avatar and other technological systems as a considerable amount of community work takes place outside the constraints of the game they play.

ALIGNMENT THROUGH ALLIANCES: TECHNOLOGIES

Moving outside the gameworld to other online spaces can be motivated by curiosity, competitiveness, or by deficiencies of the game. Seeking out new tools, communities, and alternative stories for play is commonplace. Many players make out-of-game technologies (e.g., forums, videos, databases) or other valued non-human allies that allow players to modify their identities, communities, and practices. By associating the avatar to technologies, discourses, and practices outside the game, the avatar can take on new meanings that run against the game's script.

Many players attempt to ensure their alignments have meaning; they create a projected self with desired ideals and values. The ability of individuals and groups to choose what they value (i.e., their alignments) and who they ally with truly showcase the subversive potential of play. This seems especially important for minority group players who are poorly represented. Many such different subgroups thrive, sometimes in the shadows of official alliances, from Dads of Destiny and LGBQT-friendly guilds to furries and pacifist gamers. These player factions facilitate play with identities that are important to the players, but are not freely or easily provided in most mainstream games which continue to cater to the

perceived power fantasy of white, cisgender, heterosexual men (Kafai, Richard, & Barnes, 2016; see also Fox, this volume). Through alliances with other online platforms and technologies (e.g., forums, blogs, databases, videochannels) alternative avatar alignments can be constructed, and values that are nowhere to be found in the script can be interwoven into play.

The inclusion of other technologies into the avatar assemblage can also be more direct, such as in WoW. Many guilds have specific requirements for membership consideration where use of software modifications (mods) to improve information flow, and cooperation during play is mandatory. The addition of mods increases the capability of the avatar, as they help to keep the player informed about key events during battle or assist in keeping track of progression, making a material extension of the avatar. The mods help organize and discipline players in performing the type of play they have configured as desirable, be it lazy exploration or high-paced combat, filling such key roles that they can be considered "non-human players" in the vernacular of ANT where non-human actors (e.g., technologies) are included in the analysis (Taylor, 2009; Chen, 2012; Ask, 2016).

These alternative ways of playing the same game signal a diversity of play styles and desires. Attempting to play in one of these ways is to affiliate or ally oneself to a tradition of play informed by the game design, the player community, alternative technologies, and oppositional readings. The tradition of play consequently creates a framing of the avatar. All this is to emphasize that alliances can be game defined or socially defined, but they will always be an amalgamation of both game/genre-constrained choices *and* emergent self-imposed choices.

AVATARS <3 ALLIANCES

Altogether, the avatar's values and worldviews are shaped by their associations. Players are frequently given the task of choosing these associations, either in formalistic systems that represent values, by picking sides in a conflict, or by choosing who to play with. Some choices are scripted as carefully considered decisions for players to make, with meaningful consequences and that may alter the experience or suggest a playstyle. Others are largely superficial with faction or dialogue choices that invite deliberation, but they have little actual impact on how the gameworld reacts to the avatar, which consequently encourages strategic rather than moral reasoning. However, since players tend to find other and alternative values and worldviews to associate with their avatars through community participation, superficial alliances between avatars, alignment systems, and factions do not always equate to meaningless associations.

Emergent social alliances may be more powerful than game-defined ones in shaping the values and worldviews of the avatar and player. Recognizing this gives

power to the players, decentralizing designed experiences and artificial labels in that players have freedom to make choices about their avatar's alignments and alliances, and emphasizing the avatar as a sociomaterial process where avatar values are not inherent. Avatars are made through interactions with other technologies, games, NPCs, and players. Avatars are not alone.

NOTE

1. Nod to Amaranth Borsuk for pointing this out to the authors.

REFERENCES

Akrich, M. (1992). The de-scription of technical objects. In *Shaping technology / building society. Studies in sociotechnical change.* Cambridge, MA: MIT Press.

Ask, K. (2016). *Ludic work: The assemblages, domestications and co-productions of play.* (Unpublished doctoral thesis). Trondheim, Norway: Norwegian University of Science and Technology. Retrieved from: <https://brage.bibsys.no/xmlui/handle/11250/2418295>

Belinkie, M. (2016, Sept. 27). Pokémon GO explains the 2016 election: Who will take over the White House gym? [blog post] *Overthinking It.* Retrieved from: <https://www.overthinkingit.com/2016/09/27/pokemon-go-explains-2016-election/>

Chen, M. (2009). Communication, coordination, and camaraderie in *World of Warcraft. Games and Culture, 4*(1), 47–73.

Gee, J. P. (2003). Learning and identity: What does it mean to be a half-elf? In *What video games have to teach us about learning and literacy* (pp. 51–71). New York: Palgrave Macmillan.

Heron, M., & Belford, P. (2014). "It's only a game"—Ethics, empathy and identification in game morality systems. *The Computer Games Journal, 3*(1), 34–52.

Kafai, Y. B., Richard, G. T., & Tynes, B. M. (2016). *Diversifying Barbie and Mortal Kombat.* Pittsburgh: ETC Press.

Latour, B. (2005). *Reassembling the social: An introduction to actor-network theory.* Oxford: Oxford University Press.

Sicart, M. (2010). Wicked games: On the design of ethical gameplay. In *Proceedings of the 1st DESIRE Network Conference on Creativity and Innovation in Design* (pp. 101–111). Lancaster: Desire Network.

Simkins, D. W., & Steinkuehler, C. (2008). Critical ethical reasoning and role-play. *Games and Culture, 3*(3–4), 333–355.

Taylor, T. L. (2009). The assemblage of play. *Games and Culture, 4*(4), 331–339.

Williams, D., Ducheneaut, N., Xiong, L., Zhang, Y., Yee, N., & Nickell, E. (2006). From tree house to barracks: The social life of guilds in *World of Warcraft. Games and Culture, 1*(4), 338–361.

Wizards of the Coast. (2008). *Dungeons & Dragons: Player's handbook,* 4th Ed. Renton, WA: Wizards of the Coast.

Morality & Personality

Perfect and Deviant Selves

MATTHEW GRIZZARD & CHANGHYUN AHN

Our personalities and our moral codes, perhaps more so than any other factors, represent who we are as individuals. They reflect both nature and nurture. They shape our behavior and communicate our identities. They tell others and they remind us who we are and what we are like. In everyday life, our actions and behaviors carry tremendous weight in terms of communicating our personality and morality, especially regarding first impressions. But in videogames, we are afforded potentialities that are typically inaccessible. Games allow us to engage virtually in deviant behaviors that would usually carry with them severe social or legal consequences. Alternatively, they provide us with the opportunity to craft and perfect idealized artificial manifestations of our self. It is this process of adopting an alternative personality and moral code through videogame avatars that is the focus of this chapter. Unlike other forms of media, the avatars of videogames allow media consumers to assume the role of a character within a narrative, engaging in behaviors and adopting a persona that either converges with or diverges from our own persona.

PERSONALITY AND MORALITY DEFINED

Current conceptualizations from psychology and communication describe both personality and morality in pluralistic terms. In other words, morality and personality are not monolithic, but rather are combinations of factors. A great deal of research in psychology has worked toward describing what these factors are, how they might be identified and measured, and how they correlate or predict other relevant variables.

Personality

Although various specific definitions of personality exist, most of these definitions assume that an individual's personality is made up of various traits that exhibit "temporal stability" (Boyle, Matthews, & Saklofske, 2008). That is, rather than changing drastically from moment-to-moment, day-to-day, or even year-to-year, a personality trait is a characteristic of a person—shaped by genetics and experience—that is relatively consistent across time. Perhaps the most commonly used current conceptualization of these traits can be found in the five factor model, which assumes that a person's personality is made up of the "Big Five" personality traits: conscientiousness, agreeableness, neuroticism, openness to experiences, and extraversion (Goldberg, 1993; see Table 12.1). Individuals can vary along each of these five factors independently from the others being "high," "low," or "somewhere in between" on each. For example, it is possible to be high in neuroticism and either high in extraversion or low in extraversion. Note, that this is not to say that the five factors are entirely uncorrelated with each other. In fact, individuals high in neuroticism tend to score lower in extraversion. The association between the factors, however, is far from a perfect one-to-one relationship (McCrae & Costa, 2008), which allows for varied combinations of the Big Five.

Table 12.1. Big Five personality traits with high and low descriptors.

	High	Low
Conscientiousness	Reliable, organized, thorough	Careless, negligent, unreliable
Agreeableness	Kind, trusting, warm	Hostile, selfish, distrusting
Neuroticism	Nervous, moody, temperamental	Calm, steady
Openness to experience	Imaginative, curious	Conservative, shallow
Extraversion	Talkative, assertive, active	Quiet, reserved, passive

Source: adapted from Goldberg (1993)

Morality

In common parlance, morality is concerned with differentiating behaviors in terms of good or bad, and right or wrong: some behaviors, such as charity, are good and moral, whereas others, such as lying, cheating, and stealing, are bad and immoral. However, definitions based on differentiating which *specific* actions are moral and which *specific* actions are immoral assume some external standard of morality upon which everyone can agree. Notably, this is not the case, and the moral standards that are used for determining that which is good from that which is bad vary

considerably among individuals. For example, for some individuals, capital punishment is the height of cruelty; for the others, it is just retribution. For these reasons, the scientific study of morality is based not on discovering what the ideal standard of morality is, but rather identifying how individuals make moral judgments and what standards are employed in their determination (see Graham et al., 2013, for an overview; see also, Tamborini, Eden, Bowman, Grizzard, & Lachlan, 2012, for relevance to media). Thus, like personality, current conceptualizations of morality assume that the standards that underlie moral judgment are multi-faceted and vary between individuals.

This "moral pluralism" conceptualization has been driven in large part over the last ten years by moral psychologists whose research has focused attention on the intuitive and emotional roots of moral judgment (Graham et al., 2013). Rather than morally judge behaviors or actions by the weighing of evidence or cost-benefit analysis, moral psychology suggests that we primarily make moral judgments quickly based on emotional responses—"this feels right" or "this feels wrong" (Haidt, 2012). Moral foundations theory (Haidt & Joseph, 2008) is one of the theories derived from these new intuitive-focused perspectives. It proposes that evolution has sensitized humans to actions along five "foundations" of morality. These are care, fairness, loyalty, authority, and purity. Witnessing upholding or violation of these foundations (see Table 12.2) elicits moral judgments. Although evidence suggests that these five moral foundations are universal and found in every culture (Graham et al., 2011), sensitivity to each varies within and between individuals. Some individuals are highly sensitive to authority and find actions such as failing to stand for the national anthem highly immoral; others are not as sensitive and find such an action neither moral nor immoral. Like personality, these sensitivities are likely to be both inherited and molded by experience.

Table 12.2. Five moral foundations with examples.

	Upholding	Violation
Care	Alleviating physical or emotional suffering	Causing physical or emotional suffering
Fairness	Fostering equality and equity	Fostering inequality and inequity
Loyalty	Being loyal to one's group or important others (e.g., friends, family)	Betraying one's group or important others
Authority	Showing respect for traditions and legitimate authority	Showing disrespect for traditions and legitimate authority
Purity	Avoiding disgusting or carnal behaviors	Engaging in disgusting or carnal behaviors

Source: adapted from Haidt (2012) and Graham et al. (2011)

MEDIA RESEARCH ON PERSONALITY AND MORALITY

Both personality and morality have been studied extensively in relation to media exposure. "Individual difference" research has focused attention on trait variables—some of which are akin to variance in personality—that might explain which types of people are likely to seek out various types of media content as well as when media exposure is likely to elicit effects (Oliver & Krakowiak, 2009). Although concerns about the effects of narratives and media on audiences' "morality" have existed since ancient Greece (Bryant, 2013), it is only recently that comprehensive psychological theories of moral judgment have been integrated with media effects theories (see Tamborini, 2013). Media psychologists and communication researchers have slowly been accumulating evidence of how media exposure might influence viewers, but few findings have risen to the level of axioms—that is, findings established to be true, which can be used as foundations for further research. At the same time, there are broad areas of (dis)agreement; researchers seem to agree that certain processes and variables—such as identification with a character and enjoyment of a media experience—warrant close, scholarly inspection even if there is little agreement about why or how these variables play out in relation to media exposure. Thus, this chapter will reference and incorporate the key hypotheses and models from these areas as they relate to the interplay between a player's morality and personality with the character's morality and personality.

CHARACTER TYPES IN VIDEOGAMES

The characters that inhabit videogames are varied to say the least. Some have rich biographies and elaborate backstories that the player grapples with as they complete a game (see McKnight, this volume), as in the case of Joel from *The Last of Us* (2013), whose daughter was killed when an epidemic broke out and must deal with his trauma as he becomes the guardian of Ellie, a young girl about his daughter's age. Others are simple two-dimensional shapes that the player navigates through puzzles, as in the case of *Pac-Man* (1980). Narratives encourage an interplay between the personality and morality of the character with those of the player. For example, in *The Last of Us*, Joel's traumatic past drives him to prioritize the fate of his charge Ellie over that of the entire human race; while this may not be the choice that many gamers would have liked to have made, the game's narrative forces the player to consider the perspective of Joel. Without a narrative, the interplay between a player's personality and morality with their avatar's personality and morality becomes nearly irrelevant. Let's return to *Pac-Man* as an example. Unless you are the highly creative Zach Weinersmith of the digital comic strip *Saturday Morning Breakfast Cereal*,[1] it probably never crossed your mind to

consider Pac-Man's motives. What is his personality? Is he a hero? Without some conscious consideration of a character's motives and personality, there can be no impact of an avatar's personality and morality on the player. This is not to say that the narrative and the avatar's personality must be communicated to the player through gameplay. In fact, early games did very little in the way of including narrative during gameplay. For example, the original *The Legend of Zelda* (1986) for the Nintendo Entertainment System had little dialogue or narrative within the game, sparing the occasional advice from the old man in the caves ("It is dangerous to go alone! Take this."). *The Legend of Zelda*, however, did have a larger story associated with it, which was described in the instruction manual of the game. So while narrative is necessary for the interplay between player and avatar regarding personality and morality, the narrative can come from within the game (i.e., *endo-game narrative*) or from without (i.e., *exo-game narrative*).

While an avatar's personality and morality are imparted by a narrative, videogame narratives vary substantially in their telling (Jenkins, 2004). As such, the nature of a videogame narrative must be considered in relation to the personality and morality of an avatar. Some game narratives are entirely open-ended, which Jenkins deems *emergent narratives*. Consider, for example, *The Sims* (2000)—a life simulation game. The character controlled by the player begins as a *tabula rasa*, and it develops a personality and morality through the player's interaction with the game. Without the player imbuing a narrative onto the game, none would exist. Compare these emergent narratives and their *tabula rasa* characters with what Jenkins (2004) deemed *enacting stories*. When a player delves into the *Batman: Arkham Asylum* (2009) series, the player is controlling and assuming the role of Batman, who prior to play already possesses specific personality traits and a specific moral code through a universe of comics, television shows, and films. The player cannot alter Batman's past or complete in-game tasks that will alter his personality or moral code. Rather, the player assumes the identity of Batman during gameplay and completes a pre-determined narrative using a prewritten character.

Finally, there are narratives that are a combination of emergent narrative and enacting stories, with their characters being a combination of prewritten and tabula rasa. Take for instance the *Mass Effect* (2007) series of games. The game is a futuristic science fiction space opera about the discovery of ancient advanced technology. At the beginning of the game, players can modify and create the main character that they will control throughout the game. They can choose not only the sex and appearance of the character, but also the biographical origins of the character and psychological profile of the character. For example, the main playable character, Captain Shepard, can have a background where s/he grew up on Earth, as a colonist on another planet, or as an intergalactic nomad. Similarly, the psychological profile includes three options: Shepard can be the sole survivor of a previously doomed mission, a war hero, or a ruthless "get the job done at any cost" zealot. The choices made

by the player at this early stage impact how other non-player characters respond to the player throughout the game and the missions and tasks that the player must face. At the same time, the player's own choices during gameplay in terms of how they respond to missions and challenges also impact how the game unfolds. These dynamic processes are implemented through a reputation system whereby the player accumulates "paragon" points—which are most closely associated with adhering to traditionally heroic decisions—and "renegade" points—which are most closely associated with adhering to an anti-hero role (see Ask & Chen, this volume).

Thus, there are at least three primary types of avatars that the player might control. The blank slate character whose personality and morality depend entirely upon the player's choices; the pre-made character whose personality and morality are entirely independent from the player's choices; and the blended character whose personality and morality are framed by the game's narrative but molded and altered by the player's choices during gameplay. Notably, these different character types might relate to players' motivations for gameplay.

THE INTERACTION OF CHARACTER AND PLAYER'S PERSONALITY AND MORALITY

Videogames are unique from more traditional narratives. In traditional narratives, the media user serves as a witness to the narrative events (Zillmann, 2006). Video game players, on the other hand, are active participants whose inputs into the game determine the actions that unfold (Grodal, 2000). Thus, gameplay represents a unique interaction, which some have deemed monadic identification (Klimmt, Hefner, & Vorderer, 2009). This monadic perspective posits that the two separate entities of the player and their avatar become interconnected and experienced monadically (i.e., the player and the avatar as one) rather than dyadically (i.e., the player and the avatar as separate entities). This type of monadic identification relates to several explanations regarding what types of characters players will select and how player-avatar interaction might impact players.

One theoretical explanation for why players select the characters they do relates to *wishful identification* (Konijn, Bijvank, & Bushman, 2007). Wishful identification describes a process whereby players seek out characters who possess qualities that they otherwise lack. For example, if a person is quiet and reserved, then they might seek out a videogame character who is loud and assertive as a means to roleplay. Wishful identification can be contrasted with other forms of identification, such as *similarity identification*, which occurs when players select or create videogame characters that are highly similar to themselves (Konijn et al., 2007). Videogames are likely to be especially useful forms of media for both forms of identification due to the monadic identification provided. The responses from other digital characters are dynamic and relate directly to players' in-game actions,

allowing for players to experience in real-time various potentialities associated with their choices. Players can see in a simulated environment how others might respond to them without suffering real-world consequences. This insulation from real-world sanctions also allows players to commit highly immoral actions. Still, research suggests that regarding morality, players trend toward moral rather than immoral (Boyan, Grizzard, & Bowman, 2015).

The effects of roleplaying characters with alternative personalities are bifurcated. The avatar that the player controls can lead either to assimilation of the avatar's traits or to differentiation. Research on the Proteus effect (Yee & Bailenson, 2007) suggests that players often adopt the attributes of the characters they control, at least temporarily. In fact, studies have found that an avatar's height or appearance can affect individuals' aggression (Peña, Hancock, & Merola, 2009). When players control an avatar, their own personality and morality become less relevant to completing the game's objectives while the personality and morality of the character they control become more relevant. This process leads to deindividuation—the assimilation of attributes (here, attributes of the avatar) while muting their own personality. Deindividuation is likely to be especially relevant when playing pre-determined narratives; these narratives require the character, controlled by the player, to achieve specific goals, which should increase the relevance of the character's personality for achieving such ends.

Still other processes can influence the effects of gameplay in a manner that leads to player differentiation from avatars. For example, when players violate important moral precepts in digital worlds, guilt can arise (Weaver & Lewis, 2012). Guilt is a moral emotion that can motivate "moral reasoning," or the consideration and thinking about the morality of the actions they committed (Grizzard, Tamborini, Lewis, Wang, & Prabhu, 2014). Rather than lead players to assimilate the personality and morality of the character they controlled, guilt can lead players to distance themselves from that personality (Weaver & Lewis, 2012), increasing moral sensitivity (Grizzard et al., 2014). Thus, playing the role of the bad guy in a game can, under certain circumstances, lead players to differentiate rather than assimilate the negative attributes of avatars they control. Moreover, the phenomenon of moral self-licensing (Merritt, Effron, & Monin, 2010) suggests that controlling a highly moral avatar might lead to decreases in moral sensitivity. Committing good deeds in the real world seems to allow individuals a temporary license to behave immorally. Thus, it is possible that committing virtual good deeds could lead to similar effects.

MORALITY AND DEGREES OF ME AND NOT-ME

The current research on personality and morality as it relates to videogame avatars suggests several exciting new directions. First and foremost, work on player-avatar relationships suggests that players can view and interact with their avatar in

multiple ways (Banks, 2015). Players can view their avatar purely as an object (*avatar-as-object*) they use to exert their will within the gameworld. In this sense, the character controlled by the player is hardly a character at all and more so simply a tool. Alternatively, players can view their avatar as an extension of themselves. From this *avatar-as-me* viewpoint, the character's personality and morality are not relevant to the player; rather the avatar is the player's embodiment within the gameworld. Players can also view their avatar as possessing a personality/morality that is entirely independent from their own. This *avatar-as-other* perspective leads players to view their characters as digital entities with lives and personalities that are situated within the game and divorced from the player's influence. Finally, players might view their characters as a *symbiote* between their own personality/ morality and that of the character, such that it is sufficiently "me" to feel connected to the action but sufficiently "not-me" to enable moral distancing.

Notably, the avatar-as-symbiote and avatar-as-other perspectives are the ones that are likely to elicit the strongest effects in terms of assimilation or differentiation as discussed earlier. If the player views the character only as an object or as themselves, there's little room for any potential discrepancy between the player's personality/morality and the character's to alter the player's perceptions of themselves. However, when the player merges their identity with the identity of the character or when the character's identity becomes relevant for gameplay, impacts of the character's personality on the player become possible.

It is important to note that previous research on the relationship between videogame avatars' and players' personalities and moralities has assumed transitions between the various avatar relationships as discrete states. Shifts are possible between the states; extended play with an avatar or adding a narrative frame might anthropomorphize the character, leading the player to consider the avatar's personality and morality in greater depth (Banks, 2015). For example, Bartel (2015) argues that players of *Grand Theft Auto V* (2013) might start with viewing their characters as a symbiote. However, as players advance through the game they might start to detach their own personality as the characters' personalities become more evident through narrative cutscenes. This could then lead to a relationship between player and avatar that resembles the avatar-as-other categorization, which allows the player to commit highly immoral actions that are justified roleplaying as the character.

At the same time, drastic shifts between states have yet to be formally integrated into avatar-related theories. When gameplay challenges the player's identity by asking (or forcing) them to commit extremely heinous behaviors—or even when gameplay "jumps the shark" by having a character perform an action that falls outside of her expected behavioral repertoire, drastic shifts might be predicted. These drastic shifts might cause a schism in the player-avatar interaction, leading players to distance themselves from the character they control or to

categorize what seemed to be a social being into a simple tool for their use. These questions of the dynamics underlying player-character interaction provide fruitful areas for research and theory. Moreover, they suggest exciting new avenues for game designers and players. Thus far, most morality and personality systems in videogames privilege consistency of play (e.g., developing high levels of Paragon or Renegade reputation in *Mass Effect* requires consistent adherence to making Paragon/Renegade decisions). By allowing, encouraging, or simply not punishing the player for inconsistent play, videogames might open new psychological doors and encourage existential ruminations.

NOTE

1. In one of his comics, Weinersmith (2012) described the narrative of Pac-Man as "like Kafka wrote a Lovecraft story:" Pac-Man is a person who woke to find himself a disembodied mouth who is chased by ghosts envious of the mouth's ability to consume.

REFERENCES

Banks, J. (2015). Object, Me, Symbiote, Other: A social typology of player-avatar relationships. *First Monday, 20*(2).

Bartel, C. (2015). Free will and moral responsibility in video games. *Ethics and Information Technology, 17*(4), 285–293.

Boyle, G. J., Matthews, G., & Saklofske, D. H. (2008). Personality theories and models: An overview. In G. J. Boyle, J. Matthews, & D. H. Saklofske (Eds.), *The SAGE handbook of personality theory and assessment: Volume 1 personality theories and models* (pp. 1–30). Los Angeles, CA: SAGE Publishers.

Boyan, A., Grizzard, M., & Bowman, N. (2015). A massively moral game? Mass Effect as a case study to understand the influence of players' moral intuitions on adherence to hero or antihero play styles. *Journal of Gaming & Virtual Worlds, 7*(1), 41–57.

Bryant, J. (2013). Foreword. In R. Tamborini (Ed.), *Media and the moral mind* (pp. x–xiii). New York: Routledge.

Goldberg, L. R. (1993). The structure of phenotypic personality traits. *American Psychologist, 48*(1), 26–34.

Graham, J., Haidt, J., Koleva, S., Motyl, M., Iyer, R., Wojcik, S. P., & Ditto, P. H. (2013). Moral foundations theory: The pragmatic validity of moral pluralism. *Advances in Experimental Social Psychology, 47*, 55–130.

Graham, J., Nosek, B. A., Haidt, J., Iyer, R., Koleva, S., & Ditto, P. H. (2011). Mapping the moral domain. *Journal of Personality and Social Psychology, 101*(2), 366–385.

Grizzard, M., Tamborini, R., Lewis, R. J., Wang, L., & Prabhu, S. (2014). Being bad in a video game can make us morally sensitive. *Cyberpsychology, Behavior, and Social Networking, 17*(8), 499–504.

Grodal, T. (2000). Video games and the pleasures of control. In D. Zillmann, & P. Vorderer, *Media entertainment: The psychology of its appeal* (pp. 197–214). Mahwah, NJ: Lawrence Erlbaum Associates.

Haidt, J. (2012). *The righteous mind: Why good people are divided by politics and religion.* New York: Pantheon Books.

Haidt, J., & Joseph, C. (2008). The moral mind: How 5 sets of innate intuitions guide the development of many culture-specific virtues, and perhaps even modules. In P. Carruthers, S. Laurence, & S. Stich (Eds.), *The innate mind* (Vol. 3, pp. 367–391). New York: Oxford University Press.

Jenkins, H. (2004). Game design as narrative architecture. Retrieved from: <http://www.electronic-bookreview.com/thread/firstperson/lazzi-fair>

Klimmt, C., Hefner, D., & Vorderer, P. (2009). The video game experience as "true" identification: A theory of enjoyable alterations of players' self-perception. *Communication Theory, 19*(4), 351–373.

Konijn, E. A., Nije Bijvank, M., & Bushman, B. J. (2007). I wish I were a warrior: the role of wishful identification in the effects of violent video games on aggression in adolescent boys. *Developmental Psychology, 43*(4), 1038–1044.

McCrae, R. R., & Costa, Jr., P. T. (2008). Empirical and theoretical status of the five-factor model of personality traits. In G. J. Boyle, J. Matthews, & D. H. Saklofske (Eds.), *The SAGE handbook of personality theory and assessment: Volume 1 personality theories and models* (pp. 273–294). Los Angeles, CA: SAGE Publishers.

Merritt, A. C., Effron, D. A., & Monin, B. (2010). Moral self licensing: When being good frees us to be bad. *Social and Personality Psychology Compass, 4*(5), 344–357.

Oliver, M. B., & Krakowiak, K. M. (2009). Individual differences in media effects. In J. Bryant & M. B. Oliver (Eds.), *Media effects: Advances in theory and research (3rd edition)* (pp. 517–531). New York: Routledge.

Peña, J., Hancock, J. T., & Merola, N. A. (2009). The priming effects of avatars in virtual settings. *Communication Research, 36*(6), 838–856.

Tamborini, R. (2013). A model of intuitive morality and exemplars. In R. Tamborini (Ed.), *Media and the moral mind* (pp. 43–74). New York: Routledge

Tamborini, R., Eden, A., Bowman, N. D., Grizzard, M., & Lachlan, K. A. (2012). The influence of morality subcultures on the acceptance and appeal of violence. *Journal of Communication, 62*(1), 136–157.

Weaver, A. J., & Lewis, N. (2012). Mirrored morality: An exploration of moral choice in video games. *Cyberpsychology, Behavior, and Social Networking, 15*(11), 610–614.

Weinersmith, Z. (2012, September 16). Saturday morning breakfast cereal [Web comic]. Retrieved from: <http://www.smbc-comics.com/?id=2736>

Yee, N., & Bailenson, J. (2007). The Proteus effect: The effect of transformed self representation on behavior. *Human Communication Research, 33*(3), 271–290.

Zillmann, D. (2006). *Dramaturgy for emotions from fictional narration.* Mahwah, NJ: Lawrence Erlbaum Associates Publishers.

Relationships & Reputation

Part of the Main(frame)

NICHOLAS DAVID BOWMAN

"Who casts not up his eye to the sun when it rises? but who takes off his eye from a comet when that breaks out? Who bends not his ear to any bell which upon any occasion rings? but who can remove it from that bell which is passing a piece of himself out of this world? **No man is an [island], entire of itself;** every man is a piece of the continent, a part of the main."
—DONNE (1624/2007, P. 108, EMPHASIS ADDED)

The emphasized above line is taken from a sermon from English poet and cleric John Donne, intended to remind parishioners that a deeper understanding of the self cannot be attained in isolation. Rather, the self can best (and perhaps only) understood upon reflection of the relationships that one has with others and, by proxy, the reputations that emerge from those relationships. In a sense, Donne's philosophy can be applied to how we might understand avatars in videogames. Applied in a literal sense, one could argue that a comprehensive understanding of what an avatar "is" cannot be complete without understanding that avatar's relationships and reputations with myriad elements in the gaming environment. For the most part, avatars are the central contact that a player has with the gameworld and, as such, avatars mediate the player's understanding of the digital environment. In a sense, avatars might be understood as the core node in the network of elements that can potentially matter (re: influence each other; Latour, 1992)—be they ludic or narrative elements—that connects the player to every other potentially meaningful aspect of the game experience (cf. Banks, 2014). In this way, the relationships that avatars have within their games, as well as the reputations that emerge through these relationships, is integral to reflexively understanding the avatar.

RELATIONSHIPS

At a most basic level, a relationship can be understood as the state of or manner in which two things are connected to one another. In videogames, a useful way to understand relationships—in particular, those with and among videogame avatars—is to specifically consider (a) the functional and ludic elements that make up the essence of the game (those elements that must be understood to make *cognitive* meaning out of on-screen actions) and (b) the social and narrative elements that provide supplemental context to the gameplay (those elements that must be understood to make *socio-emotional* meaning out of on-screen actions). These two dimensions, while not necessarily distinct from one another (one could activate a switch to advance a puzzle, which can also be situated inside a larger narrative), they are useful insofar as videogames commonly blend elements of problem-solving with elements of story-telling. Consider the very term videogame: one could focus on "video" in terms of film studies and interactive narratives (gamers being allowed to "choose the adventure" of their avatar), one could focus on "games" in terms of the ludic dimensions of play and logic, and one could focus on "videogames" relative to how these elements work with each other to create emotionally immersive and cognitively challenging experiences.

Functional and ludic relationships

An often-invoked and simple definition of a videogame is that it is a series of "interesting decisions" (Meier, 2012). Meier's claim is apropos for describing his own *Civilization* games (1991) in which players are charged with massive resource management to construct, expand, and defend world civilizations. For such simulation games, and for videogames in general, these interesting decisions become the essence of the cognitive demands of videogame play (usually associated with discrete in-game challenges; Bowman, 2016). Yet, the concept can be scaled down to even the most basic relationships between a single avatar and any other on-screen object. For example, one of the earliest "computer demonstrations" (early parlance for videogames, see Graetz, 1981) was a simple game with two spaceship avatars—the Needle and the Wedge—batting each other while navigating around a gravitational well. In this simple example, the Needle's relationship both with the Wedge and the well have an ever-present and variable influence on how a player understands their Needle—shifting focus from that of an aggressor to that of a defender, to a strategist, and so forth. A similarly basic example can be found by considering the contours and configurations of a given tetromino (the variable four-cubed gamepiece from *Tetris* [1984]), which holds unique and variable meaning depending on how the player has crafted the avatarial environment from other gamepieces. A vertical 1×4 tetromino might be a very poor fit for

an environment, but when rotated to the horizontal 4×1 configuration the avatar might find a more desired (at least, by the player) functional role on the play field.

In addition to these relationships of physical form, avatars may have ludic relationships with other characters based on complementary or conflicting skills and attributes. The notion of character balance (Burgun, 2011; see also Milik, this volume) is an important factor in how players engage and understand avatars. Although the concept of balance is a bit vague, the general concept is that game elements are matched such that the absolute cost-to-benefit ratios among elements are relative to other ratios, even if an element in isolation might seem out of balance. In the classic *Street Fighter II* (1991), the "balanced" characters are usually understood to be the ludic twins Ken and Ryu—most of their actions are neither very strong nor very weak (making them quite easy to understand for beginner players). Avatars such as Zangief and Balrog incredibly strong but very slow and easy to damage, and avatars such as Dhalsim are comparatively weak but very difficult to damage. In these examples, the cost-to-benefit ratios are relative, in that any one ratio cannot be understood until it is placed among others. The cost-to-benefit ratio of Zangief (strong, but slow) is different when playing Dhalsim (nimble, but fragile) than when playing Ken or Ryu (balanced). A similar example can be found in the so-called "triad of classes," popular in many MMOs, that require teams to coordinate three critical roles: DPS (offensive damage-per-second), tanks (hybrid attack and protection), and healers (defensive restoration). Each role compensates for the weaknesses of others (benefits for costs), so that a combined team is stronger than the avatars separately.

One of the more enduring examples of character balance as a central ludic game feature can be found in the classic *Mega Man* series (1987) for the Nintendo Entertainment Center. The first title offered players a freedom of choice not common to videogames of this era—players could choose to play any one of the game's six levels from the onset (rather than having to progress through each level in a linear fashion). The end goal of *Mega Man* was to defeat the six end-level bosses, acquiring their special powers (such as a fire weapon from Fireman or a spinning blade from Cutman). Defeating these six bosses unlocked the final level of the game, which was made easier using the many powers that players would have acquired along the way. Of course, in this freedom was a hidden and emergent form of gameplay: determining the correct order in which to defeat the game's six levels. While there is no official order, more astute players are able to determine logical orderings and exploit them accordingly. For example, an ice weapon such as the Ice Slasher acquired after beating Iceman might work well against an enemy who relies on fire and heat such as Fireman, so that playing the Iceman first was beneficial. Indeed, a quick Google search for "order of Mega Man bosses" reveals any number of debates about which boss to approach first, and accordingly how to balance out the strengths and weaknesses of each weapon/boss relationship

by selecting the most efficient linear progression to defeat them all. These emergent balance elements (relationships not officially stated in-game, but uncovered through play and an understanding of the character's unique properties: electric weapons defeating ice characters, ice weapons beating fire characters, etc.) are a critical aspect to developing a more intimate and enjoyable understanding of how one's avatar "fits" into the gameplay.

Social and Narrative Relationships

While all games can be understood at least in terms of the ludic relationships that establish the parameters for play—indeed, understanding these relationships is required to play, by definition (cf. Juul, 2011)—many games layer elements of social and narrative demand onto these cognitive challenges through the inclusion of interactions as well as rich storytelling (Bowman, 2016). This is done to make videogames more than just pixels on a screen, but rather to involve the players into the onscreen "world." Although the blending of emotionally tinged content with on-screen puzzle-solving is not necessarily a new thing, the evolution of videogames from more basic puzzles to more intricate stories and tales has been discussed by several game designers. Among them is noted developer Jesse Schell (a former Disney Imagineer, now head of Schell Games and a professor of game design at Carnegie Mellon University, USA), who asked a packed house of gamers at the 2013 Game Developers Conference in San Francisco "Are we going to have a Shakespeare of games? A game that was told so perfectly, and so well, that 200 years later people will insist we play it exactly as it was?" In his talk, Schell outlined what he calls the elemental tetrad of videogames' core components: mechanics, technology, aesthetics, and story. While discussions of mechanics, technology, and aesthetics are covered in other sections of this book (e.g., Boyan; Kao & Harrell; O'Donnell, this volume), Schell's focus on story is notable here in that he draws on several examples specifically based on social relationships between players and other in-game characters, both directly (e.g., having a natural language conversation with Pikachu in *Hey You, Pikachu* [1998]) or indirectly through their avatars (e.g., budding romance between player-controlled Cloud Strife and Aeris Gainsborough in *Final Fantasy VII* [1997]).

Arguably, the most obvious version of this social/narrative relationship dynamic would be the avatar's role (be it prescribed or emergent) in the larger game narrative. In most videogames, the avatar (in some cases, the player themselves) is the central actor in the game's unraveling narrative. Such narrative centrality is core to the experience of some gaming genres (e.g., roleplaying games) but can also be experienced and observed through games in which narratives are less central. As players engage the on-screen world, they actively engage in a co-authorship of the narrative present in that world (essentially, the player becomes an author

along with the game's writers and designers, cf. Bowman & Banks, 2016), and the player's actions and decisions alter that narrative. Take the classic *Super Mario World* (1990), for example, in which players engage in the classic "save the princess from Bowser" story. For most games in the *Mario* series, a simple linear progression through each world, passing Goombas and Koopas and avoiding pitfalls and moving platforms, will eventually result in Princess Toadstool's rescue. In fact, such games are often called "platformers" because they place an extreme focus on gameplay rather than narrative, with trace narrative elements serving more as a MacGuffin to provide the player an excuse to run and jump. Players' options so far as narrative are concerned are relatively binary (either finish the game and rescue the princess, or fail to finish and do not rescue her), with a bit of room for innovation (such as uncovering the infamous warp stages to get to the Princess more quickly, thus skipping some gameworlds).

What made *Super Mario World* a bit different was the player's ability to pilot their avatar through an emergent narrative in the game, in which the game shifted attention from the task at hand (rescuing a vulnerable princess) to directly challenging the player to uncover its secrets—, cleverly marked in red on the game's map. In uncovering the keys to the otherwise-hidden Special Zone, the game's prescribed narrative—and the centrality of Mario as the important avatar—is completely forgotten and instead, a dialogue between the player and the game begins. Each level's name gives the player a bit of 1980s slang encouragement ("Gnarly," "Tubular," and "Way Cool"); skilled players completing the last level ("Funky") are given a final inspiration message, spelled out in coins: "YOU ARE A SUPER PLAYER!!" The more obvious ludic elements of these hidden stages might obfuscate a more compelling discussion of player-controlled narrative: by choosing to engage the special levels, the player essentially shifts the game's central actors from the canonical avatar (Mario) and his narrative (battling Bower to liberate the princess) to head-canonical avatar (essentially, the Player) and its narrative (battling the Programmers to master the experience; see McKnight, this volume).

In addition to these narrated relationships, we could argue that most social networks in any videogame *de facto* center around the player, vis-à-vis their control of a "main" avatar. As players progress through a narrative, they are introduced to a variety of other actors in the environment, and these new actors represent a set of real or potential relationships that can form around the player. Applying Granovetter's (1973) notions of a social tie, we might consider the extent to which players form weaker or stronger relationships with other players (via their avatars) as a function of how much time they spend with each, how much information is mutually shared with each, how intimate the interactions are, and the extent to which exchanges are reciprocal. While such an understanding could be readily applied to human-to-human interactions in games (such as MMOs), we might also understand social interactions and their relative in-game role by considering

character-to-character interactions. We can also understand the relationships between a player and their avatar. Banks and Bowman (2016) proposed that the player-avatar relationship can be understood on a continuum of sociality that ranges from the asocial "tool" or "object" orientation (marked by a focus on competition and achievement) to a fully social and differentiated "other" experience (marked by high levels of emotional investment and avatar autonomy). Finally, we also know that avatars often exist in relation to other player's avatars, and as such a major motivator for gaming is for socialization (Yee, 2007)—in fact, a core component of videogame enjoyment is related to the satisfaction of intrinsic relatedness needs (Tamborini et al., 2010) and improving social competence (cf. Kowert & Oldmeadow, 2013). Altogether, a given player, a given avatar, and all other players, avatars, and characters exist in a matrix of relations (Banks & Carr, 2017).

REPUTATIONS

To this point, the discussion has centered around the relationships that an avatar might have with a player and aspects of gameworld, suggesting that those associations—while external to the avatar—impact how we come to understand the avatar. However, the relationships can both emerge from and result in the assignment of reputations to different avatars—those functional or moral character traits that can distinguish one type of element (or avatar) from others (Fombrun, 1996). Translated to avatars, and borrowing from the ludic and narrative dimensions used above to explore avatar relationships, we might expand on Fombrun's basic definition and suggest that avatar reputations are understood as the known or assigned functional or social status of an avatar relative to others.

Functional Reputations

By design (and perhaps, by default), one set of character traits that can help distinguish avatars from one other are those seemingly arbitrary (but totally not arbitrary) values assigned by the game. Games commonly feature a system of leveling, ranking, or some sort of relative scoring to help distinguish avatars from each other, which impacts gameplay—as avatars gain levels or ranks, they are often given increased access to game content, be it advanced levels or challenged or increasingly powerful and more complicated actions. Functional representations, be they explicit values (such as a player's level; see Velez, this volume) or more implicit labels (such as a player's alignment; see Johnson, this volume), are often a representation of the player's skill.

In *World of Warcraft* (WoW; 2004), for example, a player that falls short of a level (e.g., Level 110 for the *Legion* expansion) is not allowed to access parts

of the game's narrative (usually, an exercise in game balance), ostensibly because their functional reputation marks the avatar (and by extension, the player) as being ill-prepared for the challenges of a new zone. Avatars often have to earn access to game elements by boosting their functional reputation in a game, usually through natural game progression but also through level grinding, a "mathematically optimal method of acquiring in-game rewards, but the player is sacrificing variety of game play" (King & Delfabbro, 2009, p. 67). In a sense, level grinding might be a short-term reduction of play toward boosting an avatar's functional reputation in the game environment to enjoy resulting in delayed gratification for later experiences. Put simply, an avatar's level is often interpreted as its credentials: higher levels are akin to higher credentials, which result in better access to a given videogame's more advanced challenges and stories. Likewise, when players engage in online discussions with other players, their chosen avatar's level often serves as an indicator of the player's functional reputation as it is often displayed in forum posts.

Functional reputations do not always take the form of an explicit "level status" however, and are often woven into the game's narrative—sometimes in a more implicit manner. A prominent example can be found in *Grand Theft Auto: San Andreas* (2004) in which an element of gameplay tangential to the core narrative involves the player boosting their "Respect" with the eight different gangs that popular the environment—including the player's own Grove Street Families. Respect with different factions is a popular feature in many videogames, but in *San Andreas* the added layer of gang warfare challenges the player to control each of the game's 57 urban zones. The resultant Respect boost allows the player to recruit more gang members to accompany them, on command.

Moral Reputations

While functional reputations might be understood as necessary by-products of game mechanics, we can also understand avatars in terms of the moral reputations that they might develop—that is, the social judgments that we might ascribe to an avatar in relation to the larger game narrative. Moral decision-making mechanics are an increasingly embedded and popular gaming mechanic (Benedetti, 2010), as avatars are given elaborate backstories and narratives on par with Hollywood films. A complete list of games that feature morally tinged decisions would fill an entire volume, but games such as *Fable* (2004), *Infamous* (2009), and *Skyrim* (2011) track an avatar-qua-player's decisions during gameplay and construct a social reputation from these decisions that impacts short- and long-term narrative progression. According to some estimates (Grizzard, Hahn, & Tamborini, unpublished data), the game *Mass Effect* (2007) has a minimum of 321 moral decisions that a player must make to complete the game—each one pushing the player to either side of the Paragon (good) versus Renegade (bad) reputation. Schultzke (2009) wrote extensively

about moral decision-making as core to *Fallout 3* (2008), regarding the game's use of harm as an absolute (and sole) indicator of the avatar's morality. When given an explicit choice to harm (from stealing to destroying an entire village), extremely harmful actions label the avatar as "very evil" and avoiding such harm labels the avatar as "very good" and both impact how others in the game approach the avatar. In short, we generally accept that the moral decisions made by an avatar (either independent from or as a result of player agency) dramatically impact the on-screen content—both the gameplay (players acquiring too many "Wanted" stars in *Grand Theft Auto* will find that navigating their avatar through the streets of Vice City to be increasingly difficult) and the narrative (players who direct *Infamous'* protagonist Cole McGrath toward an evil, red-tinted karma will engage a plot far more related to Cole's survival and growth than those of the other stranded and starving citizens of Empire City)—in essence allowing the player to co-create the avatar's moral reputation (cf. Bowman & Banks, 2016; see also Grizzard & Ahn, this volume).

A PART OF THE MAIN

Just as it is difficult to understand a single person removed from the relationships and reputations they have with others, it is nigh impossible to understand an avatar in isolation: a static image of Mario or Master Chief provides little insight into the ludic and narrative existence of that avatar compared to playing out its relations to other characters and things in the gameworld, and in fact those ludic and narrative pressures shape the very experience of the avatar itself. Although it might be tempting to approach avatars more like isolated game pieces that activate when we take them up, a more robust understanding of an avatar requires us to understand it as an actor in a network—a part of the main(frame) that is the videogame.

REFERENCES

Banks, J. (2014). Object-relation mapping: A method for analysing phenomenal assemblages of play. *Journal of Gaming & Virtual Worlds*, 6(3), 233–252.

Banks, J., & Bowman, N. D. (2016). Emotion, anthropomorphism, realism, control: Validation of a merged metric for player-avatar interaction (PAX). *Computers in Human Behavior*, 54, 215–223.

Benedetti, W. (2010, May 6). Video games get real and grow up. *Chicago Sun Times*. Retrieved from: <http://www.msnbc.msn.com/id/36968970/ns/technology_and_science-games/#. UJE8PqNCesY>

Berscheid, E. & Peplau, L. A. (1983) The emerging science of relationships. In H. H. Kelley et al. (Eds.), *Close relationships* (pp. 1–19). New York: W.H. Freeman and Company.

Bowman, N. D. (2016). Video gaming as co-production. In R. Lind (Ed.), *Produsing 2.0: The intersection of audiences and production in a digital world* (Vol. 2, pp. 107–123). New York: Peter Lang Publishing.

Bowman, N. D., & Banks, J. (2016). Philosophy of machinima. In K. Kenney (Ed.), *Philosophy of multisensory communication and media* (pp. 214–218). New York: Peter Lang Publishing.

Bowman, N. D., Weber, R., Tamborini, R., & Sherry, J. L. (2013). Facilitating game play: How others affect performance at and enjoyment of video games. *Media Psychology, 16*(1), 39–64.

Boyan, A., Grizzard, M., & Bowman, N. D. (2015). "A massively moral game?" Mass Effect as a case study to understand the influence of players' moral intuitions on adherence to hero or antihero play styles. *Journal of Gaming and Virtual Worlds, 7*(1).

Burgun, K. (2011, June 8). Understanding balance in video games. *Gamasutra.* Retrieved from: <http://www.gamasutra.com/view/feature/134768/understanding_balance_in_video_.php>

Donne, J. (1624/1959). Meditation XVII. In J. Donne, *Devotions upon emergent occasions* (p. 108). Ann Arbor, Michigan: The University of Michigan Press.

Fombrun, C. (2015). Reputation. In Wiley encyclopedia of management, 11: Organizational behavior (pp. 1–3).

Graetz, J. M. (1981). *The origin of Spacewar.* Retrieved from: <http://www.wheels.org/spacewar/creative/SpacewarOrigin.html>

Granovetter, M. S. (1973). The strength of weak ties. *American Journal of Sociology, 78*(6), 1360–1380.

Joeckel, S., Bowman, N. D., & Dogruel, L. (2013). The influence of adolescents' moral salience on actions and entertainment experience in interactive media. *Journal of Children and Media, 7*(4), 480–506.

Juul, J. (2011). Video games and the classic game model. In: *Half-real: Video games between real rules and fictional worlds* (pp. 23–54). Cambridge, MA: MIT Press. King, D., & Delfabbro, P. (2009). Understanding and assisting excessive players of video games: A community psychology perspective. *Australian Community Psychologist, 21*(1), 62–74.

Kowert, R., & Oldmeadow, J. A. (2013). (A)Social reputation: Exploring the relationship between online video game involvement and social competence. *Computers in Human Behavior, 29*(4), 1872–1878.

Lange, A. (2014). "You're just gonna be nice": How players engage with moral choice systems. *Journal of Games Criticism, 1*(1).

Latour, B. (1992). Where are the missing masses? The sociology of a few mundane artifacts. In W. Bijker & J. Law (Eds.), *Shaping technology/building society: Studies in sociotechnical change* (pp. 225–258). Cambridge, MA: MIT Press.

Meier, S. (2012, March). Interesting decisions. Presentation delivered to Game Developers Conference, San Francisco, CA.

Schell, J. (2013, April). *The future of story telling.* Presentation delivered to Game Developers Conference, San Francisco, CA. Retrieved from: <http://www.gdcvault.com/play/1018026/The-Future-of-Storytelling-How>

Schulzke, M. (2009). Moral decision making in Fallout. *Game Studies, 9*(2). Retrieved from: <http://gamestudies.org/0902/articles/schulzke/>

Tamborini, R., Bowman, N. D., Eden, A., Grizzard, M., & Organ, A. (2010). Defining media enjoyment as the satisfaction of intrinsic needs. *Journal of Communication, 60*(4), 758–777.

Yee, N. (2007). Motivations for play in online games. *CyberPsychology & Behavior, 9*(6), 772–775.

Headcanon & Lore

Owning the Narrative

JOHN CARTER MCKNIGHT

Have you ever imagined what happens to characters after the credits roll or the book ends? Or thought of characters being as in a relationship, or with a background, that wasn't spelled out on screen or in the text? If so, you've built a *headcanon*— a personal narrative to expand on or modify what the author(s) of a story have established. Headcanons can be as subtle as seeing the villain in a sympathetic light, or as profound as imagining a character is a person of color, or gay, to relate better to them and their story; this process "can make the difference between whether or not someone connects with a work" (Asher-Perrin, para. 9). Headcanons can be shared, influencing how we see the original work, and can even influence official creators as they fill in and expand on stories in games and related media.

EXPLICATING HEADCANON AND LORE

The term "canon" originally meant the group of texts accepted by authorities as part of Biblical scripture, and came to refer to a group of foundational texts of Western literature (the things teachers make you read in grade school). In popular culture use, it refers to the parts of a collection of stories that are considered by the copyright holders to have "actually happened" in the fictional universe. Canonical stories are often called "lore"—a term from roleplaying games that refers to the world-building that surrounds a game, such as the history of Azeroth in *World of Warcraft* (2004) or the practices of Pokémon trainers in the Pokémon universe. Lore, created by the game developers and licensed writers, is always canon, even

if not all the stories told *using* the lore are. Fan's creative deviations from canon are called *headcanon*, or the collections of stories emerging in fans' minds as making sense in the narrative universe. An earlier generation of fans used the term "fanon" (fan canon) for the same phenomenon, but "headcanon" has taken favor in recent years. While a distinction between the personally constructed *headcanon* and socially constructed *fanon* would be useful, this work follows fan usage, in which "headcanon" is now used to refer to both (cf. Zekany, 2016, who posits the distinction in a footnote, but provides no evidence for its usage; Hamilton, 2016).

Stories created for anything other than licensed publications, from fan movies and novels to playing Link and Zelda on the playground, aren't canon. And some licensed stories are canon, while others aren't quite, or aren't at all. For example, there have been thousands of *Star Wars* stories created since 1977, in movies, comics, novels, games, and other media. The movies always were canon, as were the animated TV series. Before Disney acquired Lucasfilm, the novels of the "Expanded Universe" were canon as well: Luke married a woman named Mara Jade, Grand Admiral Thrawn was the brains behind the Empire after the Emperor was defeated. Stories in the videogames, however, even the much-loved *Star Wars: The Old Republic* (SWTOR; 2011), weren't quite canon—roughly equivalent to the status of apocrypha in Biblical texts. Disney declared the Expanded Universe "apocrypha," rebranding them as "Legends." (Note that the stories didn't change at all, and are still in print: what changed, and what sparked fan outrage, was their demotion from canon status.) Fans who still want Luke to have married Mara Jade, though, now have a headcanon—a story they would like to be "true" within the story universe even if it isn't canon.

Chaney and Liebler (2007) describe headcanon (though they use the older term "fanon") as a "folksonomy," a classification system creating order through bottom-up consensus. In this process, a body of fans make decisions through sharing and discussing interpretations of canon (e.g., through online forums or fan conventions), either as fanfiction or as "meta," or critical analysis. They claim headcanon exists in a symbiotic relationship with canon, just as producers and consumers exist in symbiosis. Headcanon can become canon, as with Sulu's and Uhura's names, which were eventually accepted and used by *Star Trek* producers, or it can be directly contradicted by canon, a phenomenon known as "jossing," after Joss Whedon's frequent undermining of fan-popular readings and theories in establishing canon in his works, particularly *Buffy the Vampire Slayer*. The notion of a folksonomy is supported by observations that what by then had come to be called "head!canon" (the punctuation being a fandom trope in the mid-2010s; Coker, 2012) existed largely as marginalia (Carpenter, 2011), often author's notes to a fanfiction story explaining the selection of canon elements and interpretations imposed upon them in the work. Another reason for creating works inspired by headcanon can be found in efforts to counter what a reader perceives as inconsistency in the canon narrative, or an undesirable storyline (Carpenter, 2011). Such works are often known as *fix-it fic*.

Headcanon can perhaps be most incisively defined as "the structure of meaning that informs and defines a fan's interpretation" (Carpenter, 2011, p. 20). This definition points to the value of considering player engagement with the avatar in roleplaying games, as the player's engagement with their avatar in an *interactive* medium such as a game is more strongly grounded in active, personal experience than the passive reader's or viewer's engagement with the protagonist of a narrative. While headcanon has generally been considered in relation to traditional media (books, movies, TV), what happens to that process of meaning-making in avatar-based media like videogames? When one of the characters is in some sense *you*, the stories you tell yourself can become personalized, even intimate, and can affect you in even more profound ways than with non-interactive media. Games may create more opportunities for headcanon than linear media, given Sid Meier's (2012) definition of a game as "a series of interesting decisions," which could be another way of saying "a story you tell yourself." Even games with strong narratives don't have one "right" interpretation or strong authorial intent, and in more "sandbox"-like games, your choices create all the narrative that there is.

Headcanon, as discussed here, is a collection of concepts and practices which can act as a useful, fandom-originated lens for thinking about how players identify with characters (usually examined through academic and professional lenses of player psychology, game narratology, and user experience design). It also provides a means of analyzing complex processes of feedback among players, game designers, and transmedia authors, both amateur and professional. Headcanon is an origin point of a network of the psychological and social, designed and emergent, creative and critical, forces shaping players' reactions to character and narrative. In other words, we can explore the network of play through the key node of the player-character, or avatar.

GAPS, QUEERING, FIX-IT

There's a good argument to be made for Dante's *Divine Comedy* being Bible fanfiction (Milam, 2015) and for Homer's *Iliad* and *Odyssey* being Trojan War fanfic (Kahane, 2016), and it's widely claimed that fandom and fan-created works "began" in response to Sir Arthur Conan Doyle's Sherlock Holmes stories beginning in 1887 (Wolf, 2014). However, regarding avatars, the story of fandom and fan production begins with *Star Trek* in 1966. *Star Trek's* three seasons broadly sketched out a universe (a lore, if you will) that its fans wanted more of—so they made it themselves. This work took three main forms crucial to the concept of headcanon we'll be exploring—gap-filling, queering the narrative, and fix-it fic—that are in many ways intimately linked.

Gap-filling, involves adding details not present in the canon, or official story. For instance, Lieutenants Sulu and Uhura were never given first names on the

show; fans came to agree that they were Hikaru and Nyota, respectively. *Queering the narrative, involves* creating readings of characters presented or assumed to be heterosexual in canon as something other; much of fanfiction's beginning was in stories of Kirk and Spock as romantically and sexually involved, though they had been only presented as involved with women in canon (Penley, 1997). To consider the interplays of gap-filling and queering, consider Electronic Arts' decision to remove constraints on gender expression in creating avatars in *The Sims 4* (2014). *The Sims*, a game without fixed progression or narrative, has long recognized as a means for enabling players to experiment with their own identity and roles in a safe, mediated context (Gee & Hayes, 2010), as avatarized self-representation has been shown to have substantial psychological effects on players (Shaw, 2015). The formal removal of gender-expression boundaries created even more liberal spaces, or gaps, for players to fill with and in relation to their avatars. For instance, one transgender player leveraged this space by creating a transgender avatar to express her gender identity as a prelude to transitioning (Parker, 2016).

Another example can be found in the *Mass Effect* series' (2007). Along with a *tour de force* exploration of the appeal of interspecies romance, Zekany (2016) documents the popularity of headcanon involving romance between the female version of the game's player-character, Commander Shepard ("femShep"), and the alien and distinctly non-human-looking NPC Garrus. In *Mass Effect*, a canon relationship between the two was impossible: characters were limited to relationships with members of the opposite gender and those species most human-like and conventionally attractive. Garrus's race, the Turians, are depicted as hard-carapaced, like insects, with movements inspired by birds. Canon, then, held a gap: that there were no female Turians, as the designers could not imagine a way of presenting them without resorting to conventions of (mammalian) bodily femininity. Zekany holds that fans' headcanon rejected that interpretation, holding that male and female Turians look too much alike for humans to tell the difference. She observes that "the gender confusion regarding Turians is not game-created … but the result of fannish interpretation," and thus "the ambiguous Turians are whatever the author-fan wants them to be in her own reading of the source text" (Zekany, 2016, p. 6).

In *Mass Effect*, the source of so much headcanon creation and interplay with canon, promotional materials for the game featured one canon visualization of the player-character, Commander Shepard. The canon Shepard is male, white, with close-cropped black hair, based on Dutch model Mark Vanderloo (Prell, 2011). Arguably, this rendered all other possible Shepards, particularly the femSheps, non-canon. In response to the popularity of femShep with players, in part due to the far superior voice acting of Jennifer Hale, developer BioWare staged a contest to select a canon femShep for *Mass Effect 3* (Prell, 2011, Dyce, n.d.), to effectively fill the gap of femshep's appearance. The winner was a pale-skinned redhead, who

was featured in promotional materials for the title alongside the male version. Here, a collective headcanon was developed by fans and accepted into the canon by the creators.

In a less formalized case, we see a more conventional response by fans to canon imagery in the reveal of the *Pokémon GO* trainers at 2016's San Diego Comic-Con. Upon seeing mere images of the three trainers, player-fans immediately began creating, disseminating, and building consensus on headcanon traits for the trainers, particularly in reading Blanche as nonbinary, Candela as lesbian, and Spark as asexual (Grobman, 2016). While, apparently, developer Niantic has confirmed Blanche as a woman, fans continue to assert their headcanon (e.g., McKenney, 2016), *queering the narrative* and expanding the possibilities of representation beyond, or despite, canon intent. Where the initial fan response, confronted with nothing but the team leader images, was to fill in *gaps* by creating gender identities and preferences, and personalities. (Spark is routinely called "meme lord" and regarded as not too bright, while Blanche is cool and somewhat arrogant.) After statements by Niantic ruled some headcanon as contrary to canon, its continued elaboration by fans can be regarded as both *fix-it* (a term more common with respect to non-interactive media, when fans reject certain canon storylines to develop an alternative narrative in which they either didn't happen or happened differently) and as *queering the narrative* by increasing diversity of representation beyond the limits of canon.

CANON INPUTS: MECHANICS, NARRATIVE, APPEARANCE

Headcanon, in games, begins with the shaping of the avatar as a player's character within a narrative. Particularly (but not exclusively) in roleplaying games (RPGs), and contrary to fixed narratives such as those of books or movies, the main character's actions are not predetermined by the game designers, but subject to some level of choice by the player. In other words, the game contributes a framework for the character through canonical narrative, but the player must make decisions to execute the potentials of that framework. Headcanon begins as the sum of those choices coheres into a distinct and original character composed as an assemblage of canon elements and player choice. Three key canon elements are *mechanics*, *narrative*, and *avatar appearance*.

Player choices are often analyzed in conjunction with engagement with the game's *mechanics*—running, jumping, shooting, and following paths (see Boyan, this volume). Much work in games design involves projective or retrospective consideration of player decisions in encountering game mechanics—designers observe or anticipate what players will do with the tools or opportunities given by the game. In *Deus Ex: Human Revolution* (2011), the player-character is always Adam

Jensen. Although Jensen is always a slender, black-haired, white man of early middle years, each instantiation of Jensen is shaped by a particular gameplay style. Some Jensens, are stealthy and nonviolent, taking advantage of game mechanics which enable that style of play, while others shoot everyone in sight, maximizing the game's combat mechanics. Some choose middle paths. Out of each encounter with the game's mechanics, a set of choices emerges which defines a character's personality, one player's Jensen out of all the possible Jensens enabled by the game.

Some games have additional mechanics that enable the formation of a coherent headcanon for the player character. These may include faction allegiance (in *Star Trek Online* [2010], each Romulan character begins as neutral but must choose to ally with either the peaceful Federation or the warlike Klingon Empire) or good/evil or light/dark scales (common in BioWare games, such as *Mass Effect*'s Paragon-to-Renegade spectrum or *Star Wars: Knights of the Old Republic*'s Jedi-to-Sith spectrum; see Ask & Chen, this volume). These mechanics push the player toward particular choices, but headcanon may arise from defying those expectations: the Sith who stops to heal a wounded civilian, the Jedi who strikes down a wounded enemy in cold blood—breaking from the default choices of reputation systems may give rise to just those "interesting decisions" Meier describes. In either case, these additional game mechanics act as scaffolding for character to emerge from decisions, while remaining grounded in lore (one can play a Jedi and choose cruel options to reflect my headcanon of his temptation to the Dark Side, and the game mechanics will mark that—but I can't play a Jedi Ninja Turtle, because that's not provided for in the lore; see Grizzard & Ahn, this volume).

In games with a *narrative*, particularly RPGs, another sort of interaction takes place alongside the mechanics. When a player is tasked with making "interesting choices" relating to the narrative, those choices are rarely random. They often stem from some coherent vision of what the player wants their character to do in the situations they encounter (Banks, 2015). As the player makes choices, coherent characterization emerges: the player-character becomes the sassy one, the brutal one, the respectful one, and each choice informs subsequent choices. The avatar becomes *specific* in its character, although perhaps not unique since others could follow the same path. For instance, in *Tearaway: Unfolded* (2015), the avatar "Messenger" has the option of taking the direct path on its journey to save the world from the "scraps" monsters pouring in from a hole in the sky, or to indulge in many side-paths and puzzles. If the player envisions the Messenger as a skilled adventurer the main narrative might be eschewed in favor of collecting and solving, but if the Messenger is seen as a diligent, duty-bound hero the primary story arc might be followed in a direct path to save the world from the threat.

Appearance customization involves yet another set of choices, which may inform interactions with the narrative, although it is perhaps better considered quasi-canonical input versus pure canon. The player character may be the gentle

giant, the tough shrimp, the scarred veteran, the innocent waif, such that choices of appearance and choices of action contribute to the emergence of a coherent character. In SWTOR, one might choose spiky purple hair and heavy goth makeup and then choose snarky dialog choices, take bribes, slay surrendered enemies, all using the game's choice affordances to create a Jedi fallen to the Dark Side. Choices of gender, race (both in the fantasy context of Orcs and Elves and in the more common usage of the term), age, and other attributes both allow greater identification with the character as well as tools for driving choices within the narrative. There may even be game mechanics which shape the avatar's appearance in response to player choices, be it to reflect scars, faction-specific costumes or uniforms, or other transformation of the character's appearance: in SWTOR, Dark Side-aligned characters develop glowing red or yellow eyes, a pallid complexion, and prominent facial veins; while Light Side-aligned characters smile more and develop a radiant aura.

CREATIVE AND SOCIAL OUTPUTS

A first level of headcanon, then, forms as player choice interacts with the game's *mechanics, narrative*, and *avatar appearance* to create a coherent character profile. A second level takes shape in multiplayer games, when interactions are no longer confined to a reciprocal relationship between a single player and the game narrative, but involve other players. While *roleplay* is somewhat rare in multiplayer games, for those who engage with it the scripted game narrative recedes in favor of interactions among multiple player characters, each the product of their own player's choices. These interactions may be facilitated by game tools such as character profiles, or on-screen summaries where others can view a character's name, titles or achievements, and sometimes freely written text in which players can present a brief character biography (McKnight, 2013). These tools guide other players by serving as fodder for a conversation starter, or suggesting potential storylines or patterns of interaction.

When roleplay is moved out of the game space into the physical world, it becomes *cosplay* and live-action roleplay, or *larping* (Bowman, 2010; Larsen, 2005; Lamerichs, this volume). Here the erstwhile player presents, either just visually or by acting "in character," as their avatar. Cosplay generally derives from canon characters in fixed media such as film or television; as the point of cosplay is to be recognizable as a particular character, original-character cosplay is somewhat self-defeating. However, cosplay does include both iconic and customizable RPG player-characters. *Tomb Raider*'s (2001) Lara Croft was one of the earliest cosplayed game characters, recognizable through a costume, which rarely varied within or among games. Wearing the costume evokes the impression of Croft, regardless of the cosplayer's resemblance

to the game-character's body. As with many of the concepts here, BioWare's *Mass Effect* trilogy provides an example of cosplay of a customizable player-character: distinct Commander Shepards abound, recognizable through standardized armor and gear while allowing a unique interpretation based upon one's own appearance, which need bear no relation to the canon imagery of either the male or female Shepard. Larping, meanwhile, involves the performance of a character entirely created by the player, often within a canon setting like the vampire world of *Vampire: The Masquerade* (see Stark, 2012). In short, as solo play is to roleplay in manifesting headcanon, so is cosplay to larping in acting out shared headcanon.

When headcanon manifests not as costuming and acting, but through narratives in a different medium, it becomes fanfiction (fanfic, or in the case of video, fanvid). Videogame-based fanfiction differs from that based on fixed narrative in crucial ways, largely rooted in their interactivity. In fixed-media fanfiction, the use of a character based on one's own self-imaginings is generally considered poor form, the sign of an inferior writer. Such characters are known as "Mary Sues" from an early *Star Trek* fanfiction work, in which the viewpoint character of that name was the most skilled and desirable character on the *Enterprise*. Mary Sues are seen as fantasies of self-aggrandizement rather than legitimate narrative creations (Pflieger, 1999), and distinct from other original characters who may be used in fan fiction as more organic parts of a canon-appropriate narrative. For fanfiction based on RPGs, however, the player-character becomes an inescapable element of narrative. This does not mean that all videogame fanfiction uses the player-character as main or viewpoint character; headcanon as gap-filling can manifest as pre- or post-canon stories for NPCs or other explorations of the narrative universe.

Headcanon, then, has come to subsume two related processes, one psychologically internal to the player and one socially external within the player/fan community, in which a novel reading of canon is developed, shared, or performed. These player/fan readings may in turn inform creators of canon, who may adopt or attempt to negate them. They are the genesis of player concepts of the player-character as distinct, unique, and emergent from the narrative and mechanics of the game environment, and also give rise to player-created content, from cosplay to art, fiction, video, and criticism. Unlike analytical lenses rooted in psychology, anthropology, or game design, headcanon is itself a player-created concept and provides a means for analyzing player reactions and creations on their own terms, within their own folksonomies (Chaney & Liebler, 2007) and practices.

REFERENCES

Asher-Perrin, E. (2015, Feb. 3). Creating headcanons: Everyone does it. *Tor.com*. Retrieved from: <http://www.tor.com/2015/02/03/creating-headcanons-everyone-does-it/>

Banks, J. (2015). Object, me, symbiote, other: A social typology of player-avatar relationships. *First Monday, 20*(2).

Bowman, S. L. (2010). *The functions of role-playing games: How participants create community, solve problems, and explore identity.* Jefferson, NC: McFarland and Company.

Carpenter, S. G. (2011). *Narratives of a fall: Star Wars fan fiction writers interpret Anakin Skywalker's story.* (Doctoral dissertation, University of Oregon).

Chaney, K., & Liebler, R. (2007). Canon vs. fanon: Folksonomies of fan culture. In *MIT Media in Transition 5.* Retrieved from: <http://works.bepress.com/raizelliebler/10/>

Coker, C. (2012). The Angry! Textual! Poacher! Is Angry! Fan works as political statements. In K. Larsen & L. Zubernis (Eds.), *Fan culture: Theory/practice* (p. 81–96). Tyne: Cambridge Scholars Publishing.

Dyce, A. (n.d.). *Mass Effect 3* redhead female Shepard wins fan vote. *Gamerant.* Retrieved from: <https://gamerant.com/mass-effect-3-redhead-female-shepard-wins-vote-dyce-101829/>

Gee, J. P., & Hayes, E. (2010). *Women and gaming: The Sims and 21st Century learning.* Palgrave Macmillan.

Grobman, J. (2016, Aug. 7). Everyone picked a *Pokémon GO* team leader, the transgender community picked them all. *The Mary Sue.* Retrieved from: <http://www.themarysue.com/pokemon-go-trans-team-leaders/>

Hamilton, J. (2016, Sept.). Shipping, headcanons, and OTPs: An introduction to fandom vocabulary. *Oxford Dictionaries* [blog]. Retrieved from: <http://blog.oxforddictionaries.com/2016/09/fandom-vocabulary/>

Kahane, A. (2016). Fan fiction, early Greece, and the historicity of canon. *Transformative Works and Cultures, 21.* Retrieved from: <http://journal.transformativeworks.org/index.php/twc/article/view/681/553>

Larsen, E. (2005). Real magic. In P. Bøckman & R. Hutchison (Eds.), *Dissecting Larp* (pp. 239–244). Oslo: Knutepunkt.

McKenney, K. (2016, Aug. 4). The best *Pokémon GO* fanart. *Paste.* Retrieved from: <https://www.pastemagazine.com/articles/2016/08/the-best-pokemon-go-fan-art.html>

McKnight, J. C. (2013). "So much more than something vulgar:" Constructing the abject, obscene, or essentialist avatar. In *Visions of Humanity in Cyberculture, Cyberspace and Science Fiction: 8th Annual Conference Proceedings.* Inter-Disciplinary.Net.

Meier, S. (2012, March). Interesting decisions. Presentation delivered to Game Developers Conference, San Francisco, CA.

Milam, W. (2015). 6 great works of literature that are actually fanfiction. *Geek and Sundry.* Retrieved from: <http://geekandsundry.com/6-great-works-of-literature-that-are-actually-fanfiction/>

Parker, L. (2016, Aug. 31). Video games allow characters more varied sexual identities. *The New York Times.* Retrieved from: <http://www.nytimes.com/2016/09/01/technology/personaltech/video-games-allow-characters-more-varied-sexual-orientations.html?_r=0>

Penley, C. (1997). NASA/Trek: Popular science and sex in America. London: Verso.

Pflieger, P. (1999, March). Too good to be true: 150 years of Mary Sue. Paper presented at the conference of the *American Culture Association.* San Diego, CA.

Prell, S. (2011, Aug. 8). Why the Mass Effect 3 FemShep vote was the wrong move. *Destructoid.* Retrieved from: <https://www.destructoid.com/why-the-mass-effect-3-femshep-vote-was-the-wrong-move-208186.phtml>

Shaw, A. (2015). Gaming at the edge: Sexuality and gender at the margins of gamer culture. Minneapolis, MN: University of Minnesota Press.

Star Trek [Television series]. (1966–1969). New York: NBC.

Stark, L. (2012). Leaving mundania: Inside the transformative world of live action roleplaying games. Chicago: Chicago Review Press.

Wolf, M. (2014). Building imaginary worlds: The theory and history of subcreation. New York: Routledge.

Zekany, E. (2016). "A horrible interspecies awkwardness thing:" (Non) human desire in the Mass Effect universe. *Bulletin of Science, Technology & Society*, *36*(1), 67-77.

Cosplay & Conventions

Exporting the Digital

NICOLLE LAMERICHS

Videogame fans and players do more than just couch-surf. While popular culture demands an increasing degree of participation via social media and platforms in general, games (as inherently interactive media) are even more apt at engaging their audiences. While videogames engage users to extend themselves into the gameworld, users often extend these digital worlds as well. In such participatory cultures, audiences of all kinds enjoy reworking existing material on digital and traditional platforms (Jenkins, 2006). Contemporary audiences are producers who combine production and usage, and thus engage in acts of "produsage" which have elements of both (Bruns, 2008). Through these acts, media are increasingly lived, rather than consumed, Deuze (2012) even argues.

This also holds true for videogames, such that gaming has become a wide subculture with its own repertoires, events, and communities, which export this digital culture to offline networks. Gaming fan cultures are a pivotal example of these emerging cultural dynamics. These active audiences engage with the games originating from different cultures, from the United States and Canada to Korea and Japan. Gamers are also active in communities that have been theorized as "fandoms," describes term referring to the social and creative communities around a specific slice (e.g., title, series, genre, character) of popular culture (Gray, Sandvoss, & Harrington, 2007).

Fandoms are characterized by their creativity, online and offline sociality, and their affect for the media text. Fan cultures are rich and thriving cultures, both online as well as offline, where different creative practices flourish that rewrite and subvert popular culture (Hills, 2002). The creativity of fans can be read as a type of appropriation that borrows and repurposes existing cultural materials to produce something new. Fandom fits a historical tradition of storytelling as an active,

dynamic, and often oral tradition, which relied on appropriation, and audience input. In that sense, it is akin to a folk culture where myths are shared and retold.

Cosplay or "costume play" is an iconic example of fan creativity. In this practice, fans construct and wear costumes that allow them to re-enact existing fictional characters from popular culture. These outfits and subsequent performances are a physical manifestation of their immersion into the fictional realms of videogames. In a sense, they extract avatars and other characters from digital space and *exporting* them into physical space—often into conventions where fan cultures gather to celebrate game characters, stories, and worlds.

COSTUMING AND CONVENTIONS

Cosplay can be understood as a culture of costuming that occurs beyond the institutional remit of the theatre. The purpose of cosplay is to create a look-a-like of a character—whether a game-defined character or one's own customized avatar—to create a unique performance and connect with others. Fans mimic the character not only through dress but also through the styling of wigs or hair, make-up techniques, and more recently through high-tech special effects. For instance, during Blizzard Entertainment's annual cosplay competition, you might see a carefully sculpted Orc mask complete with dramatically furrowed brow and intimidating tusks or a genderbent Lich King (from *World of Warcraft*, 2004) with theatrical smoke emanating from the character's iconic sword (BlizzCon, 2016). In many cases, fans may spend hundreds of hours crafting a single costume by hand. Importantly, although an important part of cosplay is to temporarily take on a game character's persona, cosplaying differs from roleplaying: whereas roleplaying involves a longer, joint project of telling a story and playing out one's own character, cosplaying is short term, and involves less narrativity. Fan costuming revolves around representing the digital through deeply visual performances of a character for other fans and for photographers who capture these activities.

Fan costumes also go hand-in-hand with other performances. Fan musicians often dress up in ways that suggest character performances (Jenkins, 1992). For instance, musicians like Taylor Davis perform themes from *Skyrim* (2011) and *The Legend of Zelda* (1986), often wearing costumes of those games' characters in performances and promotional media, creating a full performance around the game. Similarly, key chains, jewelry, shirts, and other game-related apparel are increasingly popular, inspired by franchises such as *Portal* (2007), *BioShock* (2007), and other classics. Dress functions as subcultural capital (Thornton, 1995)—cultural knowledge, symbols and artefacts which signify a visual and social way of belonging within subcultures. Through cosplay, gamers can connect to each other.

Theoretically, one way to view cosplay is through the concept of transmediality—a transfer or combination of form and/or content that translates an individual media

text to other media texts of the same or a different medium. Gamers are apt in transmediality. In their practices, they move betwixt and between fictional, visual, and corporal texts to rework digital texts, including creating fan fiction (McKnight, this volume), fan art, spin-off games, roleplay, and even hacking and cheats. In terms of cosplay, this movement includes the *exporting* of digital videogame characters into physical space, making them manifest through creative interpretation, crafting, and performance. While such fan practices are organic, bottom-up examples of transmediality, the media industry itself also increasingly uses transmedia designs but in a strategic, top-down fashion. For example, in the videogame industry companies such as Valve stimulate fan creations by allowing official mods (see Stevens & Limperos, this volume), and sometimes even license official game character costumes. Importantly, transmediality requires a certain literacy of the fan culture and texts, such that non-fans may not grasp the meaning of fan productions or practices. Because of this, fan costumes are frequently misunderstood by outsiders, as well as by fans. Especially costumed female fans are seen as attention seekers or inauthentic fans (Hernandez, 2013). Understanding the motivations of cosplayers, and its merit as a performance, is essential to avoid such sexualized debates.

Due to the rise of internet platforms, fan activities have become associated with digital culture, however these activities also take place offline. For instance, a key space for cosplay performance is at fan conventions: meetings at large public spaces, such as hotels, where fans can purchase merchandise or attend events related to fan practices and the original text (e.g., panels with a character designer). Such conventions are exemplary sites to observe the global dynamics of how gaming practices export to offline environments. Large conventions draw countless visitors. San Diego Comic Con (2015) had more than 167,000 visitors, many of whom attended in costume.

In these spaces, cosplay takes place in formal settings (e.g., sanctioned competitions) as well as informal settings (e.g., convention hallways). In this way, cosplay is both intimately related to festivals or urban environments in its emergent production, but also akin to sporting events in its formal production. International competitions, such as World Cosplay Summit in Japan, create a global community around this practice. Within the convention space, cosplay is a deeply explorative and social play. Fans wander through the convention both to admire the spectacle and to experience it first-hand by becoming part of the crowd and embodying the fiction itself. In media studies, fandom has primarily been studied as digital fandom and related to the emergence of online communities (Booth, 2010). However, offline spaces—and offline bodies—are crucial to cosplay.

EMBODIMENT IN COSPLAY

Fan costumes have a long history and its predecessors include historical re-enactment (Kalshoven, 2012), drag (Senelick, 2002), and gothic subcultures

(Atkinson, 2014; Spooner, 2004). In its modern form, cosplay can illuminate the ways that gamers engage avatars as characters as playful identities; cosplayers may experience a sort of transfer of a character's identity to the player's own identity, in large part through the presence and activity of the fan's physical body (Lamerichs, 2011) such that intimacy and affect are constructed through customing (Lamerichs, 2013). This embodiment, or making-visible and -tangible an avatar-as-character through one's physical body—is not well understood.

Academic discourses on "the virtual" (e.g., see Zylinska, 2002) give the impression that the physical body has become obsolete, transparent, or wired through human engagement of technological advances. For instance, in media theory, the body is often neglected or is merely a material ground for enlightened, mediated activities (McLuhan, 2003) or a cyborg, enhanced by media technology (Haraway, 1991). However, these models do not include the fact that the body is a medium in and of itself (see Westley, 1994). Fashioning and embodying media is emblematic of our current consumer culture, where the body is part of a larger media network (Featherstone, 2010).

The costumed body of the fan and gamer is playful and present. Cosplayers mediate, articulate and flesh out what they see on the screen through costumes and performative postures, gestures, and movements (see Popat, this volume)—a dagger-drawn crouch for an RPG rogue, a sensual over-the-shoulder wink for *Bayonetta* (2009), or an athletic parkour postures for Faith (*Mirror's Edge*, 2008). Because of the intimate interplays of the cosplayer's physical body and the character's exported body-concept, embodiment in cosplay is deeply complex since, temporarily through make-believe, the cosplayer's physical body could be considered an avatar for the character, allowing it to play out its persona in physical space.

Through re-enactment, cosplay can provide players with the joys of make-believe through the creation of outfits and the freedom to perform in them. Moreover, cosplayers engage in pretend-play, or *mimicry* as Caillois (1961) defines it, as a category of play in which reality is transformed into an alternative scenario. In other words, the cosplayer's physical body and environment become fictionalized accounts of those in a gameworld. Other forms of adult make-believe include live-action roleplaying, which also actualizes imagined characters and mediates them through costumes and props (Murray, 1999). For some cosplayers, however, cosplay is less about developing or performing a character and more about constituting a visual resemblance with it. Although a cosplayer can perform the character in part, for instance, by walking around with that character's attitude, the overall conveyance is a visual one (Newman, 2008).

Like customizing one's avatar, cosplay allows for a degree of appropriation in embodying a character, and in many ways, it is about establishing your own version of its persona (Crawford, 2012). Although cosplay is mainly a reenactment of limited designs of arguably flat characters, it still manages to include narrativity

conveyed by both the visual qualities of the costume, the body of the cosplayer, and the space of performance. As such, this narrativity does not depend only on the character *qua* avatar: "Cosplay scenes remind us not only of the comparatively limited presentation of game characters but also of the rounded lives of the players that embody them" (Newman, 2008, p. 88). This multiplex narrative emerges, in part, because cosplay hovers between the digital and the physical in a complex way— it constitutes different types of realness (Newman, 2008; cf. Mitchell & Clarke, 2003). Cosplay re-contextualizes a game in a different play setting: the physical world, where its characters interact with other cosplayers and new surroundings.

Critically, the division between physical and digital perhaps does not fully capture the diverse, and highly mediated spaces of cosplay. In recent studies, scholars have criticized the dichotomy between physical and digital as the "real" and the "virtual," and have shown that both frequently draw from each other (Kozinets, 2010; Pearce, 2006), especially in relation to player-avatar synergies and emergent identities (Banks, 2013). Cosplay is not only about making the avatar physically real but about personalizing it and drawing it close. It is as much related to the game and its characters as it is a creative practice that has its own rewards. Moreover, for some cosplayers, the practice is about engaging with one's own felt body more deeply by relating it to fiction. In other words, cosplay can foster affect.

EMBODIMENT AND AFFECT

Through cosplay, avatars can obtain a degree of physical realism, which can perhaps be best understood through the lens of the emotions it may create. Although we know quite a bit about the digital, social, and participatory dimensions of fandom, we know much less about the *personal*, the embodied, and the emotional life associated with gaming and fandom. It is important, then, to understand the very feelings that ground gaming, and the embodied practices that are central to gaming and acts outside the game, if we are to better understand how videogame avatars play a role in contemporary life.

Cosplay is an "affective process"—a process of different intensities and emotions that raises awareness for the felt body and the media text as it is lived (Lamerichs, 2011). This affect involves a range of emotional experiences that can lead to investments in the world through which we constitute our identity. In other words, if we feel a thing and see a thing as important to who we are, those experiences lead us to become invested in that thing—so if we feel and identify with avatar made real through cosplay, we might be more invested in that avatar as a consequential thing. Through this lens, the emphasis is on cosplay as *process* (rather than on space or practice) because it can be both something social constructed as well as something we undergo when we are touched by other fans, characters, and games.

In an affective process such as cosplay, one may constantly work through feelings for narratives again through references and re-reading—through active involvement with the fiction. Importantly, this affective process does not end or begin at a cosplay performance. Much attention is paid to creating costumes, an artistic process that may generate emotion, and might require players to go back to avatars and their videogames as source-texts. Similarly, after having cosplayed a character, players may feel new connections with a videogame, and a personal spark because they physically embodied that character (see Gn, 2011).

This emphasis on affect calls to question related notions of gender and sexuality, which are socially constructed around embodiment. The social construction of bodies is important since they lead to social constructive *discussions* of bodies. Norms about gender may influence how we look at cosplay, as well as how we consider related acts which involve cross-dressing such as crossplay (see Leng, 2013). One way in which cosplay shapes who we are is through the emancipation and representation of gender and sexuality—fan costumes support the celebration of both cosplayer bodies and those of avatars. These expressions are, however, frequently misunderstood by some convention visitors and spectators who see cosplay outside of the convention. Event organizers struggle with unwanted behavior of visitors and press toward costumed fans, because cosplayers may adopt norms that some mainstream visitors do not buy into, especially norms associated with gender and the sexualization of costumed bodies.

For example, a *Daily Star* article by Laura Mitchell (2015) on the convention NEC in Birmingham stirred debate, by stating: "These scantily-clad sci-fi and fantasy nerds had pulses racing as they flashed their flesh in racy comic-wear." When cosplayers threatened legal action, *Daily Star* hired a legal advisor, Barbara Ludlow. She concluded: "[…] in choosing to dress up as characters that are highly sexualized representations of women, they will unsurprisingly be viewed as such. This is sadly a problem of our culture and not the fault of the Daily Star." By accusing women of exhibitionism, and enablers of unwanted behavior, this debate fits into discussions on rape culture in which women are not framed as victims, but as provocateurs (see Burt, 1980).

Such positions are characteristic of a wider debate about negative affect associated with fan costumes as undesirable, gendered performances. Women and men empower themselves through videogame characters, which may sometimes have designs, which are read as "highly sexualized" by society (cf. Fox, this volume). However, the cosplay-friendly convention is ideally framed by fans as a safe space where they can also experiment with expressing themselves in new ways (Lamerichs, 2011). Embodying avatars through cosplay, in other words, is not without restrictions. The avatar is both a protagonist and character as well as a digital puppet, which symbolizes the player. Cosplayers may identify with characters, interpret them as protagonists, and feel for them as representations of themselves.

COSPLAY & CONVENTIONS | 153

However, this affective process can be misunderstood by society and even misunderstood within gaming cultures themselves.

COSPLAY AS A "THIRD LAYER"

An avatar is simultaneously a "heavy hero" (a character that can be read and interpreted) as well as a "digital dummy" (an agent of interaction and a representation of the player; Burns, 2004). Cosplay fleshes out existing videogame characters and texts through re-enactment, and this physicality also changes the function of the avatar. Cosplay teases out both hero and dummy functions of the avatar, but adds a third layer by embodying and personalizing the avatar. In this form of dress up, players engage in an embodied and affective process. The interchange between player, game, and costume is central, and each of these domains is continuously constructed across media forms. In a broad sense, cosplay is exporting the digital and mapping it on humanity's oldest media: fabrics and skin. In this way, avatars are made material through cosplay, and this materiality is of great importance. Pixels are exported and fleshed out, allowing fans to touch, feel, and *be* these characters. Cosplayers take gaming beyond the digital, and make it into a personal and embodied practice.

Following, it may be important to extend these considerations to other forms of avatar embodiment. These affective processes could be mirrored in the customization of one's game character or avatar, since this is understood as a digital form of dress-up (Fron, Fullerton, Morie, & Pearce, 2007; Wirman, 2011). Similarly, the body may be used to signify game or character fandom, as with tattoos (Jones, 2014). In other words, broader notions of avatar-related costuming include digital and physical acts of self-fashioning, and may reveal how important this form of transformative play can be.

REFERENCES

Atkinson, J. (2014). Fashion as identity in steampunk communities. In P. Hunt-Hurst & S. Ramsamy-Iranah (Eds.), *Fashion and its multi-cultural facets* (p. 123–137). Oxford: Inter-Disciplinary Press.

Banks, J. (2013). *Human-technology relationality and self-network organization: Players and avatars in World of Warcraft.* (Doctoral dissertation, Colorado State University).

Banks, J., & Humphreys, S. (2008). The labour of user co-creators: Emergent social network markets? *Convergence: The International Journal of Research into New Media Technologies, 14*(4), 401–418.

Booth, P. (2010). *Digital fandom: New media studies.* New York: Peter Lang.

BlizzCon (2016, Nov. 5). BlizzCon 2016 contest winners [blog post]. Retrieved from: <https://blizz-con.com/en-us/news/20358108/blizzcon-2016-contest-winners>

Bruns, A. (2008). *Blogs, Wikipedia, Second life, and beyond: From production to produsage*. New York: Peter Lang.

Burt, M. R. (1980). Cultural myths and supports for rape. *Journal of Personality and Social Psychology, 38*(2), 217–230.

Caillois, R. (1961). *Man, play, and games*. New York: Free Press of Glencoe.

Crawford, G. (2012). *Video gamers*. New York: Routledge.

Deuze, M. (2012). *Media life*. Cambridge: Polity Press.

Featherstone, M. (2010). Body, image and affect in consumer culture. *Body & Society, 16*(1), 193–221.

Fron, J., Fullerton, T., Morie, J., & Pearce, C. (2007, January 24). *Playing cress-up: Costumes, roleplay and imagination*. Paper presented at Philosophy of Computer Games 2007, Modena, Italy.

Gn, J. (2011). Queer simulation: The practice, performance and pleasure of cosplay. *Continuum: Journal of Media & Cultural Studies, 25*(4), 583–593.

Gray, J., Sandvoss, C., & Harrington, C. L. (2007). *Fandom: Identities and communities in a mediated world*. New York: New York University Press.

Haraway, D. J. (1991). *Simians, cyborgs and women: The reinvention of nature*. London: Routledge.

Hernandez, P. (2013). Cosplayers are passionate, talented folks. But there's a darker side to this community, too. *Kotaku*. Retrieved from: <http://kotaku.com/5975038/cosplayers-are-passionate-talented-folks-but-theres-a-darker-side-to-this-community-too>

Hills, M. (2002). *Fan cultures*. New York: Routledge.

Hills, M. (2014a). From Dalek half balls to Daft Punk helmets: Mimetic fandom and the crafting of replicas. *Transformative Works and Cultures, 16*. Retrieved from: <http://journal.transformativeworks.org/index.php/twc/article/view/531>

Hills, M. (2014b). Returning to "becoming-a-fan stories": Theorising transformational objects and the emergence/extension of fandom. In K. De Zwaan, L. Duits, & S. Reijnders (Eds.), *Ashgate research companion to fan cultures* (pp. 9–23). London: Ashgate Publishing.

Hine, C. (2000). *Virtual ethnography*. London: SAGE.

Jenkins, H. (1992). *Textual poachers: Television fans and participatory culture*. London: Routledge.

Jenkins, H. (2006). *Convergence culture: Where old and new media collide*. New York: New York University Press.

Jones, B. (2014). Written on the body: Experiencing affect and identity in my fannish tattoos. *Transformative Works and Cultures, 16*. Retrieved from: <http://journal.transformativeworks.org/index.php/twc/article/view/527/443>

Kalshoven, P. T. (2012). *Crafting "the Indian": Knowledge, desire and play in Indianist reenactment*. New York: Berghahn Books.

Kozinets, R. V. (2010). *Netnography: Doing ethnographic research online*. Los Angeles: SAGE.

Lamerichs, N. (2011). Stranger than fiction: Fan identity in cosplaying. *Transformative Works and Cultures, 7*. Retrieved from: < http://journal.transformativeworks.org/index.php/twc/article/view/246/230>

Lamerichs, N. (2013, August). Cosplay: Material and transmedial culture in play. In *DiGRA '13—Proceedings of the 2013 DiGRA International Conference: DeFragging Game Studies*. DiGRA.

Leng, R. (2013). Gender, sexuality, and cosplay: A case study of male-to-female crossplay. *The Phoenix Papers, 1*, 89–110.

McLuhan, M. (2001). *Understanding media: The extensions of man* (revised). New York: Routledge.

Newman, J. (2008). *Playing with videogames*. New York: Routledge.

Okabe, D. (2012). Cosplay, learning, and cultural Practice. In M. Ito, D. Okabe, & I. Tsuji (Eds.), *Fandom unbound: Otaku culture in a connected world* (pp. 225–249). New Haven: Yale University Press.

Senelick, L. (2002). *The changing room: Sex, drag and theatre.* New York: Routledge.

Spooner, C. (2004). *Fashioning gothic bodies.* Manchester: Manchester University Press.

Thornton, S. (1995). *Club cultures: Music, media, and subcultural capital.* Cambridge: Polity Press.

Westley, H. (1994). *The body as medium and metaphor.* Amsterdam: Editions Rodopi.

Winge, T. (2006). Costuming the imagination: Origins of anime and manga cosplay. *Mechademia, 1,* 65–76.

Wirman, H. (2011). *Playing The Sims 2. Constructing and negotiating woman computer game player identities through the practice of skinning.* (Doctoral thesis, University of the West of England, Bristol).

Zylinska, J. (Ed.). (2002). *The cyborg experiments: The extensions of the body in the media age.* London: Continuum.

The Technical

Rules & Mechanics

Parameters for Interactivity

ANDY BOYAN & JAIME BANKS

Games are multifaceted media artifacts with which individual players interact in a variety of ways. People play simulations, live out fantasies, develop emotional bonds with characters, and compete with peers (Yee, 2000). However, one thread runs through all uses of games. First and foremost, games are systems of rules and mechanics that govern interactivity (Gee, 2003). The chapters preceding this one attest to the elements of avatars that help shape them as social entities—that make them seem variably human-like and social—but it's also important to consider how a game's governing frameworks shape the perception of and engagement with avatars. Said another way, our ability to control and connect with avatars is bound to certain parameters embedded in the code (see Kudenov, this volume), and these implicitly or explicitly implement functional affordances and constraints by which avatars interact with the digital gameworld.

Although a game's governing rules and mechanics may seem interchangeable, they are markedly different. However, game designers and scholars vary in how they characterize these differences. For instance, some focus on the degree of action completion (Salen & Zimmerman, 2004), such that rules are "component elements of machines" and that mechanics are larger, game-like actions that are constrained by the rules (for example, jumping; Koster, 2011, para. 17). Alternately, the distinction has been framed in terms of their hierarchical relations, in which mechanics are systems that promote exploration within a bounded possibility space (Cook, 2005; see Sicart, 2008 for a summary). For our purposes, however, it is useful to understand rules and mechanics as distinct but related in their functions in affording (allowing) and constraining (inhibiting) player and

avatar actions (cf. Greeno, 1994). In short, rules are effectively *legal* frameworks that dictate what a game avatar should and should not do according to a game's challenge system, while mechanics are *operational* frameworks that dictate what an avatar can and cannot do according to a game's conditions (cf. Avedon, 1971).

RULES AND AVATARS

As "legal" frameworks, a game's rule system governs player actions via their engagement with the interface and with the world via an avatar. Rules are ostensibly fixed "principles that determine conduct and standards for behavior" (Avedon, 1971, p. 422). Consider the game *World of Warcraft* (WoW; Blizzard, 2004). The game's terms of use (which in part outline the "rules" for engaging the game) require that an avatar's name not be "vulgar language or which are otherwise offensive, defamatory, obscene, hateful, or racially, ethnically or otherwise objectionable" (Blizzard, 2012) but that does not mean that players do not try to linguistically hack the rules to present such names as Frostitute (for a scantily clad Frost Mage) or Cameltotem (for a saucy Shaman). In a less codified way, WoW is predicated on the "holy trinity" model in which players engage one of three key combat roles (see Milik, this volume), and player-versus-environment play functions on the assumption that players should and will appropriately take those roles according to the rules; however, this does not prevent a damage-dealer from tanking or a tank from healing teammates. In these ways, rules are effectively social agreements between game developer and player—and among player communities—on what actions are acceptable within the game, but these agreements require active player buy-in based on the notion that the game will not function optimally if not followed, and they can be broken intentionally or unintentionally (Problem Machine, 2013).

Notably, the rules of the game also govern appropriate action of avatars in explicit ways, such as when directed by the instructions to control the avatar in a particular way. Rules are explicit in that they exist as overt and socially accepted parameters for action presented by the game, including challenges, affordances, and options (Zagal, Rick, & Hsi, 2006). For example, in fighting games such as those in the *Mortal Kombat* series (1992), players are instructed to (a) defeat their opponent by draining the hit point bar and (b) this draining is to be accomplished by using punches, kicks, and other combat movements generated by pressing button combinations on the controller. What makes these rules explicit is that they are stated in the instructions for the game, and are often taught to players through tutorials in the game itself. For instance, in the tutorial in *Mortal Kombat X*, players may be instructed that it's a useful action to execute Scorpion's special "Leg Takedown" move by successively entering the combination of "←→O." These are explanations of what buttons to press in which order so that one can play the game

to be the most effective at beating an opponent; that is, they concretely define the most fundamental actions and activities that players should perform in the game according to the challenge system (Salen & Zimmerman, 2004).

MECHANICS AND AVATARS

As "operational" frameworks, a game's mechanics govern player actions by constraining what is and isn't possible according to the intersecting properties of the game environment and of the avatar. In this way, they are "specific operations, required courses of action" (Avedon, 1971, p. 422) that define a functional method for engaging the challenge system. For instance, consider the force of "gravity" in a digital world. In games, experiencing gravity may result from an interplay between coded characteristics of the environment (that is, in space, things sink to the ground) and coded characteristics of the avatar (e.g., when is it subject to environmental forces). Consider the *Super Mario Bros.* series (1985), in which the environment does indeed include a gravitational mechanic (the space operates in a manner akin to physical-world gravity, requiring courses of action consistent with those dynamics) but also affords players opportunities to deviate from this operational requirement by manipulating or augmenting an avatar (e.g., through jump commands or by collecting the flight-capable Super Leaf). In another vein, returning again to *Mortal Kombat*, mechanics may be obscured but with the intention to be found by those invested in the game—a veteran *Mortal Kombat X* (2015) player might experiment (or investigate online play guides) and come to find that the input combination "↓→↓→B" launches Reptile's "Bad Breath" fatality. As such, mechanics are effectively akin to the "physics" of a game that players must operate within to play (unless cheating or hacking; see Johnson, this volume). In comparison to rules, however, mechanics do not require player buy-in because they are coded into the game—they are impersonal (they react identically to equal inputs), they are transparent (a player doesn't need to understand them to play), and they stand in for explicit human action (impractical tasks are offloaded to the game system; Problem Machine, 2013).

Such mechanics are *implicit* in that they impact how characters and objects interact, but they are typically not explicitly disclosed as part of the game's overtly codified parameters. Importantly, this implicit characteristic does not mean that mechanics are not discernable. For instance, players can tell a difference in the way that games "handle" according to experiences with gravity as demonstrated in the different playstyles in the *Super Mario Bros.* series, which has increased the force of gravity over the life of the series (hypertextbook.com, 2017). Thus, mechanics tend to be more technical in nature, functioning within the game system independent of players' perceptions of them.

The number and complexity of mechanics also likely influences gameplay experiences. As mechanics implicitly afford and constrain player and avatar action, game complexity can depend on the degree to which mechanical information can be discerned (Piselli, Claypool, & Doyle, 2009). Games with more and more complex mechanics may be more challenging and are likely more difficult to learn and master. To improve accessibility and market appeal, some mass-market mobile games have simplistic, or even automated, mechanics to make them more accessible to casual game players. In the new mobile version of Super Mario Bros., *Super Mario Run* (2016), the player does not control running. Rather, to simplify the game for a broader audience, the game automatically runs Mario for the player, and Mario hops over small enemies, obstacles, and deadly pits all on his own.

RULES AND MECHANICS IN EMERGENT PLAY

Although explicit, legal game rules and implicit, operational game mechanics are intended to afford game-supporting behaviors and constrain game-breaking behaviors, players sometimes use them together in ways not always intended by game designers. That is, players play with the rules and mechanics themselves in addition to or instead of working toward the stated game objectives. These forms of gameplay emerge from crafting unique adoptions or combinations of rules and mechanics resulting in gameplay according to strategy or a meta-game (Salen & Zimmerman, 2004; see Paul, this volume). The strategies and meta-game approaches that players learn and develop are attempts to attain mastery over the range of potential actions afforded by the game design. In WoW, for example, different avatars have a variety of abilities that can be activated during combat. They need to activate those abilities to defeat opponents. This is an explicit rule of the game that players may choose to follow during a play session. Abilities typically have a value associated with them in terms of the output (i.e., some value representing damage to an enemy or representing healing output). They also have costs: abilities spend resources (e.g., mana, energy) to activate, or depend on a "cooldown" (a timer regulating the subsequent activation of an ability). These are all operational mechanics embedded in the game.

The objective of some emergent gameplay, then, is to determine the ideal cost-to-benefit ratio of different combinations of mechanics within the chosen rule set. In these cases, high-performing players will calculate the output relative to the costs and cooldowns to maximize their avatar's output depending on the rule-set. The maximum-efficiency rotation may be challenged by other constraints in combat encounters in the game (e.g., mechanics of a specific dungeon boss), and there is often room for improvisation in the case of unexpected events in encounters. In this case, players are integrating known information from the explicit rules and theorized information from the implicit mechanics, and making judgments in real time in response to gameplay events.

The various emergent courses of action may be substantially responsible for what makes gameplay enjoyable. This may be the feeling of flow—a highly immersive and pleasurable state that arises during challenging gameplay (Sherry, 2004). Overcoming challenges are a primary reason that people play games (Sherry, Lucas, Greenberg, & Lachlan, 2006), and rules and mechanics function together as the building blocks for these challenges. Another form of emergent play may manifest in player-crafted variations on rules and mechanics. First, where rules are not enforced by mechanics, rules may be bent according to standards agreed-upon by players. Bobby Fisher famously revised chess in this manner so that the game mechanics were changed for a different chess experience. Fisher's *Chess960* features the same rules (piece movements, turn-taking, and winning conditions) as traditional chess, but the order of pieces in the back row is randomized (Milener, 2005). Young children often make up their own rules for games, just as a four-year old might devise a unique mechanic to his version of chess: if a player's pieces are all turned backward, the other player can move as many of their pieces to any position they desire because "the other pieces aren't looking." In this manner, the avatar-enacted rules are not restricted by the code itself, but by the instructions the players choose to follow.[1] Considering mechanics, however, avatar behaviors must adhere to the encoded constraints (see Kudenov, this volume), unless the player performs significant modding of the game code to play a digital game outside of the boundaries of the game rules (Stevens & Limperos, this volume).

AVATAR CONTROL AND PARAMETER LITERACIES

The preceding sections defined game rules and mechanics, and explained how they are independently and cooperatively integral parts of how games are played. Of importance, here, is that rules are breakable social agreements and mechanics are (generally) unbreakable technical parameters for interactivity. One important subset of mechanics is integral to how players can maneuver avatars in a digital game environment. Avatar control mechanics are unique in that they directly govern a game's interactivity—although other game mechanics also influence interactivity, avatar control mechanics directly influence the extension of player agency into a gameworld via alignments between players' physical actions and avatars' digital actions. Because these affordances and constraints dictate how players engage avatars, and in turn how avatars interact with their digital world, avatars are largely presented to the player on the game's terms. Thus, in working to understand the role of avatars in players' lives, it is vital to consider how the technical systems covered here, and in the remainder of this volume, give rise to the experiences that players have (Bogost & Montfort, 2009).

In this control framework for avatars, rules and mechanics may inform each other—for instance, implicit mechanics may reinforce explicit rules (as when the WoW in-game communication mechanic enforces the rule that a given avatar is not supposed to talk to one in the opposing faction) and rules may help make sense of or support a key mechanic (as when rules against glitching through walls help maintain the challenge of reaching certain areas of a game). As such, a sophisticated understanding of avatar controls requires a certain level of *literacy* of both rules and mechanics, as well as an *ability* to act on that literacy to appropriately select and input commands.

For example, consider someone who did not have videogames systems in the house as a child. That person might go to a friend's house and be invited to play but get frustrated when unable to pass the first stage: approach a pit, walk up, press right, and jump into the pit instead of over the pit. Such a scenario may emerge because of a deficiency in literacy, as the player never learned a basic control mechanic common to many action games (running) and so was unable to overcome a deficiency in ability. In *Super Mario Bros.* games, if the player wants the avatar to run, the player must press and hold the B-button while pressing the D-pad in the desired direction so that the avatar gets an extra boost of speed required to clear the pit. While the mechanic in this instance (a requirement for enough speed to clear a gap) is implicit and enforced by the game, once a player learns the parameters for successful control, it becomes explicit through the literate translation of the operational framework to actual operation.

Research has begun to look at control in games and how control mechanics are learned. For example, McGloin, Krcmar, and Fishlock (2015) studied how players learn to shoot guns in first-person shooter games by relying on previously learned mental models. This action mapping lets players use mental models from other, often real world, situations and apply that knowledge to digital avatar control. There is also evidence that an inverse form of learning and translation may occur as well. That is, players are learning mechanics from controlling their avatars, and bringing those learned functions into analog situations including learning cultural heritage (Raptis, Fidas, & Avouris, 2016), pilot training (Kortelling, Helsdingen, & Sluimer, 2016), numerical-spatial relationships (Laski & Seigler, 2013), and laproscopic surgery ability (Rosser et al., 2007).

In these ways, there are some exciting consequences that suggest fruitful pathways for game-based learning such that game avatars may actually make very good teachers. Specifically, if avatars function according to "ought" rule frameworks and "must" mechanics frameworks, but only through individual degrees of creativity, literacy, and ability, the ways that players learn to control their avatars as a key function of gameplay, then the avatar may be a primary place to investigate how learning works in constrained contexts.

Model matching (Boyan & Sherry, 2011) is a theoretical perspective arguing that game structures make better learning environments due to the way that they teach game rules and suggest mechanics as frameworks for interacting with the game (Gee, 2007). According to model matching, players build mental models of the game rule- and mechanic-systems within the gameworld, and then run a check on their mental model by playing in the manner they think will be effective (Wasserman & Banks, 2017). Players ostensibly refine their models each time they fail or succeed (i.e., develop a more evolved literacy), testing and restructuring their mental models of the interplays of rules and game mechanics through direct experiences (Blumberg, Rosenthal, & Randall, 2008). When an experienced gamer picks up a new *Super Mario Bros.* (1985) game, they likely execute common Mario avatar movements to get a feel for the mechanics of the game. How far does Mario jump? How fast does Mario run? What can he do while airborne? Players run checks of new gameplay sessions against their existing models of previous *Super Mario Bros.* iterations. In doing so they build new mental models of how the new game functions mechanically through direct experience and control of their avatar.

It is possible, then, to think of avatars as tools for experimenting with mental models and, thus, vehicles for learning and skill development. To achieve ideal gameplay outcomes, a player must (a) draw on existing knowledge (mental models) about how worlds in general work, (b) experiment with that model how a given gameworld and avatar work, (c) adjust the mental model based on that experimentation, and (d) repeat and refine. Importantly, the avatar is the tool for this process, so parameters for controlling the avatar are effectively the parameters for learning. In games intended for learning (or games where learning is a natural outcome) it is possible and perhaps prudent to embed rules and mechanics in avatars that the game developer wishes the player to learn such that the avatar "teaches" the player a rule or mechanic, or presents a framework for learning to creatively combine rules and mechanics to solve challenges.

In considering avatars as teachers, one of the consequences of the model matching perspective is that it suggests understudied pathways for game-based learning. Traditional models of game-based learning rely on traditional media effects theories to explain how media audiences take in media content. Social cognitive theory is a commonly applied framework for explaining how players learn various game-related behaviors through observing a behavioral model (Bandura, 1986; e.g., DeWall, Anderson, & Bushman, 2011). Although there is likely some social learning occurring in gameplay, focusing on how players learn mechanics through literacy- and ability-based avatar control shifts the notion's applicability—players are not merely passively observing avatars, but are engaged in actively controlling them. Players are not just watching an avatar run faster to make a longer jump, nor are they running and jumping, but they are testing whether the

particular mechanics work in a particular way, and are not just doing so according to social norms but through voluntary adoption of a game's rule set. They test and retest, refine and perfect through active and voluntary repetition (Gee, 2007). In this way players are engaging in direct learning rather than only observational. These dynamics—these explicit actions within implicit frameworks—may suggest a need to shift the game-based learning paradigm from one of social learning to one of active, voluntary, *avatarial* learning.

NOTE

1. According to Costikyan (2005), this is how game genres are populated historically: "one novel product establishes a new gameplay dynamic, that is, a collection of mechanics, or a genre—and many games shortly appear exploiting and slightly extending that genre" (p. 2).

REFERENCES

Avedon, E. M. (1971). The structural elements of games. In E. M. Avedon & B. Sutton-Smith (Eds.), *The study of games* (pp. 419–426). New York: John Wiley and Sons.

Bandura, A. (1986). *Social foundations of thought and action. A social cognitive theory.* Englewood Cliffs, NJ: Prentice Hall.

Blizzard (2012). World of Warcraft terms of use. Retrieved from: <http://us.blizzard.com/en-us/company/legal/wow_tou.html>

Blumberg, F. C., Rosenthal, S. F., & Randall, J. D. (2008). Impasse-driven learning in the context of video games. *Computers in Human Behavior, 24*(4), 1530–1541.

Bogost, I., & Montfort, N. (2009). Platform studies: Frequently questioned answers. *Digital Arts and Culture 2009.* UC Irvine: Digital Arts and Culture 2009.

Boyan, A., & Sherry, J. L. (2011). The challenge in creating games for education: Aligning mental models with game models. *Child Development Perspectives, 5*(2), 82–87.

Bulling, A., Roggen, D., & Tröster, G. (2008). Eyemote—towards context-aware gaming using eye movements recorded from wearable electrooculography. In P. Markopoulos, B. de Reyter, W. IJsselsteijn, & D. Rowland (Eds.), *Fun and Games* (pp. 33–45). Berlin: Springer.

Costikyan, G. (2005). Game styles, innovation, and new audiences: An historical view. In *Proceedings of DiGRA 2005 Conference: Changing Views—Worlds in Play.*

Cook, (2006, Oct. 23). What are game mechanics? *Lost Garden* [blog]. Retrieved from: <http://www.lostgarden.com/2006/10/what-are-game-mechanics.html>

DeWall, C. N., Anderson, C. A., & Bushman, B. J. (2011). The general aggression model: Theoretical extensions to violence. *Psychology of Violence, 1*(3), 245–258.

Gee, J. (2003). *What video games have to teach us about learning and literacy,* 2nd Ed. New York: St. Martin's Press.

Greeno, J.G. (1994). Gibson's affordance. *Psychological Review, 101*(2), 336–342.

Hypertextbook.com. (2017). Retrieved January 3, 2017 from: <http://hypertextbook.com/facts/2007/mariogravity.shtml>

Korteling, H. J., Helsdingen, A. S., & Sluimer, R. R. (2016). An empirical evaluation of transfer-of-training of two flight simulation games. *Simulation & Gaming, 48*(1), 8–35.

Koster, (2011, Dec. 13). Rules versus mechanics [blog post]. Retrieved from: <http://www.raphkoster.com/2011/12/13/rules-versus-mechanics/>

Laski, E. V., & Siegler, R. S. (2014). Learning from number board games: You learn what you encode. *Developmental Psychology, 50*(3), 853.

McGloin, R., Farrar, K. M., & Fishlock, J. (2015). Triple whammy! Violent games and violent controllers: Investigating the use of realistic gun controllers on perceptions of realism, immersion, and outcome aggression. *Journal of Communication, 65*(2), 280–299.

Milener, Gene (2006). Play stronger chess by examining Chess960: Usable strategies of Fischer Random Chess discovered. Castle Long Publications.

Mendels, P., & Frens, J. (2008). The audio adventurer: Design of a portable audio adventure game. In P. Markopoulos, B. de Reyter, W. IJsselsteijn, & D. Rowland (Eds.), *Fun and Games* (pp. 46–58). Berlin: Springer.

Piselli, P., Claypool, M., & Doyle, J. (2009, April). Relating cognitive models of computer games to user evaluations of entertainment. In *Proceedings of the 4th International Conference on Foundations of Digital Games* (pp. 153–160). New York: ACM.

Problem Machine (2003, May 27). Rules vs mechanics. *Problem Machine* [blog]. Retrieved from: <https://problemmachine.wordpress.com/2013/05/27/rules-vs-mechanics/>

Raptis, G. E., Fidas, C. A., & Avouris, N. M. (2016, October). Do field dependence-independence differences of game players affect performance and behaviour in cultural heritage games? In *Proceedings of the 2016 Annual Symposium on Computer-Human Interaction in Play* (pp. 38–43). New York: ACM.

Rosser, J. C., Lynch, P. J., Cuddihy, L., Gentile, D. A., Klonsky, J., & Merrell, R. (2007). The impact of video games on training surgeons in the 21st century. *Archives of Surgery, 142*(2), 181–186.

Salen, K., & Zimmerman, E. (2004). *Rules of play: Game design fundamentals.* Cambridge, MA: MIT Press.

Sherry, J. L. (2004). Flow and media enjoyment. *Communication Theory, 14*(4), 328–347.

Sherry, J., Lucas, K., Greenberg, B., & Lachlan, K. (2006). Video game uses and gratifications as predictors of use and game preference. *Playing video games: Motives, responses, and consequences* (pp. 213–224). Mahwah, NJ. Lawrence Erlbaum.

Sicart, M. (2008). Defining game mechanics. *Game Studies, 8*(2). Retrieved from: <http://gamestudies.org/0802/articles/sicart>

Wasserman, J. & Banks, J. (2017). Details and dynamics: Mental models of complex systems in game-based learning. *Simulation & Gaming* [online first]. doi: 1046878117715056.

Yee, N. (2006). Motivations for play in online games. *CyberPsychology & Behavior, 9*(6), 772–775.

Zagal, J. P., Rick, J., & Hsi, I. (2006). Collaborative games: Lessons learned from board games. *Simulation & Gaming, 37*, 24–40.

Achievements & Levels

Building Affirmational Resources

JOHN A. VELEZ

Even occasional gamers can recall moments of pure excitement after beating a videogame challenge—the thrill of colors flashing, points racking up, or an inventory overflowing. A game's ability to evoke those feelings of elation after finally overcoming a seemingly insurmountable challenge determines its place among gaming classics. *Super Mario Bros.* (1985), for example, provides a mix of excitement, relief, and pride after the final jump in a series of improbable leaps to reach the flagpole. The fruit of these achievements, broadly defined here as rewards for completing or making significant progress toward a goal, almost always manifests through a change in an avatar's appearance, a medal added to an avatar's trophy room, or a piece of loot dropped into an avatar's item slot. The various types of achievements earned by players can take on different meanings as they define a game's experiences and shape players' memories. In this way, achievements accumulated across avatars and their games are frequently imbued with unique memories and feelings (Wulf, 2016).

Often these achievement-related feelings and experiences come in handy when we are not feeling like our usual selves. For example, beating other racers in *Mario Kart Wii* (2008) can relieve a bad mood by simply distracting you from its cause (Rieger, Wulf, Kneer, Frishchlich, & Bente, 2014). Bad moods, however, come in all shapes and sizes—a bad mood caused by a low test grade is different than a bad mood caused by a tumultuous breakup. The former can make you question your overall intelligence while the latter can make you feel unworthy of positive, caring relationships. Current understandings of how people use videogames

to deal with bad moods outline two (possibly concurrent) methods. People can take solace in the distracting qualities of videogames and/or substitute feelings of inadequacy with videogame successes (see Reinecke et al., 2012). However, we currently take a "one size fits all" approach when it comes to videogames' potentials to deal with most, if not all, types of bad moods. Furthermore, the current methods of using videogames to deal with bad moods may be considered maladaptive because, although they may eliminate a bad mood, they do little to eliminate the causes of a bad mood; this leaves people vulnerable to encountering the same causes and bad moods indefinitely. Avatar-based achievements, however, can provide a wealth of *tailored* resources for coping with specific causes of bad moods in positive and constructive ways.

WHAT IS AN "ACHIEVEMENT?"

Achievements can be understood as having two components: objective and subjective. Objectively speaking, achievements are rewards that players receive via avatars for completing or making significant progress toward a goal defined by a videogame. However, for an achievement to qualify as a potential resource for mood repair, the reward must subjectively represent satisfying progress for the player. While achievements are often accompanied by a complex mixture of emotions, *satisfying*, in this context, is any goal progress that evokes a sense of pride and competency in players (see Tamborini, Bowman, Eden, Grizzard, & Organ, 2010). Achievements can take many forms for players, ranging from fulfilling predefined game goals such as completing the Pokédex in *Pokémon Red* and *Blue* (1998) to personally defined goals such as beating a previous best score. Naturally, these formal and personal achievements are not mutually exclusive considering that a complete Pokédex is undoubtedly a personal victory for many and beating your personal record in the trivia game *Gimme Five* (2017) fulfills the goal requirement for the Personal Best achievement. However, a common thread among these achievements is that players sense a satisfying change in their videogame skills that surpasses their previous state or status quo.

A typology of achievements that organizes common *rewards* for progressing toward or reaching videogame goals is useful for illustrating how specific, avatarbased achievements can serve as tailored coping strategies. Although making satisfying progress toward personal goals is similarly effective as a coping strategy, the variation in personal goals across gamers makes it less productive to organize them as a systematic framework aimed at connecting achievements and mood repair. However, three achievement categories present a fairly comprehensive starting point to begin identifying ways that avatars signify satisfying progress: transformation, prestige, and feats.

Transformation achievements are changes to an avatars' body and its inherent capabilities to effectively overcome videogame challenges. For example, many achievements result in a visible *physical transformation* that changes the appearance of an avatar. Digimon (the less popular cousin of Pokémon) are digital monsters that change in physical appearance through a process called Digivolution. Players in *Digimon World* (2000) must raise and train their Digimon to take on more evolved life forms with special attributes (e.g., Gabumon digivolves into Garurumon and gains rare-metal fur and blades). Many transformations involve increases to previous skills or inherent attributes like strength but do not always manifest visibly. As in the *Dark Souls* franchise (2011), players can add points to predefined attributes such as vitality (i.e., a character's health points; see Lynch & Matthews, this volume) without a physical change in the avatar's appearance. This can be classified as an *attribute transformation*.

A second major type of videogame achievement can be called **prestige** achievements—accolades that represent the time and energy spent on some aspect of a videogame or a collection of related achievements. *Badges of honor* visually distinguish avatars of players who have earned more special achievements. For instance, a distinction is bestowed upon *Halo 3* (2007) players with 49 of the 79 possible achievements, which is represented by a solely decorative Katana affixed to the avatar's back. *Awards* are distinctions representing a completed achievement such as the Best of the Best trophy that adorns the trophy room of players who have won the Women's International Cup tournament in *FIFA 17* (2016). *Levels* (sometimes referred to as Ranks) represent interval increases toward an avatar's full potential and are often accompanied by points or currency to be spent on customizing the direction of a character's progress. For instance, the World War I-themed *Battlefield 1* (2016) awards players with war bonds for each promotion to a higher military rank.

In many cases, the main reward for an achievement comes in the form of a *dropped item* or an *unlocked game element* that represents goal progress or completion. **Feats** are acts that demonstrate a player's boldness and skills such as defeating a boss, completing a quest, or accomplishing either one in an extraordinary manner (e.g., in a short amount of time). Items dropped or received for a feat often consist of a weapon, a piece of armor, or any material or immaterial object that augments an avatar's ability to progress through the videogame. For example, the Ocarina of Time (i.e., a magical musical instrument) greatly increases Link's special abilities and is only accessible after collecting three spiritual stones and traveling to Hyrule Castle (*The Legend of Zelda: Ocarina of Time*, 1998). Many videogames unlock features after significant progress is made, giving players new gameplay experiences; for instance, *Mario Kart Wii* unlocks different maps, characters, and karts when players reach certain milestones.

It is important to note that if a player does not take pride in or feel exceptionally competent about attaining an achievement then its potential to serve as a coping strategy is greatly reduced. That is, a player must feel pride in their new physical appearance, their badge of honor they put on display, or their newly collected item. Players can also feel competent knowing their avatar can now easily dispatch previously troublesome enemies due to heightened attributes or knowing a new item makes an unbeatable boss beatable.

VIDEOGAMES, AVATARS, AND REPAIRING BAD MOODS

Bad moods are a fact of everyday life. No one is immune from an occasional bad mood and everyone has their preferred methods for dealing with them. However, what is a bad mood, exactly, and what are their common causes? Mood Management Theory (MMT; Zillmann, 1988a) provided the first conceptualization of bad moods and how they influence our media choices (Zillmann, 1988b). In essence, MMT suggests that people prefer media (consciously or unconsciously) that distract us from bad moods and prolong good moods. The cause of a bad mood is conceptualized as the under- or over-stimulation of the sympathetic nervous system that essentially controls the body's unconscious "fight or flight" responses. Someone who is overstimulated is considered to be *stressed* while someone who is understimulated is suffering from *boredom*. However, the theory is less clear about specific causes of stress or boredom and simply states that a "noxious, aversive stimulation of any kind" (Zillmann, 1988a, p. 148) can lead to a bad mood.

Early research on non-interactive media provided support for MMT (see Zillmann, 1988b) but the theory struggled when applied to the vast potential for videogames to manage moods. The proposed main benefit of videogames was their potential to absorb and distract players from bad moods given their high demand for attentional resources (Bowman & Tamborini, 2012)—you have to pay attention to play. Consider how absorbed and oblivious to surroundings you become when playing a fun videogame—the task and/or narrative demands your attention and energy to make progress in the game. However, when players are in a bad mood, the high demands of videogames can actually *worsen* a mood. As such, players have been found to prefer more intermediate levels of demand when playing videogames (Bowman & Tamborini, 2012). Although not entirely inconsistent with MMT, the findings suggested the theory was not proficient in explaining the potential for videogames to help players recover from bad moods.

More recently, researchers have expanded the causes of bad moods to include thwarting of innate and intrinsic needs universal to all humans. Self Determination Theory proposes that everyone must feel competent, autonomous, and socially connected to be psychologically healthy (Deci & Ryan, 2000). Relevant to

videogames, researchers have shown that bad moods specifically caused by feeling incompetent and not feeling autonomous can be reversed by playing videogames (Reinecke et al., 2012). That is, feelings of incompetence and lack of control can be restored through gameplay. This diverged from MMT's emphasis on distracting people from bad moods and suggested people may also reverse the specific effects of a bad mood. What is not quite understood, though, is whether and how avatar-based achievements might play a role in mood repair, and whether they can be used to cope with the nuances of bad moods.

ACHIEVEMENTS AND COPING WITH BAD MOODS

Self-Affirmation Theory is a useful theoretical framework for understanding how avatar-based achievements can be utilized as coping strategies, that may dissipate bad moods and help players avoid the causes of bad moods in the future. Thus far, bad moods have been conceptualized as the under- or over-stimulation of the sympathetic nervous system and the thwarting of innate and intrinsic human needs. How might SAT further expand these previous conceptualizations of bad moods?

Steele purported that we all have a desire to view ourselves as "competent, good, coherent, unitary, stable, capable of free choice, [and] capable of controlling important outcomes" (1988, p. 262). In other words, we like to think of ourselves as generally good and worthy people. SAT suggests this holistic perception of the self can be called our global self-integrity, which is comprised of many domains that sustain and uphold it (see Sherman & Cohen, 2006). That is, there are many areas of our lives that define us and our self-worth. We may identify as a "gamer" and take pride in our ethnic culture while also valuing academic success and maintaining a strong religious or moral foundation in our lives. All of these domains are individually tied to our global self-integrity and nourish a healthy, positive view of the self.

However, given the vast scope of this overarching self-view, we may experience several daily threats to the structure of our global self-integrity. For example, we may realize our gaming skills have gotten rusty, experience racial discrimination, perform poorly on an exam, or realize we inadvertently cut in line at the gas station. A threat to even one of these valued aspects of our lives can throw our global self-integrity into disarray. As a result, we instinctively engage in defensive coping strategies aimed at protecting our global self-integrity such as discrediting a threat and generally avoiding its implications for our sense of self-worth (see Vaillant, 1993). For instance, after receiving a poor exam score, people may discredit the exam as unfair or avoid thinking about its consequences. These defensive coping strategies are similar to the previously discussed methods of dealing with bad moods through videogame play such as distracting ourselves (MMT)

or avoiding the implications of the bad mood by reversing its effects instead of reversing its cause.

SAT proposes a more beneficial coping strategy. If one self-image that is important to our global self-integrity is threatened then SAT suggests that bolstering a different but equally important self-image domain can reduce the threat and provide a buffer against its negative effects (Steele, 1988). In essence, feeling accomplished or reaffirmed in a different but important aspect of our lives reminds us that our global self-integrity does not solely depend on *one* self-domain (e.g., the self-image under threat). The result is twofold. Not only should this affirmation alleviate a bad mood (i.e., feeling stressed; Creswell et al., 2005) but it should go one step further by allowing us to examine and consider the cause of the bad mood. By reducing the threat without discrediting or denying the cause, an affirmational coping strategy presents the opportunity for us to address the bad mood *and* its cause (see Sherman, 2006). Returning to the bad test grade example, an affirmational coping strategy would allow us to determine the problematic causes (e.g., poor study habits) and take steps to ensure it does not occur again (e.g., prioritizing study time).

Videogames play an important role in millions of lives across the globe and many identify as "gamers" who value that self-image domain. Thus, for those whose self-image as a skilled gamer is important to their global self-integrity, performing well during videogame play can be an affirmational resource for adaptive and positive coping strategies. In a recent study (Velez & Hanus, 2016), college students who received a low score on a fake intelligence test subsequently rated the test as less credible and even attempted to bolster self-perceptions of intelligence to counteract the threat (i.e., defensive coping strategies). However, after the intelligence threat, some people who played a videogame and received positive feedback (i.e., accumulating more points than the average of previous players) showed substantially decreased defensive reactions. These players rated the test as more credible and lowered self-perceptions of intelligence, which suggests the positive videogame feedback re-affirmed students' global self-integrity making them more open to contemplating the implications of the intelligence test. In line with SAT, only students who rated success in videogames as an important and valued aspect of their identities experienced the reduction in defensive strategies.

SAT introduces another expansion regarding the definition of a bad mood and how media can be used to cope with them. A cause of bad moods in the context of SAT is the cognitive dissonance (i.e., uncomfortableness) we experience after receiving negative information about a self-image domain, which threatens our global self-integrity and results in urges to reduce and diffuse the threat. However, the research suggesting that successful gameplay can affirm a player's global self-integrity does not fully appreciate the different types and implications of avatar-based achievements. A more nuanced examination of achievements and their potential to reaffirm peoples' global self-integrity in light of different

self-threats is warranted, especially in terms of how these achievements may be manifested in and reinforced by videogame avatars.

AVATARS' POTENTIAL ROLE IN ACHIEVEMENT-BASED SELF-AFFIRMATION

The main proposition of the current chapter is that different types of avatar-based achievements can be used to bolster different areas of players' global self-integrity. Avatars are, perhaps, one of the most effective tools for delivering these boosts to players' valued self-images. The connection between a player and her/his avatar during gameplay is a unique bond that can graft an avatar's persona to a player's self-image if only temporarily (Klimmt, Hefner, & Vorderer, 2009). The self-image of the player that is altered by this bond depends on both the "out of the box" persona given to the avatar and, more importantly, the persona developed by the player. By steering the avatar toward certain quests, challenges, story paths, and achievements, players can choose which aspects of an avatar are transferred over to their own self-images. Remember that achievements are objective and subjective perceptions of satisfying progress toward goals that players can take pride in and feel competent about. Avatar-based achievements should, therefore, bolster different areas of importance to our global self-integrity and, depending on the self-threat, players may strive for specific achievements in an effort to reduce and diffuse a self-threat.

The various avatar-based achievements targeted by players looking to buffer their global self-integrity depend on each players' constellation of valued self-images. Although the domains of each person's global self-integrity are unique, much of the previous SAT research has examined general areas of importance that are applicable to most people (Allport, Vernon, & Lindzey, 1960). These areas can provide a starting point for specifying areas players may seek to bolster when another area is threatened. These areas can be characterized as theoretical (valuing the discovery of truth), economic (valuing efficiency and being pragmatic), aesthetic (valuing creativity, form, and harmony), social (valuing positive relationships), political (valuing power and influence), and religious (valuing unity and comprehension of life's meaning). Therefore, after a tumultuous breakup, a player whose identity and self-worth also relies heavily on aesthetics may spend a substantial amount of time attempting a physical transformation achievement or attaining a dropped item that completes an attractive set of armor. If economics are valued, one may attempt a feat achievement that involves completing a speed run of *Dark Souls III* (2016). If a player is not doing well in school, then attempts at feat or prestige achievements that signify commitment to helping teammates may self-affirm the social area. For example, players may play as the healing character Mercy in the team-based *Overwatch* (2016) that results in medals or the coveted "Play of the Game" for healing others. Someone who is

worried about a recent immoral decision may attempt level achievements to feel powerful (i.e., the political area). Regardless of the domain affirmed, players should be able to address the actual cause of the bad mood in addition to feeling relieved.

It is important to note that attempting to boost or affirm the same self-image that was threatened is likely to intensify the negative effects of the threat (e.g., defensive coping strategies; Aronson, 1992). In essence, it would likely remind players of the previous threat and make them feel even more insecure about that self-image. Therefore, players are likely to avoid videogame achievements that remind them of the previously threatened self-image (see Aronson, Blanton, & Cooper, 1995), similar to the behavioral affinity proposition of MMT. Another important stipulation is that SAT processes may also backfire if the boosted self-image is not valued to a similar degree as the threatened self-image. In the one study that examined SAT with videogames (Velez & Hanus, 2016), those who did not value videogame success as an important aspect of their identity actually reported increased defensiveness reactions to the bad test score. It is likely that boosting a self-image that is not similarly valued only emphasizes the importance of the recently threatened and highly valued self-image.

In sum, avatars can be viewed as collections of image domains that can be grafted onto a player's own identity. Players simply need to choose an achievement that reaffirms a valued domain but is unrelated to a previously threatened domain. In this way, videogame avatars may be the most versatile resource for self-affirmation processes in players.

REFERENCES

Allport, G. W., Vernon, P. E., & Lindzey, G. E. (1960). *Study of values: A scale for measuring the dominant interests in personality* [manual]. Boston: Houghton Mifflin.

Aronson, E. (1992). The return of the repressed: Dissonance theory makes a comeback. *Psychological Inquiry, 3*(4), 303–311.

Aronson, J., Blanton, H., & Cooper, J. (1995). From dissonance to disidentification: Selectivity in the self-affirmation process. *Journal of Personality and Social Psychology, 68*(6), 986–996.

Bowman, N. D., & Tamborini, R. (2012). Task demand and mood repair: The intervention potential of computer games. *New Media & Society, 14*(8), 1339–1357.

Creswell, J. D., Welch, W. T., Taylor, S. E., Sherman, D. K., Gruenewald, T. L., & Mann, T. (2005). Affirmation of personal values buffers neuroendocrine and psychological stress responses. *Psychological Science, 16*(11), 846–851.

Klimmt, C., Hefner, D., & Vorderer, P. (2009). The video game experience as "true" identification: A theory of enjoyable alterations of players' self-perception. *Communication Theory, 19*, 351–373.

Rieger, D., Wulf, T., Kneer, J., Frischlich, L., & Bente, G. (2014). The winner takes it all: The effect of in-game success and need satisfaction on mood repair and enjoyment. *Computers in Human Behavior, 39*, 281–286.

Reinecke, L., Tamborini, R., Grizzard, M., Lewis, R., Eden, A., & Bowman, N. D. (2012). Characterizing mood management as need satisfaction: The effects of intrinsic needs on selective exposure and mood repair. *Journal of Communication, 62*(3), 437–453.

Deci, E. L., & Ryan, R. M. (2000). The "what" and "why" of goal pursuits: Human needs and the self-determination of behavior. *Psychological Inquiry, 11,* 227–268.

Sherman, D. K., & Cohen, G. L. (2006). The psychology of self-defense: Self-affirmation theory. In M. P. Zanna (Ed.), *Advances in experimental social psychology* (Vol. 38, pp. 183–242). San Diego, CA: Academic Press.

Steele C. M. (1988). The psychology of self-affirmation: Sustaining the integrity of the self. In L. Berkowitz(Ed.), *Advances in experimental social psychology* (pp. 261–302). New York: Academic Press.

Tamborini, R., Bowman, N. D., Eden, A., Grizzard, M., & Organ, A. (2010). Defining media enjoyment as the satisfaction of intrinsic needs. *Journal of Communication, 60*(4), 758–777.

Vaillant, G. (1993). *The wisdom of the ego.* Cambridge, MA: Harvard University Press.

Velez, J. A., & Hanus, M. D. (2016). Self-affirmation theory and performance feedback: When Scoring High Makes You Feel Low. *Cyberpsychology, Behavior, and Social Networking, 19*(12), 721–726.

Wulf, T. (2016, June). Play it again?! Nostalgia and the motivation to re-play video games. *Paper presented at the 65th Annual International Communication Association Conference.* Fukuoka: Japan.

Zillmann, D. (1988a). Mood management through communication choices. *American Behavioral Scientist, 31*(3), 327–340.

Zillmann, D. (1988b). Mood management: Using entertainment to full advantage. In L. Donohew, H. E. Sypher, & E. T. Higgins (Eds.), *Communication, social cognition, and affect* (Vol. 31, pp. 147–171). Hillsdale, NJ: Erlbaum.

Spells & Statistics

Inside the Black Box

CHRISTOPHER A. PAUL

As detailed throughout this book, both developers and players are presented vast options for avatar customization when they start designing or playing videogames. Developers get to set the initial terms for avatar creation and typically offer players all kinds of options for players to develop their own representations in a game. Increased computing power, combined with industry trends toward photorealism in graphics, present players with a dizzying array of choices to make about everything from what an avatar looks like to how it plays out in practice. *World of Warcraft* (WoW; 2004), for instance, lets players customize both their physical incarnation, and also their race, class, spells, and talents. *NBA 2K16* (NBA2K; 2015), like most sports games, includes a MyPLAYER mode that allows players to create ball-player characters, selecting their height, weight, skin color, tattoos, clothing, position, and key basketball attributes. The part deck building, part battle arena game *Clash Royale* (CR; 2016) strips down player choice even further, as players are left with choices about what cards to include in their deck and considerations to make about how they spend their resources, like gold and gems, but no options about their appearance in the game, beyond their player and clan names.

Effectively these choices fall into two categories: representational issues that are about graphics and how the player is represented in the game (like skin color, vocal presentation, or the skin selected in a game like *League of Legends* [2009]) and choices that impact gameplay after character selection (class or race in WoW; height, weight, and basketball skills in NBA2K; cards included in a *Clash Royale* deck). This chapter focuses on that latter group of choices, the decisions that

impact how a game plays out in practice, which are colloquially the "spells" of a game. These spells are the options and choices players can make about what their characters do and how their avatar interacts in the game environment. In an effort to optimize their choices, players turn to statistics, which can be best seen in the player-originated practice of "theorycraft" where players play a metagame, or "meta," that is now part of every large-scale game. Theorycraft is an analytical construct, a practice of using statistics and data analysis to derive the optimal approach to play. The point of a metagame is to figure out how the base game works and to exploit any inefficiency in its design. Metagaming is a social process, one where spells and statistics come together to take the vast universe of choices and pare them down to an instructive guide of what is best.

Game designers and developers use spells, abilities, and other design decisions to expand the range of choices and options for players, adding depth and verisimilitude to the gameworld. Players address those options by developing their own take on the game by weeding out some of the options to develop a meta that answers the central question: what decisions should I make to maximize my chance of success? Suddenly the possible is stripped down into a limited group of directives about the choices players should be making and a set of instructions about what they should be doing. This process is normative, as players who are either ignorant or dismissive of the meta are marginalized for their lack of knowledge, skill, or compliance to accepted standards. There are also places, particularly in multiplayer games like *Clash Royale*, where making decisions orthogonal to the meta can be a successful strategy in its own right. The impact of optimization in play has been analyzed some by academics (e.g., Paul, 2011) and is frequently discussed by players, but perhaps the best way to recognize how statistics impact spells is to examine three very different games and how the meta in each of them impacts their design and play to effectively limit the available choices made by many of the most competitive players.

WORLD OF WARCRAFT AND THE EMERGENCE OF METAGAMING

Blizzard's *World of Warcraft* was not the game where "theorycraft" was coined—as the term actually debuted in the player community of the earlier Blizzard game *Starcraft 2* (2010)—but WoW was the place where the term took off and where the development of a metagame fundamentally impacted game design and play. WoW is a game featuring an immense community of players that peaked at about 12 million (a record at the time; Vas, 2015), a deep gameworld that players have been immersed in for more than a decade, and the dizzying array of options available to players. These conditions led to a situation where organized guidance was of great value to optimize play and to avoid paralysis of choice. Effectively building

from the highly common game walkthroughs and guides, players advanced theorycraft to solve the "black box" of each avatar class and of the game. The early design of WoW was a perfect place to advance the role of statistical analysis in playing a videogame.

The endgame of early WoW was defined by raiding, where large groups of players would work together to kill a computer-controlled monster. Raiding originated in games long before WoW, but the dynamics of raiding in WoW drove players to optimize their approach. Raids in WoW had a fixed number of people who could play together and a specific, interdependent set of roles for those players (see Milik, this volume), which made the contribution of each member of the group important. The size of the community also prompted development of large, highly competitive groups of people battling to be the first group to kill new monsters. To maximize every possible advantage, players gathered together on web forums (e.g., Elitist Jerks) to try to solve the puzzle of WoW and maximize their chances at victory. Raiding as it was designed in WoW is a perfect impetus for theorycrafting, as it is effectively a puzzle-solving exercise where there are many possible answers, but always a best answer. Blizzard frequently sought to obscure parts of the answers by refusing to fully release the full details for interactions of spells, players, and enemies, but theorycrafting led to the development of guides for what players should choose for their class, race, talents, and the order in which they should cast their spells or use their abilities. Theorycrafters sought the execution of a perfect battle, where all their choices and button presses maximized their chance at victory.

The impact of this approach normalized particular strategies and choices, either subtly or overtly encouraging raiding players to get on board and subscribe to the dominant narrative of what was in their best interests. The sophistication of player efforts, combined with a general game design interest in balancing various approaches, led to a back-and-forth game between players and designers, where players would solidify around a set of strategies only to find them altered in the next update of the game. The importance of theorycrafting to the development of WoW became even more significant as several prominent theorycrafters were added to the game design team (LurkytheActiveposter, 2015).

Faced with a universe of choices to make and buttons to push to control avatars, WoW players developed and advanced theorycrafting in an effort to get better and solve the puzzles game designers put in front of them by using avatar abilities in optimal ways. However, the eventual impact of figuring out the best approach is that it crowds out all other options, leaving players to follow a script, rather than explore the full range of choices for engaging their avatar. In the wake of WoW, the norms of theorycrafting and metagaming have crept into other games, including sports games like NBA2K.

NBA 2K16, HERO BALL, AND PERFECTING MYPLAY

Sports games are quite different than MMOs like WoW. The target audiences are often comprised of players who exclusively play sports games, which results in communities that have different norms and practices than in games like WoW or CR. Further, the point of the sports game is typically to mirror a physical-world activity, rather than develop a captivating new fantasy world. NBA2K contains a number of game options, including single-player modes, like MyCAREER and MyGM, and online, multiplayer choices like MyLEAGUE, MyTEAM, and MyPARK. Creating your own league or team enables players to play as if they are running an entire NBA franchise, while modes like MyCAREER and MyPARK use the player's avatar, which is created and advanced in MyPLAYER mode to play against computer-controlled opponents or other players. Although one could certainly argue that the creation of one's own team can fulfill the role of an avatar, the primary use of avatars in NBA2K is in the MyPLAYER mode.

When creating an avatar, players are given various different choices to make, divided among those that are cosmetic (e.g., skin color, hair style, and tattoo design) and those that have an impact on the game itself, like position and how to allocate development into traditional basketball skill categories like inside scoring, playmaking, and rebounding. Notably, decisions that may be merely cosmetic in other games, like height and weight, typically have an impact on play in sports games. In NBA2K, taller players can rebound and block shots more easily, while smaller players are more agile. Larger players can push smaller players around, while smaller players are faster and are prone to fatigue more slowly. Additional appearance options are available and they typically revolve around cosmetic items, like wardrobes, however there are also choices to be made about how your avatar is introduced and how they shoot the ball. This latter choice is simultaneously cosmetic and impacts the game, as the appearance of a jump shot impacts when a player needs to press and release buttons to maximize their chances at success.

Although players can use their avatar in a variety of different modes, it is necessary to engage in MyCAREER mode to really move one's avatar forward. The version released as NBA2K featured a special version of MyCAREER designed with a storyline directed by Spike Lee that resembled the heavily scripted kind of single-player mode that would be more frequently found outside of sports games. MyCAREER is pivotal to players trying to advance their avatar because all in-game players are restricted in how quickly their avatars can attain new skills. To move your avatar forward, players need to obtain the digital currency in the game to buy upgrades, must play a sufficient number of practices in MyCAREER mode to unlock the option to level up their skills, and need to perform certain kinds of plays in games to unlock badges to make their avatar more skilled and impactful in play.

Optimization and the meta in NBA2K comes in three predominant forms: initial choices made in character selection, how one actually plays in games as their avatar, and how players manipulate the practice system to gain additional skills. The first case of the meta taking over is in character selection, where players are asked to choose among positions and preliminary body types. This is a key decision point for players, since if they want to focus on playing against computer-controlled opponents the best choice is often to play as a center, so they can demand the ball close to the basket and dominate on defense with rebounds and blocks (Appleton, 2015). On the other hand, if players want to play in the multi-player mode they can play as a center, but are far more likely to find success playing as either a point guard or a small forward in MyPARK mode (MadCatRex, 2016). These differences are largely because of what one is able to do in the various game modes. When playing with computer-controlled teammates, players can demand the ball be passed to their avatar, immediately engaging them on offense. On the other hand, while playing with other people, an inability to get, keep, or dribble the ball is a huge disadvantage, unless one is playing with people they know to be good teammates who will pass the ball.

In the case of in-game play and practice, players seeking to progress their avatar are encouraged by the game's design to play in a particular way. Players need to balance two key dynamics: higher difficulty settings lead to more in-game currency, while the lowest difficulty settings make it easier to achieve feats in game that will get their avatar badges, which helps them do any of a number of things in the game better than they would ordinarily (Hoops Gamer, 2016). If players are seeking Victory Coins, which let them upgrade their avatar and purchase new cosmetic items, and badges, they will typically try to play in a manner resembling "hero ball" that dominates the game, scoring points, gambling for steals and blocks, and obtaining a high teammate grade through their individual effort, rather than by relying on sound basketball plays. On the other hand, if they are trying to maximize their MyPLAYER they are also placed in a situation where they must enter practices to continue to have the option to buy upgrades for their player's skills. This led to the development of a meta where the best way for players to maximize their player and become a superstar is to manipulate MyCAREER. Practices can only be entered in between games, making it important for players to move through the games as quickly as possible to register for practices that can move them forward. As fully playing through games typically takes between twenty minutes and an hour, the dominant meta for how to maximize your player's potential is to intentionally foul out of games as quickly as possible. This sabotages one's career, but it gets players into practices rapidly, where they can immediately quit and then register their progress toward their next attribute upgrade. To play better basketball, players have exploited the game design by intentionally

throwing basketball games so they can become more powerful for their games against human opponents online.

In the case of NBA2K, players have actively sought ways to advance and maximize their avatar, from choosing positions and skills to playing in a manner antithetical to good basketball to become more personally successful. Game designers set the rules for play and the players of NBA2K quickly rally online with each new release to find the holes and exploits in that design, developing a meta based on what is best for their avatar, even if it has little to do with actually playing basketball. The relentless focus on an avatar and a digital representation of self is one kind of meta, but the relationship between spells and statistics also extends into games with little apparent personalization.

CLASH ROYALE AND THE "TWISTED" META

Clash Royale is a mobile game that blends elements of a deck building card game with those of a battle arena. Players build decks of eight cards and then battle over three minutes to destroy their opponent's towers while defending their own. If they are tied when time expires they go to overtime. Destroying your opponent's central tower rewards an immediate win. Players are represented in the game with stock avatars; you always have a blue king and your opponent is always red. However, players have dozens of cards to pick from to customize their deck and effectively choose how they are represented in the game. Some players build decks designed to overpower their opponents, others choose to try to control the game, and some specialize in buildings designed to frustrate and chip away at their opponent's health. Each of these strategies has both fans and vocal opponents and, largely in the interests of personalization and identification, the game's developer has publicly stated that their intention is to arouse strong feelings and reactions in their player base (The Clash Royale Team, 2016).

Progress in the game happens in two primary ways. In the main game mode, known as the ladder, players gain and lose cups based on their victories and losses. As they accrue cups they can ascend into different battle arenas, unlocking new cards that allow them the chance for more personalization and a wider variety of options. The second mode of progress is found in upgrading cards. As players obtain more copies of cards, from opening the chests that can both come from victory and are awarded on a timer or by requesting them from one's clanmates, they can eventually level up their card, making it more powerful and giving them a greater chance at winning in future matches.

These two game design mechanics produce a highly interesting meta. First, the division into different arenas and the restrictions on access to cards means that the game effectively has what game designer Markus Montola calls a "twisted

meta." The dominant metagame is twisted because the optimal choices vary based on what cards players and their opponents are likely to have at their disposal; the meta in one arena is not likely to be the same in another. There are places where the meta solidifies, particularly among the most competitive players who all have maxed out cards (a feat that typically requires over $10,000 USD in spending) and in tournament play, where cards are limited to a lower maximum level that a much larger community of players has reached (Tassi, 2016). In the meta of CR, the top players are likely to be both more skilled than most players, but they are also actually playing a different game. The broad rules are the same, but the access to different cards and cards at different power levels means that the game changes as one moves up or down the ladder. What counts as the best meta is wildly different when the players you play do not have access to the same options as those in another bracket. Second, the act of leveling cards changes how the game works. Leveling cards is expensive, requiring substantial amounts of time or money and the ability to progress them solely based on time and effort is highly limited. Players who level their cards have an automatic advantage over those who do not. For all the exploitation of a meta that a player does, running into opponents that have either cards or a player level that is more powerful can thwart even the best of plans. Finally, the impact of the meta of CR is quite different than that of raiding in WoW because the entire game is predicated on playing against other people. Because of the head-to-head nature of battles, the meta routinely changes as any approach that becomes too dominant has a counter that will rise up to answer it. There is then a counter for that counter, so the meta is routinely changing and adjusting to prevent any one approach from becoming too dominant for too long.

CR features a less obviously visible avatar because functionally the deck become the player avatar, as the options for deck customization offer a rich set of choices for players to make about how they are represented in the game. The menu from which you choose your spells, buildings, and characters offers players a chance at customization and the design of the game exploits the presence of a meta, both expecting it and designing around it to challenge players to keep changing their approach and preventing any one style from dominating for too long.

AVATAR (AND PLAYER) IN A BOX

Whether a spell-caster in WoW, a center in NBA2K, or a deck in CR, the array of options, spells, and abilities may make it seem like avatar choice is unlimited and that players can do whatever they would like. However, the use of analytics to assess, break down, and optimize games often makes them more like solved, or presumed solved, puzzles, rather than an atmosphere for dynamic choice. Even if players do not fully understand what is going on, the perception that the meta

is the best way to play normalizes and structures choice and play. For designers and scholars, this recognition presents opportunity to think about games differently. Players are going to try to exploit every angle. They will burn through content, they will test the boundaries; scholars should be looking for and detailing those occurrences while developers need to plan for the fact that many prominent players are going to eschew any choice that is not optimal. Opportunities for multiplayer interaction give developers the opportunity to build rock/ paper/ scissors-style interactions where players can develop and prosper from countering the meta, but games focused on battling a computer-controlled opponent are all too often boiled down to a singular optimal path derived from a world of opportunity. The best spells and options are quickly determined by the statistics and the acceptance of that relationship drives developers to design around the meta and players to make choices based on it. Metagaming can be fun, but it can put all of us in quite a small box.

REFERENCES

Appleton, R. (2015, Oct. 26). A step-by-step guide to creating a monstrous MyCareer player in NBA 2K16. *Venture Beat.* Retrieved from: <http://venturebeat.com/2015/10/26/a-step-by-step-guide-to-creating-a-monstrous-mycareer-player-in-nba-2k16/view-all/>

Hoops Gamer. (2016, Apr. 18). How to upgrade your NBA 2K16 My Player fast. Retrieved from: <https://hoopsgamer.com/how-to-upgrade-your-nba-2k16-my-player-fast/>

LurkytheActiveposter. (2015, Oct. 1). Why did Elitist Jerks die out? [forum post]. Retrieved from: <https://www.reddit.com/r/wow/comments/3n4fjv/why_did_elitist_jerks_die_out/>

MadCatRex. (2016, Jan. 2). Best builds for my career and my park and pro am [forum post]. Retrieved from: <https://www.reddit.com/r/NBA2k/comments/3z6xbh/best_builds_for_my_career_and_my_park_and_pro_am/>

Paul, C. A. (2011). Optimizing play: How theorycraft changes gameplay and design. *Game Studies, 11*(2).

Tassi, P. (2016, Apr. 1). The world's best 'Clash Royale' player has spent $12K on the game, and for good reason. *Forbes.* Retrieved from: <http://www.forbes.com/sites/insertcoin/2016/04/01/the-worlds-best-clash-royale-player-has-spent-12k-on-the-game-and-for-good-reason>

The Clash Royale Team. (2016, 14 June). Emotes. *Clash Royale* [blog]. Retrieved from: <https://clashroyale.com/blog/news/emotes>

Vas, G. (2015, May 7). Why World of Warcraft lost so many subscribers. *Kotaku.* Retrieved from: <http://kotaku.com/why-world-of-warcraft-lost-so-many-subscribers-1702814469>

Class & Role

Frameworks for (Inter)Action

OSKAR MILIK

The act of playing a digital game, especially for a new player, can be an extremely difficult task. One needs to understand different components of the game: the physics, the combat, the plot, and the objectives. In multiplayer games, additional requirements are added for the understanding of social cues as they are seen in the digital realm. The player may be responsible for being able to relay and follow instructions in a group setting, for understanding and responding to communications from others, and even presenting a particular identity for others to see. In both single-player and multiplayer games, the avatar serves as a focusing lens through which an individual can perform these duties. As such, the avatar becomes a tool of interaction that frames the events that occur in-game. The character class (e.g., priest, spy, hacker) and the combat role of an avatar (the "holy trinity" of tank, support, damage) in a group context serve as interactional shorthand for an individual to be able to predict what sorts of actions they are to perform, and what sorts of behaviors others may express toward them in return. Where class establishes how an individual should interact with the gameworld, the role establishes how to act in relation to other players. At the same time, an avatar's identity may be linked to a specific social class, or may take on specific roles within an organization as the player serves functions such as human resources, organizational strategy, or logistics. Character class and role, then—as both functional and social categories—help to establish rules for how to act, shape interactions with other players, and even scaffold a gameworld's social structures.

CLASSES, ROLES, AND NORMS

The developers of digital games use ludic mechanisms to simplify a player's interaction with the gameworld and with the other players. This is particularly visible in games meant to encourage the interactions of multiple individuals simultaneously such as massively multiplayer online games (MMOs), multiplayer online battle arenas (MOBAs), and networked first-person shooters (FPSs). One such mechanism is the assignment or selection of an avatar class or role. The assignment of classes (archetypes of character traits) such as "warrior" or "sniper" gives the avatar specific abilities and skills allowing them to interact with non-player characters (NPCs) and entities within the game environment. Classes and their labels vary by the theme and structure of a game; for instance, fantasy roleplaying games often feature mages and warrior classes (e.g., *Final Fantasy XIV*, 2013) while superhero-themed games may identify class by a types superpower (e.g., Fire, Earth, or Atomic, as in *DC Universe Online*, 2011). Roles (the equivalent to an in-game "job"), on the other hand, help to define how an avatar is intended to interact with other avatars. For instance, most multiplayer games rely on the trio of tanks (survivable avatars that draw enemy aggression), healers (relatively weak avatars that heal teammates), and damage-dealers (variably strong avatars intended to inflict larger amounts of damage to enemies; Rowlands, 2012) but can also include such roles as off-tanks and support. By giving players a very specific set of parameters that define how the avatar is intended to act, the developer can direct action without necessarily controlling every behavior. For example, certain MMO encounters force players to move to avoid effects cast by enemies; players, then, can move the avatar as intended, or fail to move and the avatar takes damage.

The purpose of class distinctions in the creation and application of an avatar is relatively straightforward. Character classes have certain consistent features among games and even genres and can be tied directly to different types of gameplay. In any context, for instance, a "sniper," due to shared cultural understandings gained through film, books, and even games, can be assumed to have several play-defining features. They should engage enemies from a distance, they should be extremely accurate, and they should only be able to perform a single attack action a time. Any avatar that is given the "sniper" classification can be seen to follow these rules, whether it is the hunter class's marksman specialty in *World of Warcraft* (WoW; 2004), or the Sniper in *Team Fortress 2* (2007). These class characterstics are useful for the new player, who can immediately enter a gameworld with a "class fantasy" in mind, and engage with the game without having to deeply unpack each character class.

The purpose of a role, when assigned to an avatar, is similar to that of class, but aimed specifically at organized group play. When performing solo-player activity in WoW, there is no need to differentiate between a warrior who is a "tank"

versus one who operates as a "damage-dealer" (also known as a "DPS" or "damage per second"). When grouped with others, however, the avatar's class and specialty translate to a specific role that is important for organizing and performing a group task in the game. Traditionally, there are three major roles known collectively as the "holy trinity": the tank who directly engages enemies in the front of a group and takes damage, the damage dealer who is to avoid being hit while providing the attacks for the team, and the support who makes sure the others are protected or healed (Figure 19.1). This also helps to reinforce interdependence upon others, for a group attempting difficult encounters without a healer will very quickly realize—likely through repeated deaths—the need to expand their team. The role also helps to govern how avatars should be positioned during combat: a "healer" in WoW, a "support" in *League of Legends* (2009), or a "logistics" ship in *EVE Online* (2003) should always be relatively close to some of their teammates to support them, but not be in front of them so they can still be protected from immediate damage. Roles can also help to determine prioritization or triage during critical times. If a

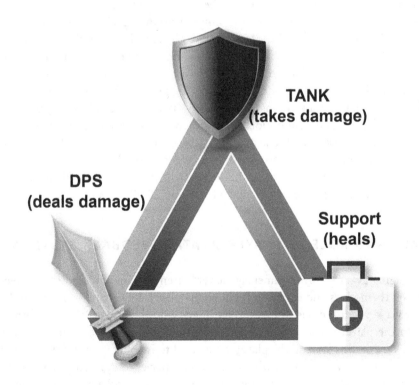

Figure 19.1. "Holy Trinity" model of class interdependence.
(Source: editor, with components from FreePik)

healer must choose between the group's tank or damage dealer, they often choose to save the tank to ensure that the others are protected as long as possible, leading to a higher chance of success. By placing the avatar into this framework of roles, group action takes on a specific structure through which organized behavior can be predicted and performed in multiple different situations. This allows for stream-lined interaction among avatars, and leads to more efficient play.

An avatar, in being constructed to fit into an archetypical class or role in the game, is immediately imbued with meanings that establish its identity and playstyle. This means that aspects of the class fantasy—the narrative framing of archetypical class functions—often become associated with the actions of players who use similar archetypes in the games. In WoW, for instance, rogues are more often perceived as being untrustworthy. This is often tied to people's experiences with "griefers" (those that cause disruption to other's gameplay to inspire anger or despair in others) within the game, who tend to prefer the rogue class due to its playstyle's focus on precision and evasion (Lin & Sun, 2005). Even in cases where this might not necessarily be true, others within the game-world may assume that this connection between avatar and behavior has merit. This behavior suggests that social meanings surrounding character classes may be culturally constructed at the intersection of class mechanics and player behav-iors over time. These types of characteristics surrounding classes and roles can impact the creation of characters as well. Players that want to focus on the role of healing, for instance, are far more likely to "gender-bend" their characters, and play a female if they are male themselves (Barnett & Coulson, 2010). This is tied to the cultural assumption that women are more nurturing than men. Because characteristics of the avatar are often explicitly or implicitly linked to expected game behaviors, many new players can spend a long time in the char-acter creation screen, considering the long-term ramifications of their avatar's appearance, name, and characteristics (Hagstrom, 2008).

CLASS AND ROLE AS PLAYER-AVATAR FEEDBACK SYSTEMS

In engaging avatars during gameplay, players often encounter a feedback system between themselves and an avatar. That is, the player delivers information to the avatar via keyboard, mouse, or controller inputs, and the avatar delivers informa-tion to the player via on-screen responses, either compliant or resistant (Banks, 2015). Within this system, the player is expected to interact with the avatar itself according to its class and role, which may force a player to develop new mechan-ical skills (Yee, 2005) or to find new ways to interact with others (Ducheneaut & Moore, 2005). For instance, a person playing a tank avatar, is often relied upon to be authoritative and to set the pace for the other group members, such that the role

may move the player to be more authoritative and proactive in general—perhaps through practice, or through priming effects (Yee & Bailenson, 2007).

When entering group play, players often encounter multiple pressures to fit an avatar's behavior to its selected in-game role. There are pressures of the game mechanics and the visual look of the avatar itself, and then there are the social pressures of the others around them (Bowman, 2016). Players of *League of Legends* or other MOBA games will often harass or verbally abuse players who do not play avatars according to their roles (LeJacq, 2015). The formalization of these types of role heuristics are a tool used to quickly create groups and to have them successfully complete objectives in the game. In WoW, for instance, ad hoc groups are able to complete many tasks within the game without ever exchanging words (Eklund & Johansson, 2010), based on a shared understanding of tasks and roles. The ubiquity of these understandings can also be used against an opponent. In the *EVE* Alliance Tournament, for instance, some teams will bring a "decoy" ship on their team, which is a support class of ship meant to look like it fits the support role (making it a great target for attack), but was specifically designed to last far longer, essentially creating an unexpected tank target. This shows that savvy players understand the constructed nature of these roles and manipulate them as a tool to enhance play.

SOCIAL CLASSES AND INTERACTIONAL ROLES

While classes and roles are traditionally focused, as noted, on mechanical and cooperative differences in gameplay, it is important to note that these aspects of the avatar also can serve as indicators of social meaning. That is, class can also refer to the *social class* an avatar holds in a game's "society," and the role may indicate what types of *interactional roles* the avatar occupies in inter-character exchanges. These social aspects can function as the root of projected identity (Gee, 2005), constructed through the interactional process of meeting and working with other avatars (see also Bowman, this volume). Even when the avatar is the interactional actor, a player can express human qualities such as competence. Due to the persistent nature of many online games as well as a growing interest in eSports (Taylor, 2012) and news events in games such as *EVE*, the actions of an individual can become known among millions of other players to help generate reputation for an avatar. What this means is that individuals who are interested in growing a social persona online will work on projecting the traits they wish through the avatar (Vasalou & Joinson, 2009).

This persona, while tied to the player, can also be tied directly to the avatar that is that is seen by other players in game, on streaming services, or in online forums. This also means that the avatar's reputation is tied to online performance. These reputations become a form of online social capital, as a resource to indicate "class"

or status in society (Weber, 1946). There is not often much trust between anonymous players with respect to personal qualities and values. Often, they can be faked and replicated, such as the high scores for many online leaderboards being assumed to be cheats or hacked entries. Such forms of capital have played a major part in creating a social resource over which players can compete, and that avatars can collect in the digital world. The creation of such a resource means competition. As certain individuals successfully gain and use this resource within their game's social field (spaces of competition for social resources, such as reputation, see Bourdieu, 1984), this hierarchy based on social reputation may eventually give rise to distinct social classes of player (Adler & Kwon, 2002). This can be seen in MMOs that have had active participants for many years. There are avatars in *RuneScape* (2001), for instance, that have collected enough in-game currency to be able to manipulate the markets of their entire server (De Sousa & Munro, 2012). Similarly, there are individual avatars in *EVE* such as The Mittani that have the resources and organizational power to affect the play of tens, if not hundreds of thousands of other players in the gameworld through the construction of large structures, alliances, and wars (Webber & Milik, 2016).

This "gaming capital"—social currency earned and spent in the course of game-related interactions (Consalvo, 2007)—helps to make sense of the different social classes that can arise in games of this nature. When an avatar is used for social representation of achievement, competence, and dedication, this may assist the individual in conveying themselves—via avatars—as superior to others. Some players are considered relative experts: they may be asked for advice, have their forum posts highlighted and shared, and be given an extra voice through sharing of blogs or third-party site links. In the game, however, these experts will be sought out *via* their avatar, or their avatar's online profile may be consulted as a reference for copying their abilities and spells. This type of popularity and reputation may also be officially recognized; many relatively famous players have been hired on by development companies in an official capacity. For instance, WoW developer Blizzard Entertainment hired video-maker and blogger "Lore" as a full-time employee and community representative (Grace, 2013). This change in role from player to expert points to the intersections of avatar and player in the production of social capital.

Through these forms of gaming capital accumulation and exchange, players may adopt a social identity in the digital realm, via avatar, as the player takes part in the sociality of that space. In this way, the interactional roles associated with interpersonal interactions are extended to in-game groups. Rather than always being a series of brief, usually violent encounters between strangers, group interactions and even competitive matches become ritualized play in the dramaturgical sense (Goffman, 1959)—that is, avatar-mediated interactions are consistent and reliable according to the norms for "playing out" interactions, and this consistency

may transfer to a range of in-game social situations. For instance, leaders of large in-game organizations (e.g., guilds, clans, and corporations) may create and maintain cultures that guide players and avatars into social roles. To maintain a group's culture, new player-avatars entering a group may need to be taught to follow the social norms of the group (Milik, 2015), often accomplished through explicit, playable roles that shape how new members will interact with others in a group.

Many such organizing social rules and regulations aren't explicitly stated in any official document. In many groups, for instance, a certain level of sexism and racism is acceptable, but there is an unspoken threshold, which should not be passed, lest the offending player-avatar be sanctioned by a group leader (Chen, Sun, & Hsieh, 2008). The entry into any social group can be a scary one for the newcomer, with inside jokes and language acting as a sort of barrier to being considered a full member of the group. To ease this process, a leader will often have in place a specific entry role for these new members. One role of this type would be "trial" members attempting to enter a competitive raiding guild in WoW. These trial roles allow greater leeway in terms of behavior and social interaction (i.e., they are to be forgiven for not understanding interaction norms) but are judged more critically in terms of the gameplay performance of the avatar. This identity role of "trial" is linked directly to the avatar. A player can easily escape this role by changing to a different avatar, or removing the avatar from a social group. In maintaining these relationships, however, the avatar is following the rules of this role, and at the same time reinforcing it for others. There are similar roles in different games: *EVE Online* has "newbros," LoL has "newbies," and FPS games have "n00bs." Group leaders are able to highlight different aspects of the entry role, the EVE leader may not care as much about mechanical expertise as the WoW guild leader, but instead may want to highlight the importance of having an avatar consistently on hand for territorial defense (Milik, 2015). Similarly, a LoL newbie is more likely to be have an avatar kicked from the game for not knowing the meta-game than they would be in an FPS based group.

By having the authority and capability of creating these roles, the leaders of organizations in gameworlds can establish what aspects of avatar interaction are important to defend. Is it more important to be inclusionary to women than it is to allow completely free speech for current members? Such decisions affect all members entering the organization because, as a leader places these roles upon avatars and makes them permanent, the social culture of the organization is formalized (Andrews, 2010). Changing organizational cultures after social roles are codified is difficult and often causes the organization to collapse or to split. In one example, the famous WoW guild <Method> changed its culture to monetize the group's success (see Method Gaming Limited, n.d.). They advertised to gain members, sought sponsorships, and started a social media campaign. Because this changed the culture of the group from being achievement-focused to being money-focused, several member avatars split off to create a new group called Serenity,

with the stated intent of protecting the cultural norms of the organization before these changes.

The creating and exchange of gaming capital has become an objective that players can pursue through videogame avatars. By collecting and using resources inside and outside the game, certain avatars are able to establish themselves as being of a different social class than others. By taking on leadership roles and crafting organizational cultures, some of the members of the higher social classes are then able to gain power over others, and decide how an avatar is allowed to act in the online context.

These two different definitions of class and role—the ludic and the social—are intimately tied to avatars and play a major part in creating opportunities for interaction. At the same time, it creates limitations for what is acceptable behavior within specific online spaces. A character class gives a player a wide set of behaviors that can help them succeed in the game, but it can also be used to determine how their avatar should behave in battle. Similarly, the role offers a way that the avatar fits into in-group content, but at the same time creates a place in the group that the avatar is meant to fill. In the interactional sense, the social class of an avatar allows them to create and maintain a reputation, but means that they must act in particular ways to protect their gaming capital. In these ways, an avatar's class and role creates a framework for player-avatar success but also for interactional limitations and punishments.

REFERENCES

Adler, P. & Kwon, S.K. (2002). Social capital: Prospects for a new concept. *The Academy of Management Review, 27*(1), 17–40.

Andrews, S. (2010). *The guild leader's handbook.* San Francisco, CA: No Starch Press.

Banks, J. (2015). Object, Me, Symbiote, Other: A social typology of player-avatar relationships. *First Monday, 20*(2).

Barnett, J., & Coulson, M. (2010). Virtually real: A psychological perspective on massively multiplayer online games. *Review of General Psychology, 14*(2), 167–179.

Bourdieu, P. (1984). Distinction: A social critique of the judgement of taste. Cambridge: Polity Press.

Bowman, N. D. (2016). Video gaming as co-production. In R. Lind (Ed.), *Produsing 2.0: The intersection of audiences and production in a digital world* (Vol. 2, pp. 107–123). New York. Peter Lang Publishing.

Chen, C.H., Sun, C.T., & Hsieh, J. (2008). Player guild dynamics and evolution in massively multiplayer online games. *CyberPsychology & Behavior, 11*(3), 293–301.

Consalvo, M. (2007). *Cheating: Gaining advantage in videogames.* Cambridge, MA: MIT Press.

De Sousa, Y., & Munro, A. (2012). Truck, barter and exchange versus the endowment effect: Virtual field experiments in an online game environment. *Journal of Economic Psychology, 33*, 482–493.

Ducheneaut, N., & Moore, R. (2005). More than just "XP": Learning social skills in massively multiplayer online games. *Interactive Technology & Smart Education, 2*, 89–100.

Eklund, L. & Johansson, M. (2010). Social play? A study of social interaction in temporary group formation (PUG) in World of Warcraft. In *Proceedings of DiGRA Nordic 2010*.

Gee, J. P. (2005). Pleasure, learning, video games, and life: The projective stance. *E-Learning and Digital Media, 2*(3), 211–223.

Grace, O. (2013, May 1). WoW community member Lore joins Blizzard Entertainment. *Engadget*. Retrieved from: <https://www.engadget.com/2013/05/01/wow-community-member-lore-joins-blizzard-entertainment/>

Goffman, E. (1959). *The presentation of self in everyday life*. New York: Anchor Books.

Gygax, G. (1978). *Advanced Dungeons & Dragons: Player's handbook*. New York: Random House.

Hagstrom, C. (2008). Playing with names: Gaming and naming in World of Warcraft. In Corneliussen, H. & Rettberg, J. (Eds.), *Digital culture, play, and identity: A World of Warcraft reader* (pp. 265–286). Cambridge, MA. MIT Press.

LeJacq, Y. (2015, March 25). How League of Legends enables toxicity. *Kotaku*. Retrieved from: <http://kotaku.com/how-league-of-legends-enables-toxicity-1693572469>

Lin, H. & Sun, C. (2005). The 'white-eyed' player culture: Grief play and construction of deviance in MMORPG's. In *FDG'05 Proceedings. Proceedings of the international conference on the Foundations of Digital Games*. New York: ACM.

Method Gaming Limited. (n.d.). Method. Retrieved from: <method.gg.>

Milik, O. (2015). Virtual warlords: An ethnomethodological study of leaders in EVE Online. *Games and Culture* [online first]. Retrieved from: <http://journals.sagepub.com/doi/abs/10.1177/1555412015597814>

Myers, D. (2008). Play and punishment: The sad and curious case of Twixt. Paper presented at the meeting of *The Center for Computer Games Research*. Copenhagen, Denmark.

Rowlands, T. (2012). *Video game worlds*. Walnut Creek, CA: Left Coast Press.

Taylor, T. L. (2012). Raising the stakes: E-sports and the professionalization of computer gaming. Cambridge, MA: MIT Press.

Vasalou, A., & Joinson, A. (2009). Me, myself and I: The role of interactional context on self-presentation through avatars. *Computers in Human Behavior, 25*, 510–520.

Webber, N., & Milik, O. (2016). Selling the Imperium: Changing organisational culture and history in EVE Online. In *DiGRA'16 Proceedings of the 2016 conference of the Digital Games Research Association*.

Weber, M. (1946). The Protestant sects and the spirit of capitalism. In G. Hans & W. Mills (Eds.), *From Max Weber*. New York: Oxford University Press.

Yee, N. (2006). The demographics, motivations and derived experiences of users of massively-multiuser online graphical environments. *PRESENCE: Teleoperators and virtual Environments, 15*, 309–329.

Yee, N., & Bailenson, J. (2007). The Proteus effect: The effect of transformed self-representation on behavior. *Human Communication Research, 33*(3), 271–290.

Resources & Inventories

Useful Fictions

ISAAC KNOWLES

A player interacts with the digital world of a videogame through an avatar. The avatar drinks the potion and loots the dragon; it gets the quest and saves the child; it refines the ore and takes it to market; it wields the pistol and stores the ammo. Through an avatar, the player gathers, stores, transports, refines, and consumes the resources found in the digital word. The rules of the game define exactly what can be gathered, how much of it stored and where, how it can be moved, the ways it can be refined, and the effect of its use. This combination of rules over resources and inventories determine many of the constraints and affordances available to the avatar and thus the player, and their interaction is of fundamental interest to game designers, game players, and all students of videogames.

The examples given above suggest definitions of *resource* and *inventory* that are used throughout this essay, to wit: resources are present in the digital world—they are not properties of the avatar, but rather things that the avatar uses to manipulate itself or the digital world around it. In contrast, inventories are a characteristic of the avatar. They define what and how many resources the avatar can take with it from place to place, enabling action over a distance. The examples above also suggest that some privilege is taken in the breadth of these definitions. For instance, it's assumed here that quests, memories of conversations, and tidbits of story are all resources that the avatar can use. Moreover, these resources are held in an inventory—usually some kind of log. The point of this broad view is not to exclude other ways of defining what a quest or piece of ore or a backpack are, for there are many alternatives; rather, it emphasizes the connections among things as mundane as a piece

of coal and as grand as an epic quest for glory through the ability of the avatar to carry those game objects into different parts of the gameworld.

A BRIEF HISTORY

Compared to other common features of modern avatars, most of the innovation in resource use and inventories occurred relatively early in the history of videogames. One can identify in early text-based RPGs, like Zork (1979) and MUD (1978), many of the same resource and inventory systems that are at work in today's most popular games. Perhaps the precociousness of these systems is due to the fact that early game developers were simply unable to compete on other dimensions. Without 3D graphics and animation and without access to fast, cheap servers, game developers were forced to distinguish themselves from one another by innovating on a game's systems, including inventories and resources. Or perhaps these were just practical questions that had to be answered, even in the earliest games: in his 2003 tome on virtual worlds and MMO design, Richard Bartle discusses in detail the kinds of questions that designers will have to answer when deciding how resources and inventories will operate in the game. Important issues include how objects can be combined, the transfer of properties of one object to another, and the relationships between objects and containers.

Specific discussions of inventories and resources as they relate to the avatar seem to not have moved beyond the game design community; however, the implications of resources and inventories for gameplay experience are easy to relate back to issues of interests to academics, including ludologists and media psychologists. For example, Jesper Juul (2005, Ch. 5) emphasizes the way that rules reflect the fictions of a game and vice versa. As noted below, there are few if any hard and fast rules governing inventories. Instead, the existence and properties of both resources and inventories are nothing more than useful fictions that either (a) create problems for players to solve, (b) give them means to solve problems, or (c) make the gameworld follow familiar logics.

The nature and effects of resources and inventories on players have not been much-studied by media scholars, though there are references to both in the extant literature. For example, Ducheneaut, Wen, Yee, and Wadley (2009) in a study of *Second Life* (2003) residents found that users had an average of 41 outfits stored in their inventory. Economists who study games have noted that inventory properties will affect the volume of trade on in-game markets—an inventory's capacity affects how many resources users can bring to market (no more than what can fit in their bag), and how frequently they must visit centers of commerce (as often as necessary to empty bags; Castronova, 2001). Finally, because inventories create resource management problems, it is possible that solving (or failing to solve)

those problems may impact players' feelings of efficacy or need satisfaction (Tamborini, Bowman, Eden, Grizzard, & Organ, 2010).

RESOURCES AS GAME ARTIFACTS

The word *resource* denotes any game artifact that an avatar can obtain, lose, dispose of, consume, trade, or transport. The breadth of this definition allows us to include almost any object in the game through which the avatar can have an impact on the environment. Thus, it includes weapons, armor, and other items that can be equipped to the avatar, as well as any currencies, keys, books, consumable power-ups, garbage, quest items, and anything else that avatars hold in some kind of bag or slot. The definition additionally includes hit points, mana, stamina, energy, skill points, and any other resource that affects the avatar's power and capacity for action. Finally, it can include quests in a log and memories or synopses of past conversations, either with other players or with non-player characters.

That last bit may be controversial: after all, couldn't quests and conversations instead be part of the story, or a part of the game's interface, rather than a resource? This is certainly a valid perspective, and their inclusion as a resource here is not meant to deny that view, but rather to emphasize a conception of story and quest as a part of the avatar's memory, which the avatar then uses to act upon the world. For example, consider a conversation in which the avatar is told the keycode to open a locked door. Functionally, this is no different than having a key for that door, but it takes the form of information, rather than an object that displaces digital tumblers in a digital keyhole. Similarly, the knowledge of where to search for clues, or who to speak to in the next town over, or which monster to kill, are all valuable pieces of information to the avatar.

Resources may have any number of qualities that distinguish them from one another according to how the avatar can interact with them. Depending on the underlying game mechanics, a resource may take one or more of the following properties:

- Wearable—It changes the avatar's appearance or capabilities.
- Consumable—The avatar can consume it, after which the resource is removed from the avatar's inventory.
- Useable—The avatar can use or re-use the item at will.
- Improvable—The avatar can increase its quality, recharge, or make it useable.
- Miscible—The avatar can combine the resource with other resources.
- Convertible—The item can be turned into some other resource, either through some action of the avatar upon the item, or through trading the item in for some other good (e.g., Currency from a vendor).
- Disposable—The avatar can remove the item from all of its inventories.

In addition, most resources have volume, heft, or both. This is important because these properties can limit the use and value of an item. For example, the currency in many MUDs and some early MMOs had a non-negligible mass, which limited the amount of currency that could be transported (Bartle, 2003).

INVENTORIES AS AVATAR ARTIFACTS

If an avatar obtains a resource and does not immediately consume it, then that resource is held in an *inventory*. An inventory is any container that allows the avatar to hold and transport a resource from one time and place in the gameworld to another. Oftentimes avatars have multiple inventories, each capable of holding only certain types of resources. Inventories are characterized by their *capacity*—the maximum volume of resources that they can hold; their *interactivity*—the ability of the avatar to move resources in and out of the inventory; their *inclusivity*—the number of different kinds of resources they can hold; and their *commutativity* with respect to other inventories—that is, their ability to hold resources that can also be held in some other inventory.

Capacity

Capacity constraints can manifest in many ways. Some inventories have a limited number of slots. In most game genres, avatars face practical limitations on the number of items that they can hold. They are also usually limited in the number of equipment slots; for example, only one sword can be held in each hand and only one helmet on the head. In *Super Mario Bros.* games (1985), Mario and Luigi are often granted one or two slots to hold items in reserve. Health, mana, and experience bars are another example: an avatar's hit points cannot exceed some maximum amount, and many games impose a level cap on the avatar, effectively limiting the number of experience points that can be accumulated. Quest logs are still another example found in some roleplaying games, which limit the number of quests that can be active at once.

Other inventories have no explicit capacity constraint; however, if the amount of the resource in the inventory exceeds some threshold, the avatar is debilitated until it sheds that excess. For example, in the games *Skyrim* (2011) and *Fallout 3* (2008), an avatar whose backpack becomes too heavy can become encumbered, which greatly reduces the avatar's mobility.

Finally, some capacity limits are not the result of game rules, but rather of the limitations of the software and hardware systems on which games are played. For example, for many years the amount of currency that could be held by an avatar in *World of Warcraft* (2004) was 2,147,483,647 copper: the maximum value of a signed

32-bit integer, and a limitation imposed by the operating systems of the servers that hosted the game. Eventually, the game's servers were upgraded to 64-bit operating systems, at which point Blizzard lifted the maximum to 999,999,999,999. It's interesting to note that that the new limitation comes not from the software but from the game rules, as a database on the new operating system could have stored much larger numbers.

Interactivity

Each of an avatar's inventories is more or less interactive. The degree of interactivity lies in two dimensions: the avatar's ability to add resources to the inventory and the ability to subtract resources from it. Backpacks tend to be the most interactive type of inventory because the player can both add and remove resources from them at will. On the other hand, while players can almost always modulate the rate at which their avatar accumulates experience points by making more or less effort, they are usually prevented from ever reducing the level of an experience bar.[1] Some quest logs can get longer but never shorter (e.g., *Skyrim*, 2011), while many energy bars can be consumed and then only fill back up over time. Hit point and mana bars can often be filled and depleted, but the player's agency over these movements is often limited.

Inclusivity

The inclusivity of an inventory refers to the number of different resources the inventory can hold, where "difference" can be thought of in terms of whether the resource shares a label with another resource (e.g., "power-up," "gun," or "quest"). A number of avatar inventories are completely *exclusive*: experience bars can only hold experience points, and hit point bars can hold only hit points. Quest logs and equipment slots are somewhat more inclusive: a quest log can hold any quest, and quests—unlike experience points—are often different from one another. An avatar's wrist slot can hold many different sets of bracers, but this may be limited by other avatar characteristics: an avatar limited to wearing cloth items cannot wear more protective chainmail bracers, but the converse is usually not true—a mail-wearer can usually wear the lower-level cloth. If an avatar has a bag, it is often the most inclusive inventory, capable of holding almost any resource the player could encounter in the game.

Commutativity

The subtlest feature of an inventory is its *commutativity*. This refers to the extent to which the resources that can be held in the inventory can also be held in some other inventory. Commutativity is related to inclusivity: the more inclusive an inventory is, the more likely it is to be able to hold resources that can be held in

another inventory. Perhaps the most recognizable manifestation of commutativity lies in the ability of an avatar to hold equipment either in its backpack or in one of its equipment slots. For example, a sword can usually fit in an avatar's hand slot, or it can be stored in a backpack. The equipment-backpack example also highlights the fact that commutativity is not symmetric: a backpack can hold a robe or a potion, but a chest slot is usually reserved for robes, alone. Most inventories have no commutativity with respect to one another, often owing to their exclusivity. An experience bar cannot hold a raptor tooth, and a mana bar cannot hold a quest. A quest log is somewhat more inclusive, in the sense that the resources it holds (quests) are different from one another, but it is not at all commutative: it cannot hold a hit point, or any other resource that isn't a quest.

The commutativity of inventories raises several interesting questions. For example, although an experience bar cannot hold quests, a quest can be thought of as holding a reserve of experience points (earned once the quest is completed). Similarly, a backpack cannot hold hit points, but it can hold a health potion that can add hit points to the health bar once consumed. There are many examples like this, where an inventory holds a resource (like a health potion or a quest) that, when consumed, adds resources (like hit or experience points) to another inventory (like a health or experience bar). This suggests that the commutativity of one inventory with respect to other is not discrete; rather, it lies on a spectrum, depending on the ease with which the conversion of one resource to another takes place. The degree of commutativity would then depend on the amount of effort that the player would have to engage in to convert one resource to another. For example, backpacks may be highly commutative with respect to health bars if health potions are easy to create, while quest logs may be less commutative with respect to experience bars if quests are difficult to complete.

INVENTORIES AS USEFUL FICTIONS

In games, there are no practical limitations on what resources can be stored where; after all, the "what" and the "where" are fictions. That quests are not kept in a flower pot worn on an avatar's head does not reflect a fundamental limitation on game design. Rather, quest logs exist as separate entities presumably because game designers believe that such an arrangement makes more narrative sense, or that it improves user experience. Inventories and their properties are *useful fictions*: they give the avatar dimension, they introduce constraints that the avatar must work around, and they force the avatar to interact with the digital world in a way that would be unnecessary but for the constraints. They may also make the world more relatable for players by importing some version of Newtonian physics and basic biology into the digital world (see Bown & Olson, this volume)—the digital world makes sense in ways similar to how the physical world makes sense.

Inventories give an avatar dimension by defining many of its weaknesses and strengths, and by saying something about the avatar's culture. Limits on the volume of health bars make the avatar vulnerable, while capacious experience bars create an avatar that must work hard and learn to advance. The inability to hold thoughts in a backpack or health potions in a log book may make it easier for the player to focus on what's important: the story, the mechanics, and the broader digital world. The restraints themselves are also part of the story, in that they say something about the world in which the avatar lives—not just the physics, but the culture as well. Evidently, wearing a flower pot on one's head is considered taboo in most gameworlds.

Flipping the theme of this book on its head, one might hypothesize that an avatar exists to serve the inventory and not the other way around. An avatar is a useful fiction to keep players from wondering why they are even bothering with all these bags, bars, and log books in the first place. The game is often in the inventory management, in which case the avatar gives a story for why players should manage their inventories. The existence of weigh limitations, for example, is rarely justified by the material or volume of the bag, but rather by the fortitude of the avatar.

Finally, inventories are a property of avatars that are increasingly used to monetize games. In recent years, sales of both resources and inventories have come represent an important and even primary source of revenue for game companies. Resources are usually sold directly to the player and then immediately stored in the avatar's inventory, as when *Second Life* residents purchase a new piece of furniture and it instantly appears in the avatar's sub-foldered inventory. However, in some multiplayer games, players may sell the resources to one another directly. For example, in *The Settlers Online* (2012), players can pay for more trading slots, which allows them to increase the volume of their trades. Other ways of monetizing inventories are possible, of course, but are never seen. For example, a change to the inclusivity of a backpack, so that it can hold (say) magic points, could be of value to players. Nevertheless, sales of enhancements like these seem to be rare, perhaps because they are difficult to justify in the context of a game's narrative (they are apparently not very useful fictions).

The design of inventory and resource systems seems to have changed very little in the last 40 years, but the advent of augmented reality games (ARGs) may provide impetus for evolution. ARGs promise to significantly blur the boundary between player and avatar—and thus between the player's inventory and the avatar's inventory. For example, the mobile ARG *Pokémon GO* (2016) requires a great deal of power from player's mobile phones. The game's wild popularity led to a surge in purchases of peripherals and portable chargers that served to conserve power or increase the lifespan of users' batteries (Kraft, 2016; Griswold, 2016). Suddenly, a player's phone battery status indicator took on the air of an energy bar—an inventory that must be managed carefully if the player is to advance.

Looking forward, one can imagine a plethora of devices (such as Bluetooth-enabled sneakers or backpacks sold by the game designer) or other items (such as snacks for the road) that ARG players would want to carry on their person *cum* avatar to make their ARG sessions successful or more engaging. ARG designers will need to carefully balance their game's inventory and resource systems against the need for the game to be usable by a diverse audience. And while designers have long had to adjust their games' aesthetic content to the cultural mores of their audiences (Malliet, 2007), the rise of the player-as-avatar may force designers to adjust their inventory mechanics to according to the local legal and cultural milieux of their player, as well. For example, peripherals may need to respect age or disability discrimination laws, or conform to other cultural standards, in order for the "avatars" to be able to carry them in their inventory.

The case of ARGs suggests a future for games where the avatar and the player are one and the same. Inventories and resources are a concrete way in which this blurring will manifest, as players' real-world economic, cultural, and geographic circumstances will come to bear on their digital selves in ways that have not been so obvious before. As they do so, the rules surrounding those systems may no longer be useful fictions—they will be decidedly true, with real force and effect for players, designers, and society-at-large.

NOTE

1. One notable exception is the early version of *EverQuest* (1999), in which an avatar that died also lost some experience points. Another example may be found in games that allow players to revert to a prior saved game state, which will effectively reduce the number of experience points to a previous, lower level. It's interesting to note that early console games were often limited in the number of available save states, to conserve power on the onboard battery that kept the saved states in memory (see Lynch & Matthews, this volume). Thus again we have an example of inventory limitations arising from software and hardware limitations.

REFERENCES

Bartle, R. (2003). *Designing virtual worlds*. Berkeley, CA: New Riders.

Castronova, E. (2001). Virtual worlds: A first-hand account of market and society on the cyberian frontier [SSRN Working Paper]. Retrieved from: <https://ssrn.com/abstract=294828>

Griswold, A. (2016, July 18). The Pokémon GO craze has people out searching for more than just Pokémon. Quartz. Retrieved from: <http://www.qz.comf>

Juul, J. (2005). Half-real: Video games between real rules and fictional worlds. Cambridge, MA: MIT Press.

Kraft, A. (2016, July 21). How to double your battery life for "Pokémon GO." CBS News. Retrieved from: <http://www.cbsnews.com/news/pokemon-go-how-to-double-your-battery-life-for/>
Malliet, S. (2007). Adapting the principles of ludology to the method of video game content analysis. *Game Studies, 7*(1).
Tamborini, R., Bowman, N. D., Eden, A., Grizzard, M., & Organ, A. (2010). Defining media enjoyment as the satisfaction of intrinsic needs. *Journal of Communication, 60*(4), 758–777.

Code & Logic

Procedural Desire

PETER KUDENOV

In the cyberpunk classic *Snow Crash* (1993), Neal Stephenson described how high-fidelity three-dimensional (3D) graphics and sound can make a digital world appear real: "By drawing the moving 3D image at a resolution of 2K pixels on a side, it can be as sharp as the eye can perceive, and by pumping stereo digital sound through the little earphones, the moving 3D pictures can have a perfectly realistic soundtrack" (p. 24). Stephenson's explanation of the "matrix"-like world available to hackers in *Snow Crash* reflects the complexity residing at the heart of any videogame: code (programming instructions) and logic (conditional evaluations) brings the digital world to life. "A [game] platform's influence as experience by a user is mediated through code, the formal behavior of the program, and the interface" (Bogost & Montfort, 2009, section 8, para. 4). Specifically, behind every game, code is performing logical evaluations that create visible consequences in the ludic experience and connect the player's actions with the avatar; the push and pull between the avatar and the player is the product of code and the logics it implements.

DEFINING CODE

Avatar code is the driver of user experience for many genres of games, and it aggregates system and player attention in myriad ways. For a roleplaying game like *Fallout 4* (2015), a player manages an avatar's movement, plays with and against the physics of the gameworld, juggles gear and weapons, and may obsess over their

character's statistics (strength, agility, etc.) or agonizes over which quests to take; a player determines which non-player characters (NPCs) to be sarcastic toward, decides which factional reputations to emphasize, and some will spend a great deal of time modifying their character's appearance. Additionally, *Fallout 4* players will shoot a lot of guns while sneaking through the Commonwealth wasteland. Code makes all of these actions possibly by implementing and responding to character physics, player inputs, and the world simulation. Take character appearance, for instance. The game's code "sees" player avatars in its own way: where a player sees an avatar wearing power armor, the game sees a "player" object with, perhaps, a Boolean flag set to "true" indicating the presence of power armor, and simple data structures describing the properties of what the avatar wears in each location (e.g., legs, torso, arms) along with asset identifiers for the 3D models each relates to, allowing it render them in the world (Figure 21.1).

What players see:

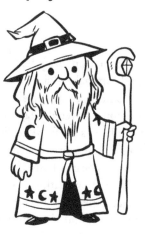

Attributes used by game engine to render what players see:

ID	Location	Asset
55	Head	Crumpled Cloth Hat
56	Chest	Celestial Smoking Jacket
87	Waist	Simple Sash
217	Legs	Demure Tights
49	Shoes	Dora's Dancing Shoes
17	Weapon1	Valiant Casting Rod

Figure 21.1. How a player sees a character versus how code sees it.
(Source: editor, with components from FreePik)

The code, or source code, that facilitates this way of "seeing" can broadly be understood as programming statements stored in a text file (e.g., "main.cpp"), which can then be interpreted, compiled, or assembled into an application executable (a program) or object library (a set of resources that can be dynamically linked). Code can be a verb or a noun: a developer may respond, "I haven't coded that yet" or project managers may request a "code review." But what is code, exactly? Friedrich Kittler examined the history of the term and found its roots in encryption, citing Wolfgang Coy's definition that, "from a mathematical perspective [a code is] a mapping of a

finite set of symbols of an alphabet onto a suitable signal sequence" (in Kittler, 2008, p. 40). The significance of Coy's definition is twofold: first that "a code" is one set of symbols corresponding to one set of signals, and second that those symbols, when *translated*, become those signals. Statements in source code contain symbols, and a process (i.e., to "interpret," "compile," "assemble") translates those symbols into signals that enact game events. An implicit relationship resides in Coy's definition: for code to be consistently translated into signals, one code must *discretely* translate into one signal. If compilers had to infer meaning from human significations—metaphors, thesauri, connotation—computers would rarely accomplish any work. Signals, for computers, are instructions with discrete meanings, allowing code to perform work.

Source code comprises human-readable, ordered instructions telling a computer to perform tasks, and as a medium, stores computer instructions. Programmers use tools, like compilers, to convert source code from human-readable statements into machine instructions, which become programs. The order of operations in code is crucial: while humans can derive meaning from jumbled words, computers are linear creatures running instructions sequentially. Programmers, therefore, work hard ensuring instructions are in the proper order. Well-ordered statements are not only necessary for computers, but help other humans read and maintain the program. Despite its readability, by itself source code only shows so much: references to libraries of functions (like game engines) have public and private code and data. Coders can see a public function, read its documentation, but may not know how it works. Executed code also "becomes" in its own ways: even if *we* can read source code, logic is conditional, which means we cannot read it linearly for meaning, like a book. It comes down to "if/then" logic: computers can ignore large portions of a program if certain conditions are not met, which we see in games all the time. To complete quests in *Fallout 4*, players (via avatars) must complete their conditions, otherwise the game will not reward them.

PERSPECTIVES ON CODE

Given the conditional nature of code, when trying to understand how people engage avatars, is it better to consider the source code or the running game program? The answer depends on your perspective. Consider the perspectives of Software Engineering, and of three humanities domains: Software Studies, Critical Code Studies, and Kittlerian Media Studies.

Software Engineering solve problems using code; code is valued for its correctness. Brooks (1995) argued that to implement a software task, one should allot "1/3 [of their time for] planning, 1/6 coding, 1/4 component test and early system test, 1/4 system test, all components in hand" (p. 20). For a 100-hour project, a team should spend 33 hours *planning*, 50 hours for *testing*, and 16.5 hours *coding*. Based on Brook's

ratios, coding is the smallest part of a software task with the emphasis instead on problematics: understanding them, conceiving and implementing solutions, ensuring solutions are correct. Code's value is secondary to the solutions it expresses.

In *Software Studies*, Chun (2008) argues against "fetishizing" code by overemphasizing its importance, because "reading" it does not reveal the consequences of its effects: "[software] blurs the difference among human-readable code (readable because of another program), its machine-readable interpretation, and its execution by turning the word 'program' from a verb to a noun, by turning process in time into process in space, by turning execution into inscription" (p. 303). Software is so fully present in our day-to-day experiences that it has "become a universal language, the interface to our imagination and the world" (Manovich, 2013b, para. 4). Software Studies examines what software does as it executes (Manovich, 2013a).

Code, in *Critical Code Studies*, is the product of technical, social, and cultural epistemologies. Marino (2006) argued that "computer code, program architecture, and documentation" are susceptible to "critical hermeneutic[al]" interpretations (para. 18). Code can often mean *more* than the instructions it specifies if we pay attention to *why* it does what it does. Sample (2013) demonstrated this perspective, by examining how neighborhood crime rate values are calculated in *Micropolis* (2008), an open-source *SimCity* clone. *SimCity* (1989), he found, "specifies a maximum crime rate. Crime in *SimCity* is … a rigidly defined quantity" (para. 10), meaning algorithms are "totalizing and deterministic" (para. 12). Examining the rules implemented by *Micropolis'* code revealed a never-zero crime-rate, and higher rates for neighborhoods closer to the city center—rules having cultural significance. Sample's work revealed how cultural values translate into code by demonstrating the belief that, not only is crime is a constant, but it will always be worse in inner-cities.

Kittlerian Media Studies distrusts code, regardless of its form (text, electricity): "[even] elementary code operations, notwithstanding their metaphorical promises … amount to strictly local manipulations of signs and therefore … to signifiers of varying electric potentials" (Kittler, 2013, p. 223). Kittler argued for a form of Foucauldian discourse analysis: to know what one is programming, the translation (from text to electricity) must be observable, else code's meanings are hopelessly entangled in power/knowledge relations. We can never be sure that what we program is performed as such, because as third-parties, as outsiders, we have no authority to define codes' denotations. The act of coding requires programmers to trust their tools to be implicitly truthful. Thus, in Kittlerian projects, we are tasked to observe what code says and does, discovering what is materially seeable and sayable.

Each of the four approaches to code emphasizes different dimensions of code, but all illuminate aspects of technology, which were previously opaque. Considering game avatars as interfaces into complex game systems, then, they are static and dynamic in nature and are produced by code and produced by tools produced by code (see O'Donnell, this volume). Studying an avatar's code can reveal the

assumptions and goals game designers sought to achieve, as well as the technical solutions (and work-arounds) needed to achieve them.

THE LOGICS CODE IMPLEMENTS

Code expresses logic, where logic is an expression where one state is evaluated in terms of another. Consider how ATM machines work. Say you want to withdraw $100; if your account has less than $100, the ATM will deny your withdrawal. The evaluation may be read as follows: if balance greater than or equal to amount withdraw money else deny withdrawal. Videogames, as computational systems, rely on procedural logics, which evaluate one or more conditions over time. A procedure is something that is repeatable: a unit of procedural logic may be an algorithm, which is defined by computer scientists as a series of instructions a computer follows to solve a problem (Weiss, 2000). When it comes to analyzing the code and logic of avatars, it is appropriate to treat "procedural logics" and "rules" synonymously, given that they are phenomenologically the same: players experience the rules of the game per their manifestation in procedural logics, as rules govern play (cf. Boyan & Banks, this volume). Further, rules are arbitrary things: when Huizinga (1955) described games of dice, he recognized that dice rolls had to meet specific conditions if they were to be considered games at all (i.e., rolling seven wins, a two loses). Procedural logics comprise all the conditions and evaluations that must be met to make an avatar act within a game. Everything an avatar does is governed by code enacting logical rules: code instructs hardware to correctly render a scene, to handle controller input, to translate input into actions—like determining if a player's avatar can jump at all, and if so, triggering the correct animation and audio responses for its present context—to updating each mote of dust's particle state. Effectively, games observe players through procedural, logical relationships.

Games are a macro-expression of many procedural logics. In a survey of games studies research, the procedural logics code implements underlay discussions of game rules (de Zwart & Humphreys, 2014); of software representing "well-developed systems that allow [a] player to interact with them in a consistent manner" (Jorgensen, 2012); that the "rigidity of code" permits some things to happen while denying others (Pearson & Tranter, 2015); and how, broadly, "the programming of a game generates the game world" (Wood, 2012). While there are many types of logics employed in videogame programming (e.g., asset management, visualizations, audio processing, and networking), the analysis of events and event-driven logics are the easiest exemplar for the discussion of how code gives rise to and governs engagement of avatars. Events are a type of occurrence that initiate, facilitate, maintain, or stop some type of change (e.g., an avatar's shift from still to moving, or continuing to cast a spell), encapsulating the procedural logics of a game that

allows players to *play*. In other words, events allow interactivity, receptivity, and responsiveness through avatarial behavior shifts: "[when] and how players identify with avatars largely depends on what the game is doing *to* them at any given moment" (Taylor, Kampe, & Bell, 2015, para. 13).

Take, for instance, the avatar in *Silent Hill*, as it moves through a world of "suggestive and worrisome noises like footsteps, wing beats, [and] bad plumbing" (Carr, 2003, para. 4), revealing procedural and event-driven logics common to many types of games. First, the game must respond to player input, so code "watches" for player actions by polling the control pad. Code evaluates detected inputs and determines if anything should change: is the input for movement, a menu, an interaction? If movement, code triggers a "step" sound if the player pushes the direction pad long enough to meet a time threshold: push the left-stick up long enough, perform a full "walking-a-step" animation, and hear the footstep sound. Second, the sound of bad plumbing plays when the game's avatar moves within a certain distance of a boundary demarcating a proximal event, say entrance to a new room with faulty pipes. Boundary checking occurs by comparing one object's coordinates to another; do they intersect? Monsters in *Silent Hill* constantly "cast" invisible rays toward gameworld objects (including avatars) to determine if it intersects with their boundaries; if a monster ray intersects with an avatar it can "see" it. Ray casting allows game engines to know *when* to play specific sounds and when *not* to, and as a mechanism, facilitates identification between players and avatars by allowing creatures to interact with them in the game's world. Third, proximity logic allows games to model physical behaviors; code allows the avatar to appear to walk, and determines if and where it can walk. Mimetically, avatars are stopped by closed doors, walls, and steep hills, and are constantly stopped by visible (and sometimes invisible) obstacles confining player behavior into specific game areas: subtle unclimbable walls or invisible barriers. Finally, *Silent Hill* needs monsters to be scary, and likely uses an approach to artificial intelligence (AI) called a "finite state machine," where "each state determin[es] a specific behavior" for a creature (McShaffry, 2013, p. 616). State machines allow monsters to roam areas looking for avatars, i.e., in a "searching" state, and once found, they switch to an "attacking" state, which may also trigger aggressive wing-beating sounds. If the avatar hides and monsters cannot find it, they switch back to "searching," and the wing-beats become less aggressive. Programmers and game designers use many such code-based, procedural logics to allow players to interact with their avatars and the gameworld.

PROCEDURAL DESIRE

While—through these interplays of code and logic and states—games are complex, we can simplify things by considering code as a performative language that implements and enforces the developer's rules. Code is both "dead" (stored in text

files, read like a book) and "alive" (compiled and executed, turned into electrical signals); code is what it does and does what it signifies. But why is it that some code expresses the behaviors of avatars so well, and other code effectively fails, and how do we tell the difference? To approach these questions, Deleuze and Guattari's concept of "desire" can describe how avatars' procedural logics relate to avatars and players. Desire is "an active and positive reality" and "an affirmative vital force" that is not Freudian or sexual in nature; rather, it is a productive force encouraging connections (of touch and sight, of things seen and felt, of sensors and feedback systems, of ports and dongles) to form among parts of a system (Gao, 2013, p. 406). Connections are places where parts interact, and are constantly formed between players and control pads, between servers and clients and network packets, eyes, and screens. Further, Deleuze and Guattari believed that "the whole cannot predetermine the future of the part" (Genosko, 2014, p. 55), meaning that connections often have their own intensities and meanings: whether made or broken, systems are always "bringing forth continuous intensities" when they connect; they are always becoming "little machines" that are "plunged into other collective machines" when needed (Deleuze & Guattari, 1987, p. 161). Intensity, here, is the measure of a connection being made to and from different parts of a system to other parts of a system (like a person, a platform, software) using a contextually relevant metric (such as millisecond latency between player action and game response). Some systems can establish highly intense and long connections, while others will disconnect under the same circumstances. This means that the different connections among code, players, and avatars have their own values and significance, such that a whole avatar emerges from its many parts and connections.

The notion of *procedural desire*, then, is a way of explaining connections among things, of processes to other processes and systems by measuring their intensities, and by tracing those connections out from code. Essentially, procedural desire is discovered by tracing and measuring intensive connections between parts of one or more systems to explain outcomes of play. Through this lens, then, avatars are expressions of procedural logics designed to form reciprocating connections between their digital bodies and the physical bodies of players. Interrogating a game's code reveals how connections between avatars and players are formed, evaluated, maintained, and broken. We can interrogate code even in its absence: while it is often impossible to obtain the source code for a commercially available game, reading books about game programming can offset this lack, because many programmers use the same methods and techniques (consider, for example, the many games using Epic Game's Unreal engine—engines allow programmers to repeat the same processes to produce games; see O'Donnell, this volume). By working backward from code to the avatar and its player through its connections. We might discover how even when an avatar's implementation disrupts those connections

(e.g., laggy controls, awkward appearances, buggy gameplay; see Johnson, this volume), some players still *love* them, and love their connections with them. By searching for procedural desire, we can show *what is and what is not*, by—as Bogost and Montfort (2007) argued—looking at the platform holistically: if code performs the rule-based logic that governs the intensities and connections of desire to, from, and through computational systems, *procedural desire* recognizes the reality that avatars are regulated sets of connections, which are themselves governed by rules affecting different intensities in and across system boundaries.

In such an approach, the parts of interest determine the code to be considered. If interested in why some avatars are immediately accessible and tactile creatures while others are clumsy and off-putting, consider that players relate to avatars through controllers. This guides us to the code that manages player actions, handling button presses and direction controls. If we can discover efficiencies or awkward latencies in the procedural logics used to translate player actions into avatar movements, the relationships among code, system tactility, and embodied players' haptic experience may explain why high input latencies might reduce desire, and low input latencies increase it. And if such an analysis is insufficient to describe why a player might enjoy a game with terrible controls, *other* code and procedural logics can be evaluated. Because avatars mediated gameplay experiences, they are crucial points of connection: their logics facilitate and meter flows of desire to and from players and their games. In other words, the code that constructs the logic of avatars is the effective force binding player to game.

Avatars are a complex of states and affective products, connected in kind with many of the other "parts" outlined in this volume, and their code evaluates and channel flows of desire, systems which "work according to regimes of syntheses that have no equivalent in the large aggregates" (Deleuze & Guattari, 1977, p. 288). This means that, when connections are made, the product of that connection is a new synthesis of some kind—a coming together of parts, an assemblage of things and relationships. Consider that, while gamers do not actively evaluate bounding box intersections, they can *feel* the product of the interaction when their avatar is stopped by a wall, which is, in and of itself, the wonder of the relationship which emerges and is synthesized through intensive connections. Procedurally, desire flows to and from us through modulating intensities. Somewhere among many thousands of procedural evaluations across a couple of hundred milliseconds the human need for connection (Deci & Ryan, 2012) is channeled, synthesized, and reciprocated by and within the avatar's systems.

Code and logic create all manner of procedural desire by producing the material conditions by which avatars *become*, and accounting for what they do *not* become. For videogames, code moves and arranges flows of desire among parts of the system: screens, eyes, hands, control pads, processing units; affective, precognitive states; and through entanglements with procedural logics. To

date, game studies have codified the products of large interactions, the overarching rules and logics that drive relationships between systems, but work remains in examining the myriad connections that code shapes and aggregates to better understand what values, data, and conditions comprise the relationships between player and avatar as systems. By attending to procedural desire, the connections made through technical assemblages of avatars and its phenomenological outputs may be made clear.

REFERENCES

Bogost, I., & Montfort, N. (2009). Platform Studies: Frequently Questioned Answers. In *DAC'09 Proceedings of the Digital Arts and Culture Conference*. Retrieved from: <http://escholarship.org/uc/item/01r0k9br>

Carr, D. (2003). Play dead: Genre and affect in *Silent Hill* and *Planescape Torment*. *Game Studies, 3*(1).

Chun, W. H. K. (2008). On "sourcery," or code as fetish. *Configurations, 16*(3), 299–324.

Deci, E. L., & Ryan, R. M. (2012). Motivation, personality, and development within embedded social contexts: An overview of self-determination theory. In R. M. Ryan (Ed.), *Oxford handbook of human motivation* (pp. 85–107). Oxford: Oxford University Press.

de Zwart, M., & Humphreys, S. (2014). The lawless frontier of deep space: Code as law in EVE Online. *Cultural Studies Review, 20*(1), 77–99.

Gao, J. (2013). Deleuze's conception of desire. *Deleuze Studies, 7*(3), 406–420.

Genosko, G. (2014). *The life and work of Felix Guattari: From transversality to ecosophy. The three ecologies*. London: Bloomsbury Academic.

Deleuze, G., & Guattari, F. (1977). *Anti-Oedipus: Capitalism and schizophrenia*. New York: Viking Press.

Deleuze, G., & Guattari, F. (1987). *A thousand plateaus: Capitalism and schizophrenia*. Minneapolis: University of Minnesota Press.

Huizinga, J. (1955). *Homo Ludens: A Study of the play-element in cult*. Boston: Beacon Press.

Jorgensen, K. (2012). Between the game system and the fictional world: A study of computer game interfaces. *Games and Culture, 7*(2), 142–163.

Kittler, F. (2008). Code (or, how you can write something differently). In M. Fuller (Ed.), *Software studies* (pp. 40–46). Cambridge, MA: The MIT Press.

Kittler, F. A. (2010). *Optical media: Berlin lectures 1999* (English ed.). Cambridge: Polity Press.

Kittler, F. A., & Gumbrecht, H. U. (2013). *The truth of the technological world: Essays on the genealogy of presence*. Stanford, CA: Stanford University Press.

Manovich, L. (2013a). *Software takes command: Extending the language of new media*. New York: Bloomsbury.

Manovich, L. (2013b, Dec. 16). The algorithms of our lives. *The Chronicle of Higher Education*. Retrieved from: <https://chronicle.com/article/The-Algorithms-of-Our-Lives-/143557/>

Marino, M. C. (2006). Critical code studies. *Electronic Book Review*. Retrieved from: <http://www.electronicbookreview.com/thread/electropoetics/codology>

Pearson, A., & Tranter, K. (2015). Code, Nintendo's Super Mario and digital legality. *International Journal for the Semiotics of Law - Revue Internationale de Sémiotique Juridique, 28*(4), 825–842.

Sample, M. L. (2013). Criminal code: Procedural logic and rhetorical excess in videogames. *Digital Humanities Quarterly*, *7*(1).

Stephenson, N. (2008). *Snow crash*. New York: Bantam Books.

Taylor, N., Kampe, C., & Bell, K. (2015). Me and Lee: Identification and the play of attraction in The Walking Dead. *Game Studies*, *15*(1).

Weiss, M. A. (2000). *Data structures and problem solving using C++* (2nd ed). Reading, MA: Addison-Wesley.

Glitches & Lag

Unanticipated Variables

MARK R. JOHNSON

The online competitive multiplayer mode of 2004's *Halo 2*, developed by Bungie Studios, is known primarily for two reasons. It is most commonly noted for its tremendous success as a multiplayer game mode: it boasted millions of players, a robust and generally well-developed matchmaking system, and a competitive multiplayer community with significant longevity (by the standards of games of that era). Secondly, to a smaller number of people, it is known for suffering from—or being enhanced by—two conditions: glitches and lag. These are both unintended game features or "interruptions" that impede, alter, or potentially augment avatar use.

A precise definition of the term "glitch" is surprisingly elusive (Lewis et al., 2010, p. 115) in large part due to the ambiguity over intended and unintended forms of gameplay, which can depend upon both technical specifics (Bainbridge & Bainbridge, 2007) and relevant social norms. Despite this terminological and epistemological fuzziness, a glitch can perhaps be best defined as an unexpected moment in the use of a piece of software, or possibly more generally in any kind of complex system; it involves a moment where the system ceases to function as designers *intend* or users *expect*, and this normal functioning becomes disrupted. In games this might take many forms, such as an avatar passing through a wall, an inventory item disappearing, a character saying the wrong thing, or the game failing to load correctly and preventing the player from progressing at all. Glitches thereby range from the trivial to the game-breaking, and in doing so have substantial impact upon player experience. They break the player out of the expected flow of play. They offer possibilities in a game that, a moment before, didn't seem to be; they change our perception of in-game avatars (and other elements). This makes

them important for our understandings of digital avatars and their (ab)normal functioning.

FLYING, BOUNCING, AND STANDBYING IN HALO 2

The glitches in *Halo 2* are certainly too many to list here, but two of the most famous are *sword-cancelling* and *super-bouncing*. Sword-cancelling was a glitch by which a player wielding the *energy sword* weapon would target a player, initiate an attack, and then immediately press another button on the controller in the split-second gap between the attack and the impact with the enemy player. Doing this with correct timing would then trigger, and instantly cancel, the sword attack, resulting in players flying *over* the target player but *without* attacking them at the end of the move. This enabled players to reach areas that were supposed to be inaccessible, move across the map far faster than seems possible, and thereby deploy tactical options through this glitch that should never been present in the game. Super-bouncing, meanwhile, involves the curious act of having one's avatar crouch and walk into a gap between two particularly angled polygons in the gameworld, standing there for several moments. If done correctly this will prevent the player from standing up straight after they leave the small area, resulting in a permanent crouch. By then climbing up to a great height, jumping off that height, and hitting the ground at the extremely small intersection between two other polygons, the game incorrectly judges the player's position, comes to believe the player has fallen underneath the map, and launches them at tremendous speed *into the air*. While sword-cancelling transformed the *horizontal* mobility of an in-game avatar, super-bouncing transformed *vertical* mobility. These glitches came to fundamentally change the abilities of in-game avatars; they could reach places never before reached, move with incredible speed, and cease to function as avatars that act like the baseline humans they visually resemble.

Halo 2 was nevertheless one of the most-played multiplayer games to ever be released for the Xbox. Although in ideal conditions it ran well and without issues, a weak internet connection would cause a range of strange effects because of lag. *Lag* as traditionally understood is when game events are visually or functionally delayed past the time they were meant to occur, generally through a failure in software or hardware that is unable to continue the flow of game events at the intended pace. For example, in a first-person shooter, one might press the trigger of one's weapon and then find the bullet only being launched half a second later rather than almost instantly, due to *lag* between the input (the physical controller press) and the output (the digital bullet). Alternatively, one might take aim and fire at someone standing in a location, but then discover the other avatar had actually moved on from that location; the game was *lagging* and hadn't updated the other avatar's position, and therefore the shot vanished into the aether despite the correct aim of the shooting

player. In *Halo 2*, players found various ways to abuse internet connections to progress themselves more fully up the ranks. It was possible to deliberately induce lag for various players, both enemies and allies to advance one's team within a match, while the system of "standbying" or "lag switching" would go further and render some matches effectively unplayable (Davidson, 2014). This entailed players who were "hosting" the match (the player whose internet connection was being used as the core of that contest) deliberately pressing the "standby" button on their modems, causing players to continue moving as they were before the standby, but allowing the host to kill them. Upon the re-establishment of the connection, other players would simply see themselves instantly die and respawn; this would make the game unplayable for all the opponents of the player who was exploiting this system.

The case of *Halo 2* illustrates that glitches and with lag change and structure both gameplay and how we treat avatars and their capabilities within the digital world. Glitches and lag were both fundamental to the *Halo 2* experience—although glitches were unintended and unanticipated and lag unintended but most likely anticipated, they came to be representative of a substantial volume of play experiences for a substantial number of players. In both cases, avatars *ceased to act* in the ways intended by developers and expected by players, and came to adopt new behaviors. Avatars would fly through the air through the deliberate actions of their controlling players, or would suddenly die and return to life, or continue sprinting forward indefinitely, at the control of a malicious or at least deliberately disruptive individual.

Of course, less exciting outcomes can also take place—avatars get stuck in walls, or suffer from a poor framerate that makes them jerkily move across the screen, and so forth. These practices and how they affect gameplay also set up a situation of avatar disparity in a game where all avatars were, in principle, created equal, since there was no way to transfer avatar abilities between multiplayer matches and all avatars were supposed to be effectively just duplicates of the same character. *Avatars* thereby became differentiated according to the ability of their controlling *players* to utilize glitches and lag to their advantage as well as (or in some cases overriding) differentiation according to traditional metrics of player skill and ability. Examining these phenomena from an avatar-centric perspective can help us move beyond the quotidian insistence on the *undesirability* of glitches, to unpick in greater detail how these elements affect interactions between online avatars, their players, and gaming communities.

GLITCHED CHARACTERS AND PLAYER EXPERIENCE

Within computer science and traditional software development, glitches in software are treated as something erroneous and undesirable, something that clearly disrupts the single intended function of the software package—to be a word

processor, a spreadsheet program, a database manager—and must therefore be eliminated (Bainbridge & Bainbridge, 2007). Game *developers* treat glitches as do traditional program developers, aware that a game notorious for glitches will rapidly accrue criticism and scorn. However, game *players* do not always see matters this way. Most players for any game tend to pursue the experience of a game that is glitch-free and functions "correctly" (however *correctly* is defined), but small communities can actually come to embrace and actively pursue glitches, either as instrumental objectives toward other game accomplishments or as entirely self-contained accomplishments in their own rights. From this perspective, glitches and glitched avatars are not necessarily faults or divergences from the smoothly functioning game norm, but rather are an alternative form of gameplay and game functioning that redefine the affordances and capabilities of avatars. It is a different way of perceiving and acting within those same affordances, where such activities entail "innovation and, possibly, subversion" (Sundén, 2002, p. 2) of intended game rules.

Glitch videos, for example, entail the deliberate pursuit of glitches, which are then recorded and uploaded to video sharing websites for the purposes of amusement; players find humor in the surreal, unexpected, or physically impossible acts that take place as a result of the glitch (cf. Lewis et al., 2010). Glitch art of this sort draws on the loopholes (Sundén, 2009) and emergent properties (Apperley, 2013) of computer games to discover previously unknown ways of creating art and entertainment, instead of adhering to the game's intended mode(s) of consumption. This playful process of exploiting the system and altering the meaning of what takes place within the gameworld; within the context of this chapter's consideration of avatars, it is a process of altering the *acceptable* affordances and capabilities of in-game avatars and other digital actors. A bizarre change in an avatar's experience would ordinarily be seen as a serious issue that needs to be resolved to ensure continued gameplay, but within a glitch video, the act of creating and recording this same change of the avatar's appearance is actually the core objective. The boundaries and constraints of intended and anticipated play of a game thereby become reconstituted (cf. Bowman & Banks, 2016), which in turn means that avatars come to function as the site of experimentation and entertainment, rather than the embodiment of player intentions.

As Holmes (2010) puts it, glitches result in "paradoxes and extremities of distance, geometry, velocity and shadow" (p. 256). Avatars cease to look like the personas they pretend to be, and become quite obviously, collections of polygons (Altizer, this volume), or digital characters who repeat the same sentence endlessly or refuse to respond to any external stimuli. We might thereby also thereby regard the character glitch as damaging to the suspension of disbelief; if the character's continuity and integrity is broken, any attempt to create a convincing and well-realized character is destroyed. Glitches reveal the "artifice" (Apperley, 2013, p. 147) of the game software, bringing players out of an otherwise convincing gameworld that seems to

adhere to a set of realistic (or at least self-referentially consistent) rules and norms, and reminding players that everything they see is generated by computer code. These "strange apparitions" (Holmes, 2010, p. 264) therefore have a tremendous effect on how we experience in-game avatars, and change the avatar from its original form as a *character* into a selection of variables that can be tweaked and changed for amusement or interest. Glitches disrupt both the aesthetic and ludic functions of the avatar, and it is the combination of these elements that highlight the importance of glitches to a critical understanding of avatars. They change the appearances and abilities of avatars, they upset our expectations of those avatars, and they can even shift what avatars are capable of within their digital world, thereby affecting gameplay itself and resulting in a game that is inevitably altered by the presence of a substantial glitch.

LAG AND AVATAR PERCEPTION

Lag is ordinarily understood as an infrastructural and technological problem—either the network on which an online game is being played is unable to handle the full level of data transfer required or the computers that people are playing the game on are unable to render the game fast enough or unable to process the number of elements that must be tracked within the gameworld. For many who remember the state of online gaming several decades ago, lag might seem like a distant and far-away problem, one consigned to an era of dial-up internet and early graphics cards. However, such a perspective is highly contemporary (eliding the historical relevance of lag), readily forgetting daily lag problems that beset many massively multiplayer games to this day, and unduly focused upon wealthy developed countries. It forgets that for each country with the internet speed and technological sophistication of nations in Western Europe, North America or Eastern Asia, there are ten without modern internet and modern hardware (James, 2005). For the millions of game-players throughout the poorer but rapidly industrializing parts of the world, lag remains a pressing and immediate concern, and one that strongly affects their online interactions with their avatars, each other, and the rest of the world.

Game avatars behave according to temporal and spatial norms relating to how they traverse through a digital space (e.g., see Bown & Olson, this volume; Popat, this volume), and the lengths of time certain actions are expected to take. A full examination of this topic would merit a book but we can give a broad outline of such enquiries here. We expect the same input in the same context to always yield the same distance of avatar movement; we expect avatars to move at the same speed within the same gameplay context; we expect the avatar to respond to our inputs immediately; we expect them to always react within the space in the same way with regards to mundane rules such as gravity and friction (and seemingly obvious yet rarely explicit rules such as the inability to walk through solid objects). When

we command our avatar to jump, we expect them—unless they are in a situation where we know they cannot jump, such as swimming underwater—to jump, with no exceptions. Such an expectation, and the "guaranteed" payoff, is an essential part of building the player's comfort in controlling the avatar (cf. Grodal, 2000).

Lag upsets these assumptions, causing avatars to jump backward and forward with unexpected speed, traverse digital spaces in ways that should seem impossible, or to fail to respond to the player's inputs for an unusually long period of time. For example, in competitive online shooters such as *Counter-Strike* (2000), skill and success are dependent on players possessing a good aim and being able to land accurate shots upon rapidly moving opponents. Implicitly, therefore, this requires the avatars of one's opponents to be "truly" (according to the game's systems) where they "appear" (according to what the game is showing) to be. This is not ordinarily a problem, until lag enters the equation. The greater the lag, the greater the difference in timing between the perception of the player and when the perceiving player should shoot (or carry out some other activity that requires aim or reflex precision); this means lag inevitably affects how avatars can help and battle against one another in such a context. The avatars of other players become less clear and increasingly ambiguous, no longer inhabiting a single clear location but rather inhabiting a probability distribution of potential locations, which means that their apparent location cannot be fully trusted.

One will note that this resembles a glitch, but the nature is different—the avatar is still performing the "correct" action, but portraying it incorrectly, or slowly, or in small portions rather in a single smooth movement. These are not *glitches*, for the avatars are not "truly" moving faster than they should, but they are moving faster than they should in the eye of the external beholder whose computer or internet connection cannot maintain the game at its proper speed, and thus shows a strangely accelerated or disjointed sequence of freeze-frames. This is akin to one watching a horse race and taking a long blink, and then noting that the horses have moved positions without the viewer having observed their transition. Avatars seem behave once more in strange and unusual ways, but for reasons outside the game itself rather than reasons inside the game, such as faulty code or some easily exploitable in-game system.

THE FLUIDITY OF DIGITAL BODIES

Glitches and lag both effectively alter the abilities, functions, and behaviors of avatars. Glitches affect avatars by pushing our experiences of those avatars beyond their intended range of actions, while lag gives avatars the *appearance* of new abilities. That is, lag delays result in avatars that appear to be behaving in strange and unusual ways and performing their intended actions at extremely low or extremely

rapid speeds, whilst glitches give avatars *truly* new abilities, allowing them to transgress the intended bounds of their actions. This distinction between actual and apparent alterations to the abilities of the avatars shows firstly that we are right to consider glitches and lag together, as two sides of one avatar-changing coin, and secondly that avatars as a whole are not universally stable and unchanging but can become quite *fluid* with the right combination of software and hardware factors.

As such, glitches and lag should not be seen as simply *errors*, but should instead be understood as being an integral—if often, but not always unwanted—part of the ebb and flow of gameplay. Glitches are generally to be avoided, yet open up the possibility for new kinds of play and the ability to access areas of the game unintended, or gain amusement and interest from phenomena unanticipated; similarly, lag is generally to be avoided, but can level or rebalance a competitive game away from those with traditional game skills and create a new field of skills, biased toward those able to play with lag in place and take advantage of the strange visual movement it creates. Aarseth (2007) argues that although subversive and innovative play (of this sort) is relatively rare when taking in contrast to the volume of players who adhere to intended forms of play when taking part in gameplay experiences, it is essential to making sense of gameplay and game culture because such moments are those that are the most memorable, the most recorded, and the most talked-about. In keeping with this understanding, glitches and lag are extremely important for our understanding of avatars, and particularly our understanding of how avatars are perceived and understood by players. They also upset and challenge our fixed notions of the unity of a single avatar, revealing the avatar to be a complex, changing and protean thing that is dependent upon a range of technical elements, not just the many complex social and cultural factors that go into, for example, the design of player avatars. Glitches and lag can be resisted or taken advantage of, and although the *former* is by far the more common, it is the *latter*, which perhaps most strongly highlights their importance to contemporary gaming culture.

REFERENCES

Aarseth, E. (2007). I fought the law: Transgressive play and the implied player. In *DiGRA '07—Proceedings of the 2007 DiGRA International Conference: Situated Play* (pp. 24–28). DiGRA.

Apperley, T. H. (2013). The body of the gamer: Game art and gestural excess. *Digital Creativity, 24*(2), 145–156.

Bainbridge, W. A., & Bainbridge, W. S. (2007). Creative uses of software errors: Glitches and cheats. *Social Science Computer Review, 25*(1), 61–77.

Bowman, N. D., & Banks, J. (2016). Playing with a zombie author? Machinima through the lens of Barthes [chapter sidebar]. In K. Kenney, *Philosophy for multisensory communication*. New York: Peter Lang.

Davidson, J. (2014). Halo 2's ancient multiplayer cheat "standbying" is back … seriously. *Techno Buffalo.* Retrieved from: <https://www.technobuffalo.com/2014/11/17/halo-2s-ancient-multiplayer-cheat-standbying-is-back-seriously/>

Grodal, T. (2000). Video games and the pleasures of control. In D. Zillmann & P. Vorderer (Eds.), *Media entertainment: The psychology of its appeal* (pp. 197–213). Mahwah, NJ: Lawrence Erlbaum.

Holmes, E. (2010). Strange reality: On glitches and uncanny play. *Eludamos. Journal for Computer Game Culture, 4*(2), 255–276.

James, J. (2005). The global digital divide in the Internet: Developed countries constructs and Third World realities. *Journal of Information Science, 31*(2), 114–123.

Lewis, C., Whitehead, J., & Wardrip-Fruin, H. (2010). What went wrong: A taxonomy of video game bugs. In *FDG'10 Proceedings of the fifth international conference on the Foundations of Digital Games.* New York: ACM.

Sundén, J. (2009). Play as transgression: An ethnographic approach to queer game cultures. In DiGRA '09—Proceedings of the 2009 DiGRA International Conference: Breaking New Ground: Innovation in Games, Play, Practice and Theory. DiGRA.

Pixels & Polygons

The Stuff of Light-Beings

ROGER ALTIZER, JR.

Graphics pioneer Jim Blinn once began one of his classes on computer graphics by forcefully tapping a piece of chalk against a blackboard, pointing at the newly made dot and declaring it to be a pixel, stating that a pixel was just a dot (Blinn, 2005). He went on to draw on an Indian folk tale, arguing that just as a number of blind people might touch an elephant (not being told it is an elephant) and each describe it differently—as a tree (having touched the leg), a wall (the side), a rope (the tail), a snake (the trunk), or a spear (the tusk)—a pixel can be many things, described many ways. For instance, to those interested in an avatar's display quality, pixel density contributes to a display's resolution; to those interested in how pixels contribute to perceptually real avatar bodies, a pixel might convey a color sample, or one best-fit combination of cyan/magenta/yellow/black as sampling of a theoretically perfect image; to those interested in using avatars as tools to engage a game's challenges, pixels might be the effectively transparent "DNA" of how that system is displayed. But just as an elephant is not actually a tree, wall, rope, snake, or spear, a pixel—and its three-dimensional (3D) counterpart, the polygon—is not a collection of abstractions. A pixel's meaning depends on how it's engaged and who engages it.

While their subjective meanings are relative, both pixels and polygons can be simply defined. Pixels are the smallest and most fundamental visible unit of the avatar—the smallest points of illumination in a screen. Polygons are the two-dimensional (2D) planar shapes that compose 3D models, and these are generally presented in two dimensions via pixels. This chapter explores these "building

blocks" of videogame avatars, relative to their ultimate joint function for players: to organize light on a screen to translate an avatar's code and convey it as something discernibly and actually real. The light coming out of the monitor allowing you to see your avatar is as real as the light bouncing off a physical object, allowing you to appreciate it.

AVATARS AS REAL ABSTRACTIONS

The chapters in Part Two of this volume have deconstructed avatars into their very concrete parts—as they are digital bodies made of mechanics and code and physics and devices, these chapters focus on the technical side of the avatar. Players, though, don't think about avatars according to these concrete components—avatars usually don't *seem* like code and hardware when we're playing them. In this way, the things that make avatars physically real are actually—and intentionally—*perceptually abstract*. Despite this abstraction, avatars are quite real in that they are made of light. By abstracting the physically real components that are the less fantastical bits native to our everyday world, designers can privilege the digitally real components that allow us to indulge in the fantasy of a game environment. The graphical art and science of this abstraction relies on pixels and polygons—these light-dots and forms translate the perceptually abstract into something discernible that players may attach meaning to.

A key function in this translation from perceptually abstract to perceptually real is the organization of information in two or three dimensions. Game code contains a *lot* of information. Pixels are discrete dots of light initiated by a game's code. Frequently there is more data than can be displayed, which is why the same game might have more pixels given a better video card and monitor. Polygons, in turn, are collections of pixels organized as geometry to convey different shapes and sizes linked together in a 3D mesh to form a 3D model.

Until recently, the difference between 2D (pixel art) games and 3D (3D graphics) games was regarded as being indicative of whether it was high- or low-tech—whether it was retro or recent (Byford, 2014)—a distinction that was brought into question by the return to retro-styled, pixel art games. Pixel art games are no longer considered "old" when compared to 3D games. Notably, however, these distinctions are a bit clumsy since the ways a game conveys an avatar as a high-fidelity representation of a being in the physical world (or not) does not necessarily respond to the way a person perceives it as real. Both 2D and 3D avatar forms may be conveyed as meaningful signs and symbols, conveying both thingness and concepts to the players that perceive them (see Saussure, 2011).

This perception is a bit different for videogame avatars and other content, compared to how we see things in physical space. Designers use pixels and polygons

to create cognizable avatars, using them to organize information that is eventually represented as a character's face and hair (Ahn, this volume), clothing and swords (Robinson & Calvo, this volume), and its movements (Popak, this volume). In physical space, the perception of objects—the seeing and understanding—results from light (from some external source) being reflected off physical objects (Hubel, 1995). Our perception of avatars, however, is a bit different. Instead of a reflection of light from an external source, an avatar's light is *created*—still by a physical process but controlled by equations crafted by a designer and embedded in the game code. This is the dynamic that gives game designers the freedom to craft digital bodies that go beyond the constraints of physical objects—rather than relying on perceivable objects, they can *create* light representations in the same way that you might use Legos, assembling original light-points in different combinations to craft different forms.

A history of the pixel as a point of light can be found in a history of the term itself. The term "pixel," which was coined by Fred C. Billingsley of Caltech's Jet Propulsion Lab in 1965 (Lyon, 2006), is a portmanteau of the words *picture* and *element*, and it describes the smallest visible dot that, when assembled in groups with other pixels, creates a picture. The term "pel," which was introduced by William F. Schreiber at MIT in 1967, was a competing term that also stood for picture element. Both pixel and pel were used for several decades before pixel became the overwhelmingly dominant term that is used today as pel came to be seen as old-fashioned (Lyon, 2006). The word pixel itself was predated by the concept of a picture element by nearly a century. In 1874, Herman Vogel coined the term *bildpunkt* or "image point," which referred to the focal plane of a camera lens where rays of light converge on a point (Barbirato, Morassutto, & Temporelli, 2008; Fukinuki, 1998). Indeed, the concept of the pixel was born by the idea that many tiny convergences of light can be turned into something the eye can detect. The term *bildpunkt* would be used again in 1885 for inventory Paul Nipkow's patent for a mechanical-scanning television (*Elektrisches Teleskop*).

The mechanical-scanning television used either a rotating disc with apertures or a rotating mirror to scan the light from a scene which was then used to generate a video signal (Hogan, 1954). Unlike film, Nipkow's television operated on the same concept as a modern video camera, whereby one-inch square images formed electronic reconstructions of light, rather than physical reconstructions (in the case of film one sees the "negative" image with the naked eye but not in the broadcast signal). Nipkow's television transformed broadcast signals into dots that, when viewed as a group, made fuzzy moving pictures. Thus, the digital world, generated by images of emitted rather than reflected light, was born—not from light reflected from objects, but emitted and manipulated to create images received directly by the eye and understood by the brain. These early moving-picture innovations are the technological foundations of today's pixel-projected avatars.

MORE PIXELS, BETTER AVATARS?

While graphics technologies have advanced from the fuzzy images of Nipkow's *Elektrisches Teleskop* to remarkably realistic videogame depictions of agents and spaces, the reliance on pixels as the smallest elements of an on-screen image remains (Smith, 1995). The more pixels that are accumulated on-screen, the better the resolution, and the better the resolution, the more real an avatar may seem. But what do we mean by *better*?

For all their amazing potentials for crafting beings of light, one of the problems with pixels is that they represent avatars through a low-fidelity representation of its ideal, designed form. They are, in effect, a destructive representation of the avatar, in that data is lost or "destroyed" in the translation from perceptually unreal (avatar as code) to perceptually real (avatar as on-screen image). This destruction affects players' experiences of avatars by impacting the *degree* to which we can perceive the abstracted information. At the simplest, the more pixels that are on a screen (its resolution), the more information can be presented; with fewer pixels on a screen, less information can be presented.

It is not uncommon, for example, for a smartphone camera to record pictures at a higher resolution than the phone's screen can display. For example, an 8-megapixel smartphone camera records at a resolution of 3264 pixels by 2448 pixels. If one were to capture a picture with a smartphone and display it on a 1080p HDTV (which has 1920 by 1080 pixels), one would not view the picture at full resolution; many pixels from the original image would be missing as it was condensed through processing by software and hardware. Without processing (filtering), the image would appear as a series of diagonal lines with jagged edges, also referred to as "jaggies" (Schenkman, 2003). Filters reduce the occurrence of jaggies by changing the colors of pixels around the edges of the image to make them appear fuzzy. This process, known as anti-aliasing, is designed to make images appear softer, more realistic, and to make edges appear less jagged (Mammen, 1989) in the face of data loss. Such pixel processing has a profound impact on the final appearance of an avatar, and it is highly hardware dependent, forcing data to be created or removed to compensate for individual screen capabilities. If your computer or television screen resolution is low, data is lost, filtering occurs, and your avatar might look fuzzy or jagged as a result; if your screen resolution is high, it can accommodate and display more information from the original image. If the resolution is high enough that there's *not enough* information in the original image, processing may actually use algorithms to predict what colors should be placed into those missing pixel-slots. In any of these cases, the appearance of the avatar-as-designed is altered. The original data remains in the avatar files, but it is not possible to display all the data or the data must be manipulated to accommodate specific visualization hardware.

This tense interplay between avatar design and players' hardware in part drives the market for more advanced gaming technologies. In the home PC and console markets, the drive to display graphics with reduced pixel loss leads to the never-ending release of more powerful video cards and higher-resolution monitors. Games are also increasingly designed in ways that produce more pixel data (even if beyond the current state of display technologies) so that games will remain visually competitive as those hardware upgrades are released. Thus, most computer systems and consoles distort and/or fail to display all of the avatar data, resulting in a sub-optimum user experience: your favorite avatar, which may be designed to stand proudly with finely detailed armor, weathered facial features, and magical particle effects may actually fail to appear as such on your screen. Like an arms race, the gap between avatar datasets and avatar display abilities will never truly close because the capabilities of new displays and graphics cards will never fully satisfy the growing needs of avatar creators who will always create bigger and more complex avatar datasets. It will likely always be the case that more detailed avatars will "live" inside the game system than are displayed on the screen.

POLYGONS: THE KEY TO 3D

While pixels convey the information displayed on a screen, for 3D avatars *polygons* help shape what information exists in the first place. The theoretical origins of modern videogame graphics emerged more than 2,000 years ago with the work of the Greek mathematician, Euclid—the "father of geometry." Euclid's work *Elements* (c. 300 B.C.) ranks among the most important mathematical works, grounding our modern understanding of the polygon as a mathematically defined shape (Mueller, 1981). Specifically, polygons can be understood as 2D shapes with three or more straight edges. The polygons that make up 3D avatars are conceptually very similar to the shapes that Euclid described so very long ago. 3D avatars are a series of connected polygons behind which lies complex geometry. From faces to fencing foils, 3D avatars and their constituent parts consist of these mathematically derived, 3D shapes, and we see these shapes on a monitor, displayed through pixels.

In modern videogame graphics, the polygons used to construct the on-screen, digital objects and avatars are usually made of triangles and/or squares—"tris" or "quads" (Patnode, 2008)—and the specific combinations of those polygons dictate how the object appears. Take, for instance, a very simple example: a simple 3D sphere that represents a mage avatar's crystal ball. The sphere could be presented through collections of tris or quads, and the configurations of these 2D polygonal building blocks contributes to how authentically sphere-like the shape may appear. Large numbers of small tris that are constructed from high pixel densities result in the appearance of smooth polygons. Larger numbers of triangles—"high-poly"

require more complex mathematics and, hence, more computing power. "Low-poly" graphics (a common requirement of lower-powered computing devices, such as smartphones) simply means that fewer tris or quads are used to create the on-screen polygons. High-end graphics, then, often refers to the use of more tris on a screen at a given time.

Every item of clothing, every body part, is made up of many of tris and quads positioned together in 3D space to appear on the screen as objects that we recognize. Importantly, though, many complex computations are needed to make the polygons look like the avatar, especially as it appears in relation to its environment and moves through spaces—so polygons by themselves only go so far in creating a realistic avatar. In particular, texturing, the act of wrapping a flat image around a 3D object, is also needed to make the avatar look like a real object, rather than simply a collection of polygons. The technique of texturing was developed by Ed Catmull, of Disney Pixar fame (Catmull & Smith, 1980; see Kao & Harrell, this volume for more on graphical textures).

A POWER PROBLEM

One of the driving forces behind gaming innovation, in general, is the race toward better graphics. Quite frequently, what we judge as being "better" has little to do with style or substance, but is instead a matter of the number of pixels and polygons. It is common for games journalists to post screenshots or videos of several multiplatform games side by side as a means of comparing graphics. A showdown between an Xbox One and PlayStation 4 game tends to come down to which game has better textures (less muddy), which has better graphics (fewer jaggies), and which has more animation in background elements, such as a waving crowd in a sports game. Interestingly, while older side-by-side comparisons would feature all three consoles, more recent ones only feature Sony and Microsoft systems. Nintendo appears to have eschewed graphical fidelity in favor of other aspects of gaming, including local multiplayer, capitalizing on classic or "retro" properties, and a lower price point for their hardware.

When referring to retro graphics in modern games, terms such "8-bit art" or "low-poly" are used. The term "8-bit art" refers to 8-bit color graphics, and was used in game machines in the 1980s; perhaps most widely known is the Nintendo Entertainment System (NES), originally released as Famicom in Japan, with such games as Mike Tyson's *Punch-Out!!* (1987). While modern 8-bit style games are developed on and for computer systems that use far more advanced processors than the now outdated 8-bit systems, developers continue to emulate the original 8-bit art styles (as in the indie darling *Nuclear Throne*, 2015), perhaps in response to retro gaming nostalgia among both designers and gamers (see Suominen, 2008).

Low-poly is an art style that simply refers to graphics with small number of polygons, an aesthetic common to early 3D games. Although low-poly graphics require far less computing power than today's high-poly aesthetics, the low-fidelity, blocky representations also challenged game designers to consider alternate ways to 'translate' the game characters and concepts and make them perceptually real. Take the Super NES game *Star Fox* (1993), for instance—a game in which the protagonist, Fox McCloud, flies spaceships through enemy-dotted environments. It had a dedicated 3D chip in the cartridge that allowed it to render low-poly (few tris) graphics on a system that was intended to display only 2D sprite-based games. During the development of *Star Fox*, the lead game developer, Shigeru Miyamoto, believed that low-poly spaceships, while cool, would be difficult for players to empathize with (Bailey, 2016). He worked to overcome this limitation by incorporating 2D pixel art avatars at the bottom of the screen; accompanied by text dialogue, the player could see the character inside the spaceship and read the character dialogue, thus making the avatar not only perceptually real, but also more like an authentic being. So, while the simple geometry of the time worked well for hard-surface objects (vehicles and buildings), it was not sophisticated enough to represent characters; following, for quite some time characters actually relied on the affordances of low-poly 2D graphics until graphics technology evolved to accommodate high-poly character design. In addition to relying on more "primitive" pixels, game designers also relied on narratives to stand in for graphical shortcomings, effectively drawing on human players' cognitive and creative processing powers to complement game systems' limited computer processing power. For example, while Mario of *Super Mario Bros.* (1985) does not *graphically* look much like a person of Italian descent who is employed as a plumber, the backstory and game narrative convey those character details. Sometimes however, this narrative framing had to come from outside the game and was lost to those without those resources, especially since sometimes (as in the earliest commercial games) the graphic fidelity was so low than misinterpretation could easily occur. For example, in the first graphical roleplaying game, *Adventure* (1980) on the Atari 2600, the roaming enemy dragon was (and still is) frequently mistaken for a duck. When viewing the game without the support of instructions and cover art that informs players otherwise, it is easy to see how one might think that the dragon is actually a duck since the limited number of pixels leaves much to the imagination.

As graphic fidelity increased, so did players' options for customizing avatars. The MMO *City of Heroes* (CoH; 2004), for instance, was among the first to feature a robust character creation system whereby sufficient polygonal complexity allowed players to create their own versions of almost any imaginable avatar (from Wolverine and Superman, to this author's own Sailor Moon look-alike). Unlike *Adventure*'s duck-like dragon, the avatars created by COH players were recognizable by people other than the individual avatar creators. For example, it was

possible that—through customization and multiplayer functions—an avatar could be recognized as being Spiderman by other players. This unprecedented ability for creation and recognition of characters, while novel and interesting to many users— can also bring complications. In one instance, one player's recreation of 'Superman' using a CoH avatar prompted a complicated legal battle between Marvel (the copyright owner of many superhero characters) and NC Soft (developers of CoH; Bowler, 2005). The dispute was not over whether NC Soft directly violated Marvel's rights by using copyrighted characters, but rather whether providing players with powerful avatar creation tools (meaning having enough pixels and polygons) enabled the violation of Marvel's copyrights by end users (see Ochoa, this volume).

THE NOVELTY OF LIGHT-BEINGS

Although avatars are more than collections of pixels and polygons, as evidenced by the distinct and collected chapters in this volume, digital bodies become *discernible* through these points and organizations of light. Through interplays of designers' creativity and technological affordances, the abstract (series of code that spells out what an avatar should be) is translated (made visible through pixels) and becomes the subject of interactive experience (through human perception and engagement). This experience is novel—in our everyday lives we experience physical objects by sensing light bounced off them, but we experience avatars according to their own generated light. They are, at their core, beings of light.

REFERENCES

Bailey, K. (2016, April 18). Star Fox's history of innovation, for better or worse. *US Gamer.* Retrieved from: <http://www.usgamer.net/articles/star-foxs-history-of-innovation-for-better-or-worse>

Barbirato, W., Morassutto, L., & Temporelli, M. (2008). Fracarro, from the disk of Nipkow to the digital convergence. In *2008 IEEE History of Telecommunications Conference* (pp. 96–101).

Blinn, J. F. (2005). What is a pixel? *IEEE Computer Graphics and Applications, 25*(5), 82–87.

Bowler, S. (2005, February 1). City of copies: Marvel vs. NC Soft. *Game Girl Advance.* Retrieved from: <http://www.gamegirladvance.com/2005/02/city-of-copies-marvel-vs-nc-soft.html>

Byford, S. (2014, July 3). Pixel art games aren't retro, they're the future. *The Verge.* Retrieved from: <http://www.theverge.com/2014/7/3/5865849/pixel-art-is-here-to-stay>

Catmull, E., & Smith, A. R. (1980). 3D Transformations of images in scanline order. In *Proceedings of the 7th Annual Conference on Computer Graphics and Interactive Techniques* (pp. 279–285). New York: ACM.

Fukinuki, T. (1998). Television: Past, present, and future. *Proceedings of the IEEE, 86*(5), 998–1004.

Hogan, J. V. L. (1954). The early days of television. *Journal of the Society of Motion Picture and Television Engineers, 63*(5), 169–173.

Hubel, D. H. (1995). *Eye, brain, and vision.* New York: Henry Holt and Company.

Lewis, M. L., Weber, R., & Bowman, N. D. (2008). "They may be pixels, but they're MY pixels:" Developing a metric of character attachment in role-playing video games. *CyberPsychology & Behavior, 11*(4), 515–518.

Lyon, R. F. (2006). A brief history of "pixel." In *Proceedings of SPIE*, Vol. 6069, Digital Photography II.

Mammen, A. (1989). Transparency and antialiasing algorithms implemented with the virtual pixel maps technique. *IEEE Computer Graphics and Applications, 9*(4), 43–55.

Miller, R. (2005, December 14). Marvel vs. City of Heroes lawsuit settled. *Engadget*. Retrieved from: <https://www.engadget.com/2005/12/14/marvel-vs-city-of-heroes-lawsuit-settled/>

Mueller, I. (1981). *Philosophy of mathematics and deductive structure in Euclid's elements.* Mineola, NY: Dover Publications.

Nipkow, P. (1885, January 15). *German Patent No. DE188430105.* Retrieved from: <http://www.google.com/patents/DE30105C>

Patnode, J. (2008). *Character modeling with Maya and ZBrush: Professional polygonal modeling techniques.* Burlington, MA: Focal Press.

Saussure, F. de. (2011). *Course in general linguistics.* New York: Columbia University Press.

Schenkman, B. N. (2003). Appearance, clarity, acceptance and beauty of jagged letters on computer screens. *Displays, 24*(1), 15–23.

Schreiber, W. F. (1967). Picture coding. *Proceedings of the IEEE, 55*(3), 320–330.

Smith, A. R. (1995). A pixel is not a little square, a pixel is not a little square, a pixel is not a little square! *Microsoft Computer Graphics, Technical Memo, 6.* Retrieved from: <http://ftp.alvyray.com/Memos/CG/Microsoft/6_pixel.pdf>

Suominen, J. (2008). The past as the future? Nostalgia and retrogaming in digital culture. *Fibreculture, 11*, 1–8.

Embellishment & Effects

Seduction by Style

DOMINIC KAO & D. FOX HARRELL

For nearly 40 years, researchers have sought to understand how graphics in videogames and computer games impact users—ranging from whether some types of visual images displayed on a screen help to make educational games more fun to how different types of avatar graphics impact players (with Malone [1980] as one of the earliest attempts). A key concept in such work is that of *embellishment*. Consider the game *Limbo* (2010), in which environments are rendered in minimalistic black and white graphics resembling shadowy silhouettes. Such graphics feature minimal embellishment. In contrast, other systems might feature much more detailed, full-color, more painterly or photorealistic images—hence more embellishment. Figure 24.1 depicts this contrast using the example of the player character in *Limbo* contrasted with the painterly player character in *Braid* (2008). As such, while it refers to levels of detail, embellishment is no mere matter of extraneous graphical details. Rather, as it is used here the term "embellishment" is inextricably linked with notions of visual style in a more holistic sense.

A second important aspect of graphics in videogames and computer games are their "effects,"—or changes to the game's graphics over time (e.g., animations). For instance, consider *Mortal Kombat*'s (2002) character Sub-Zero who can freeze to ice and shatter a defeated opponent, a series of multiple sequential effects. On the other hand, in *DotA 2* (2013), the faint glow of green signals that a health potion was recently consumed, adding an aesthetic quality to an important feedback component. These features can perhaps be understood as *seductive details* of these digital bodies, enticing both our aesthetic sensibilities as well as our sense of ludic dynamics associated with game events.

Figure 24.1. Player-character in *Limbo* (left) versus that in *Braid* (right).
(Source: Playdead and Number None, Inc., respectively, reprinted with permission)

Prior work has suggested myriad ways that embellishment and effects (again, more holistically understood as style) in digital games may impact users' experiences, from learning to engagement. This chapter focuses on perhaps one of the most important, but underconsidered, areas of visual embellishment and effects: *avatars'* degrees of graphical embellishment and effects—i.e., the level of detail, aesthetic style, and visual feedback.

JUICINESS AND INSTRUMENTALITY

Let us start by looking at effects. Graphical effects—even those seemingly secondary such as blood expelled by avatars—can impact players' behaviors in game (Ballard & Wiest, 1996). One study—taking place in *Mortal Kombat: Deadly Alliance* (2002)—compared four different levels of blood; when avatars expelled the most blood, participants had increased hostility, arousal, and weapon usage (Barlett, Harris, & Bruey, 2008). A graphical effect like blood spurting—for all its potential vulgarity—can play an important role in some violent games as a form of feedback indicating, for instance, that an avatar is near death and needs to be healed. It also raises a question. Can we account for the impacts of graphics on players in a more general way?

We can view graphical effects in games as *aestheticized feedback*. Viewing such feedback as both informational—e.g., what is the current state of the game?—and aesthetic—e.g., what is visually pleasing, vexing, or otherwise engaging?—can be a useful spectrum in thinking about effects. Many effects are both informational and aesthetic in function. The graphical effects of videogames have been described in the literature using the evocative, if somewhat colloquial, term: "juiciness" (e.g., Gray, Gabler, Shodhan, & Kucic, 2005). While juiciness has sometimes been defined as excessive positive graphical feedback (Juul, 2010), here we draw upon definitions that describe juiciness as the sensory quality of a game that "feels alive" and "responds to everything you do—[providing] tons of cascading action and response for minimal user input." (Gray et al., 2005, p. 3) Examples of "juiciness" abound—"bouncing through a room full of coins, blinging with satisfaction," *Mario Bros.* (1983), and "enemies exploding and flinging blood to an almost unjustified extent" (*Alien Hominid*, 2004; Gray et al., 2005, p. 3). Effects can be mainly instrumental or aesthetic in nature ("juiciness" often represents an ideal merger of the two). Some effects are virtually wholly aesthetic. Consider the *DotA 2* "courier"—an aesthetic item without instrumental utility in the game—that sold for $38,000 USD for its then-rare particle effect. Or consider the *Team Fortress 2* (2007) graphical elements "hats," avatar headwear that are purely cosmetic items with no impact on gameplay. One such hat sold for nearly $20,000 USD, presumably because of its *burning flames* effect. These types of effects—which are rare *and* visually pleasing to players—command the highest premiums (see Robinson & Calvo, this volume). On the other hand, effects can be a primary mean of instrumentally communicating feedback—e.g., taking damage, status effects, healing, etc. Effects that communicate feedback should be designed with several aspects in mind. Deterding (2015), for instance, suggests a set of feedback *design lenses* which provide general principles in creating feedback: e.g., immediate (feedback immediately after the action), glanceable (feedback without visually obstructing the view), and juicy. Effects that represent feedback are often obscure—lines of motions created by characters communicating different ambiences, e.g., delicate and dynamic (curved) in *Journey* (2012), or slow and peaceful (straight uprights and horizontals) in *Superbrothers: Sword & Sworcery EP* (2011).

The concept of juiciness inherently raises several questions. Should we add effects to everything? Should we "juice" every interaction? There's good reason to believe that adding more effects will—up to a point—increase engagement, while minimizing effects will increase performance. Seductive details and juiciness can positively impact player engagement and negatively impact player performance (Kao & Harrell, 2017). For instance, imagine we have two versions of *Super Mario Bros* (1985). One version is the "juiced" version: get a coin? Fireworks. Kill an enemy? Explosion. Break a block? Screen explodes. Engaging, *but distracting*. The second version is "instrumentalized" (Zimmerman, 2011) to provide players with

maximal clarity. In this instrumentalized version, screen elements such as Mario, coin boxes, and so on are each depicted as single, solid, colored boxes against a white background. The notorious enemies called goombas are graphically mere black squares with legs. Jumping on them results in uniquely identified simple sounds. There is no rich animation in this version. Defeated enemies simply disappear. This version would be very unambiguous, *but dry*. We can imagine that games that carefully manage embellishment can provide high levels of both performance and engagement (see Kao & Harrell, 2017).

TOWARD EMBELLISHMENT: EFFECTS AS SEDUCTIVE DETAILS

This dichotomy between juiciness and instrumentality is particularly relevant in the learning sciences. For decades, researchers have found that embellishing instruction with seductive details that add up to fully realized styles with fantastic themes (Fullerton, 2014) improves instructional efficacy. Games are touted as moving beyond the "content fetish" (Gee, 2004)—the all too common view that any subject is a body of information, and that learning is the teaching and testing of that information—and immersing players in an experience where there are *intentional* inefficiencies and imperfections in game mechanics. Instead of trying to rush toward "instrumentalized" games, it is specifically in the embellished ambiguities (aesthetics that may obscure instead of reveal) that create opportunities to explore (Fullerton, 2014). But this is opposite what some researchers in the learning sciences would postulate—that such embellishments would constitute *seductive details* that impede educational efficacy as they lure attention away from the tasks at hand (Garner, Gillingham, & White, 1989).

Researchers describe three concerns related to *seductive details* as follows: *distraction* (taking attention away from the relevant and moving it toward the irrelevant), *disruption* (making it harder to create correct mental schemas), and *diversion* (priming prior knowledge that is unhelpful; Harp & Mayer, 1998). One example is in instructional media, where seductive details are known to both distract and create ambiguity (e.g., line sketches vs. 3D graphics; Butcher, 2006). Yet some researchers argue that seductive details have motivational affordances (Fullerton, 2014)—that is, graphical effects may actually *encourage* students to engage in game-based learning. For instance, one study compared three different visual themes—changing only the textures of the background and UI elements—and found that the more embellished, and more ambiguous, visual themes thwarted performance (and self-efficacy—or the belief in one's ability to succeed at a task), but *improved* engagement (Kao & Harrell, 2017). In performance-related contexts such as education, this is crucial, since higher performance and self-efficacy can influence people to choose STEM-related careers (Pajares, 1996).

AVATAR EMBELLISHMENTS AND THEIR (IN)EFFICIENCIES

In understanding the impacts that graphical features may have on gameplay outcomes in general—and educational outcomes in particular—the notion of *embellishment* provides a useful framework. For us, embellishment is more than seductive details. We refer to a type of holistic embellishment that refers to the overall degree of specificity and detail in creating graphical images for a system. In this way, embellishment is intertwined with notions like visual style and theme. Embellishment is any type of additional level of detail beyond the "bare bones" instrumental forms required for a system. When considered through this framework—from simple, functional forms variably embellished toward greater perceptual realism—three key dynamics emerge related to play performance, influence, and immersion as follows.

Simple Avatars Perform as Well as Embellished Ones

It is often implied in the games industry that added embellishment gives interactive, computer-based experiences a greater sense of realism and immersion (i.e., that the depiction is true-to-life and overtakes the senses; Lombard & Ditton, 1997). But embellishment, with respect to performance, can have its downsides. For example, a virtual reality user's confidence in stepping off a high ledge is no different when you have a simple, line-drawn avatar compared to a full-body, gender-matched avatar. However, having no avatar at all made users believe they could comfortably step off high ledges (Bodenheimer & Fu, 2015). Furthermore, both a robot avatar and an avatar made only of yellow cubes forming a human shape induced a higher feeling of digital body ownership, compared to human-like avatars (Lugrin, Latt, & Latoschik, 2015). Moreover, people who use a simpler avatar when performing virtual tasks have a similar task performance when using complex, realistic avatars (Linebarger & Kessler, 2002). In an educational context, players using simpler avatars (such as shapes) have been shown to outperform players using "likeness" avatars that bear players' resemblances (Kao & Harrell, 2016). Abstract/non-figurative avatars might provide a means of "outcome dissociation"—a greater indifference to the outcome of the virtual task, whether successful or not—via the user being less attached to them (Kao & Harrell, 2016) and less distracted via less-embellished avatars (Kao & Harrell, 2017). Furthermore, as they contain very few salient identity characteristics, abstract avatars might mitigate "stereotype threat," the notion that broader stereotypes in society affect performance at the individual level simply by *thinking* about them (Steele & Aronson, 1995)—more embellished avatars being one potential avenue of reminding users of those stereotypes.

This last point, mitigation against stereotype threat, suggests a broader potential for avatars. It is possible that digital bodies might help obviate some of the more negative impacts of oppressive graphical identity representations game

players face (see Nowak, this volume). Stereotypes like "white is good," classically described by the revolutionary theorist Frantz Fanon (2008) as a Manichean worldview, serve to disenfranchise many individuals in society. The pervasiveness of such worldviews (in society in general, not only those identified as "white") were historically made quite clear in the notorious Clark study in which African American children *consistently* showed a strong preference for a white-skinned doll *over* a brown-skinned doll (Clark & Clark, 1947). Taking a cognitive science perspective, these negative self-stereotypes may be the results of a *phantasm*—an integration of imagery, belief, and knowledge that occurs even without conscious reflection (Harrell, 2013). Given the underrepresentation of many social categories in Science, Technology, Engineering, and Mathematics (STEM) and the resulting stereotypes, people may find themselves questioning if they belong in a particular career path. In such cases where there is a conflict between a user's perceived identity and the stereotypical expert in a task domain such as STEM, obviating such oppressive phantasms becomes especially important (Ratan & Sah, 2015). In such domains, simple avatars may facilitate *identity protection*—buffering players from stereotypes that exist both at the individual level and throughout society more widely—enabling diverse players to see themselves as learners and doers in the domain without the hindrance of stereotypes they may face.

These patterns may hold true beyond the case of educational games. Even in virtual reality systems, evidence so far has consistently suggested that simple avatars are as effective, or even *more* effective (e.g., in terms of player performance when using them), than photorealistic, full body, gender-matched (in relevant cases), human avatars (Bodenheimer & Fu, 2015; Lugrin, Latt, & Latoschik, 2015). Researchers have hypothesized that differences between more abstract and more human-like avatars could be a result of various phenomena, including the Uncanny Valley effect in which an animated "almost" human elicits revulsion (Mori, 1970), "object-like" avatars increase a focus on game mechanics (Banks, 2015), etc. Though we are often keen on photorealism, simple avatars are still effective representations. However, they do not always support the needs of particular games or users. Hence, it is important to look at avatars that also more directly reflect the humanness of users in their graphical appearances.

Dynamic Embellishment Can Improve Performance Over Static Appearances

Videogame avatars often change graphically over time, especially as the player characters they represent become more powerful in the gameworld (Velez, this volume). Hence, it is important to look at avatars that change over time, or *dynamic* avatars, and even *type-changing avatars*. Players that use an avatar that is in their likeness only when achieving a goal, and at all other times a geometric shape have

significantly increased play performance and playing time compared to players that had the inverse. That is, when during gameplay a player's avatar is a simple shape, but when the player completes a level the avatar briefly changes to an avatar in the player's likeness as a congratulatory message is shown, that dynamic embellishment produces higher performance than static scenarios, as when likeness/shape are inversely shown, when the player always had a shape avatar, or when the player always had a likeness avatar (Kao & Harrell, 2016). This so-called *successful likeness* representation, it is suggested, results in higher identification with the likeness avatar facilitating vicarious experience of achievement, and lower identification with the object avatar facilitating the outcome dissociation of failure. Games, and perhaps virtual tasks more generally, might benefit from such a model of representation, shielding users from internalizing failure with, for example, a shape object during normal gameplay and trial-and-error, and basking them in self-success-identification with, in contrast, a likeness avatar during goal achievement. But this is only *one* possibility in the space of dynamic avatars—what other morphing, shapeshifting, transforming avatars have we still to imagine?

Self-similar Embellishment Is More Impactful

The *persona effect* was one of the earliest studies that revealed that the mere presence of a life-like character in a learning environment increased positive attitudes vis-à-vis the experience (Lester et al., 1997). A wealth of empirical research since then has demonstrated that digital characters are more influential (e.g., on performance, attitudes) when they have such similarities as competencies (Kim & Baylor, 2006) or genders (Baylor & Kim, 2004). This is posited to be a result of similarity-attraction, a theorized phenomenon in which people are attracted to similar others (see Kao & Harrell, 2016).

As a result, system designers may be tempted to always maximize the similarity of anthropomorphic avatars. This is likely not a bad heuristic, but one that may in fact be sub-optimal in some situations. Users may benefit more, in some situations, by avatars that embody some aspirational aspects, such as avatars resembling someone who should be skilled in the game domain, which we shall also call role-model avatars. While these could be some paragon in a field such as Marie Curie in science or Frida Kahlo in art, they could also be some ideal such as a blend between the user's ethnic and racial category and an action or fantasy hero in those game genres. Role models, in an offline context, have been shown to boost the academic performance of learners and reduce stereotype threat (Lockwood, 2006), while recently studies have been performed using role-model avatars (Kao & Harrell, 2015).

In a study in which participants were randomly assigned to either a scientist (e.g., Marie Curie), athlete (e.g., Muhammad Ali), or shape (e.g., triangle)

avatar—both scientist and athlete avatars led to significantly higher engagement. For female participants, the use of scientist avatars led to highest immersion and positive affect, and lowest tension and negative affect (Kao & Harrell, 2015)—confirming the notion that role models are effective for groups that have traditionally faced stereotypes within the task domain (in this example being women in STEM). For male participants, alternatively, the use of athlete avatars led to the biggest performance boost. Interestingly, this would appear to contradict our earlier assertion that embellishment can hinder performance (here the role model avatars outperform the shape avatars). In this case, the role model effect is stronger than any additional embellishment incurred by these avatars. Social identity—for role model avatars—influences avatar impact. In the previous section on dynamic embellishments, we saw that the actual event taking place in the game itself—if the player has just achieved a goal—also influences avatar impacts. Numerous other considerations may be of variable importance, discussed in the next section.

GRAPHICAL ELEMENTS AND WAYS OF (SCIENTIFICALLY) SEEING

The effects and embellishments of avatars will always be constrained by the systems from which they emerge, from sociocultural systems of thought and experience (McArthur, Teather, & Jenson, 2015) to social norms (Kafai, Fields, & Cook, 2010). Technological considerations are still important, including texture size (digital storage taken up by some graphics; Liang, Motani, & Ooi, 2008), pre-fetching and caching (saving data for future use; Bolger, Corrao, Hamilton, O'Connell, & Snitzer, 2015), and whether a game engine uses the CPU versus GPU for various particle effects (Unreal Engine, 2016). Of course, aesthetic considerations, e.g., the shape or timing of particle effects (Gilland, 2009) has been and always will be a priority.

Interpretation of graphics is, inevitably, subjective. While some technical details may be objectively true—for instance, textures make up a large majority of network traffic in *Second Life* (2003; Liang, Motani, & Ooi, 2008)—there are innumerable *ways of seeing* (Berger, 1972). In other words, there are multiple mechanisms for absorbing the world around us—including videogames and avatars—and establishing our place in it, each of them leading to questions, approaches, and interpretations. Many visual methodologies exist, and any one of them is valid: compositional interpretation, cultural analysis, discourse analysis, semiology, etc. (Rose, 2016). How harmonious are the colors? What is the spatial organization, the rhythm of the lines, the connections or isolations? Where is the viewer's eye drawn to? How will interpretation differ across people? How is power being constructed

or reproduced? We must constantly remind ourselves to step back, remain open, and consider other ways of seeing. More importantly, in our view, supporting other ways of seeing will inform the capacity of our systems to empower diverse users and learners and otherwise strive to support the social good.[1]

NOTE

1. This work is supported by NSF Award IIS-1064495, NSF STEM+C Grant 1542970, and a Natural Sciences and Engineering Research Council of Canada (NSERC) fellowship.

REFERENCES

Ballard, M., & Wiest, R. (1996). Mortal Kombat (tm): The effects of violent videogame play on males' hostility and cardiovascular responding. *Journal of Applied Social Psychology, 26*(8), 717–730.

Banks, J. (2015). Object, Me, Symbiote, Other: A social typology of player-avatar relationships. *First Monday, 20*(2).

Barlett, C. P., Harris, R. J., & Bruey, C. (2008). The effect of the amount of blood in a violent video game on aggression, hostility, and arousal. *Journal of Experimental Social Psychology, 44*(3), 539–546.

Baylor, A., & Kim, Y. (2004). Pedagogical agent design: The impact of agent realism, gender, ethnicity, and instructional role. In J.C. Lester, R. M. Vicari, F. Paraguaçu (Eds.), *Intelligent Tutoring Systems. ITS 2004. Lecture Notes in Computer Science* (Vol. 3220). Berlin: Springer.

Berger, J. (1972). *Ways of Seeing.* London: BBC.

Bodenheimer, B., & Fu, Q. (2015). The effect of avatar model in stepping off a ledge in an immersive virtual environment. In *Proceedings of the ACM SIGGRAPH Symposium on Applied Perception* (pp. 115–118). New York: ACM.

Bolger, R. M., Corrao, A., Hamilton, R. A., O'Connell, B. M., & Snitzer, B. J. (2015). Pre-fetching items in a virtual universe based on avatar communications. Google Patents.

Buechley, L., Eisenberg, M., & Catchen, J. (2008). The LilyPad Arduino: Using computational textiles to investigate engagement, aesthetics, and diversity in computer science education. In *Proceedings of the SIGCHI conference on Human factors in computing systems* (pp. 423–432). New York: ACM.

Butcher, K. R. (2006). Learning from text with diagrams: Promoting mental model development and inference generation. *Journal of Educational Psychology, 98*(1), 182–197.

Clark, K. B., & Clark, M. P. (1947). Racial identification and preference in Negro children. In *Readings in Social Psychology* (pp. 169–178). New York: Henry Holt.

Deterding, S. (2015). The lens of intrinsic skill atoms: A method for gameful design. *Human-Computer Interaction, 30*(3–4), 294–335.

Fanon, F. (2008). *Black skin, white masks.* New York: Grove Press.

Fullerton, T. (2014). What games do well: Mastering concepts in play. In W. G. Tierney, Z. B. Corwin, T. Fullerton, & G. Ragusa (Eds.), *Postsecondary Play: The Role of Games and Social Media in Higher Education* (pp. 125–145). Baltimore, MD: Johns Hopkins University Press.

Garner, R., Gillingham, M. G., & White, C. S. (1989). Effects of "seductive details" on macroprocessing and microprocessing in adults and children. *Cognition and Instruction, 6*(1), 41–57.

Gee, J. P. (2004). Game-like situated learning: An example of situated learning and implications for opportunity to learn. *A Report to the Spencer Foundation*. Madison WI: University of Wisconsin.

Gilland, J. (2009). *Elemental magic: the art of special effects animation*. Burlington, MA: Focal Press.

Gray, K., Gabler, K., Shodhan, S., & Kucic, M. (2005). How to Prototype a Game in Under 7 Days. *Gamasutra*. Retrieved from: <http://www.gamasutra.com/view/feature/130848/how_to_prototype_a_game_in_under_7_.php>

Harp, S. F., & Mayer, R. E. (1998). How seductive details do their damage: A theory of cognitive interest in science learning. *Journal of Educational Psychology, 90*(3), 414–434.

Harrell, D. F. (2013). *Phantasmal media: An approach to imagination, computation, and expression*. Cambridge, MA: The MIT Press.

Juul, J. (2010). *A casual revolution: Reinventing video games and their players*. Cambridge, MA: MIT Press.

Kafai, Y. B., Fields, D. A., & Cook, M. S. (2010). Your second selves: Player-designed avatars. *Games and Culture, 5*(1), 23–42.

Kao, D., & Harrell, D. F. (2015). Exploring the impact of role model avatars on game experience in educational games. In *Proceedings of the 2015 Annual Symposium on Computer-Human Interaction in Play* (pp. 571–576). New York: ACM.

Kao, D., & Harrell, D. F. (2016). Exploring the effects of dynamic avatars on performance and engagement in educational games. *Proceedings from the Games+Learning+Society Conference: Vol. 6*. Pittsburgh, PA: ETC Press.

Kao, D., & Harrell, D. F. (2017). Toward understanding the impact of visual themes and embellishment on performance, engagement, and self-efficacy in educational games. In *The annual meeting of the American Educational Research Association*. Washington, DC: AERA.

Kim, Y., & Baylor, A. L. (2006). A social-cognitive framework for pedagogical agents as learning companions. *Educational Technology Research and Development, 54*(6), 569–596.

Lester, J. C., Converse, S. A., Kahler, S. E., Barlow, S. T., Stone, B. A., & Bhogal, R. S. (1997). The persona effect: affective impact of animated pedagogical agents. In *Proceedings of the ACM SIGCHI Conference on Human factors in computing systems* (pp. 359–366). New York: ACM.

Liang, H., Motani, M., & Ooi, W. T. (2008). Textures in Second Life: Measurement and analysis. In *ICPADS'08. 14th IEEE International Conference on Parallel and Distributed Systems* (pp. 823–828). IEEE. Linebarger, J. M., & Kessler, G. D. (2002). The effect of avatar connectedness on task performance [technical report]. Lehigh, PA: Lehigh University.

Lockwood, P. (2006). "Someone like me can be successful": Do college students need same-gender role models? *Psychology of Women Quarterly, 30*(1), 36–46.

Lombard, M., & Ditton, T. (1997). At the heart of it all: The concept of presence. *Journal of Computer Mediated Communication, 3*(2).

Lugrin, J.-L., Latt, J., & Latoschik, M. E. (2015). Avatar anthropomorphism and illusion of body ownership in VR. *In Virtual Reality (VR), 2015 IEEE* (pp. 229–230). IEEE.

Malone, T. V. (1980). What makes things fun to learn? Heuristics for designing instructional computer games. *In Proceedings of the 3rd ACM SIGSMALL symposium and the first SIGPC symposium on Small systems* (pp. 162–169). New York: ACM.

McArthur, V., Teather, R. J., & Jenson, J. (2015). The avatar affordances framework: Mapping affordances and design trends in character creation interfaces. In *Proceedings of the 2015 Annual Symposium on Computer-Human Interaction in Play*. New York: ACM.

Mori, M. (1970). The uncanny valley. *Energy, 7*, 33–35.

Pajares, F. (1996). Self-efficacy beliefs in academic settings. *Review of Educational Research, 66*(4), 543–578.

Ratan, R., & Sah, Y. J. (2015). Leveling up on stereotype threat: The role of avatar customization and avatar embodiment. *Computers in Human Behavior, 50*, 367–354.

Rose, G. (2016). *Visual methodologies: An introduction to researching with visual materials*. London: Sage.

Steele, C., & Aronson, J. (1995). Stereotype threat and the intellectual test performance of African Americans. *Journal of Personality and Social Psychology, 69*(5), 797–811.

Unreal Engine. (2016). 1.1—CPU and GPU sprite particles comparison. Retrieved from: <https://docs.unrealengine.com/latest/INT/Resources/ContentExamples/EffectsGallery/1_A/>

Zimmerman, E. (2011). Let the games be games: Aesthetics, instrumentalization & game design. Presentation delivered to the 2011 Game Developers Conference, San Francisco, CA.

Perspective & Physics

Frames for Play

RYAN BOWN & GABE OLSON

The birth of modern videogames, and the physics that drive them, is due largely to researchers in academia striving to find a way to showcase computing power through entertainment. The first videogame, *Tennis for Two*, was created in 1958 by developer William Higinbotham after learning that the Donner Model 30 analog computer could simulate trajectories with wind resistance. By employing physics of the physical world—the nature and properties of matter and energy including mechanics, heat, light and other radiation, sound, electricity, magnetism, and the structure of atoms—*Tennis for Two*, though rudimentary by today's standards, emulated physical processes. The game became popular during the Brookhaven National Laboratory annual public exhibition, so much so that they continued to build upon the model year to year. The next year they added to the simulation by including different gravity levels. They discovered the processor computing power could calculate ballistic missile trajectories and wind resistance. This created the foundation for what we play today. "[Higinbotham] later recalled his intentions were that 'it might liven up the place to have a game that people could play, and which could convey the message that our scientific endeavors have relevance for society'" (Bruce, 2008).

Not too far away, Steve Russell at MIT, was working on a similar project and in 1962 developed *Spacewar!* This game pitted two players against each other in space combat revolving around a gravity well. The game followed Newton's Laws of Motion (1687/1728); an object in motion stays in motion, and an object at rest stays at rest until acted upon by a force. Just 12 short years later, Ralph Baer, widely renowned as the father of videogames, brought gaming home. He saw the potential

within the concept originated by Higinbotham and Russell; following, the first home console, the Magnavox Odyssey, came shipped with the game *Table Tennis* in 1972, which inspired Atari's *Pong* (1972), and gaming took new life. Making use of physics utilized previously, and combining that with the art of perspective (drawing solid objects on a two-dimensional [2D] surface so as to give the right impression of their height, width, depth, and position in relation to each other when viewed from a particular point), gaming catapulted from dots and lights to lifelike realism over the next 20 years. In the 1980s, *Battlezone* (1980) used three-dimensional (3D) vector art and 3D collisions, *Donkey Kong* (1981) employed jumping and traversing platformers, and Nintendo engaged the *Mario Bros.* (1983) using physics movements to break blocks, run, and swim in water. An increase in computing power and 3D engines, brought with it games such as *Myst* (1993), *Doom* (1993), and *Quake* (1996) and the evolution continued with ragdoll physics, avatar play, and game collision detection and reaction. Intense, avatar-driven storytelling and action games such as *Halo* (2001), *Half Life 2* (2004), and *Gears of War* (2006) were the result. The act of merging physics (frameworks for the properties and interactions of physical elements) with perspective (camera angles reflecting points of view) created games that became more than just scenes on a television screen. They became an interactive playground for the avatars to enjoy and explore.

PHYSICS IN PLAYER-AVATAR CONNECTIONS

As games have matured, developers have facilitated connections between the avatar and the player by empowering players to find creative solutions to obstacles during gameplay. Rather than applying a linear storyline, option-based outcomes result in meaningful engagement demanding the player to engage in if/then logic, and intuitively asking the avatar rhetorically "What happens if I do this?" Option-based outcomes give the player power and purpose while at the same time control and doubt. Here we bring Newton's Laws of Motion back into play. His Third Law states that for every action, there is an equal and opposite reaction; where such laws do transfer (e.g., into simulation games), greater authority and autonomy that is given to the avatar through gameplay the more the player will be attracted to the idea of exploration. Understanding that every action has an equal reaction, the player will naturally be excited to indulge the avatar in determining what it can and can't do, and how far it can take the gameplay. Each physics interaction that the avatar is involved with creates a chain reaction, which in turn produces a network of allowed actions that the avatar can further explore. These physical affordances rest on the avatar's interaction with them (Pinchbeck, 2009). The more game physics emulate the natural world, the more enticed the player may be to push its limits.

TRUE PHYSICS ARE BORING PHYSICS

Although mirroring everyday physics emerged out of sophisticated computing systems sometimes, true realistic physics just aren't that fun. The very design of a digital world is that it differs—or can differ—from the natural world. Realistic physics can also be unpredictable when implemented into a gameplay scenario, leading to glitches, disrupted gameplay, and unexpected or possibly unfavorable reactions. Additionally, true physics in many cases can be too expensive, for reasons such as actor count or system limitations and available memory within game systems; whereas virtual physics help keep games running efficiently by creating a set of physics rule sets by which the game designer can manage the avatar's interactions. Digital physics can be adjusted and tweaked from actual physics to conceive the imagined world. Such is the case in the game *Scrap Mechanic* (2016) where the avatar is a mechanic who uses his engineering abilities to build its own unique physics-based machines, which interact with the world in unique and unexpected ways, but doing this requires experimentation with the physical interplays of those machines and the environment.

Sometimes clever level design is required to make unreliable physics work. In *Half Life 2*, puzzles abound where the players must locate objects that provide enough weight to lift shift levers or pulleys to allow access to future sections of the game, even though occasionally, a player might find it frustrating that multiple bricks found in game do not provide as much weight as to clear a puzzle as say a washing machine. Physics must be contained to avoid frustrating the players, however when implemented properly, game physics should not break immersion (the player's sense of being perceptually lost in the gameworld; Lombard & Ditton, 1997), but instead invite interaction, which can push the player toward experimentation and creative problems solving and play in the digital world (cf. Kessing, Tutenel, & Bidarra, 2009).

This can be seen in games such as Atari's arcade classic *Marble Madness* (1984) and Rovio's new age blockbuster *Angry Birds* (2009), where the physics objects are the avatars themselves. In other words, the digital bodies—marbles or birds—are active embodiments of the physical dynamics of the gamespace. Physics mechanics that invite interaction aid the avatar in realizing its purpose. In both these games, gameplay follows pure physics chain-reaction mayhem. *Marble Madness* is experienced from a three-quarter top-down camera perspective, as a marble-avatar is navigated along a series of ramps and obstacles, constantly feeling the tug of both gravity and momentum. *Angry Birds* is experienced from a front orthographic perspective, in which the bird-avatar is literally being cast into the action via a slingshot, leading it to crash into crafted physics objects (snarky pigs and various structures). The experience of each from third-person, action-framed distance allows the player to witness the effects gameworld physics have on its

avatar because of the player's actions, through effects and secondary animations. Both these types of avatar-centric physics games require continued experimentation and creative practice to solve each puzzle, in which key parameters of the puzzle are gameworld physics.

PERSPECTIVE AS AN EXPERIENTIAL FRAME FOR PHYSICS

Within the physics of the play space, the perspective offered is the one that offers more insightful play to the gamer. The interaction between the avatar and everything within the world depends wholly on what is visually presented on screen. When the avatar is engaged via a first-person perspective (seeing the gameworld through the eyes of the character), gameplay is likely experienced *as* the protagonist, such as crafting portals in *Portal 2* as a quirky automaton (2011) or operating on aliens as a surgeon in *Surgeon Simulator 2013*. From this perspective, it is possible that players may psychologically merge with the avatar (Lewis, Weber, & Bowman, 2008) such that the player may feel the effects of their interaction with the environment and have a sense of direct influence over their environment and objects. In third-person perspectives, however, the player has an omniscient view, experiencing how all elements in the environment—from avatars and objects and forces—influence each other, through observations made during gameplay. For instance, in *World of Goo* (2008), players see a field of obstacles and caches of goo balls (effective avatars), and must work to construct networked combinations of goo balls in ways that overcome the obstacles. Simply put, third-person perspective (3PP) places the avatar(s) on screen the majority of the time, versus seeing gameplay through the eyes of the avatar as is the case in first person perspective (1PP).

Each of these perspectives may move players to experience avatar and gameworld physics differently through different emphases on embodied action versus situated action, and these orientations often correspond with the types of gameplay tasks at hand. In short, 1PP privileges a player's perception of an environment while 3PP emphasizes a player's perception of the avatar *in* an environment. For instance, take a competitive fighting game such as *Toribash* (2006), a turn-based, 3D, third-person tactical martial arts fighting game using physics-based attacks. In this game, players manipulate the joints and appendages of a mannequin-like avatar to perform fighting movements. To play such a game in FPP would be far less engaging and entertaining as it would limit the interaction between player and digital body, as a core mechanic to gameplay. Manipulating the avatar's animations through forces and collisions to create realistic movement produces acrobatic feats and crazy bone-cracking finishing moves. The avatars themselves become the spectacle driving the players' understandings of the physics-based animation system. None of these dynamics would be visible from 1PP. Like the game *QWOP*

(2008), the game incorporates a joint-based movement system involving relaxing, holding, contracting and extending the player avatar's various joints, and muscle groups, including grabbing and ungrabbing of the hands. After player inputs are tallied, the player and spectators watch as the special move unfolds, and the avatar becomes subject to the system's ragdoll physics, observable through a 3PP camera. Conversely, consider *Portal 2*—a first-person puzzle-platformer game in which players use a portal gun to solve spatial and physics puzzles requiring the digital body to move through space. The experience of the spatial puzzles would be entirely different if experienced from a 3PP, as many of the puzzles require attention to and manipulation of the avatar's body in relation to the gamespace. That is, the enjoyable challenge of the game relies on players' abilities to move their digital embodiments through (and in spite of) space using embodied problem-solving skills like spatial cognition and mental rotation (cf. Shute, Ventura, & Ke, 2015).

Both 1PP and 3PP lend to a sense of believability in the gameworld, so long as the physics are internally consistent; however, each presents unique challenges in game design that must be accounted for. In 1PP, developers must anticipate every fork in the road, knowing that the player is bound to try something unexpected. They must put themselves in the players' proverbial shoes as a seeker of novel experiences and fantasy, given that players often play games in attempts to escape the mundane activities of everyday life (Yee, 2006); because players may seem embodied fantasy, through 1PP they may be more apt to attempt to "break" the gameworld and their place in it. In 3PP, by contrast, cameras put the focus on the avatar rather than squarely on the environment, such that player attention may more likely be on how the avatar (rather than the player) can influence the environment. This scope of potential action may give developers less decision-driven variables to account for as the avatar may be seen as a system of mechanics (see Boyan & Banks, this volume) rather than as an autonomous ego-agent.

PHYSICS AS AN EXPERIENTIAL FRAME FOR INTERACTIVITY

How we experience and engage in gameplay does not just offer insight into the rules and mechanics, it gives purpose. There can be no doubt that mankind enjoys the craft of games and finds joy in playing. These joys—and expectations for them—can be observed in young children playing with puzzles to older individuals attending sporting events. Videogames emulate the psychological tradition of play, by giving the player an avatar to manipulate, as they find the playfulness in discovering ways to interact:

"Interactivity means the ability to intervene in a meaningful way within the representation itself, not to read it differently. Thus, interactivity in music would mean the ability to change the sound, interactivity in painting to change the colors,

or make marks, interactivity in film … the ability to change the way the movie comes out." (Cameron, 1995; in Salen & Zimmerman, 2004, p. 58–59)

Even though passive mediums, such as books, art, and movies can invite player participation, games by definition, are driven by player input. Games that are driven by physics along with avatar interactions, create this affordance. Once a player realizes that an object can move, or can be manipulated by physics, there may be an expectation for *everything* in a game to have this same capability. When this expectation of what is supposed to happen is broken, or something unexpected happens, this can lead to a suspension of gameplay immersion. During this moment of disbelief, the brain is fixated and fully engaged with the seemingly impossible relationship of the actions of the avatar and the physical interactions happening in the game. Because humans learn at an early age, through observation, how things should behave in the physical world we carry these expectations into digital gameworlds until we are given context to believe otherwise. Unexpected moments of action between avatar and physics interactions during gameplay may give the player something to look forward to relating to additional affordances that aren't realized, yet will want to find ways to repeat.

This means sometimes letting the player experience the unexpected, and physical novelty appears to invoke surprise and interest across humans at various developmental stages. The Yale Infant Cognition Center has undergone experiments to see if babies understand physics like adults do. These studies focus on habituation (becoming psychologically accustomed to something) and are designed to identify at what point repetition bores the human mind. In these studies (Bloom, 2013), psychologists showed babies magic tricks (e.g., making a block disappear or appear to float midair) as a way to observe responses to events that seem to violate physical laws. The babies spent longer periods looking at the "magic" scenes compared to other nearly identical (but not physics-violating) scenes, suggesting that they expect the world to function according to physics principles. "That is, babies think of the world in some of the same ways that adults do: as connected masses that move as units, that are solid and subject to gravity, and that move in continuous paths through space and time" (Bloom, 2013, p. 22). From this, we see that humans innately find interest in conditions where natural laws are bent or broken. This experience seems to be just as valid when viewed through the eyes of an in-game avatar.

BREAKING AND BENDING THE FRAMES

As we better understand how the brain works and what it responds to, we can create not only more believable worlds but more engaging experiences. Designers can engage the player by introducing unexpected events, which capture the player's

interests, such as objects that defy the rules of the gameworld, or the ability for the player to gain power or some control over the laws of the universe. In Nintendo's classic side scrolling action-adventure game, *Super Metroid* (1994) the player's avatar, Samus, gains increasingly powerful abilities throughout the game, and these abilities free her from the environmental effects. Some of these power-ups include a double jump, super running, and the ability to stick to walls. Adding to the immersion factor is the perspective used. In 3PP, there is emphasis on the avatar being subjected to the environment and its effects on the avatar, which can be seen in the avatar's animation while interacting with static and passive actors.

Physics-based sandboxes such as *Garry's Mod* (2004), where there are no real game objectives other than avatar interactions with in-game objects, are rich game environments that deviate from the norm of storyline-based gameplay. They emulate the physical world in which we live, encourage player participation by giving the avatar a plethora of missions, and offer the player a break from continuation. The rules and mechanics of the sandbox are revealed to the player through interaction. With such complexity in design comes multiple solutions for the player to get from point A to point B, such that rules may be bent. In fact, the player may decide that bypassing B to get to point C is a lot more fun, and abandons the traditional envisioned design. This brings us back to meaningful engagement, and demanding the player to engage in if/then logic. All of these dynamics intertwined provide the perfect petri dish for avatar-led gameplay. As the player gains a deeper understanding of the physics of the game, learning what they can bend and break, an emerging suspension of disbelief presents itself—the player may engage the avatar and its world as authentically real. When this type of effect is introduced, the player now has identified dimensional gameplay where moods, design, and interpretation of avatar experience with the physics environment enter the gameplay sphere. At this point, it can be said that the avatar has broken free of the rules and constraints originally intended by the designer (see Boyan & banks, this volume). The avatar is now free, in a way, to direct its own destiny in finding new rules and actions that govern those choices as it traverses this new unknown frontier of emergent gameplay.

PHYSICS AND PLAYFUL EXPERIMENTATION

As media technologies have advanced, so has our ability to make more complex games. As outlined at the beginning of this chapter, the first videogame worked to mimic the physical world, fashioned after a physical game of tennis, and designers spent 12 years trying to perfect this simulation. Over time, pushing the limits, developers discovered how much of the physical world could be replicated in digital spaces—not just aesthetically, but more importantly, physically. Physics is the tool used to create immersive play.

Physics-based game environments are the implementation of playable digital worlds fashioned after the physical world. They emulate the physical world in which we live and encourage player participation and interaction. Physics are encapsulated within the environment to create gameplay, motive, and direction for the avatar, but allow for variation based on creativity, imagination, and desires. Just as the designer can implement these forces into gameplay, the player can unlock them through the quests an avatar experiences. Certain expectations and behaviors came along with those physics, because they are based on everyday laws, however, players innately understand the laws and systems which govern actions within the game regardless of how they are changed to fit the parameters of the new world and the new game. The game itself, the objects within the game, and the way the avatar interacts within the framework of the game becomes a toy for the player to experiment with. Rules and mechanics of gameplay are revealed through interaction, gameplay, and discovery.

The physics game system imitates the physical world in application, but doesn't replicate it fully. This is turn sparks curiosity in the player to test the game system against their familiarity with and deeply rooted expectations of the natural world. Utilizing physics engages the player by inviting playful experimentation. Players often become willing to accept the system for what it is, understanding the many unknowns and unseen variables and are much more forgiving with the outcomes—even anticipating the exploration and ensuing discovery.

REFERENCES

Bloom, P. (2013). *Just babies: The origins of good and evil.* New York: Broadway Books.

Lambert, B. (2008, Nov. 7). Brookhaven honors a pioneer video game. *The New York Times.* Retrieved from: <http://www.nytimes.com/2008/11/09/nyregion/long-island/09videoli.html?_r=2>

Cameron, A. (1995). *Dissimulations: Illusions of interactivity.* (Unpublished manuscript).

Kessing, J., Tutenel, T., & Bidara, R. (2009). *Service in game worlds: A semantic approach to improve object interaction.* In S. Natkin & J. Dupire (Eds.), *ICEC 5709* (pp. 276–281). Laxenburg, Austria: International Federation for Information Processing.

Lewis, M. L., Weber, R., & Bowman, N. D. (2008). "They may be pixels, but they're MY pixels:" Developing a metric of character attachment in role-playing video games. *CyberPsychology & Behavior, 11*(4), 515–518.

Lombard, M., & Ditton, T. (1997). At the heart of it all: The concept of presence. *Journal of Computer-Mediated Communication, 3*(2).

Newton, I. (1728). *The mathematical principles of natural philosophy.* (A. Motte, Trans.). London: Middle-Temple-Gate. (Original work published 1687).

Pinchbeck, D. (2009). An affordance based model for gameplay. In *DiGRA'09 Proceedings of the Digital Games Research Association.* DiGRA.

Salen, K., & Zimmerman, E. (2004). *Rules of play: Game design fundamentals.* Cambridge, MA: MIT Press.
Shute, V. J., Ventura, M., & Ke, F. (2015). The power of play: The effects of Portal 2 and Lumosity on cognitive and noncognitive skills. *Computers & Education, 80,* 58–67.
Yee, N. (2006). Motivations for play in online games. *CyberPsychology & behavior, 9*(6), 772–775.

Mobility & Context

Of Being and Being There

EDWARD DOWNS

There is a long-standing debate in philosophical circles as to whether humans are products of their environments. While it is beyond the scope of this chapter to answer this question with certainty, it's safe to say, in brief, that the answer is likely both yes and no. On one hand, a quote from author C. J. Heck famously illustrates the "yes" position, stating: "We are all products of our environment; every person we meet, every new experience or adventure, every book we read, touches and changes us, making us the unique being we are." On the other hand, anthropologist Margaret Mead advocates for the "no" position, stating: "The notion that we are products of our environment is a sin; we are products of our choices." Both have a point. If a person is born into an English-speaking family and learns to speak in English, it is reasonable to say the person is a product of the environment. Point for Heck. However, if they decide to study Farsi, Japanese, or Papiamentu, then their choice has dictated how they will engage the world through these languages. Point for Mead.

This may seem like a strange way to begin a chapter on avatars, but the tension between fate and free will—that is to say, emerging from environment or choice—is as real in the digital world as it is in the physical world. In gameworlds, some experiences and interactions are scripted through game dynamics—some are defined by game constraints and some are chosen in relation to them. In both worlds, the ability to experience and express begins with the recognition and acceptance of a body to inhabit the *space* (the variable dimensions available to be occupied by a body, and that expanse's properties). However, whatever a gamer's

experience as a player-avatar may be, is not devoid of *context* (emergent or constructed circumstances framing that dimensional occupation; Gee, 2008). With these ideas in mind, this chapter will first discuss the dialectic process through which the digital body is recognized by the gamer. It will then explore how the avatar may be deconstructed into two parts: (1) the avatar can be recognized as that which has the ability to move within and engage across spaces, or "avatar as mobility" and (2) the avatar may be regarded as an extension of the environment in which it is situated, or "avatar as context."

A LOGIC OF BEING

If the physical world requires a body to have experiences in it, then the gameworld (more often than not) requires a functional equivalent—the acceptance of a digital surrogate (Gee, 2008) to use as a vehicle to have digital experiences. Although videogames are a decidedly 20th-century phenomenon, the method through which a game player assumes a digital body may have been explained hundreds of years ago by German, Idealist philosopher, Georg Wilhelm Friedrich Hegel (1770–1831). In the process referred to as the Hegelian Dialectic, Hegel visualized a tripartite model (James, 2007) involving the Anglicized terms: *thesis*, *antithesis*, and *synthesis* (in his native German, *Sein* [being], *Nichts* [nothing, or not-being], and *Das Werden* [becoming], respectively). Although Hegel did not coin these terms (they reportedly came from the lectures of his contemporary, Heinrich Moritz Chalybäus; Mueller, 1958), scholars generally agree that Hegel's contribution was proposing the logic of the architecture and the components' relationships to each other in a repetitive, fractal chain (McRobert, 1995).

According to Hegel (as outlined by Beiser, 1993), thesis is understood as some finite concept, a single idea, or intellectual proposition. Antithesis is a conflicting idea or a negation of the original proposition—it stands in contrast to the original thesis. The inherent conflict that exists between thesis and antithesis reconciles itself by incorporating the two ideals into a new reinterpretation of both, the synthesis. Once synthesized, the chain of events starts over, transforming the synthesized proposition into the new thesis that then undergoes a new generation of antithesis and synthesis. This process is thought to occur in perpetuity, until some grand or absolute ideal is attained (McTaggart, 1910).

Although Hegel and other philosophers contextualized the dialectic process in terms of historical processes, the architecture of the dialectic lends itself to scrutiny in other disciplines as well. Hegel's logic can be extended into the world of videogames when considering how the game player takes a digital body. Although not referenced specifically in their works, there are some scholars who allude to the importance of Hegel's model in digital worlds. For example, Biocca (1997) juxtaposes the

MOBILITY & CONTEXT | 259

recognition of the physical body with the recognition of the digital body in immersive digital environments. This could be interpreted as the conflict between thesis and antithesis. Filiciak (2003) describes the relationship in the following manner: "The subject (player) and the other (the on-screen avatar) do not stand at the opposite sides of the mirror anymore—they become one" (p. 91). Klimmt, Hefner, and Vorderer's (2009) notion of a monadic, or "merged" relationship between the individual gamer and avatar also speaks to the very nature of the dialectic synthesis. In these ways, players "inhabit" surrogate bodies; becoming "attuned" to the values, beliefs, goals, and mental states of the digital character (Gee, 2008).

Putting these thoughts together allows the dialectic model to be recognized. The videogame player is a living, breathing, sentient being that exists in the physical world. In Hegel's terms, this person represents the thesis or *Sein*. The avatar that the gamer is playing as is a digital representation of life that is comprised of code (see Lynch & Matthews, this volume; Kudenov, this volume). Once the videogame player puts down the game controller, the avatar ceases to move, defend itself, or elude stimuli. The avatar's inability to do anything in the game-scape without the flesh-and-blood gamer represents the antithesis or *Nichts*. These competing ideals—an autonomous human who exists in the physical world versus an avatar that lacks intrinsic autonomy—creates the opposing thesis and antithesis. Synthesis occurs in the physical act of the game player picking up the controller and engaging the avatar by pushing buttons and making symbolic gestures or kinesthetic movements to animate it. At this point, the gamer no longer exists solely in the physical world nor solely in the digital world. The gamer must straddle both words and navigate each simultaneously. The recognition of the gamer in the avatar and the avatar in the gamer completes the architecture of the dialectic through synthesis or *Das Werden*. Salient attributes of the player merge with salient attributes of the avatar, and something uniquely different than either of the two in isolation emerges. And so, the player takes a body—the player and avatar become the player-avatar.

GAME HISTORY AS CHANGE IN MOBILITY

Once the player has taken the digital body, it is up to the player-avatar to have experiences in the space of the digital world through enacting ways of being there. This requires that the avatar be set in motion. The history of game development is in many ways a chronology of motion or game mechanics. For our purposes, mobility and/or motion, may be defined as the process through which a game player navigates digital spaces with an avatar. The names given to certain types of games are, in fact, an acknowledgment that motion mechanics have changed. Early games like *Pong* (1972) and *Asteroids* (1979), both examples of *multilevel*

games, afforded game players limited options for motion. *Pong* allowed for simple up-and-down motions of a bar along one side of the screen, while *Asteroids* afforded the player little more than a spinning motion to change directions of a ship-avatar. *Vertical shooters* like *Space Invaders* (1978) added variety to avatar movement by changing the orientation of motion in gameplay from left-to-right to up-and-down. *Side-scrollers* and *parallax-scrollers*, then, changed motion in two ways: (1) by creating the illusion that the digital world was bigger than what could be captured on-screen at any given moment and (2) by creating the illusion of depth by manipulating the speed of back-, middle-, and fore-grounds. Eventually, developments in processing power, data storage, and programming languages allowed gamers to play *isometric* games like Q*Bert (1982) and Zaxxon (1982) from different perspectives. 3D games like *Wolfenstein 3D* (1992) and *Doom* (1993) imagined digital spaces so large that paper maps needed to be added to help gamers keep track of their motions in digital space. Finally, the *sandbox*-style, open environments of today, such as those exemplified by *World of Warcraft* (2004) and *The Elder Scrolls V: Skyrim* (2011), allow players to freely move around and explore environments that are in some ways just as complex as everyday, physical environments. In tandem with these advances, not only has mobility *in* videogames changed but mobility *of* videogames has changed. Experiences in digital worlds previously required that gameplayers be tethered to PCs, consoles, or bulky televisual displays. Today, avatars inhabit digital spaces within mobile devices that fit in our pockets and can be called upon for quick escapes or marathon gaming sessions with little effort. They also, in *Pokémon GO* (2016) trainer fashion, inhabit through augmented reality technologies the physical spaces that players move through on a daily basis.

MOTION AS AESTHETIC

Today's game designers recognize the importance of motion as an antecedent to gameplay experience. The mechanics, dynamics, and aesthetics (MDA) framework (Hunicke, LeBlanc, & Zubek, 2004) acknowledges the role of motion through the lens of game mechanics. MDA states that mechanics, including actions (read: motions), behaviors, and controls afford gamers the opportunity to act and experience a game. These experiences manifest themselves through game dynamics. These dynamics or "run-time" experiences such as interacting with others and decision-making sets the stage for aesthetics. This last part of gameplay is responsible for eliciting emotional responses from the gamer. Leveling up, rewards, cinematic scenes, and game finales complete the aesthetic framework (see Velez, this volume). Motion is not simply the game mechanic that allows us the ability to experience game dynamics *en route* to an aesthetic game experience. It is also the catalyst through which gamers interact with and are affected by gameplay.

Both the predetermined outcomes (embedded through game programming) and decided outcomes (choices made by the game player) will impact both the bodies of the avatar and the corporeal gamer. This is perhaps, nowhere more pronounced than in contemporary games where these bodies are in motion thanks to interfaces that capture real movement. In the early days of gaming (with a few notable exceptions) motion and movement in digital worlds was accomplished symbolically through button pushing (see Popat, this volume). That didn't stop gamers in heated gaming sessions from occasionally yanking the controller up into the air, as if to somehow put more emphasis on a jump, for example. Sadly, those extra motions, however vigorous, never translated to the digital bodies on screen. Today's games, using gyroscopes and motion sensing technologies (special cameras, platforms, sensors, and software), capture the kinesthetic motions of gamers and translate those enactive performance motions into gameworlds, animating the body on-screen. Having to control and maintain two bodies (one real and one digital) can be difficult and requires intense concentration to do both simultaneously. The motion through the synthesis of the player and avatar affects both in different ways. The digital body moves, eludes, manipulates, and (hopefully) has the experiences necessary to achieve desired game outcomes. The physical body gains dexterity, in-game experience to apply to future game challenges, and (especially if using a motion controller) the physical experience and rehearsal mechanism for opening the brain biology connection (Downs & Oliver, 2016; see Roth et al., this volume).

BEING THERE

The player now has a digital vehicle through which she or he can express herself or himself, and the player-avatar focuses on the act of moving and experiencing the gameworld before them. While "being there" in some circles refers to feelings of presence or immersion (Lombard & Ditton, 1997), the idea of *being there* in this case refers to being an active participant in the environment in which the player-avatar is situated—a phenomenal and material output of the player-avatar synthesis. Being, in context, requires the player-avatar to engage with the objects and inhabitants of the digital landscape. They must, move, explore, avoid, make, build, and do. As the player-avatar moves through its digital surroundings—ostensibly, to experience and understand that which is afforded by its surroundings—the digital environment becomes as much a part of the avatar as any other characteristic that the avatar may possess. Getting to know the avatar requires a player to know the context, situation and environment that the avatar is part of (see Bown & Olson, this volume). The avatar and its environment are in many ways as scholars liken knowledge to context, in that they are "inextricably a product of the activity and situations in which they are produced" (Brown, Collins, & Duguid, 1989, p. 33).

Being present, interacting, and accumulating the "experience of a 'lived-life'" allows game players to experience the "worldness" of a game[1] (Klastrup, 2003, p. 104). From this perspective, being an avatar is being part of a larger digital environment.

As the gamer plays out game scenarios, the digital body inhabited by the player becomes realized and understood as part of the player-avatar synthesis and, by extension, part of the larger gameworld context. The body becomes an integral part of a digital ecosystem. The goals and skills of the avatar and player "mesh" (Gee, 2008, p. 258) so the player-avatar can achieve game objectives. The digital body mutually influences and is influenced by its surroundings. It is through the lens of this animated digital body that the tension between fate and free will arises again. Some experiential elements in the gameworld are predetermined. For example, the boss that one needs to overcome to level up, may be the same for everyone who plays a game (identical in form, statistics, or mechanics). Or the move that is necessary to defeat a boss may not change, regardless of who is playing (a certain combination of spells executed in a particular order). Here, game mechanics ensure that all those who take up the digital body will have a roughly similar experience as they move through the pre-programmed space and time. In other cases, the decisions and actions of the player-avatar will permanently alter the narrative and the challenges that lie ahead in the digital environment. One example, console game *Mass Effect* (2007), is known for how the decision-making process changes not only the immediate environment but in some cases the outcomes of the subsequent titles in the series.

Once the player has given themselves over to the avatar and to the digital world, through the process of synthesis, events are literally and figuratively put into motion. The mechanics of gameplay demand the game player's full attention, as the gamer makes sense of the narrative or action on-screen. Mundane trappings of everyday life may fall away from conscious observation as the gamer becomes immersed in gameplay. Suspension of disbelief may occur, identification with the game avatar may occur, and experiences will begin to unfold that will shape the real-world gamer as well as the player-avatar synthesis. The common thread in the digital experience provided by any game, regardless of narrative, is that of motion in context.

SITUATING GAMEPLAY IN THE DIALECTIC

With the digital body in motion, the game player could have a near-endless array of experiences. Somewhere along the path of gameplay, digital bodies will encounter other digital bodies—both preprogrammed (non-player characters or NPCs), as well as other players' syntheses (embodied others) in the digital world. Even though the Hegelian Dialectic may be a useful frame for understanding what happens when a player picks up a game controller, it is better understood in its original

context—one carrying a stronger sociological orientation. As Durkheim cautioned, "Whenever a social phenomenon is directly explained by a psychological phenomenon, we may be sure that the explanation is false" (in Lukes, 1982, p. 7). That is not to say that it is inappropriate or wrong to borrow from philosophy to understand individual experiences in digital worlds. Rather, it is a caution that full understanding of the embodied digital character needs to explore phenomena *beyond* the game player. Examining player-avatar relationships at the individual *and* social levels will provide a more robust understanding of this association than either one by itself. A question helps to focus the potential of this line of inquiry by looking at these relationships from a sociological perspective. The question— "What happens when people's syntheses meet other people's syntheses?"—articulates the complexities of the individual player-avatar nested within a larger sociological framework (the gameworld as it is entangled with the physical world). As individual players give way to dyads, dyads give way to groups, groups give way to guilds, and guilds give way to factions—and beyond—these environments provide the raw materials to shift the focus from the individual to the sociological nature of the dialectic, and shapes the next links in the Hegelian fractal chain.

NOTE

1. "Worldness" is used here differently than in Klastrup's work, in that she would likely say worldness could only exist as a product of a digital environment that is persistent and spatially extended. Although not all games have these qualities, all digital games have in their own poetics unique yet un-named versions of worldness.

REFERENCES

Beiser, F. C. (1993). Introduction: Hegel and the problem of metaphysics. In F. C. Beiser (Ed.), *The Cambridge companion to Hegel* (pp. 1–24). New York: Cambridge University Press.

Brown, J. S., Collins, A., & Duguid, P. (1989). Situated cognition and the culture of learning. *Educational Researcher, 18*(1), 32–42.

Downs, E., & Oliver, M. B. (2016). Examining relationships between technological affordances and socio-cognitive determinates on affective and behavioral outcomes. *International Journal of Gaming and Computer-Mediated Simulation, 8*(1) 28–43.

Gee, J. P. (2008). Video games and embodiment. *Games and Culture, 3*(3–4), 253–263.

Hunicke, R., LeBlanc, M., & Zubek, R. (2004). MDA: A formal approach to game design and game research. *Proceedings of the AAAI Workshop on Challenges in Game AI*. Tech Report WW-04-04. Menlo Park, CA: AAAI Press.

James, D. (2007). *Hegel: A guide for the perplexed*. New York: Continuum Publishing Group.

Klastrup, L. (2003). A poetics of virtual worlds. In *Proceedings of the Fifth International Digital Arts and Culture Conference* (pp. 100–109). Melbourne: RMIT.

Klimmt, C., Hefner, D., & Vorderer, P. (2009). The video game experience as "true" identification: A theory of enjoyable alterations of players' self-perception. *Communication Theory, 19*, 351–373.

Lombard, M., & Ditton, T. (1997). At the heart of it all: The concept of presence. *Journal of Computer-Mediated Communication, 3*(2).

Lukes, S. (1982). Introduction. In S. Lukes (Ed.), *Durkheim: The rules of sociological method and selected texts on sociology and its method* (pp. 1–30). New York: The Macmillan Press.

McRobert. L. (1995). On fractal thought: Derrida, Hegel, and chaos science. *History of European Ideas, 20*, 815–821.

McTaggart, J. (1910). *Commentary on Hegel's logic.* Cambridge: Cambridge University Press.

Mueller, G. E. (1958). The Hegel legend of thesis-antithesis-synthesis. *Journal of the History of Ideas, 19*, 411–414.

Engines & Platforms

Functional Entanglements

CASEY O'DONNELL

Avatars are built upon and play within black boxes—various technologies and tools used to create videogames and digital worlds. In particular, game engines (the software systems upon which games are developed) and platforms (computational frameworks) have significant design impacts on the games that they are used to create. Exploring the entanglement of designer, engine, and computational platform is a useful framework for thinking about design and the broader social/cultural implications of games and avatars.

When we think about avatars, we often think about the places and spaces that they inhabit, and about the kinds of activities and actions they allow us to perform. Avatars are our conduit through which we explore, play, and sometimes shape digital worlds. While much attention has focused on players' identification with avatars, little work has examined the complex intertwining of social and technical systems that predicate avatars' very existence. In its simplest form, every avatar is made. Sometimes they are made or modified or constructed by players or users, but often they are based on some predetermined set of options (see Falin & Peña, this volume). Avatars and their worlds are constrained by the possibility space that their underlying game engines and the platforms that support them.

In trying to understand these intertwinings, it's useful to acknowledge a sentiment by sociologist John Law, that when we try to describe complex things we tend to make a mess of them. "This is because simple clear descriptions don't work if what they are describing is not itself very coherent. The very attempt to be clear simply increases the mess" (2003, p. 2). Every avatar is a mess. They are

more complicated than we think they are, and this discussion of their complica-
tion will make it *even more* complicated by bringing in a variety of sociotechnical
perspectives that are often taken for granted. The patchwork of systems—human,
technological, political-economic—often disappear between friendly monikers or
behind custom controls, and their entanglements often have important impacts on
how games are played.

FOUR FACETS OF PLATFORMS

There has been a tendency to use the word "platform" as an analytic framework syn-
onymous with Platform Studies, which relies heavily on the idea that "hardware and
software platforms influence, facilitate, or constrain … computational expression"
(Montfort & Bogost, 2009, p. 3). While this remains an important perspective, it is
useful to broaden the frame for what a platform is to draw on a more multifaceted
perspective. Platforms can often depend on four broad categories of elements: com-
putational, architectural, figurative, and political elements (Gillespie, 2010). While
it might be argued that this could conceivably collapse inward also engines and
tools, they behave quite differently. While an engine might also be a platform and
an engine might be a tool, they shape development practice in quite different ways,
so disentangling them makes sense, particularly in the case of avatars.

The *computational* aspects of a platform are often at the level of hardware.
What can a given platform do or not do? What kinds of controls or controllers
are available to a player? Is it played on a television, a desktop computer, mobile
device or some other system? Particularly with the rise of consumer-grade virtual
reality (VR) systems, the importance of player immersion will come to have sig-
nificant impacts on the underlying research and experiences that players will have
with these systems. New forms of player input will also have significant impact
on players and the kinds of research that these platforms can sustain (Roth et al.,
this volume). Thus, it is frequently tempting to identify a platform as a kind of
tangible object, an Xbox, PlayStation, or Nintendo computing platform. These are
certainly platforms, and may be mentioned in passing in a description of game-
play—"players were fitted with an Oculus Rift unit …"—but that relatively simple
description doesn't unpack the platform that is the Oculus Rift, complete with
very specific political-economic goals and a host of broad social and technological
apparatuses that support it.

The *architectural* aspects of platforms are often more difficult to pull apart.
While the controls and hardware that a platform makes available are obvious, the
ways in which they are organized and controlled by underlying operating systems,
software systems, application programming interfaces (APIs), and numerous other
systems may often be opaque to most people. In many cases these systems may also

be hidden away, requiring licensing and possibly even non-disclosure agreements to understand. Yet these systems can often have significant impact on a player's experience of an avatar. Platforms can layer an important array of systems across a platform, such as social network integration, streaming capabilities, and friend or status updates. It is also possible that architectural elements of a game will be more emergent, as they enable user-created mods (modifications; see Stevens & Limperos, this volume) or other gameplay elements (Taylor, 2009). While the focus may be on the avatar, the supporting visual elements within a game (i.e., a HUD, or heads up display), provide detailed information about the avatar and its world. While not all platforms support this kind of customization but, when it does, it too becomes an important aspect of how avatars function.

For many, platforms stop at this point. What can be appreciated Gillespie's definition, which extends platforms to include figurative and political elements, is that it draws the platform out into the broader world. To put this more succinctly, there is a politic to allow politics and the *figurative* use of the term to also play a role in what a platform is: the term "does not drop from the sky … It is drawn from the available cultural vocabulary by stakeholders with specific aims … not only to sell, convince, persuade, protect, triumph or condemn, but to make claims about what these technologies are and are not, and what should and should not be expected of them" (Gillespie, 2010, p. 359).

The platform of a game and the rhetoric and *politics* it carries with it matters for the kinds of experiences that occur around it. While an avatar exists within a digital space, that space is defined, controlled, and maintained by a wide variety of forces that also shape the experience players have when interacting with that world, existing within a broader context. The kinds of rhetoric that surround *Second Life* (2003) and the politics of the platform and the company that birthed is has meaning for what it means to be a denizen of that world (Malaby, 2009). The same is true for *League of Legends* (2009) or even *Rocket League* (2015). These platforms and the companies that support them have significant impacts for the kinds of experiences that players have and the ways in which they interact with their avatars and the broader worlds they are contained within. Within this frame, the importance of the platform is simply for gamers, designers, and researchers to have the opportunity, and perhaps even obligation, to engage with the ways in which a platform structures various gameplay experiences.

ENGINES AS PHILOSOPHICAL FRAMEWORKS

The distinction between platform, engine, and tool is a difficult and slippery one. It could be claimed that *Unity* (aka "*Unity 3D*"), a popular game engine, is also a platform. Indeed, it exhibits many of these characteristics. Yet, in considering

avatars, it is important to distinguish engines from platforms, because they serve very different purposes. Pre-existing games already deployed on a platform carry a different set of characteristics than those of a game or digital world developed specifically for experimental impulses. Often these experiences will make use of a game engine, such as *Unity, Unreal,* or even those specifically designed for VR experiences. These software packages often serve as building blocks for the development of custom player experiences.

Engines are important to pay close attention to because they are more versatile than a tool, yet they are also what could be called "blunter" than a tool, often designed to allow for a variety of games or experiences to be created within their boundaries. They are software systems that enable the design and development of new software experiences. Yet, they contain affordances that encourage specific approaches to experience design. For example, many engines focus explicitly on being designed for two-dimensional (2D) or three-dimensional (3D) style games. Put simply, choosing an engine not only begins to lock down what a game can possibly look like, but it shapes the entire creative process of game/experience design and development. Game engines also encapsulate many ideas about how games are supposed to be developed and how content is supposed to flow into a game. For example, *Unity* was designed to have a very visual development style, such that users of the engine could drag and drop elements into the game space and then attach scripts to those elements. While this works well when a level or gamespace is being defined by hand by a developer, the whole model falls apart if a game's content is dynamic or generated at run-time. This is not to say that these models don't "work" in Unity, rather that they weren't exactly what the engine's development team had in mind.

Many engines also contain pre-built modules or components that can be quickly added to a project to enable rapid development. For instance, "controller" modules can be added to objects. A first-person controller or a third-person controller can be dropped on to an object and suddenly the control scheme is defined (see Roth et al., this volume). While this certainly enables developers to rapidly prototype and try out game ideas, these pre-built controllers are precisely that, and so are easy to recognize as going hand-in-hand with an engine. The same is true for visual components. A good example of this is the "shininess" that goes along with the *Unreal* engine, which is a product of the various shaders that the game uses, often resulting in a specific visual style.

Again, this isn't to say that modularity or distinctiveness is good or bad, but it has important impacts on a game and thus on a player's or user's experience of that world through their avatar. Perhaps even more mundanely, game engines also make all kinds of demands on developers about the underlying scripting languages that can be used to customize those engines. These scripting languages can range from C++ and C# to variants of JavaScript to less widely used ones such as Lua and Python. It is

interesting to see just how many mobile-focused and 2D-specific game engines have chosen to leverage the language Lua over others. This may seem somewhat trivial to note, but these various programming/scripting languages have very different conventions in how a designer must then organize their thinking about a game—they provide a very different set of affordances that then shapes the worlds being created.

It isn't simply that these various engines provide different sets of interfaces and languages through which developers must then engage, they actively shape how a game is "supposed" to be developed. They encapsulate numerous ideas about the game development process in ways that are significantly impactful for development teams. They encourage particular lines of development and actively discourage others. This is often why the choice of an engine is critically important in the game development process. Picking the wrong engine can have disastrous effects later in the development process. In many cases, changing engines is more difficult than changing platforms. Either can have massive impacts for the teams creating a game or experience, but changing engines can completely decimate a development project.

THE PRECISION AND MESSINESS OF TOOLS

Tools are much "sharper" software systems used during the game development process—that is, they are features of development frameworks that allow for precise and discrete design actions. Tools can exist as part of an engine or platform, but they may also be stand-along software packages. Most often they take a very specific kind of form, such as a level-creation tool, or processing tool that then produces a variety of intermediate data or files that can then be integrated into an engine. While some tools may span a variety of games, most often they are very specific to their task. Tools are important, because they often encapsulate a great deal of the internal logic of how a game works at the level at its underlying systems. For example, a tool may allow a designer to rapidly place elements into a game level without the need to open and edit the entire file. Another example might be a tool that takes a variety of files provided by an artist and process them in some way that produces a more efficient piece of data that can then be read into the game or used within the engine.

Tools are often created later in the development cycle of an engine or platform as a development team better understands the what is needed for game creation and so reduces the need for experimentation. As the requirements of any given level, scene, avatar, or other game element become clearer, tools provide a means to rapidly iterate and produce those requirements. In some cases, tools are made available to players or users later in a game's development cycle, providing the opportunity for players, users, or researchers to create custom levels or maps that can be used in a game.

It is also possible to view the wide array of software development packages that co-exist in the broader ecosystem of game development as part of this tool ecosystem. Software packages like *Adobe Illustrator* and *Adobe Photoshop* are widely used for the creation of 2D artistic assets for use in a game. 3D software packages, such as *Blender, Autodesk Maya* and *Autodesk Max* are used to construct models that can then be placed into the game's engine. Audio effects elements are widely produced by very specific software packages such as *Wwise* or *FMOD* and any number of software packages may be used to further create, record, and edit background audio elements. All of these elements must then be processed in one form or another with a variety of software tools, often referred to as a "pipeline," or "asset pipeline," that places them in a form that can then be read and leveraged by the underlying game engine.

At each point in the design process, the future possibilities for avatars and the worlds they inhabit become intimately entangled with this array of social and technological systems, which are also entangled with broader social, technological, and political-economic systems. For example, the 3D modeling program *Blender* emerged from the Free and Open Source Software movement; this origin is important because a team opting to use *Blender* will likely have done so in the interest of flexibility, lower costs, and stability, and those logics will push the development of a game in impactful ways. And, much like a game engine, each one of these tools encodes very particular ideas about the "proper" process by which to create game content.

Game developers will frequently utter the phrase, "find the fun," at some point if you get them talking about the iterative character of game design and development. The idea that it isn't always clear what players of a game will find interesting or "fun" is widely pervasive in design communities. This sentiment is mirrored in the daily practices of research scientists. Put another way, both game developers and scientists rarely know *precisely* what they are hoping to find, but they have a hunch and they pursue it with the tools that at their disposal. From the history of science, we can productively parallel this kind of "experimental system":

> [It] can readily be compared to a labyrinth, whose walls, in the course of being erected ... blind and guide the experimenter. In the step-by-step construction of a labyrinth, the existing walls limit and orient the direction of the walls to be added. ... [It] is not planned and thus cannot be conquered by following a plan. It forces us to move around by means and by virtue of checking out, of groping, of tâtonnement. He who enters a labyrinth and does not forget to carry a thread along with him, can always get back. (Rheinberger, 1997, pp. 74–75)

It would be a mistake to see the construction of most games and digital worlds as any kind of master plan. The process is far messier and contingent. The metaphor of the labyrinth is a good one, as the labyrinth is a digital world that we

enter with our personal selves (an avatar of sorts) and attempt to explore. Yet, the labyrinth is a designed and constructed system. Someone with something in mind created it. It did not spring magically from the earth in such a way to simply be explored. It was made with human hands and tools with ideas in mind about what the role and purpose of the labyrinth is. We should see the digital spaces that avatars explore as no different. Yet, even if this is the case, then what is the responsibility of the gamer, designer, or researcher in trying to make sense of the mess? To bring it back to Law's concern, how do we not make a mess of the avatar in our collective endeavors?

THE IMPORTANCE OF ENTANGLEMENT

In some respects, while platforms, engines, and tools are the everyday domains of game designers, encouraging scholars studying avatars and gamers using avatars to pay close attention to them can seem an intimidating request. Yet, we must reconcile the reality that digital spaces are entangled at every moment of development and use with these much broader systems. Platforms, engines, and tools all shape the design and development process of that games and spaces that players then encounter in their exploration through avatars.

In research on the design and development of videogames, the notion of "The Dance of Agency" (Pickering, 1995) is a productive tool for thinking about the process of how games are made, which is a complex and detailed process (O'Donnell, 2009). The "dance" helps us understand that an avatar isn't just a direct translation of a designer's creative intent into reality. Rather, that creative process is more dynamic:

> [Creation is] a dialectic of resistance and accommodation, where resistance denotes the failure to achieve an intended capture of agency in practice, and accommodation an active human strategy of response to resistance, which can include revisions to goals and intentions as well as to the material form of the machine in question and to the human frame of gestures and social relations that surround it. (Pickering, 1995, p. 22)

Thus, the call here is somewhat more modest—merely that scholars and gamers should be attentive to when it matters to their research questions or gameplay experiences. Of course, no study or play can pay attention to all aspects that impact users and their avatars, it should remain a question for consideration. When do scholarly claims or playful experiences intersect with these components of an avatar's existence? It is a provocation to be aware that while these considerations may not always be salient, they can often be important analytical elements worth considering. It is a provocation rooted heavily in science and technology studies (STS) because it asks that scholars see avatars and their worlds as not entirely

ready-formed, but rather the product of human endeavor that contains its own social, cultural, and technological considerations (Postigo & O'Donnell, 2017).

Of course, like any good call, there is a politics to this call as well. Having rooted this argument in STS, it is a request to examine critically one's own technological practice, particularly those that may create and develop custom or derivative avatar experiences for work or play. This can feel uncomfortable for those unaccustomed to turning their critical gaze reflexively on themselves. This can feel as if it somehow undermines their scientific or entertainment practice. Yet, I would say it does the opposite. By placing the assumptions and limitations and aspects of what might "limit" their work by contextualizing it among broader social, technological, and political-economic structures, it makes the arguments stronger and the play more appreciable. It examines their claims and play for what they are.

REFERENCES

Gillespie, T. (2010). The politics of 'platforms.' *New Media & Society*, *12*(3), 347–364.

Law, J. (2003). Making a mess with method. In W. Outhwaite & S. P. Turner (Eds.), *The Sage handbook of social science methodology* (pp. 595–606). London: Sage.

Malaby, T. M. (2009). *Making virtual worlds: Linden Lab and Second Life*. Ithica, NY: Cornell University Press.

Montfort, N., & Bogost, I. (2009). *Racing the beam: The Atari video computer system*. Cambridge, MA: MIT Press.

O'Donnell, C. (2016). Platforms in the cloud: On the ephemerality of platforms. *Digital Culture & Education*, *8*(2), 185–190.

O'Donnell, C. (2009). The everyday lives of videogame developers: Experimentally understanding underlying systems/structures. *Transformative Works and Cultures*, 2.

Pickering, A. (1995). *The mangle of practice: Time, agency, and science*. Chicago, IL: University of Chicago Press.

Postigo, H., & O'Donnell, C. (2017). The sociotechnical architecture of information networks. In U. Felt, R. Fouché, C. A. Miller, & L. Smith-Doerr (Eds.), *The handbook of science and technology studies* (pp. 583–607). Cambridge, MA: MIT Press.

Rheinberger, H.-J. (1997). Toward a history of epistemic things: Synthesizing proteins in the test tube. Stanford, CA: Stanford University Press.

Taylor, T. L. (2009). The assemblage of play. *Games and Culture*, *4*(4), 331–339.

Interfaces & Mods

Customizing the Gateway

NATHAN STEVENS & ANTHONY LIMPEROS

The aesthetics, features, and capabilities of avatars within videogames are heavily shaped by the constraints imposed by a game interface. The dictionary definition of interface is essentially "the place or area at which different things meet and communicate with or affect each other" (Merriam Webster, 2017). While video game interfaces share some similarities with interfaces in general (such as communication and interaction between on-screen content and gamer), gaming interfaces open an interactive, ever-evolving world by providing mechanisms for players to influence that content. For example, a game such as *Final Fantasy XV* (FFXV; 2016) uses an interface heads-up display (HUD) that evolves as the gameplay switches from exploration to action. When exploring the world of Eos in FFXV, there are not many on-screen cues to interact with. Instead, the focus is mainly on pulling up menus manually through your console's control scheme. When the characters begin a battle with enemies, the on-screen interface brings up options on its own, such as features to indicate throwing a spell or ordering a set of characters to attack.

Some such interfaces are simplistic and intuitive, working with the gamer and not against them, almost as if there is a virtual butler bringing options to use at your disposal. If you overcomplicate an interface system or make it inefficient for the user to interact with, such as putting certain often-used controls away from each other or make it impossible to create a macro system (shortcuts to assign complicated moves to single buttons), then you run the risk of losing gamer interest, especially if the interface is a necessity to the game design. In contrast, other

interfaces like FFXV's online brethren, *Final Fantasy XIV* (FFXIV; 2010), can be challenging and require more input from the user. FFXIV allows the user to add or subtract interface components of his or her choosing, which is typically the case in many massive multiplayer online (MMO) games. Moving certain spells, items, or weapons into a macro position on the screen for easy access during gameplay allows for some heavy customization even though the interface's overall structure remains relatively static.

So, how is this related to the way in which we experience and use avatars? In the broadest sense, interfaces are gateways to players' experiences of avatars—and these gateways can be modified to fit a *desired* avatar experience. In many different games, there are modifications players can make to match their interface with avatars they have created. Having a connection between their digital persona, especially if a gamer has put in hours and effort to create that persona, can be complimented through a customized interface created by the user. Matching their avatar with their user interface (UI) has become quite popular in recent years. For example, if you're a Sith Lord (bad guy) in *Knights of the Old Republic II* (2004), which is a character that is notorious for featuring a red/black color scheme, there is a modification download available that will allow you to match your interface look/style/color scheme with your character in the game. While some gaming interfaces natively contain the tools for this customization, a good amount of it takes place by way of software modification.

Changing or altering original videogame content for aesthetic, competitive, or remedial purposes is known as "modding" (Scacchi, 2010). Even though video game modifications (known as "mods") have been used in the gaming community for quite some time, they have seldom been part of the research dialogue surrounding games and are not widely known outside of gaming communities. Though modding can be a functional part of gaming, it also represents somewhat of a countercultural way of playing videogames since it allows players to change virtually every aspect of a game. Since avatars are typically limited by the parameters that an interface affords and since mods essentially allow game players to change the gaming interface, it becomes important to understand the emerging symbiotic relationship between gaming interfaces, mods, and avatars.

HISTORICAL ROOTS AND RISE OF INTERFACE MODS

Even though the definition of modding is relatively straight forward, a mod can take on different meanings depending on exactly how it is deployed, and how it influences the game interface and avatars in a game environment. Some of the most common mods involve applying a "patch" (additional computer data designed to fix or improve software) to pre-existing content to change things such as outfits of

avatars, objects in the game environment, and aspects of the user interface. Sometimes mods are created to finish games that are broken upon release, such was the case with *Star Wars: Knights of the Old Republic II: The Sith Lords* (2004), which had severe coding issues that resulted in the game being nearly unplayable. The modding community—emergent groups of players with an interest in adapting games—built patches to fix the glitches that the developer had ignored to make the game more playable. Other mods change every aspect of a game (from art to interface), but maintain the engine on which it was built (e.g., an "alien game" based on the engine running the 1993 id Software game called *Doom*). Regardless of the different mod types, they have strong foundational roots in the PC gaming community, and they seem to have support from some developers and publishers who sometimes include modding tools to make the practice easier (e.g., the RAGE tool kit provided by id Software for its *RAGE* [2011] game).

The first official mod to go mainstream was *Castle Smurfenstein* (1983) on the Apple II in 1983 (Dyer, 2016). The game was based off another game called *Castle Wolfenstein* (1981), which put gamers in the role of an allied trooper determined to invade a Nazi castle to acquire secret plans. Built in the same vein, the Smurfenstein mod took the Nazi characters, and any signs of their allegiance, and replaced them with Smurfs and Smurf-themed environments (e.g., castles became giant mushroom-shaped dwellings). Instead of Nazis shouting in German, the game featured the cries of Smurfs. Literally every aspect of the game (besides the gameplay conventions) was transformed, signifying the remarkable power of modifications to alter gameplay experiences.

Once the PC community started to mod, the mods were pushed between communities through digital delivery systems, such as bulletin board systems (BBS). Much like the spread of a popular tweet on Twitter, once mod distribution began, the practice took off. It hit a permanent stride during the 1990s when id Software released its commercially successful games *Doom* (1993) and *Doom II* (1994; Lowood, 2006) whose game engine featured easily replaced modular data files. The easier it is to work with a game's engine, the easier it is to make modifications to the game. The first mod for *Doom* gave birth to a game called *Aliens Total Conversion* (ATC; 1994). The mod changed the entire gameplay design for *Doom*. Rather than playing a famous space marine and destroying demons on Mars, ATC took a more stealth gameplay route. Aliens replaced demons, and instead of shooting to kill, sneaking around proved to be the most important objective in the ATC game. The mod was embraced by PC gamers for essentially bringing an entirely new experience to a game they were familiar with and the mod was surprisingly accepted by id Software, which began to see the value in modding as keeping their aging software fresh to the gaming community.

While there are certainly aspects of modding that require a good bit of programming knowledge, it isn't a necessity. Thanks to technological delivery

advancements, the emergence of the Internet in the late 1990s, and a strong and dedicated PC gaming community, there are plenty of online spaces that contain thousands of mods, making it easy to locate these content manipulations. Consider the game, *The Elder Scrolls V: Skyrim* (2011), for a moment. There is an entire community called Nexusmods Skyrim, underneath the umbrella of a larger brand called Nexusnetworks, dedicated solely to creating *Skyrim* mods. These mods include such simple things as instituting high definition and properly shaped and rendered trees in the *Skyrim* environment, or as wildly complicated as placing bikinis on all the Dwarven women avatars in the game. All of these mods are available through a delivery system (called Nexus Mod Manager) that stores, sells, and distributes mods, but it is also possible to deploy mods in a manual fashion. Despite these development and distribution advantages, a community this large that features thousands of *Skyrim* mods does come at a price. Nexusmods Skyrim charges a premium membership fee to download mods. Regardless, there are plenty of networked mod communities out there and that are popular with game players, which do offer some of the same content as a Nexusmod, including UI and avatar modifications.

Simply deploying and using a mod is common, but if one wishes to create a mod, many tools and skills are required. Those tools are either provided by the game company (e.g., a game's software development kit [SDK] via its game engine) or a modder might find tools created by a third party designed specifically to mod a certain game title. If a mod creator chooses the first option, depending on the game-development company or the publisher and the game tools they offer, there might be some limitations. For example, if someone wanted to create a mod for DICE's Electronic Arts *Battlefield 1* (2016), then DICE would have to provide modding game tools built specifically for their title or an SDK for their Frostbite engine, which they developed in-house. The likelihood of that happening is slim, but if someone wants to add something like a World War II soldier avatar or a Hummer into a World War I environment, they would have to work with DICE in some capacity to acquire the right tools to do so.

Game tools and SDKs are the doorways into games, which allow players to add scripts to the logic process, add animation that wasn't previously there, and other modifications to change avatars and user interfaces in many unique ways. Currently, there are many ways to perform modifications on a game that modders have a bevy of choices when it comes to creation and implementation. Some of the solutions are as simple as placing a file in a folder to update the game, while others will require more effort.

Valve Software has fostered its own modding community through its digital client, Steam, that mixes both simple and complex modding for users. They have provided an SDK to the gaming community and have also made Steam the central hub for other SDKs provided by various developers that it hosts. Valve's

SDK provides the modding community tools to adjust some of Valve's popular titles, such as *Half-Life 2* (2004), *Portal* (2007), and to an extent the popular game *Counter-Strike* (2012). Once tools and an engine are acquired, the next decision a modder must make is exactly what type of mod they are going to create (see Lowood, 2006; Scacchi, 2010 for a broader discussion of mod types). You can mod game attributes such as visuals, which would allow you to add trees to the landscape of Bethesda's Skyrim. You also have avatar modding, such as the Northborn Scar mod, which allows you to add scars to the faces of characters within Skyrim.

Since *Doom*, thousands of mods have made their way to PC gaming over the years. The PC gaming community is largely responsible for the advent of mods and they remain the catalysts today, constantly pushing the envelope to put together more creative additions, changes and updates to a wide array of games. Modders create mods to express themselves, enhance gameplay, create a form of art, contribute to a community, and because they believe the skills they use develop mods have both practical and monetary value (Sotamaa, 2010). This research underscores that modding has become an important and intricate part of videogame culture. Furthermore, the value and success of modding is driven by the fact that game players can create, access, and deploy these tools to completely change the way a videogame and its avatars are experienced.

ALTERING THE AVATAR GATEWAY

Beyond simply adding content to games or fixing buggy code from unfinished development, mods have focused on customizing the game to the user experience. For example, *Star Wars: The Old Republic* (SWTOR; 2011), a massively multiplayer online game (MMO), has a modding community called SWTORUI (Star Wars: The Old Republic User Interfaces) that provides customized UIs for specific character types inside the game. This is important for gamers who wish to personalize their UI interfaces to match the personality of their avatars inside the game. For example, if a player wants a Jedi Knight UI because he or she plays a Jedi Knight inside SWTOR, then the community has one pre-packaged. If something visually specific to Sith Inquisitors is desired, SWTORUI has that as well. The customized UI helps to play off the strengths of the avatars in the game, such as quicker access to healing other characters, as well as helping to improve more technical features, such as fitting comfortably on a 16:9 screen. Beyond the pre-built UI, the community also has a section that provides tools and utilities created by users to help customize UI for its community members.

The *World of Warcraft* (WoW; 2004) MMO, which reached 5.5 million community members in 2015 (Statista, 2016), has a gamer-friendly UI customization environment to play with and adjust. Soren Johnson, lead designer/programmer

for *Civ4* (2005) and *Spore* (2008), talked about WoW's UI gamer-friendly customization by stating:

"One of the most impressive things about that game [WoW] is the flexibility it gives users to create their own custom interfaces. The interesting thing about this decision is that while it taps into the incredible resources of the user modding community, it is also a tacit admission that a game's interface is best developed in concert with the players." (as cited in Targett, Verlysdonk, Hamilton, & Hepting, 2012)

Targett et al. (2012) also discuss the importance of UI modding regarding the WoW experience and even goes as far as to say that UI mods are used to improve or extend a player's interaction with an avatar and avatar-mediated content. WoW allows for modifications through XML and Lua scripting languages as well as through Activision/Blizzard-supplied modification kits. Regardless of delivery system, Activision/Blizzard appears to have an open-door policy when it comes to modding their WoW user interface within reason of the company's Terms of Service limitations. Allowing for users to adjust the UI provides customizable gameplay experiences that are personal to the user (such as the avatar), while at the same time helping to increase the flexibility and entertainment value of the game experience. Maximizing the possibilities of UI customization gives users the power to play their game how they feel most comfortable, as well possibly create a connection between user persona, avatar, and interface.

Even though mods serve a variety of purposes, one of their most vital functions is extending the entertainment value of the game itself. Keeping a game going and making it more interesting through gameplay design changes can extend the life of a game by many years. For example, mods for *Skyrim* can add new content, changing the dimension of the gameplay, and even going against the story to provide something incredibly different, yet still entertaining. One of the wilder mods in the *Skyrim* modding community is the inclusion of a character skin depicting the late WWE wrestler, Randy "Macho Man" Savage. Deploying this mod in the *Skyrim* environment essentially changes every dragon into the Macho Man. Bizarre as this many sound, it is actually quite a popular mod that directly changes the game's non-player characters. As if Macho Man is not enough, there is yet another mod, which transforms dragon avatars into the children's character Thomas the Tank Engine. This transformation is not solely one of appearance, as the dragon "roars" are replaced with train "toots." While there is perhaps no practical value of doing either of these, as it doesn't improve the *Skyrim* gameplay design, nor does it provide patch work for the game, but it does produce entertainment value, which can extend a game's longevity.

This entertainment experience and additional modifications to the original game are productive contributions to the PC gaming industry, especially when it comes to retaining the gamer. Extending the life of a game past its usual prime

through modding helps to justify establishing a more mod-friendly industry supported by publishers and developers, while concurrently continuing the expansion of profits for a company that might have thought their game would only have a two-year shelf life. For example, *Minecraft* (2011) hasn't really changed its vanilla flavor since the first year of its release. The concepts behind the game are the same, as is the adventure of continuously building structures and avoiding creepers. It's like LEGOs for this generation of gamers. The main game could have gotten old a long time ago, but a strong modding community has offered additions of new avatar and game features—from crafting avatar armor out of any material in the game to changing the default "Steve" avatar skin to one mimicking Marvel's Wolverine. The game is still popular, bringing in nearly 4000+ new gamers a day (Minecraft, 2016). Adding new avatars and including familiar properties, such as *The Simpsons* (2007) and *Skyrim* characters, has helped to extend the interest within the *Minecraft* gaming community.

The more success and longevity a company can get out of its product, the more likely they may be to see the value in modding. Cooperating with modders and opening their once-sacred, untouchable intellectual property (IP) to independent coders to fiddle with and improve is important for maintaining a fanbase, as well as bringing a user custom experience, even when it comes to simple mods as customizing avatars to the user's liking. This convergence between game players and makers, as foreshadowed by Jenkins (2006), will only strengthen as game companies continue to support fan modding communities complete with tools and development kits. Official publishers have already begun to create these spaces for modders. For example, The Steam Community Workshop provides such a place and even goes as far as creating an accessible amount of information to help modders out with the tools they need to start modifications. A company having an even balance of control over accessible modding tools for the public, while encouraging the modding community to push the boundaries of vanilla games is likely to pay off for developers and gamers alike. Bethesda's Skyrim is an example of this, as it came out in 2011, yet continues to thrive on the PC and the most recent consoles because of modding communities.

FROM MODDING CHARACTERS TO MODDING PLAYERS

As the PC industry starts to shift from traditional gaming where users sit back and relish personal creations on a monitor, to virtual reality-based gaming environments where users engage the experience through perceptual immersion, modding too may shift to a more immersive practice. While current modding practices influence avatar-mediated experiences by modifying how we engage avatars through an interface, the shift to more fully embodied digital experiences may

represent a shift to modifying *ourselves* as we become immersed in digital spaces. For instance, in parallel with modding a game interface to more clearly reflect an avatar's hit points, spell cooldowns, or ideal combat actions, self-modding might introduce modding a VR interface to more clearly reflect a player's physical spatial boundaries (don't hit that lamp!), physiological responses (heartrate is up!), or prompts for embodied action (extend your arm!). In other words, the adjustment of interfaces may be adjusting experiences of ourselves.

REFERENCES

Dyer, A. (2016). PC game mods—from Smurfs to Counter-Strike and beyond! *GEFORCE.* Retrieved from: <http://www.geforce.com/whats-new/articles/history-of-pc-game-mods>

Jenkins, H. (2006). *Convergence culture: Where old and new media collide.* New York: New York University Press

Lowood, H. (2006). High performance play: The making of machinima. *Journal of Media Practice, 7,* 25–42.

Merriam Webster (2017). *Interface.* Retrieved from: <https://www.merriam-webster.com/dictionary/interface>

Minecraft. (2016). *Sale stats.* Retrieved from: <https://minecraft.net/en/stats/>

Scacchi, W. (2010). Mods, modders, modding, and the mod scene. *First Monday, 15.*

Sotamaa, O. (2010). When the game is not enough: Motivations and practices among computer game modding culture. *Games and Culture, 3,* 239–255.

Statista (2016). World of Warcraft subscribers. Retrieved from: <https://www.statista.com/statistics/276601/number-of-world-of-warcraft-subscribers-by-quarter/>

Targett, S., Verlysdonk, V., Hamilton, H., & Hepting, D. (2012). A study of user interface modifications in World of Warcraft. *Game Studies, 12*(2).

Controllers & Inputs

Masters of Puppets

DANIEL ROTH, JEAN-LUC LUGRIN, SEBASTIAN VON
MAMMEN, & MARC ERICH LATOSCHIK

Picture vibrant cities of the future or battlefields of the past—we can dive right into these fantastic scenarios by means of modern technology. The digital characters that populate these and various other digital worlds are distinct. Some are referred to as "agents" and are driven by the machine—they wander about and behave based on algorithmic instructions. Others are "avatars" and are driven by human movement, like puppets: "The interaction of the player with the video-game is the puppetry. Puppetry describes how the player starts approaching the video-game until eventually the game being played is the outcome of the actions of the player" (Calvillo-Gámez, Cairns, & Cox, 2015, p. 47). As the puppet Pinocchio's creation was famously characterized by his maker Gepetto: "The legs and feet still had to be made. As soon as they were done, Geppetto felt a sharp kick on the tip of his nose. 'I deserve it!' he said to himself. I should have thought of this before I made him. Now it's too late!" (Collodi, 1881/2012).

Although Collidi's Pinocchio and Gepetto seem to be disconnected entities, it is Gepetto's intentions and physical actions, in combination with his senses, that *control* his wooden companion. To become the puppeteer of an avatar, breathing life into its digital body, *controls* are a necessity for every interactive system and are, in contrast to other components, "universally applicable to every style of game" (Rogers, 2014, p. 163). As the linking channel between the user's intentions and the avatar behavior, controllers and inputs are a crucial component of avatar-based systems. A *controller* in this sense can have two distinct meanings, either in terms of a physical input device (e.g., a joystick) or in terms of a part of a system. The *input* is the information the physical device is sensing and delivering to the system.

THE USER AS THE CONTROLLER

Just as this book treats avatars as an assemblage—as a system of interconnected parts—avatars are, in turn, part of the game as an even more complex system. By definition, a system is a collection of components linked together and organized to be recognizable as a single unit (Englander & Englander, 2003). Accordingly, a system can be characterized by its interconnectivity, the structural organization and the behavior of its components. In systems theory, a controller (as part of a control system) obtains, in combination with other components (*actuator* and *process*) a desired system response. Consider, for instance, using a microwave stove. It typically requires the user to set a timer to a given time (the input, via the controller). The stove (actuator) will then heat the food (process) until the timer runs out. The set time is the input of the system, whereas the timer represents the controller. Such a simple system, an *open-loop* control system, does not use feedback to determine if the goal is reached, and does not compensate for any disturbances. Its input-output relationship can also be described as a cause-effect relationship (Dorf & Bishop, 1998). Alternatively, the controller might be informed by the system's state, i.e., the temperature of the heated food. In modern control systems, this feedback control is an essential part of most systems. In so-called *closed-loop* feedback control systems, the actual output and feedback is measured using a sensor and compared to the desired output response (Dorf & Bishop, 1998). In our microwave example, the food temperature can be measured by a sensor and compared to the reference input (desired temperature) by the controller. The controller may consequently increase or shorten the remaining heating time.

Applying this logic to controlling avatars in games or other digital environments, the human becomes part of a real-time interactive system (RIS), a system that senses external events (user actions), processes the input, and provides corresponding outputs of this interaction loop at real-time speeds (Englander & Englander, 2003). In a way, we can describe any RIS, including games and interactive digital environments, as combinations of actuators and sensors to perceive the users' actions, the users themselves as controlling (and consuming) entities, rules that determine system behavior based on its state and any given inputs, and actuators that provide feedback to the users. Specifically, the user can control various attributes of component sets of the system (von Mammen, 2016), for example, by pressing a key to move an avatar. The keyboard provides the information that drives the system behavior, e.g., the movement of the avatar, and a screen provides the output to the user. It is the user's task to close the loop of information flow, to utilize the feedback to adjust his control actions and thus achieve a given intention or goal (Figure 29.1). Taking on the job of the controller is typically the challenge that brings about the fun in videogames (Koster, 2013).

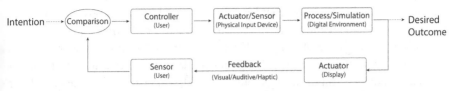

Figure 29.1. Closed-loop control (real-time interactive) system for avatar control.
(Source: author, adapted from Dorf & Bishop, 1998; Englander & Englander, 2003)

The human player is the entity responsible for driving its avatar-counterpart to perform an action (i.e., deliver input), and the computer or console is the hardware and software that is responsible for simulating the avatar action and its respective visual feedback. Human and computer are interacting parts of one system. The system's design defines the input-output structure of the loop of interaction. In our keyboard example, the human (as controller) interacts with other parts of the system using a mechanical controller (a physical device) as actuator. This notion brings us to the second meaning of the term controller in our context, the controller as an *input device*.

THE CONTROLLER AS AN INPUT DEVICE

While it may be intuitive to think about a game interface in terms of things that happen on a screen (cf. Limperos & Stevens, this volume), devices used to influence or directly control on-screen events are equally important. Here, a controller is an input device for communicating from the user to the computer—a technical construct that measures activity of the user in one or more physical or physiological dimensions (degrees of freedom), and transforms this information into digital data (input) digestible by a computer system.

Controlling an avatar, then, refers to the central, dynamic relationship between the user and the system, in which the input device acts as a medium through which the user's intentions are conveyed and the user-avatar relationship in part unfolds. This medium can channel various forms of user activity depending on the affordances and capabilities of the input device, the game or digital environment and its platform, and the user's intentions. Input devices can be purely passive, if they continuously create data without any physical interaction with the device (e.g., controlling the avatar's eyes through eye-tracking sensors that sense the user's gaze direction), or purely active, if physical interactions with the device are required (Bowman et al., 2004).

In general, we can distinguish between two forms of input signals for controlling an avatar: *discrete* input, such as a signal generated by a brief keyboard

button press, and *continuous* input, such as the held horizontal position of a joystick or a maintained mouse position. For the sake of illustration, consider the controls in sports games such as the *FIFA, NBA,* or *NFL* series by Electronic Arts in which passing the ball from one digital ball player to another is discrete action evoked by a discrete input (a single button press), whereas steering the ball player around a digital football field requires continuous input (holding a joystick position). Discrete inputs report a single data value (e.g., button pressed: yes or no) that can change over continuous time, whereas continuous inputs report a continuous value (e.g., axial position of the joystick) changing over continuous time. In this regard, our definition holds a flaw, as continuous *digital* input devices are not actually time continuous or value continuous. Rather, they capture a precise measure of discrete values over discrete sampling periods (frequency of data) which can be considered quasi-continuous. These frequencies (typically measured in Hertz) can vary to large extend and can impact on the overall processing time for the input.

The time between when a user provides input and this input is processed until the appropriate feedback is created can be critical for the user experience of both continuous and discrete input. If the period takes too long, the user or player might experience latency or "lag" (see Johnson, this volume), or a crucial input sample might be missed leading to system misinterpretations of the user's actual intentions. For example, to make Mario perform a higher jump (double jump) in *Super Mario 64* (1996) the player needs to press the jump button twice in a narrow time window. If the avatar control system's input sampling frequency is too low, it is not capable of detecting both button presses and the process does not result in the desired outcome due to the system's limitation. Such deviations may result in a degraded game experience, e.g., poor response times and "sticky" controls, which may lead to player frustration. In general, latency in digital environments can result in decreased efficiency or negative training effects, degraded vision, degraded performance, breaks in presence, and can be a cause for cyber sickness (Jerald, 2015). In these ways, accurate translation of both discrete and continuous inputs is essential for a successful interaction.

CONTROLLING AVATARS THROUGH CONTROL SCHEMES

Considering the dynamics noted above, interaction relies on specific mappings of physical actions to digital data and a system response to perform a task; these mappings are known as interaction techniques (Foley, van Dam, Feiner, & Hughes, 1990), and a combination of interaction techniques and their semantic mappings can be described as a control scheme. Technically speaking, a control scheme is the conceptual framework around which system components and feedback are structured; in games and other digital environments they include the schematic

mapping of multiple user actions to multiple avatar mechanics, as well as a translation interface between the (human) physical behaviors and the (avatar) digital behaviors. Let us refer to the double jump example once again. While if we tried to physically jump twice, the height of our second jump would not stack atop the height of our first jump. However, when controlling Mario, we press a button twice and the avatar's behavioral mechanic is executed, i.e., its animation state changes. This abstraction of the intended physical behavior (jumping) as it is mapped onto a controlling device (Gamepad Button A) together with the semantic mapping of power ("push button twice") define the design of the control scheme. Control schemes are determined by the general design, the expressivity, and the complexity of the controller device, which can be measured by the degrees of freedom and input device affordances.

A BRIEF HISTORY OF CONTROLLERS AND CONTROL SCHEMES

While a more detailed history of game controllers and their influence on games warrants a tome of its own (see Cummings, 2007, to start), it is worth offering a short review. Early controllers of *Tennis for Two* (1958) *or Spacewar!* (1961) were custom-developed digital control boxes consisting of discrete digital button and knob inputs that evolved to paddles and joysticks, and eventually to gamepads. With the 1990s and 2D/3D first-person shooters such as the *Doom* (1993) and the *Quake* (1996) series, new control schemes evolved that used the keyboard keys (e.g., arrow keys or WASD) to steer and rotate. Later, mouse control allowed controlling avatar movements and the camera's rotational perspective (e.g., "mouselook" in *Quake*) or selecting and navigating in real-time strategy games.

Beyond mainstream formats, less usual control devices were developed, including rhythm pads for dance games, light guns, and even drums for music games. Striving for more naturalness in control, touch and multi-touch approaches link the human finger input with control schemes such as, double tab, timed tab, hold and drag, touch and hold, and swipe (Rogers, 2014), to give the user greater control over the applications. Interfaces that leverage touch, gesture, gaze, speech, or handwriting to control an application are often referred to as "natural user interfaces," or NUIs. Fostering the transportation of emotion, algorithms and sensors today offer possibilities for real-time facial control of an avatar (Weise, Bouaziz, Li, & Pauly, 2011). New motion-controllers such as Leap Motion are especially interesting for avatar control, as they enable systems to sense the spatial (biological) motion of the human hand and to transfer the input to avatar behavior. Similarly, full-body motion controllers (e.g., Microsoft Kinect) are utilized to detect the body's pose, as in in the dance training game *Kinect Dance Central 3* (2012)

where the player's dancing moves are mapped to the avatar. Modern algorithms and frameworks can detect gestures, poses, and social signals from behavioral data and other modalities. Marker-based motion tracking techniques allow for more precision in motion control by using multiple reference points placed on the human source body, and sometimes these reference points can be reduced in numbers by applying inverse kinematic algorithms. Compared to other input device types, motion tracking establishes a more direct translation between the movement of the user in the physical world and avatar movement in the digital world by utilizing the numerous degrees of freedom of the human body. Given compatible kinematic structures between the user and the avatar (that is, matching movements and forces), it almost allows a real 1:1 mapping between user (source) actions and avatar (target) movements, mirroring the original movements in real-time.

By means of such controllers and control schemes, the user "puppeteers" the avatar which results in a *sense of control*, making the user feel responsible for the avatar's behavior (Calvillo-Gámez et al., 2015). In the physical world, the "sense of intending and executing actions, including the feeling of controlling one's own body movements, and, through them, events in the external environment" (Tsakiris, Prabhu, & Haggard, 2006, p. 424) is understood as *agency*, which only evolves from voluntary actions of control.

AVATAR EMBODIMENT AND VIRTUAL BODY OWNERSHIP

Controlling an avatar and exploring digital environments essentially creates a connection between the character and the user. In the physical world, we experience *embodiment*—a sense of being present with our own body and having a sense of it (corporal-awareness, self-awareness; Longo, Schüür, Kammers, Tsakiris, & Haggard, 2008). Through embodiment, we experience body ownership, or the perception of our "own body as the source of sensations" (Tsakiris et al., 2006, p. 424). Under certain circumstances, it is possible to trick the human mind into perceiving an *illusory body ownership* for other objects and accept them as part of one's own body. First experimentally investigated inducing an illusion of owning a rubber hand as part of one's body (Botvinick & Cohen, 1998) researchers found this phenomenon extended to digital bodies (Slater, Pérez Marcos, Ehrsson, & Sanchez-Vives, 2008). By utilizing motion-tracking technologies for kinematic avatar control, the level of perceived control over the avatar (and therefore the level of agency) may be improved. As agency is a concept strongly related to the illusion of body ownership, and the coupled avatar can represent the human behaviors to a large degree, the system can induce an *illusion of virtual body ownership*, ranging from the assumption of single body parts to whole, digital bodies (Slater et al., 2009). Researchers started to investigate driving factors of virtual body ownership illusions. Reviewing

the findings, processes such as the identity and synchronicity between visual and motor perception (sensuo-motor coherence), synchronicity between visual and tactile stimuli (visuo-tactile), as well as the visualization of the environment from an avatar's first-person perspective are main factors for the illusion of virtual body ownership, which may be influenced by the character's realism (Maselli & Slater, 2013).

The importance of the first-person perspective emphasizes the interplay between controls and camera. In contrast to two-dimensional displays, virtual reality displays (especially head mounted displays) directly link the user's head position and orientation to the camera perspective in the digital environment. The user literally steps into the shoes of the avatar, evoking vivid, immersive experiences. The technical realization of virtual body ownership illusions poses a challenge. It was shown that increased end-to-end latencies reduce motor performance and body ownership (Waltemate et al., 2016). Therefore, engineers must solve current issues of latency, lag, and jitter (Rogers, 2014) and regain control over timeliness and the game/simulation loop.

THE FUTURE IN AUTONOMY AND HYBRID SYSTEMS

Perceptually real controls turn *steering* Mario through a digital world into *being* Mario in a digital world. Consumer VR and behavioral controller technologies open a large design space for future development of digital worlds populated by avatars, agents, and even hybrids (Roth, Latoschik, Vogeley, & Bente, 2015). Part of the human control will then be in the hands of the machine, modifying interactions and behaviors for the sake of better virtual rapport (Gratch et al., 2007) and nonverbal synchrony (Roth et al., 2015). Avatar systems can help to understand, assess, and train communicative impairments (Georgescu, Kuzmanovic, Roth, Bente, & Vogeley, 2014) and the appropriate AI may transform to adequate behaviors. Hybrid forms of "ourselves" enable constant embodied conversation and co-presence, whether connected or disconnected from our digital "selves" (Gerhard, Moore, & Hobbs, 2004). Social artificial intelligence (AI) will allow for multiple, fully registered interactions at the same time and for transporting messages by means of newly learned behavioral patterns not accessible in the physical world. Gestures, speech, and social reactions will be learned and adapted across intercultural differences, serving and mediating even among large groups of people.

With the rising complexity of hybrid avatar/agent systems, we will soon reach the limits of natural inter-human communication. To this end, brain-computer interfaces and implants may provide solutions for new dimensions of sensing and display. Avatars will be the "interface" to our "selves" in these systems, but for puppeteering multiple selves in hybrid systems, metaphorically, we again find ourselves in another exciting era of *Pong*.

With individual programs controlling the digital agents in future digital worlds, the theme of self-organization will play an increasingly important role. While each avatar or agent in a system may only act based on locally provided information, many of them together may have an impact on the digital world that only a few could not possibly achieve (Schmeck, Müller-Schloer, Çakar, Mnif, & Richter, 2010). Harnessing this distributed constructive power by only a few (or even only one player or avatar) motivates the field of human-swarm interaction (von Mammen, 2016). It investigates according interfaces that provide the means to instruct, influence, or inspect groups of agents that otherwise act autonomously. In the end, it is not only a pragmatic but also a philosophical and ethical question: to what degree human society will trust the machine to puppeteer, and to what degree we take control ourselves.

To ensure that we can engage with digital worlds of considerable complexities, we need to promote the incorporation of multimodal and neural sensing and control as components of avatars. We need to master and innovate the "avatar" as the "interface" in computer-mediated communication and games. This implies that avatars need to become perfectly "natural" to increase behavioral realism, social presence, and trust (Bente, Rüggenberg, Krämer, & Eschenburg, 2008). Part of this naturalness lies in the user's opportunity to detect and react to subtle cues of behavioral control. When translated to the domain of embodied agents and hybrid systems, the underlying social AI needs to be developed as well. Beyond mere reactive AIs that seek perfection in mimicking natural presentations, AIs will need to serve and promote the users' individuality and consider the multifaceted, open-ended ways of human communication. Not unlike organic computing systems (Schmeck et al., 2010), such AIs may draw from expert knowledge and learn models based on large data sets, but they also need to learn continuously during runtime. To foster the rapid and diverse representation of individual behaviors, AIs for avatar-agent systems necessarily need adapt information about the human controller's intuition and self-awareness. In symbiosis with the human controller and as part of one control system, machines need to process and learn signals that remain unconscious for the human and their underlying neural correlates (Roth et al., 2015).

Returning to the puppet and puppeteer:

"'There he is,' answered Geppetto. And he pointed to a large Marionette leaning against a chair, head turned to one side, arms hanging limp, and legs twisted under him. After a long, long look, Pinocchio said to himself with great content: 'How ridiculous I was as a Marionette! And how happy I am, now that I have become a real boy!'"

The avatar of the future might strike us in the very same way, opening doors to new worlds of experiences, understanding, and communication. Similar to Pinocchio's awareness of himself as a living entity, the input and control elements of avatar

systems allow us to experience worlds as different entities. It is our intentions and intuition rather than the patterns of performing actions that have to control these entities in future avatar-based digital environments.

REFERENCES

Bente, G., Rüggenberg, S., Krämer, N. C., & Eschenburg, F. (2008). Avatar-mediated networking: Increasing social presence and interpersonal trust in net-based Collaborations. *Human Communication Research, 34*(2), 287–318.

Botvinick, M., & Cohen, J. (1998). Rubber hands "feel" touch that eyes see. *Nature, 391*, 756–756.

Calvillo-Gámez, E. H., Cairns, P., & Cox, A. L. (2015). Assessing the core elements of the gaming experience. In *Game User Experience Evaluation* (pp. 37–62). Cham, Switzerland: Springer.

Collodi, C. (2012). The adventures of Pinocchio: The tale of a puppet. (Trans: C. D. Chiesa). La Maddalena, Italy: Aonia. (Original work published 1881).

Cummings, A. H. (2007). The evolution of game controllers and control schemes and their effect on their games. In *Proceedings of The 17th Annual University of Southampton Multimedia Systems Conference* (Vol. 21).

Dorf, R. C., & Bishop, R. H. (1998). *Modern control systems*. Menlo Park, CA: Addison-Wesley.

Englander, I., & Englander, A. (2003). *The architecture of computer hardware and systems software: An information technology approach*. Hoboken, NJ: Wiley.

Foley, J. D., van Dam, A., Feiner, S. K., & Hughes, J. F. (1990). *Computer graphics: Principles and practice* (2nd Ed.). Boston, MA: Addison-Wesley Longman Publishing.

Georgescu, A. L., Kuzmanovic, B., Roth, D., Bente, G., & Vogeley, K. (2014). The use of virtual characters to assess and train non-verbal communication in high-functioning autism. *Frontiers in Human Neuroscience, 8*.

Gerhard, M., Moore, D., & Hobbs, D. (2004). Embodiment and copresence in collaborative interfaces. *International Journal of Human-Computer Studies, 61*(4), 453–480.

Gratch, J., Wang, N., Okhmatovskaia, A., Lamothe, F., Morales, M., van der Werf, R. J., & Morency, L.-P. (2007). Can virtual humans be more engaging than real ones? In *International Conference on Human-Computer Interaction* (pp. 286–297). Berlin: Springer.

Jerald, J. (2015). *The VR book: Human-centered design for virtual reality*. Williston, VT: Morgan & Claypool.

Koster, R. (2013). *Theory of fun for game design*. Sebastopol, CA: O'Reilly Media, Inc.

Longo, M. R., Schüür, F., Kammers, M. P., Tsakiris, M., & Haggard, P. (2008). What is embodiment? A psychometric approach. *Cognition, 107*(3), 978–998.

Maselli, A., & Slater, M. (2013). The building blocks of the full body ownership illusion. *Frontiers in Human Neuroscience, 7*, Article 83.

Norman, D. A. (2010). Natural user interfaces are not natural. *Interactions, 17*(3), 6–10.

Rogers, S. (2014). *Level up! The guide to great video game design*. West Sussex: John Wiley & Sons.

Roth, D., Latoschik, M. E., Vogeley, K., & Bente, G. (2015). Hybrid avatar-agent technology—A conceptual step towards mediated "social" virtual reality and its respective challenges. *i-Com - Journal of Interactive Media, 14*(2), 107–114.

Roth, D., Waldow, K., Stetter, F., Bente, G., Latoschik, M. E., & Fuhrmann, A. (2016). SIAM-C—A socially immersive avatar mediated communication platform. In *Proceedings of the 22nd ACM Conference on Virtual Reality Software and Technology* (pp. 357–358). New York: ACM.

Schmeck, H., Müller-Schloer, C., Çakar, E., Mnif, M., & Richter, U. (2010). Adaptivity and self-organization in organic computing systems. *ACM Transactions on Autonomous and Adaptive Systems (TAAS)*, 5(3), no. 10. New York: ACM.

Slater, M., Pérez Marcos, D., Ehrsson, H., & Sanchez-Vives, M. V. (2009). Inducing illusory ownership of a virtual body. *Frontiers in Neuroscience*, 3(2), 214-220.

Tsakiris, M., Prabhu, G., & Haggard, P. (2006). Having a body versus moving your body: How agency structures body-ownership. *Consciousness and Cognition*, 15(2), 423–432.

von Mammen, S. (2016). Self-organisation in games, games on self-organisation. In *Games and Virtual Worlds for Serious Applications (VS-Games), 2016 8th International Conference on* (pp. 1–8). IEEE.

Waltemate, T., Senna, I., Hülsmann, F., Rohde, M., Kopp, S., Ernst, M., & Botsch, M. (2016). The impact of latency on perceptual judgments and motor performance in closed-loop interaction in virtual reality. In *Proceedings of the ACM Symposium on Virtual Reality Software and Technology*. New York: ACM.

Weise, T., Bouaziz, S., Li, H., & Pauly, M. (2011). Realtime performance-based facial animation. In *ACM SIGGRAPH 2011 Papers* (p. 77:1–77:10). New York: ACM.

Licensing & Law

Who Owns an Avatar?

TYLER T. OCHOA & JAIME BANKS

Leeroy Jenkins is a videogame character of wide internet and gamer culture fame. He first came to popular attention in 2005, in an iconic game scenario in which—while his cohort was diligently planning a complex dungeon battle—he suddenly sprang to life, let out the gravelly battle cry *Ah'Leeerooooooy Ah'Jeeennnkiiinnns!*, and led his compatriots into a slaughter by dragon whelps. He subsequently noted: "At least I have chicken" (DBlow2003, 2005/2014). The ridiculousness of this event led first to the viral appropriation of the character—crafted into memes about everything from riots and warfare to politics and cinema—and this broader reception led to an increased presence in other videogames and game-related products, from the digital card deck-building game *Hearthstone* (2014) to third-party t-shirts and allusions in films like *Wreck-It Ralph* (Spencer & Moore, 2012). While it's not uncommon for game companies to carry characters from one property to another (e.g., the host of characters imported into *Super Smash Bros.* [1999]), Leeroy's case is different. He wasn't created by a game company. He was created by a *player*, Ben Schulz, as he played the MMO *World of Warcraft* (WoW; 2004).

As outlined in various chapters in this volume, both players and game developers have great influence over how avatars—via their assembled components—manifest in digital gameplay. Developers craft their foundational platforms and draw on those infrastructures to craft dynamic code that enables movements, appearances, and abilities. But those potentials call into question whether avatars are avatars until they are played—players click avatars into being, customize their bodies and attire, drive their actions and interactions, and sometimes bring them

outside the gameworld through physical representations. So, given avatars' joint reliance on developers and players, and given legal frameworks such as copyright law, who really "owns" a videogame avatar?

The answer was, perhaps, simpler at one point than it is now. Although early games offered little to no customization based on variations in rudimentary pixel combinations, many modern games afford players a range of creative potential, especially in the MMO genre. These more advanced systems generally offer customization along four dimensions: visual appearance (shape and features of the body; see chapters by Ahn, Nowak, Robinson, & Calvo, this volume), abilities (types of spells and strengths; see chapters by Paul & Milik, this volume), behavior (action of the avatar in the gameworld; see Popak, this volume), and dialogue (aural or textual speech conveyed as or by the avatar; see Wirman & Jones, this volume). Although the latter two dimensions are largely governed by the investment of the player (to the extent the player offers inputs to the avatar to engender its movement or speech), the former two dimensions are effectively governed by the game's designers, as the technical features offer the "raw ingredients" for players to use in customization play. These constraints, however, still often function only as a framework for players' engagement of the system. Take, for instance, the MMO *City of Heroes* (2004). In creating an avatar, users select a character archetype (hero or villain), an origin (e.g., mutant or magic), a primary and secondary power set, and a visual appearance varying by sex, body type, physique features, head (15 types with 26 features), skin color, gear and ornamentation, weapons, auras, animations, name, voice, and backstory. Accounting for all possible variations of these factors, players could quite literally craft *trillions* of unique character forms (see Ochoa, 2012). Because the game's potentials don't account for the unique contributions of players to how an avatar "lives" in a gameworld through enacted avatar behaviors and speech, a question emerges as to whether players' contributions to avatars as customized content warrant some or all of the legal rights associated with authorship and ownership.

THE LIMITED LOGIC OF LICENSE AGREEMENTS

In addressing this question, the first consideration is a given game's End-User License Agreement (EULA) or Terms of Use (ToU), which define a game developer's or publisher's ownership of the game code and of the copyrightable expressions that players may produce during gameplay. For instance, the WoW ToU states that "All rights and title in and to the Service (including without limitation any user accounts, titles, computer code, themes, objects, characters, character names, stories, dialogue, catch phrases, locations, concepts, artwork, animations, sounds, musical compositions, audio-visual effects, methods of operation, moral rights, any related documentation, 'applets,' transcripts of the chat rooms, character

profile information, recordings of games) are owned by Blizzard or its licensors" (Blizzard, 2012, para. 4). Many developers require players to agree to a EULA before they are permitted to access game content, to protect the company's interests associated with original and derivative game content.

While such agreements may seem cut and dried, EULAs do not offer a definitive answer to the question of avatar ownership. For instance, even if a player consents, a EULA may be unenforceable or invalid if a court considers it unconscionable, a violation of public policy, or preempted by federal copyright law (see Lemley, 1999). Certain attributes of authorship and ownership cannot be assigned via contract (e.g., termination rights, see *Marvel Characters, Inc. v. Simon*, 2002). Moreover, "reliance on a EULA is intellectually unsatisfying and logically backwards"— in considering ownership, it is more prudent to consider "who owns what in the absence of an agreement to the contrary" (Ochoa, 2012, p. 965). This approach allows default ownership to be determined and, from that baseline, one can consider the validity and enforceability of contractual alterations to the default. Who, then, owns an avatar when there is no agreement to the contrary?

COPYRIGHT AND AVATARS AS "WORKS"

The issue of default avatar ownership comes in its potential status as a copyrightable "work of authorship," and the extent to which developer and player creatively contribute to that authorship. "Copyright protection subsists ... in original works of authorship fixed in any tangible medium of expression" (Copyright Act of 1976, § 102(a)). *Original* denotes that a work is independently created and contains a minimal (even slight) amount of creativity (*Feist Publications, Inc. v. Rural Telephone Service Co.*, 1991). Copyright protection for original works, however, is limited to the unique expression of an idea and not the idea itself (Copyright Act, § 102(b)). For instance, the layout of controls for a golf videogame (e.g., on-screen arrows and ball flight path) are driven by minimal necessary functions and so are not sufficiently creative or original (*Incredible Technologies, Inc. v. Virtual Technologies, Inc.*, 2005). While early games did not exhibit a great deal of creativity, often relying on simple geometric shapes with predictable movement (e.g., *Pong*, 1972), modern games arguably afford a much greater array of creative potential.

A work is *fixed* "when its embodiment in a copy [a material object such as a computer disk] ... is sufficiently permanent or stable to permit it to be perceived, reproduced, or otherwise communicated for a period of more than transitory duration" (Copyright Act, § 101). Although computer code driving a game's audiovisual outputs is considered fixed in a permanent form (cf. *Stern Electronics, Inc. v. Kaufman*, 1982), one must consider whether the audiovisual outputs themselves are fixed. Because—in addition to the appearance and visibility dimensions

of customization—players can manipulate avatars as on-screen content toward highly variable behavior and speech, these aspects of avatars arguably are crafted in real time and so are not fixed in this fashion. "That makes playing a videogame a little like arranging words in a dictionary into sentences or paints on a palette into a painting. The question is whether the creative effort in playing a videogame is enough like writing or painting to make each performance of a videogame the work of the player and not the game's inventor" (*Midway Manufacturing Co. v. Arctic Intl. Inc.*, 1983). Courts' early answers to this question relied on early games' repetitive nature, such that one could ostensibly replicate a player-created display by performing the same movements (Ochoa, 2012). As games have become more complex, more reliant on random events, and multiplayer-driven, however, this conclusion regarding fixation becomes less persuasive; on-screen events are perhaps more akin to live, improvised performances, which are not considered "fixed" unless they are simultaneously being recorded (Copyright Act, § 101).

Finally, the Copyright Act lists eight kinds of *works of authorship*—literary, dramatic, musical, pantomime/choreographic, pictorial/graphic/sculptural, audiovisual, sound recordings, and architectural (§ 102(a)). Videogames fit into two of these categories, as they comprise computer code (a copyrightable literary work) and that code, when run, generates audiovisual output. Despite this duality, Copyright Office regulations provide that a game need only be registered as one of these two types to protect both the code and its output (U.S. Copyright Office, 2014, § 721.10(A)).

In considering default ownership of avatars, one must also determine whether or not an avatar is a separate work of authorship, apart from its game. The Copyright Act fails to provide a definition of "work," but one can draw an analogy to a literary or graphic character that is protected by copyright if it features identifiable, persistent traits that make it original and distinctive (e.g., *Gaiman v. McFarlane*, 2004). Although many graphic media characters meet this criterion quite easily, it is nonetheless difficult to determine whether an avatar constitutes a work distinct from the game in which it is embedded. In implementing the "minimum size principle" (Hughes, 2005, p. 609), however, the Copyright Office forbids registration of words or short phrases (U.S. Copyright Office, 2014, § 313.4(C)), but it allows registration of literary, dramatic, or visual works that describe or depict a character (U.S. Copyright Office, 2014, §§ 911, 912). Therefore, an audiovisual work that features an avatar's distinctive appearance and attributes could be copyrighted, and that copyright would protect that avatar as an aspect of the work.

Assuming an avatar qualifies as a "work of authorship," is it fixed? While discrete, coded visual properties and algorithms that underlie avatars' abilities may be considered fixed by virtue of their permanent storage on a material object such as a hard drive (a game provider's or a player's), the dynamic features of an avatar (i.e., the enactment of those abilities, and behaviors and speech) may be too fleeting or fluid to be deemed fixed. Indeed, *because* of this fluidity, the engagement and

conveyance of these potentials may be considered a public performance, the live transmission of which can be fixed if it is permanently recorded (e.g., via machinima recordings; Copyright Act, § 101).

As to whether an avatar is original, it must be (a) distinctive and detailed enough to be distinguished from generic, similar characters, which are treated as unprotectable ideas (*Gaiman v. McFarlane*, 2004) and (b) sufficiently different from previous copyrightable characters, unless the derivative character was created with authorization (Copyright Act, § 103(a)). It must be acknowledged that many avatars (say, in an MMO where avatars are often quite similar) are not sufficiently different from preexisting characters and not distinct from avatarial tropes in a given game. Nonetheless, it is likely that some (perhaps many) user-crafted avatars are imbued with the minimal "creative spark" required for originality (cf. *Feist Publications, Inc. v. Rural Telephone Service Co.*, 1991).

But who is the font of this creativity—who is the creative author? From a deterministic perspective, a game developer may claim to be the author, because the avatar cannot be anything that the game's designers and programmers do not allow it to be. This view, however, overlooks the fact that the avatar is much more than just code—the program *constrains* but does not *dictate* the avatar's customizable expressions. Depending on the degree to which players can influence the form and function of on-screen content (Steuer, 1992), games necessarily give players some degree of freedom that *may* warrant copyrightable authorship in avatar appearance and behavior within the program's constraints. If a game offers a sufficient range of interactivity and player choice such that the productive gameplay can no longer be said to be solely authored by the developer, the player must be considered to have some degree of original authorship (Ochoa, 2012). By analogy, a word-processing program or paint program is copyrightable, but the literary and artistic works produced with those tools are not owned by the program's copyright holder (*Berkla v. Corel Corp*, 1999). Thus, in a game that offers only a limited range of customization options and limited interactivity (e.g., moving left or right and jumping only), the developer could be said to be the sole author of any avatars, since any player customization is limited and all avatars are derivative of the basic template. However, given that most games today afford a wide range of options for avatar customization by appearance, abilities, behavior, and speech, it cannot be said that a game developer is the sole author of such an avatar—at a minimum, the player must be considered a joint author of the avatar.

ON JOINT AUTHORSHIP AND OWNERSHIP

Let us return now to the question of who owns an avatar. The Copyright Act accounts for four types of collaborative authorship: works of joint authorship,

derivative works as successive authorship, works made for hire, and collective works (§§ 101, 103, 201). These forms of authorship depend on the relationship among collaborators and on the nature of their contributions, and these forms in turn determine ownership. Notably, however, none of these four frameworks account for the collaborative dynamics between MMO developers and players. While it is beyond the scope of this short chapter to delve into the nuances of fit (for this, see Ochoa, 2012), suffice it to say that each disadvantages one or both parties without fully addressing the contributions of both.

Given a choice of four imperfect options, an MMO is perhaps best considered a collective work (an option that provides some protection to both player and developer contributions), and individual avatars perhaps are best viewed as separately copyrightable contributions to that collective work (because many games afford customization systems requiring considerable player creativity). If so, it must still be determined who owns the copyright to those avatars as contributions. Should a specific avatar be counted as a joint work of the game provider (providing the template) and the player (fleshing out that template)?

It may be useful to consider each avatar as a compilation—a work in which "preexisting materials ... are selected, coordinated, or arranged in such a way that the resulting work as a whole constitutes an original work of authorship" (Copyright Act, § 101). An avatar can be viewed as a selection and arrangement of components provided by the game developer, in which case the player would be considered the author through his or her lawful selection and arrangement and may claim copyright (Copyright Act, § 201(c)). Thus, the game developer owns the program and audiovisual content copyrights (created by employee-programmers as work made for hire), while the program delivers to players the raw materials for avatar creation. A player selects from these materials, arranging them in an original, creative way to form an avatar (a compilation) that is then contributed to the MMO (a collective work). Viewed in this way, developers would enjoy a default statutory privilege to use the avatar in certain ways, but players could arguably enforce their avatar copyrights outside of the game.

THE VALUE AND FUTURE OF AVATAR OWNERSHIP

The previous discussion begs a question: *should* copyright law provide rights to players? Consider the question in light of the two principal rationales for copyright protection: the utilitarian model (predominant in common-law countries) and the natural-rights model (predominant in civil-law countries). On one hand, the utilitarian perspective posits that copyright exists to benefit the public by encouraging (through rights and economic protections) the creation and distribution of new literary and artistic works (e.g., *Harper & Row Publishers, Inc. v. Nation Enterprises*,

1985). Copyrights and patents may be granted to "promote the Progress of Science and useful Arts, by securing for limited Times to Authors and Inventors the exclusive right to their respective Writings and Discoveries" (U.S. Constitution, Art. I, § 8, cl.8). This view suggests that only game developers should be owners of avatars, since the creation of MMOs is the type of capital-intensive endeavor which most heavily relies on the financial incentive provided by copyright ownership. The game engine, the character-creation system, and the avatar's integration with the gameworld all require significant investment to create. Developers often rely on monetization of these properties through other media forms to cover development and maintenance costs, and the development of such derivative works could be inhibited if players could assert copyright claims to avatars. Conversely, players do not require monetary incentives to create avatars—they do it for entertainment, and often pay for the right to do it.

On the other hand, the natural-rights perspective suggests that one has a natural right to profit from the products of one's artistic labors (Locke, 1690). In this vein, the Universal Declaration of Human Rights (1948) states that "[e]veryone has the right to the protection of the moral and material interests resulting from any scientific, literary or artistic production of which he [or she] is the author" (Article 27). From this perspective, players should indeed own their avatars, as they have invested time, money, and creative effort into the avatar through customization and gameplay, and so deserve to be compensated if that investment is exploited by another. In other words, it would be unfair for game companies to benefit from player labor without compensation. In tandem, however, both perspectives advise against considering MMOs as joint works and avatars as derivative works, because these framings would not accurately reflect both companies' and individuals interests and would disrupt commercial dealings relative to those interests. Instead, each avatar should be considered a joint work (jointly owned by the player and the game provider) that is a contribution to a collective work, the MMO (Ochoa, 2012). The fact that this proposed solution is an imperfect fit, however, highlights how the theoretical and practical dimensions of interactive media content ownership are not easily and neatly aligned.

It is likely that as videogame play and other forms of interactive media use become more complex—through technological advances like virtual reality, social evolutions such as user literacies, and industry shifts toward specific content and sales models—so too will issues of authorship and ownership become more complex. For instance, as game programming becomes a mainstream skill set, how does one parse out the integration of platform-delivered code with player-created code, as with the complex compilations of game-native and user-crafted items composing avatars in *Second Life* (2003) and *High Fidelity* (2013)? And how might we untangle authorship and ownership of fixed works like Twitch gameplay streams, that draw on content from game companies, engaged creatively by players, but

are fixed by streaming companies? And might avatars themselves at some point deserve authorship credit, given impending advances in artificial intelligence? These and other unexpected collaborative authorship and ownership dilemmas will undoubtedly arise, requiring both theoretical and practical evaluations of these dynamics in ways that protect the interests of players, developers, and avatars alike.

REFERENCES

Berkla v. Corel Corp., 66 F. Supp. 2d 1129, 1133 (E.D. Cal. 1999), *aff'd on other grounds*, 302 F.3d 909 (9th Cir. 2002).

Blizzard. (2012). World of Warcraft Terms of Use. Retrieved from: <http://us.blizzard.com/en-us/company/legal/wow_tou.html> (last visited March 24, 2017)

Copyright Act of 1976, as amended, 17 U.S.C. §§ 101 et seq.

DBlow2003. (2014). Leeroy Jenkins HD (high quality) [video]. Retrieved from: <https://www.youtube.com/watch?v=hooKVstzbz0> (originally posted in 2005)

Feist Publications, Inc. v. Rural Telephone Service Co., 499 U.S. 340, 345 (1991).

Gaiman v. McFarlane, 360 F.3d 644, 659-61 (7th Cir. 2004).

Harper & Row Publishers, Inc. v. Nation Enters., 471 U.S. 539, 558 (1985).

Hughes, J. (2005). Size matters (or should) in copyright law. *Fordham Law Review, 74*(2), 575–637.

Incredible Technologies, Inc. v. Virtual Technologies, Inc., 400 F.3d 1007, 1013-14 (7th Cir. 2005).

Lemley, M. A. (1999). Beyond preemption: The law and policy of intellectual property licensing. *California Law Review, 87*(1), 111–172.

Locke, J. (1690/1988). Second treatise of government. In P. Laslett (Ed.), *Two treatises of government.* Cambridge: Cambridge University Press.

Marvel Characters, Inc. v. Simon, 310 F.3d 280, 288 (2d Cir. 2002).

Midway Manufacturing Co. v. Artic International, Inc., 704 F.2d 1009, 1011 (7th Cir. 1983).

Ochoa, T. T. (2012). Who owns an avatar? Copyright, creativity, and virtual worlds. *Vanderbilt Journal of Entertainment and Technology Law, 14*, 959–991.

Stern Electronics, Inc. v. Kaufman, 669 F.2d 852, 855 n.4 (2d Cir. 1982).

Steuer, J. (1992). Defining virtual reality: Dimensions determining telepresence. *Journal of Communication, 42*(4), 73–93.

Universal Declaration of Human Rights (1948). G.A. Res. 217 (III) A, U.N. Doc. A/RES/217(III).

U.S. Constitution, Art. I, § 8, cl. 8.

U.S. Copyright Office. (2014). *Compendium of copyright office practices*, 3rd Ed.

Walt Disney Productions v. Air Pirates, 581 F.2d 751, 755 (9th Cir. 1978).

Spencer, C., & Moore, R. (2012). *Wreck-It Ralph* [motion picture]. United States: Walt Disney Pictures.

Contributors

Changhyun Ahn (M.A., Cleveland State University) is a doctoral student of communication at University at Buffalo, The State University of New York. His favorite videogame avatar is Geralt of Rivia from *The Witcher 3: Wilde Hunt*, who has a kindness buried deep in his heart that causes him suffering as he fights evil, often forcing him to make morally difficult decisions.

Sun Joo (Grace) Ahn (Ph.D., Stanford University) is associate professor of advertising at the Grady College of Journalism and Mass Communication, University of Georgia, and the director of the Games and Virtual Environments Lab. (@sunjooahn)

Roger Altizer, Jr. (Ph.D., University of Utah) is co-founder of the Entertainment Arts and Engineering program, director of Digital Medicine for the Center for Medical Innovation, founding director of The GApp lab (Therapeutic Games and Apps), and associate professor in population health sciences. His favorite videogame avatar was his *Phantasy Star Online* ranger android named 8675309 who not only proved to him that console MMO's can be great but that not everyone remembers Jenny's phone number. (@real_rahjur)

Kristine Ask (Ph.D., Norwegian University of Science and Technology Studies [NTNU]) is assistant professor of Science and Technology Studies at NTNU. Her favorite videogame avatar is a dwarven priest with an attitude named Kanita from *World of Warcraft*, that she spent years of play and research with. (@kristineask)

Jaime Banks (Ph.D., Colorado State University) is assistant professor of communication studies at West Virginia University, and is a research associate with WVU's Interaction Lab (#ixlab). Her favorite videogame avatar is her original *World of Warcraft* hunter, Shauxna, who (with spirit bear, Talitha) illuminated questions that launched her down the path to videogame studies. (@amperjay)

Nicholas David Bowman (Ph.D., *Michigan State University*) is associate professor in communication studies at West Virginia University and is the lab director of WVU's Interaction Lab (#ixlab). Among his favorite avatars is the always-balanced Ryu from *Street Fighter* (which he's played for nearly 28 years) and his self-created first-baseman Niko Mangosteen from *MLB The Show* franchise (where he hopes to soon receive the call-up from AAA to MLB). (@bowmanspartan)

Ryan Bown (MFA, University of Utah) is assistant professor (lecturer) of entertainment arts and engineering at University of Utah and associate at the GApp Labb in the School of Medicine at The UoU. His favorite videogame avatar is the Master Chief, from *Halo: Combat Evolved*, which allowed players to assume the identity of the faceless protagonist.

Andy Boyan (Ph.D., Michigan State University) is assistant professor of communication studies at Albion College. His favorite videogame avatar is Xiaoyu from *Tekken 3*, because of the pure satisfaction of making opponents miss again and again until their controller was thrown across the room. (@andyboyan)

David Calvo is a self-taught, award-winning French writer and game designer. His favorite videogame avatar is Zak McKracken from *Zak McKracken and the Alien Mindbenders*, because he knows how to play kazoo. (@metagaming)

Mark Chen (Ph.D., University of Washington) is an independent games scholar and designer and part-time professor of interaction design, qualitative research, and games studies at University of Washington Bothell and Pepperdine University. His favorite avatar is the accidental hero, Thoguht, who he brings out of retirement whenever the need is dire. (@mcdanger)

Edward Downs (Ph.D., Pennsylvania State University) is associate professor in the Department of Communication at University of Minnesota Duluth, and director of the Communication Research Lab. His favorite videogame character is Crash from the *Crash Bandicoot* series, because Crash is the perfect mix of awkward and awesome all in one.

James M. Falin (M.A., Michigan State University) is a doctoral student at University of California, Davis, and research associate with UCD's VICTR Lab. His favorite videogame avatar is his original *Final Fantasy XIV* Dragoon/Warrior/Scholar,

Vesperlyn Hayle, who has led him to investigate relationships in virtual spaces. (@Varizen87)

Jesse Fox (Ph.D., Stanford University) is assistant professor in the School of Communication at The Ohio State University and director of the Virtual Environment, Communication Technology, and Online Research (VECTOR) Lab. Her favorite avatar is Nuna and the fox from *Never Alone* because of a strong and resilient female protagonist and, well, a fox. (@CommFox)

Matthew Grizzard (Ph.D., Michigan State University) is assistant professor of communication at University at Buffalo, The State University of New York. His favorite videogame avatar is John Marston from Red Dead Redemption, whose death caused him to save the game just prior to the final mission so that John will always remain a playable character. (@MattGrizz)

D. Fox Harrell (Ph.D., *University of California, San Diego*) is professor of digital media in both the Comparative Media Studies Program and the Computer Science and Artificial Intelligence Laboratory (CSAIL) at MIT. His favorite avatar was his custom member of the Light Wizards' Guild from *Alternate Reality: The Dungeon*—the avatar was not depicted onscreen, it only ever appeared as meticulously illustrated in a long-lost sketchpad. (@ICELabMIT)

Mark R. Johnson (Ph.D., University of York) is postdoctoral fellow in the Science and Technology Studies Unit at the University of York, and researcher in residence at the UK Digital Catapult. His favorite videogame avatar is the Chosen Undead from the original *Dark Souls*, whose first exploration of Lordran was one of the most thoughtful and beautiful gaming experiences he could imagine. (@UltimaRegum)

Rhys Jones (M.Sc., The Hong Kong Polytechnic University) is a research associate assisting with the game stream of the M.Sc. in Multimedia and Entertainment Technology program in the Hong Kong Polytechnic University. His favorite videogame avatar is Sackboy from LittleBigPlanet, who he spent many hours with playing, creating, and sharing levels for others to enjoy.

Dominic Kao (M.S.E., Princeton University) is a doctoral candidate at MIT in the Electrical Engineering and Computer Science program. One of his favorite game avatars is Cloud Strife from the *Final Fantasy* series, whose ability to wield a giant sword always impressed him.

Isaac Knowles (M.S., Louisiana State University) is a doctoral candidate in The Media School at Indiana University and a data analyst working at Epic Games, Inc. His favorite avatar belongs to the n00b he's got centered in his sights …

Peter Kudenov (M.A., University of Alaska Anchorage) is a doctoral student in communications, rhetoric, and digital media at North Carolina State

University. His favorite character is the Vault Dweller from the original *Fallout*.

Nicolle Lamerichs (Ph.D., HU University of Applied Sciences Utrecht) is senior lecturer and head of media at the bachelor program international communication and media. Her favorite videogame avatar is *Bayonetta* from the titular game, as she is kinky, clever, and always in control of her own sexuality and social life. (@Setsuna_C)

Marc Erich Latoschik (Dr., Bielefeld University) is full professor for Human-Computer Interaction and chair for Computer Science IX at the University of Würzburg.

Anthony Limperos (Ph.D., Penn State University) is assistant professor of communication and the founder/director of the Video Game Research Lab at the University of Kentucky. His favorite videogame avatar is the character Wario because of his devious personality, moustache, and the fact he is the most lovable villain in Nintendo history.

Jean-Luc Lugrin (Ph.D., Teeside University) is assistant professor for Human-Computer Interaction at Würzburg University.

Teresa Lynch (Ph.D., Indiana University) is assistant professor of Communication at The Ohio State University. Her favorite videogame avatar is her *Elder Scrolls V: Skyrim* witch, Olawan, whose combined abilities in potion making and fire magic make for many vanquished foes and tasty stews. (@teresa_lynch)

Nicholas L. Matthews (Ph.D., Indiana University) is visiting professor of communication at The Ohio State University. His favorite avatar is Kahleed Shepard from *Mass Effect* because his egalitarian philosophy and indomitable drive to discover the unknown helped order a galaxy in chaos. (@_nicmatthews)

John Carter McKnight (J.D., New York University; Ph.D. Arizona State University) is assistant professor of sociology of emerging technologies at Harrisburg University of Science and Technology. His favorite videogame avatar is Captain Kastian Quandry in *Star Trek Online*, whose five-year mission in a roleplaying team has led to endless trauma, humor, snark, and NPC romance. (@john_carter)

Oskar Milik (Ph.D., University College Dublin) is an occasional lecturer at UCD. His favorite avatar is his warrior in *World of Warcraft*, where he has helped and participated with competitive raiding guilds for years. (@lordskar)

Kristine L. Nowak (Ph.D., Michigan State University) is associate professor and HCI Lab director at the University of Connecticut. Her favorite avatar

is Clippy from Microsoft Office because interacting with him in graduate school inspired her research on the influence of avatars.

Casey O'Donnell (Ph.D., Rensselaer Polytechnic Institute) is associate professor in the Department of Media and Information at Michigan State University. His favorite avatar will always be Samus Aran of Metroid. (@caseyodonnell)

Tyler T. Ochoa (J.D., Stanford University) is professor with the High Tech Law Institute at Santa Clara University School of Law. His children and his students got him interested in writing about avatars, as he currently does not have any avatars of his own.

Gabe Olson (MFA, University of Utah) is assistant professor (lecturer) of entertainment arts and engineering at University of Utah and associate at the GApp Labb in the School of Medicine at The UoU. (@melvinsqualor)

Christopher A. Paul (Ph.D., University of Minnesota) is associate professor and chair of the Communication Department at Seattle University. His favorite avatar related gaming moment was when in *NBA2K* when his Chris Paul blocked the shot of that other Chris Paul and sent him out of the game with a knee injury. (@real_chris_paul)

Jorge Peña (Ph.D., Cornell University) is associate professor of communication at University of California, Davis and is director of UCD's VICTR lab. His favorite avatar is the Latino "Comandante" Shepard he designed for *Mass Effect 2*. It was he that saved the galaxy; accept no substitutes.

Sita Popat (Ph.D., University of Leeds) is professor of performance and technology at the University of Leeds. Her favorite videogame avatar is Sorda, a gnome priest in *World of Warcraft*, with whom first she discovered that virtual worlds can be "here" as much as "there." (@sitapopat)

Rabindra A. Ratan (Ph.D., University of Southern California) is assistant professor in the Department of Media and Information at Michigan State University. His favorite recent avatar is his Rocket League vehicle, which happens to be Sweet Tooth from *Twisted Metal*, because nostalgia (and functional congruency). (@raratan)

William Robinson (M.A., Concordia University) is a doctoral candidate at Concordia University's Centre for Technoculture, Art and Games (TAG). His favorite videogame avatar is *DotA 2*'s Pugna, whose continually misunderstood strategic role and technical complexity has challenged him to think about the intersections of the social and the tactical. (@DangerWillRobin)

Daniel Roth (M.E., University of Applied Sciences, Cologne) is research assistant at the Human-Computer Interaction Group of the University of Würzburg.

His favorite avatar is Sarge, which he played in *Quake III CPMA* because he looked best carrying both railgun and cigar. (@rothnroll).

Nathan Stevens (University of Kentucky) is the College of Communication and Information media officer and managing editor for Digitalchumps.com. His favorite videogame avatar is Gillian Seed, an intriguing Blade Runner-esque character in a futuristic Tokyo setting featured in Hideo Kojima's classic 1990s game *Snatcher*. (@digitalchumps)

John A. Velez (Ph.D., The Ohio State University) is assistant professor at Texas Tech University. His favorite videogame avatar is Master Chief from the *Halo* franchise due to the chief's individual role in saving the universe while being universally relatable to the individual player.

Sebastian von Mammen (Ph.D., University of Calgary; habilitation, University of Augsburg) is associate professor of games engineering at the University of Würzburg. Eventually, his favorite avatar will be myriads of agents that he commands solely by means of his will power.

Hanna Wirman (Ph.D., University of the West of England) is research assistant professor at the School of Design of the Hong Kong Polytechnic University where she leads the M.Sc. study stream in game development; she also serves as President of Chinese DiGRA. Her favorite videogame avatar is Princess Peach whose damsel in distress role is questioned in numerous alternative works created by fans. (@hannawirman)

Ludography

Adventure. (1980). Sunnyvale, CA, USA: Atari.

Alien Hominid. (2004). San Diego, CA, USA: The Behemoth.

Aliens Total Conversion. (1994). Independent Publisher Justin Fisher.

Angry Birds. (2009). Keilaniemi, Espoo, Finland: Rovio Entertainment.

Asteroids. (1979). Sunnyvale, CA, USA: Atari.

Baldur's Gate. (1998). Edmonton, Canada: BioWare.

Batman: Arkham Asylum. (2009). London, UK: Rocksteady Studios.

Batman: Arkham VR. (2016). Burbank, CA, USA: Warner Bros. Interactive.

Battlefield 1. (2016). Stockholm, Sweden: EA DICE.

Battlezone. (1980). Sunnyvale, CA, USA: Atari.

Bayonetta. (2009). Osaka, Japan: PlatinumGames.

Beat 'Em & Eat 'Em. (1982). US: Mystique.

Bioshock. (2007). Cambridge, MA, USA: 2K.

Black Desert Online. (2014). Korea: Pearl Abyss.

Borderlands. (2009). Plano, TX, USA: Gearbox Software.

Botanicula. (2012). Brno, Czech Republic: Amanita.

Braid. (2008). Berkeley, CA, USA: Number None, Inc.

Call of Duty: Modern Warfare 2. (2009). Woodland Hills, CA, USA: Infinity Ward.

Candy Crush Saga. (2012). London, UK: King.

Castle Smurfenstein. (1983). Dead Smurf Software.

Castle Wolfenstein. (1981). Baltimore, MD, USA: Muse Software

City of Heroes. (2004). Los Gatos, CA, USA: Cryptic Studios; Mountain View, CA, USA: Mountain View Studios.

Civilization. (1991). Hunt Valley, MD, USA: MicroProse, et al.

Civilization IV. (2005). Sparks, MD, USA: Firaxis Games.

Clash Royale. (2016). Helsinki, Finland: Supercell.

Climb, The. (2016). Frankfurt, Germany: Crytek.

Conan Exiles. (2017). Oslo, Norway: Funcom.

Counter-Strike: Global Offensive. (2012). Bellevue, WA, USA: Valve.

Custer's Revenge. (1982). US: Mystique.

Dance Central 3. (2012). Cambridge, MA, USA: Harmonix.

Dark Souls. (2011). Tokyo, Japan: FromSoftware.

Dark Souls III. (2016). Tokyo, Japan: FromSoftware.

DayZ. (2013). Prague, Czech Republic: Bohemia Interactive.

DC Universe Online. (2011). San Diego, CA, USA: Daybreak.

Dead or Alive: Xtreme Beach Volleyball. (2003). Tokyo, Japan: Team Ninja.

Demon's Souls. (2009). Tokyo, Japan: FromSoftware.

Destiny. (2014). Chicago, IL, USA: Bungie.

Deus Ex. (2000). Dallas, TX, USA: Ion Storm.

Deus Ex: Human Revolution. (2011). Dallas, TX, USA: Ion Storm.

Deus Ex: Invisible War. (2003). Dallas, TX, USA: Ion Storm.

Diablo. (1996). San Mateo, CA: Blizzard North.

Diablo 2. (2000). San Mateo, CA: Blizzard North.

Diablo 3. (2012). Irvine, CA, USA: Blizzard Entertainment.

Digimon World. (2000). Tokyo, Japan: Bandai.

Dishonored. (2012). Rockville, MD, USA: Bethesda Softworks.

Donkey Kong. (1981). Kyoto, Japan: Nintendo.

Doom. (1993). Mesquite, TX, USA: id Software.

Doom II. (1994). Dallas, TX, USA: id Software

DotA 2. (2013). Bellevue, WA, USA: Valve.

Dragon's Dogma. (2012). Osaka, Japan: Capcom.

Duke Nukem 3D. (1996). Garland, TX, USA: 3D Realms.

Dungeons & Dragons [Tabletop]. (1974). G. Gygax & D. Arneson.

Elder Scrolls III: Morrowind, The. (2002). Rockville, MD, USA: Bethesda Softworks.

Elder Scrolls IV: Oblivion, The. (2006). Rockville, MD, USA: Bethesda Softworks.

Elder Scrolls V: Skyrim, The. (2011). Rockville, MD, USA: Bethesda Softworks.

EVE: Valkyrie. (2016). Reykjavik, Iceland: CPP Games.

EVE Online. (2003). Reykjavik, Iceland: CCP Games.

EverQuest. (1999). San Diego, CA, USA: Sony.

Fable. (2004). Guilford: Big Blue Box Studios; London: Lionhead Studios.

Fallout 3. (2008). Rockville, MD, USA: Bethesda Softworks.

Fallout 4. (2015). Rockville, MD, USA: Bethesda Softworks.

Far Cry Primal. (2016). Montreal, Canada: Ubisoft.

Farmville. (2009). San Francisco, CA, USA: Zynga.

FIFA 17. (2016). Burnaby, BC, Canada: EA Canada.

Final Fantasy. (1987). Tokyo, Japan: Square.

Final Fantasy VII. (1997). Tokyo, Japan: Square.

Final Fantasy X-2. (2003). Tokyo, Japan: Square.

Final Fantasy XIV. (2010). Tokyo, Japan: Square Enix.

Final Fantasy XV. (2016). Tokyo, Japan: Square Enix.

Garry's Mod. (2004). Walsall, England: Facepunch Studios.

Gears of War. (2006). Cary, NC, USA: Epic Games.

Gimme Five. (2017). United Kingdom: shuboarder.

God of War. (2005). Santa Monica, CA, USA: SIE et al.

Gran Turismo. (1997). Tokyo, Japan: Polyphony Digital.

Grand Theft Auto: San Andreas. (2004). Edinburgh, Scotland: Rockstar North.

Grand Theft Auto V. (2013). Edinburgh, Scotland: Rockstar North.

Half-Life. (1998). Bellevue, WA, USA: Valve.

Half-Life 2. (2004). Bellevue, WA, USA: Valve.

Halo: Combat Evolved. (2001). Bellevue, WA, USA: Bungie.

Halo 2. (2004). Bellevue, WA, USA: Bungie.

Halo 3. (2007). Bellevue, WA, USA: Bungie.

Hearthstone. (2014). Irvine, CA, USA: Blizzard Entertainment.

Hey You, Pikachu! (1998). Kyoto, Japan: Nintendo.

Infamous. (2009). Bellevue, WA, USA: Sucker Punch Productions.

Journey. (2012). Los Angeles, CA, USA: Thatgamecompany.

Lara Croft: Tomb Raider. (2001). Derby, England: Core Design, et al.

Last of Us, The. (2013). Santa Monica, CA, USA: Naughty Dog.

League of Legends. (2009). Los Angeles, CA, USA: Riot Games.

Legacy of Kain: Soul Reaver. (1999). Redwood City, CA, USA: Crystal Dynamics.

Legend of Zelda, The. (1986). Kyoto, Japan: Nintendo.

Legend of Zelda: Ocarina of Time, The. (1998). Kyoto, Japan: Nintendo.

Legend of Zelda: A Link to the Past, The. (1991). Kyoto, Japan: Nintendo.

Leisure Suit Larry. (1987). Oakhurst, CA, USA: Sierra.

Limbo. (2010). Copenhagen, Denmark: Playdead.

LittleBigPlanet. (2008). Guildford, Surrey, UK: Media Molecule.

Marble Madness. (1984). Sunnyvale, CA, USA: Atari.

Mario Bros. (1983). Kyoto, Japan: Nintendo.

Mario Kart. (1992). Kyoto, Japan: Nintendo.

Mario Kart Wii. (2008). Kyoto, Japan: Nintendo.

Mass Effect. (2007). Edmonton, Canada: BioWare.

Mass Effect 3. (2012). Edmonton, Canada: BioWare.

Mega Man. (1987). Osaka, Japan: Capcom.

Metal Gear Solid IV. (2008). Tokyo, Japan: Kojima.

Metroid. (1986). Kyoto, Japan: Nintendo.

Mike Tyson's Punch-Out!! (1987). Kyoto, Japan: Nintendo.

Minecraft. (2011). Stockholm, Sweden: Mojang.

Mirror's Edge. (2008). Stockholm, Sweden: EA Dice.

Monopoly. (1935). E. Magie & C. Darrow.

Mortal Kombat. (1992). Chicago, IL, USA: Midway Games.

Mortal Kombat: Deadly Alliance. (2002). Chicago, IL, USA: Midway Games.

Mortal Kombat X. (2015). Chicago, IL, USA: Midway Games.

Ms. Pac-Man. (1981). Chicago, IL, USA: Midway Games.

MUD. (1978). R. Trubshaw and R. Bartle.

Myst. (1993). Mead, WA, USA: Cyan Worlds.

NBA 2K16. (2015). Novato, CA, USA: Visual Concepts.

Neverwinter Nights. (2002). Edmonton, Canada: BioWare.

Nuclear Throne. (2015). Utrecht, The Netherlands: Vlambeer.

Octodad: Dadliest Catch. (2014). Edmonton, Canada: BioWare.

Overwatch. (2016). Irvine, CA, USA: Blizzard Entertainment.

Pac-Man. (1980). Tokyo, Japan: Namco.

Pokémon Red/Blue. (1998). Tokyo: Game Freak.

Pokémon GO. (2016). San Francisco, CA, USA: Niantic.

Pong. (1972). Santa Clara, CA, USA: Atari

Portal. (2007). Bellevue, WA, USA: Valve.

Portal 2. (2011). Bellevue, WA, USA: Valve.

*Q*Bert.* (1982). Sunnyvale, CA, USA: Atari.

Quake. (1996). Mesquite, TX, USA: id Software.

QWOP. (2009). Oxford, MA, USA: Foddy.net.

RAGE. (2011). Richardson, TX, USA: id Software.

Resident Evil. (1996). Osaka, Japan: Capcom.

Rocket League. (2015). San Diego, CA, USA: Psyonix.

Rogue Legacy. (2013). Toronto, Canada: Cellar Door Games.

RuneScape. (2001). Cambridge, England: Jagex.

San Francisco Rush: Extreme Racing. (1997). Chicago, IL, USA: Midway Games.

Saint's Row: The Third. (2011). Champaign, IL, USA: Volition.

Scrap Mechanic. (2016). Stockholm, Sweden: Axolot Games.

Second Life. (2003). San Francisco, CA, USA: Linden Lab.

Settlers Online, The. (2012). Düsseldorf, Germany: Blue Byte.

Shadowgate. (1987). Wheeling, IL, USA: ICOM Simulations.

Skylanders. (2011). Novato, CA, USA: Toys for Bob, et al.

Spacewar! (1962). Boston, MA, USA: S. Russell.

Spore. (2008). Redwood City, CA, USA: EA Maxis.

Star Fox. (1993). Kyoto, Japan: Nintendo.

Starcraft 2. (2010). Irvine, CA, USA: Blizzard Entertainment.

Silent Hill. (1999). Tokyo, Japan: Konami.

SimCity. (1989). Redwood Shores, CA, USA: Maxis.

Simpsons Game, The. (2007). Redwood Shores, CA, USA: Visceral.

Sims, The. (2000). Redwood Shores, CA, USA: Maxis.

The Sims 3, The. (2009). Redwood Shores, CA, USA: Maxis.

Sims 4, The. (2014). Redwood Shores, CA, USA: Maxis.

Star Trek Online. (2010). Los Gatos, CA, USA: Cryptic.

Star Wars: Knights of the Old Republic. (2003). Edmonton, Alberta, Canada: BioWare.

Star Wars: Knights of the Old Republic II. (2004). Irvine, CA, USA: Obsidian.

Star Wars: The Old Republic. (2011). Edmonton, Alberta, Canada: BioWare.

Street Fighter II. (1991). Osaka, Japan: Capcom.

Superbrothers: Sword & Sworcery EP. (2011). Toronto, Canada: Capybara Games, et al.

Super Mario 64. (1996). Kyoto, Japan: Nintendo.

Super Mario World. (1990). Kyoto, Japan: Nintendo.

Super Mario Bros. (1985). Kyoto, Japan: Nintendo.

Super Mario Bros. 3. (1988). Kyoto, Japan: Nintendo.

Super Mario Run. (2016). Kyoto, Japan: Nintendo.

Super Metroid. (1994). Kyoto, Japan: Nintendo.

Super Smash Bros. (1999). Kyoto, Japan: Nintendo.

Surgeon Simulator 2013. (2013). London, England: Bossa Studios.

Table Tennis. (1972). Napa, CA, USA: Magnavox.

Tamagotchi. (1996). Tokyo, Japan: Bandai.

Team Fortress 2. (2007). Bellevue, WA, USA: Valve.

Tearaway: Unfolded. (2015). Malmö, Sweden: Tarsier, et al.

Temple Run. (2011). Raleigh, NC, USA: Imangi Studios.

Tennis for Two. (1958). Upton, MA, USA: W. Higinbotham.

Tetris. (1984). Russia: A. Pajitnov.

That Dragon, Cancer. (2016). Indianola: Numinous Games.

Toribash. (2006). Singapore: Nabi Studios.

Unreal. (1998). Cary, NC, USA: Epic, et al.

Virtua Fighter. (1993). Tokyo, Japan: SEGA.

Wii Sports. (2006). Kyoto, Japan: Nintendo.

Wolfenstein 3D. (1992). Mesquite, Texas, USA: id Software.

World of Goo. (2008). San Francisco, CA, USA: 2D Boy.

World of Warcraft. (2004). Irvine, CA, USA: Blizzard Entertainment.

X-COM: UFO Defense. (1994). Harrow, England: Mythos Games; Hunt Valley, MD, USA: MicroProse.

XCOM: Enemy Unknown. (2012). Hunt Valley, MD, USA: Firaxis Games.

Xenoblade Chronicles X. (2015). Tokyo, Japan: Monolith Soft.

Zaxxon. (1982). Tokyo, Japan: SEGA.

Zork. (1979). Cambridge, MA, USA: Infocom.

Index

Q*Bert, 260
Quake, 85, 248
Queering the narrative, 140–141
Quest logs, 200–202, 204
QWOP, 250–251

Racial bias reduction, 37
Racial identity, 34
Racism in digital environments, 34, 37
Ragdoll physics, 248
RAGE game, 275
RAGE tool kit, 275
Raids, in *World of Warcraft,* 181
Ratan, Rabindra A., 97
Ray casting, 212
Real-Money Auction House, 90
Real-money auction house (RMAH), 92, 95
Real-time interactive system (RIS), 282, 283
Relationships of avatars, 127–132. *see also*
 Player-avatar relationships
Reputations of avatars, 132–134, 191–192
Resources, 197–200
Retro graphics, 230
Retro-styled pixel art games, 226
Ritual quitting, 17–18
Robinson, William, 89
Rocket League, 267
Rogue Legacy, 17
Role, avatar, 187, 188–194
Role model avatars, 241–242
Roleplaying
 cosplay *vs.,* 148
 voice chat services, 63–67
Roleplaying games, 2. *see also* individual names
 of games
 alignment systems in, 108–110
 character class in, 188
 factions in, 111
 headcanon and, 141–142
 resource and inventory systems, 198
 usernames, 82
 voice in, 64–65
Roleplay talk, 63
Rolsten, Ken, 62
Roth, Daniel, 281
Rovio, 249

Rules
 avatars and, 160–161
 character class and role helping to establish, 187
 in emergent play, 162–163
 interactivity with mechanics, 163–164
 mechanics *vs.,* 159–160, 163
 over resources and inventories, 197
 reflecting fictions of a game, 198
RuneScape, 192
Russell, Steve, 247

Safety training courses, 29–30
Saints Row, 24
Saints Row: The Third, 61, 66
Sandboxes, physics-based, 253
Sandbox-style, 260
San Francisco Rush: Extreme Racing, 14
Satisfying goal progress, 170–172
Saturday Morning Breakfast Cereal, 120
Save-anywhere technology, 15–16
Schell, Jesse, 130
Schreiber, William F., 227
Schulz, Ben, 291
Science and technology studies (STS), 271–272
Scientist avatars, 242
Scrap Mechanic, 249
Scripting languages, 268–269, 278
Second Life, 18–19, 53–54, 73, 90, 93–95, 98, 104–105, 198, 203, 242, 267, 297
Seductive details, 238
Sein (being), 258–259
Self-affirmation, achievement-based, 173–176
Self-affirmation theory, 173–174
Self-awareness, 59
Self-congruency, 101–104
Self-determination theory, 172–173
Self-expression, 26, 95, 98
"Selfies," 58
Self-objectification, 48
Self-similar embellishment, 241–242
Semi-autonomous digital companions, 99–101
Sense of control
 control schemes and, 286

General Editor: **Steve Jones**

Digital Formations is the best source for critical, well-written books about digital technologies and modern life. Books in the series break new ground by emphasizing multiple methodological and theoretical approaches to deeply probe the formation and reformation of lived experience as it is refracted through digital interaction. Each volume in **Digital Formations** pushes forward our understanding of the intersections, and corresponding implications, between digital technologies and everyday life. The series examines broad issues in realms such as digital culture, electronic commerce, law, politics and governance, gender, the Internet, race, art, health and medicine, and education. The series emphasizes critical studies in the context of emergent and existing digital technologies.

Other recent titles include:

Felicia Wu Song
 Virtual Communities: Bowling Alone, Online Together

Edited by Sharon Kleinman
 The Culture of Efficiency: Technology in Everyday Life

Edward Lee Lamoureux, Steven L. Baron, & Claire Stewart
 Intellectual Property Law and Interactive Media: Free for a Fee

Edited by Adrienne Russell & Nabil Echchaibi
 International Blogging: Identity, Politics and Networked Publics

Edited by Don Heider
 Living Virtually: Researching New Worlds

Edited by Judith Burnett, Peter Senker & Kathy Walker
 The Myths of Technology: Innovation and Inequality

Edited by Knut Lundby
 Digital Storytelling, Mediatized Stories: Self-representations in New Media

Theresa M. Senft
 Camgirls: Celebrity and Community in the Age of Social Networks

Edited by Chris Paterson & David Domingo
 Making Online News: The Ethnography of New Media Production

To order other books in this series please contact our Customer Service Department:
 (800) 770-LANG (within the US)
 (212) 647-7706 (outside the US)
 (212) 647-7707 FAX

To find out more about the series or browse a full list of titles, please visit our website:
 WWW.PETERLANG.COM